PAINTING THE TEXT

The Bible in the Modern World, 8

Series Editors
J. Cheryl Exum, Jorunn Økland, Stephen D. Moore

Editorial Board
Alison Jasper, Tat-siong Benny Liew, Hugh Pyper, Yvonne Sherwood,
Caroline Vander Stichele

PAINTING THE TEXT

The Artist as Biblical Interpreter

Martin O'Kane

SHEFFIELD PHOENIX PRESS

2009

Copyright © 2007, 2009 Sheffield Phoenix Press
First published in hardback 2007
First published in paperback 2009

Published by Sheffield Phoenix Press
Department of Biblical Studies, University of Sheffield
Sheffield S10 2TN

www.sheffieldphoenix.com

A CIP catalogue record for this book
is available from the British Library

Typeset by ISB Typesetting, Sheffield
Printed on acid-free paper by Lightning Source UK Ltd, Milton Keynes

ISBN 978-1-905048-36-6 (hardback)
ISBN 978-1-906055-92-9 (paperback)

ISSN 1747-9630

Contents

LIST OF ILLUSTRATIONS

LIST OF ABBREVIATIONS

BibInt	*Biblical Interpretation*
CBQ	*Catholic Biblical Quarterly*
JSNT	*Journal for the Study of the New Testament*
JSOT	*Journal for the Study of the Old Testament*
JSOTSup	*Journal for the Study of the Old Testament, Supplement Series*
NTS	*New Testament Studies*
SJOT	*Scandinavian Journal of the Old Testament*

PREFACE

Exploring the interrelationship between biblical text and image is nothing new. The biographers of the sixteenth-century Venetian painter, Jacopo Bassano, a prolific painter of biblical subjects, tell us that when fatigued by painting, the artist would resort to scriptural reading. Reading was his 'virtuous' activity, attuning him to the nuances and subtleties of the biblical narrative and enabling him to paint for his viewers a range of subjects, impressive in number and variety. The fifteenth-century Carmelite monk and artist, Fra Filippo Lippi, aware that his viewers were already familiar with many stories and events from the Bible, planned his images to be used as loose frameworks, enabling the individual to make a personalized range of associations and offering flexibility in determining and interpreting the meaning the biblical subject contained. The twentieth-century artist, Marc Chagall, for whom the Bible was 'the greatest work of art in the entire world', insisted that his biblical paintings were not intended simply to illustrate the text but to provide a commentary on it in the light of contemporary social and political events.

The essays contained in this volume explore how the visual interpretations of a number of texts from both the Old and New Testaments enrich our understanding and appreciation of the biblical narrative itself. In particular, they focus on how the nuances and subtleties contained in the narrative are frequently highlighted by the painter, allowing us to 'see' aspects of the text we may previously have been unaware of. I am grateful to The Continuum International Publishing Group for permitting me to include 'The Flight into Egypt' that first appeared in Martin O'Kane (ed.), *Borders, Boundaries and the Bible* (JSOTSup, 313, 2002) and to Koninklijke Brill N.V. for allowing me to reprint 'Picturing The Man of Sorrows' from *Religion and the Arts* (vol. 9.2, 2005) and 'The Artist as Reader of the Bible' from *Biblical Interpretation* (vol. 13.4, 2005).

I would like to express my gratitude to Professor J. Cheryl Exum, not only for her constant enthusiasm and support in the preparation and publication of this volume, but also for the inspiration and encouragement her own pioneering scholarship has given me, without which this volume would never have come into existence. My thanks are also due to The Barber Institute of

Fine Arts at the University of Birmingham, in particular its curator, Professor Richard Verdi, and Ms Yvonne Locke, Exhibitions Coordinator, who gave me so much time and help in locating several of the images included in this volume.

1

The Bible and the Visual Imagination

One of the irritating obstacles to the full incorporation of the arts into the generality of the work of the mind is the inability of the non-art people to see that art deals with fundamental issues. It is considered an enrichment of the human life, an extension of the forms of feeling, a symptom of movements of the mind (and therefore a diagnostic instrument) a reflection or illustration of ideas. It is not often considered a fundamental thinking about fundamental ideas.[1]

Visibility as a Literary Value

Everyone knows a painting, fresco or sculpture inspired by the Bible. It may be Michelangelo's *Creation* in the Sistine Chapel, his *David* sculpture in Florence, Rembrandt's *Bathsheba*, Leonardo's *Annunciation*, Botticelli's *Nativity*, or any one of a host of lesser-known artworks that portray biblical characters or events in striking and impressionable ways that so readily come to mind whenever we read or hear the corresponding biblical text. Visual images stir the imagination and we admire both the skill of the artists and the creative and original ways their artworks interpret and depict the narrative; yet there is a vital difference between the use of visual imagery to convey biblical stories to largely illiterate or semi-illiterate audiences, say in the period of the Middle Ages or the Renaissance, and the way we, as readers of the Bible today, can compare what the painting of a text visualizes with what the text itself actually says. Whereas earlier generations relied on the visual image— and the visual tradition represented by the artist—for their knowledge of the Bible, our starting point today is generally the written word. Even so, the written word, too, constantly exercises our imagination so that it is not only the artist, but in fact every reader who is invited to visualize in the mind's eye the colourful images and pictures so skilfully created by the biblical writers.

1. John W. Dixon, *Art and the Theological Imagination* (New York: Seabury Press, 1978), pp. 23-24.

Encouraged by scholars such as Alter and Fokkelman, we have now become more attuned to the Bible's literary subtleties and nuances—and less preoccupied with its theological perplexities—but we still pay scant attention to the visual imagery contained in the narrative and to the way its language is designed to appeal to the reader's visual imagination. Ignatius of Loyola, on the other hand, made a virtue of such practice: in his *Spiritual Exercises*, he urged his followers to engage in visual contemplation of biblical texts, 'to see from the view of the imagination' the physical place and characters of the scene, as Italo Calvino puts it:

> The believer was called upon personally to paint frescoes crowded with figures on the walls of his mind, starting out from the stimuli that his visual imagination succeeds in extracting from even the most laconic verse from the Gospels.[2]

Catholicism of the Counter-Reformation possessed a fundamental vehicle in its ability to use visual communication: through the emotional stimuli of sacred art, the believer was supposed to grasp the meaning of the verbal teachings and biblical doctrines of the Church. But it was always a matter of starting from a *given* image, one proposed and sanctioned by the Church and not 'imagined' by the individual believer. What distinguishes Ignatius's procedure is the shift from the word to the visual image as a way of attaining knowledge 'of the most profound meaning' and his attempt to open up a field of infinite possibilities in the way the individual imagination depicts biblical characters, places and scenes in motion.

In his *Six Memos for the Next Millennium*, Italo Calvino includes 'visibility' as an indispensable literary value that we must cherish but that we are fast in danger of losing.[3] The irony, he notes, is that in spite of being part of a culture characterized by the mass produced image,

> we run the danger of losing a basic human faculty: the power of bringing visions into focus with our eyes shut, of bringing forth forms and colours from the lines of black letters on a white page, and in fact of *thinking* in terms of images.[4]

In our highly visual world, Calvino warns, we have lost the capacity to visualize. The images we see and that influence us are those created by others: we have less need to, or are less inclined to, exercise our visual imagination to conjure up our own original images from the pages we read, an exercise that Ignatius rated so highly.

2. Italo Calvino, *Six Memos for the Next Millennium* (London: Random House, 1996), p. 86.
3. See his chapter on 'Visibility' in Calvino, *Six Memos*, pp. 81-99.
4. Calvino, *Six Memos*, p. 92.

Visibility as a fundamental literary value, in the way Calvino draws attention to it, is not something emphasized by contemporary biblical commentators. The impact of so many powerful and striking images in Hebrew narrative designed to create vivid pictures in the reader's mind remains, for the most part, unexplored—compared to the considerable interest shown in the role of the imagination across a wide range of theological and philosophical studies.[5] Yet it is the visual elements of the narrative that so often draw the reader into the immediacy of the scene and create a sense of empathy with its characters. Biblical commentators have explored 'visual' themes relating to light and darkness or sight and blindness in their various literal and metaphorical permutations and many art historians have published compilations of 'biblical' paintings; but little interest has been shown by either group in exploring how the visual imagery contained in the narrative itself exercises the reader's imagination, or how the processes at work in the way a viewer sees and reacts to a biblical painting might serve as a paradigm or model for the way a reader should engage with highly visual texts. The analysis of Velázquez's *Christ with Martha and Mary* by biblical critic, Philip Esler, and art historian, Jane Boyd, is the first major contribution in this area,[6] yet their methodology shows that they are interested primarily in comparing and contrasting the biblical story's social and cultural contexts with the artist's, rather than addressing the essential issues—namely, in what sense does the interaction between viewer and painting mirror the relationship between reader and text? What does an appreciation of a range of biblical paintings really add to our understanding of the text? These are the questions that the various essays contained in this volume seek to address.

In this initial chapter, I want first to draw attention to several important and recurrent aspects of visibility in biblical literature (rather than explore any specific biblical painting) and show how the emphasis on the visual forms a vital and frequently unifying role in the narrative. Second, I want to highlight the preoccupation, so evident throughout the Bible, that seeks to draw a clear distinction between what the reader is expected to see, and that which the biblical writers insist must always remain invisible, hidden and out of sight. Indeed, the ambiguities and paradoxes associated with visuality in the Bible are so complex that in many instances we can only begin to grasp

5. For example, in the writings of Paul Tillich, Hans Ur von Balthasar, Hans Küng and Immanuel Kant. See the two chapters in Michael Austin's *Explorations in Art, Theology and the Imagination* (London: Equinox, 2005) on 'Art and the Theologians', pp. 19-33 and 'Art and the Philosophers', pp. 51-71.

6. Jane Boyd and Philip F. Esler, *Visuality and the Biblical Text* (Florence: Leo S. Olschki Editore, 2004). See especially the section, 'Towards an Integrated Biblical/Visual Methodology', pp. 17-20.

their significance through the language of metaphor. Metaphor, with its capacity to conceal and hide as well as to reveal and disclose, enables the biblical authors to let us 'see' what we read, while at the same time shielding important details and characteristics, especially those relating to God, from our gaze, rendering them almost invisible or present to us only in dim and obscure ways. As I shall illustrate later in the chapter, it is only through the medium of metaphor that we can begin to understand and articulate the nuances and subtleties of visibility in the Bible. In addition, metaphor is fundamental not only to our understanding of language but also to our appreciation of the visual arts. It provides that common ground between text and image that helps us explore the parallel processes at work in the way a reader draws out the telling silences from a text, and the way a viewer draws out what lies hidden or subtly obscured in a painting. But to begin with, I want to explore how the intensely visual nature of biblical language influences the way we read and understand the narrative.

Visuality and its Ambiguities

From beginning to end the Bible abounds in vivid descriptions of landscapes, people and events, expressed in language designed to appeal to the reader's visual imagination. It opens with the image of God surveying all his work with the artisan's eye to detail in Genesis 1 and closes with John's dramatic vision of the new heaven and earth and the new Jerusalem coming down out of heaven from God in Revelation 21. The images we are expected to visualize in our mind's eye are vast in number and demanding in range: from the featureless desert plains of Exodus to the intricate processes of sowing and harvesting of dill and cumin in Isaiah 28, from the detailed description of Goliath in 1 Samuel 17 to the prophet's startling vision of strange otherworldly creatures in Ezekiel 1. The visual impact becomes even more striking when we look beyond specific texts and explore the overall effect created by the accumulation and interaction of visual images across large sections of literature such as the Pentateuch or the Book of Isaiah. The Pentateuch, for example, from its depiction of the creation of the universe in Genesis 1 to its closing panoramic view of the Promised Land in Deuteronomy 34, becomes a giant canvas on which is painted a whole series of contrasting landscapes— mountains, deserts and seas as well as the moon and stars of the heavens—all of which form an essential backdrop to the narrative. It is the description of the crossing of the Red Sea that creates such a visual impact on our reading of the Exodus story, the depiction of Mount Sinai that assures a sense of drama and otherworldliness, the image of desert barrenness that articulates the inner emotions and conflicts of the nomadic Israelites, the sight of the starry sky at night that convinces Abraham that he will be the father of

many[7] and the immediacy of the multi-coloured rainbow that illustrates so vividly the permanence and reliability of the rather abstract theological notion of covenant. The visual impact of the narrative is clearly conveyed in the Ashburnham Pentateuch, one of the earliest mediaeval illuminated manuscripts of the Old Testament, in which the main events of the narrative—the creation, the deluge, the sacrifice of Abraham and the crossing of the Red Sea—are given the greatest visual emphasis while the lesser narratives are presented as small vignettes crowded onto the page.[8]

Striking too is the way aspects we associate with visualization—and with the artistic mind—such as light, space and form are subtly nuanced for maximum effect by the author and how differing degrees of light and darkness, shade and reflection, set the scene and mood of the narrative. For example, the play of light and darkness in the story of Jacob wrestling with the angel is what makes the episode so mysterious and Jacob's adversary seem so obscure. While the wide plains of the desert suggest the spaciousness necessary for the travelling hordes on the Exodus journey, the enclosed space of Sarah's tent is more in keeping with the intimacy surrounding Isaac and Rebekah's marriage. It is hardly surprising, then, that the stories people remember best from the Bible are those that are most striking visually; furthermore, it may well have been the impact of the visual on the imagination of the author that provided the impulse to create the story in the first instance. In the Metaphor Seminar of the 2005 European Association of Biblical Studies conference, Gert Kwakkel argued convincingly that the visual images contained in many metaphors in prophetic literature, particularly those relating to 'the wings of Yahweh', were inspired directly by material artefacts.[9] In the light of this, the role of the visual imagination becomes an important factor for consideration both in regard to the author of the biblical story as well as to its subsequent readers and interpreters.[10]

Paradoxically, however, in spite of the biblical authors' vivid depictions of characters, places and events, at the same time we encounter an unmistakable

7. In Gen. 15.5, God uses the visual display of the stars to impress upon Abraham how great the number of his descendants will be: 'Look up to the heavens and count the stars if you can count them...so shall be your seed', a scene that Alter refers to as 'the grand solemnity of a didactic display, not merely a verbal trope to be explained' (Robert Alter, *Genesis* [New York: W.W. Norton, 1996], p. 64).

8. Dorothy Verkerk, *Early Medieval Bible Illumination and the Ashburnham Pentateuch* (Cambridge: Cambridge University Press, 2004), p. 60.

9. Gert Kwakkel, 'Taking Refuge in the Shadow of YHWH's Wings' (unpublished paper, European Association of Biblical Studies, Dresden: August 2005).

10. The writer and novelist Calvino, (*Six Memos*, p. 89), argues that visual images (for example, landscapes or people) 'develop their own potentialities, the story they carry within them'. When creating a story, the first thing that comes to Calvino's mind is 'a visual image that for some reason is charged with meaning'.

ambivalence towards, indeed more often a deep suspicion and distrust of, the visual in the Bible, the notion that in the superabundance of pleasurable things to see we must always exercise restraint. We are urged to visualize and explore different ways of seeing, yet the threat of blindness—the inability to see in the Bible's highly visual world, or seeing only dimly and obscurely—is forever present and forcefully articulated.[11] As well as the piercing light of day in which we see clearly, there are also many areas of darkness, obscurity and hiddenness in the Bible that the eye cannot penetrate. The God who is all-seeing prefers to remain out of sight and we are warned sternly against creating any visual likeness of him—yet he creates humankind in his image. He gives sight and yet makes people blind; he displays the skills of an artisan and artist,[12] yet he is suspicious and distrustful of humans who mirror the same creativity.[13] What are we to make of this obsession with visibility and hiddenness that permeates the Bible? Why do its authors create stories evidently intended to stimulate and exercise the reader's visual imagination and yet appear so suspicious of the consequences?

Given the ambiguity we encounter in biblical literature in relation to visuality, it is not surprising that attempts were made to provide clarification at important junctures in the history of interpretation (particularly during the Council of Nicaea, the Reformation and Counter-Reformation), since the illiterate faithful in effect relied on the visual to understand and appreciate the significance of biblical stories.[14] The fear that any ambiguity regarding

11. Ambiguities and contradictions in relation to sight abound. No one can see God and live but the rule is often broken: he appears to, or lets himself be seen by (niphal ראה), Abraham (17.1; 18.1), Isaac (26.2, 24; 35.1), Jacob (35.9; 48.3) and Moses (Exod. 3.2,16; 4.1, 5; 6.3) while in Gen. 16.13-14 the climax of the story of Hagar's expulsion centres on how Hagar has survived the experience of seeing God whom she calls El-Roi (God who sees me) and how she names the well Beer-lahai-roi (Well of the Living One who sees me). With regard to the divine presence in theophanies, Walter Houston ('Exodus', in John Barton and John Muddiman [eds.], *The Oxford Bible Commentary* [Oxford: Oxford University Press, 2001], pp. 67-91[71]) notes that the visual descriptions are so graphic that we can really only *picture* them and not explain them (Judg. 5.4-5; Ps. 18.7-15; 50.1-6, Hab. 3), although Calvin argues that the whole point of theophanies is *to conceal* God and protect his essential invisibility.

12. Many Christian theologians have described God as an artist. Bonaventure, commenting on the New Testament passage, 'Consider the lilies of the field..', describes God as the supreme artist and nature as his opus. Von Balthasar interprets the verb יצר as 'modelling', 'creating' in Gen. 2.7-8, 19 and, from this, sees God as an artisan. For a discussion of the way philosophers have seen God's creativity as the source of the artist's imagination, see Patrick Sherry, *Spirit and Beauty* (London: SCM Press, 2nd edn, 2002), pp. 130-31.

13. In Acts 17.29 we are warned against thinking 'that the deity is like gold, or silver or stone, an image formed by the art and imagination of mortals' (τέχνης καὶ ἐνθυμήσεως ἀνθρώπου)'.

14. See Charles Barber, *Figure and Likeness: On the Limits of Representation in Byzantine*

the place and role of images could lead to idolatry or moral corruption developed into a desire to control the way the faithful 'saw' the Bible. But from our standpoint today, what is surprising is that the arguments for or against the use of images should have centred on the interpretation of a relatively small number of biblical texts and indeed some that we might today consider quite obscure. We must keep in mind, however, that since the aim was to ensure that a largely illiterate faithful did not mistake the power of the images for the power of God himself, the biblical texts to support this aim were chosen for doctrinal reasons. The dangers of the allurement of visual images had to be refuted on very specific grounds and so very specific texts had to be identified in support of the argument.

The Hebrew Bible cannot be more uncompromising in its condemnation of crafting idols or likenesses. It is forbidden to make an image or likeness of a being of any kind (Exod. 20.4)[15] and several texts concerning the worship of idols roundly condemn any such practice: the incident of the golden calf in Exod. 32–33, Jeroboam's two calves of gold in 1 Kgs. 12.28, Micah's molten image in Judg. 17–18 and the destruction of images especially those of the goddess Asherah in 2 Kgs. 23. In addition, since the Israelites did not see God's form at Sinai but only heard his voice (Deut. 4.12-31), so the argument goes, no one should ever presume to make any likeness of him for, if he were to be revealed, imagined or visualized, he could be controlled and manipulated. It was precisely in relation to these texts that several Church Fathers argued that the use of any visual image illustrating biblical characters or scenes should be banned.[16] Those defending the use of images had a weaker argument: for example, they appealed to instances where God had commanded images to be made for inclusion in the furniture of worship or as part of the Temple (Exod. 25; Ezek. 41).

David Brown argues forcefully that the New Testament provides no qualification or clarification whatsoever of the harsh attitudes towards the proscription of images in the Hebrew Bible.[17] It is only the Incarnation, God-made-visible, that really allows a rationale for art, he argues, and it is only from the Church's later history that a critique could be thrown back upon

Iconoclasm (Princeton: Princeton University Press, 2002), especially 'Word and Image', pp. 125-37, and David Morgan, *The Sacred Gaze: Religious Visual Culture in Theory and Practice* (Berkeley: University of California Press, 2005), pp. 141-46.

15. As David Brown points out, *Tradition and Imagination* (Oxford: Oxford University Press, 1999), p. 340, Jerome's translation in the Vulgate, *non facies tibi sculptile*, makes the prohibition even more stark.

16. For example, Origen, *Contra Celsum* IV.31; VI.4; VII.44, 62-67; VIII.17-19; Clement, *Stromateis* VI.16, 18 and *Exhortation to the Heathen* IV.57-62, cited in Brown, *Tradition*, p. 333.

17. Brown, *Tradition*, pp. 342-44.

scriptural assumptions through a refocused understanding of the full implica-
tions of the Incarnation:

> The ancient priority of hearing in biblical thought …had now been forced to
> yield to the priority of seeing as a consequence of the Incarnation…as Word,
> God was still there to be heard and obeyed…but as Light, he was now there to
> be seen as well—and therefore to be visualized.[18]

This was precisely the argument used at the Council of Nicaea. As an exten-
sion of the principle of the Incarnation, it was declared, the function of
visual images was merely to call up memories of their archetypes and so the
honour paid to an image is, in reality, directed to the person it depicts and
therefore can be a source of instruction and edification. (In the thirteenth
century, Thomas Aquinas was to defend the use of visual images in a similar
way based on the Pauline relation of things seen to things unseen in Rom.
1.20). The Council appealed specifically to texts relating to the function of
the cherubim (Num. 7.89; Ezek. 10.16-20 and Heb. 9.1-5) but particularly
Exod. 25.17-22 that describes in detail the crafting of the two cherubim of
gold.[19] But Calvin was later to use the same texts to argue that the function
of the cherubim was *to conceal* the mercy seat with their wings and therefore
to protect and maintain the essential incomprehensibility and invisibility of
God. Indeed, his suspicion of the visual led him to claim: 'We may infer [from
Scripture] that the human mind is, so to speak, a perpetual forger of idols'.[20]
He did make a distinction, however, as to which parts of the Bible might
rightfully be represented visually:

> Both sculpture and paintings are gifts from God … to be used purely and
> lawfully. It is unlawful to give a visible shape to God because he has forbidden
> it…the only things to be painted or sculptured are things which can be pre-
> sented to the eye; the majesty of God which is beyond the reach of any eye
> must not be dishonoured by unbecoming representations. Visible representa-
> tions are of two classes: historical which give a representation of events and
> pictorial which merely exhibit bodily shapes and figures. The first are of some
> use for instruction but the second are only fitted for amusement.[21]

Old Testament narrative, Calvin concluded, is more appropriate for visual
representation than any scenes from the New Testament that included
Christ.[22]

18. J. Pelikan, *Imago Dei: The Byzantine Apologia for Icons* (Princeton: Princeton
University Press, 1990), p. 99, cited in Brown, *Tradition and Imagination*, p. 342.

19. See Brown, *Tradition*, p. 332 n. 33.

20. John Calvin, *Inst.* 1.11.8, cited in John Sandys-Wunsch, 'Graven Image' in David
Lyle Jeffrey (ed.), *A Dictionary of Biblical Tradition in English Literature* (Grand Rapids:
Eerdmans, 1991), pp. 320-23 (322).

21. Calvin, *Inst.* 1.11.12, cited in Sandys-Wunsch, 'Graven Image', p. 322.

22. Luther, however, permitted more iconography than Calvin and encouraged painting

The extent and intensity of the so-called iconoclastic debate illustrate the legacy of ambiguity and suspicion of the visual we are left with, not only from biblical literature itself but also from the entire history of interpretation. What is different today, however, given the popularity and range of literary (as opposed to doctrinal) approaches, is that the questions raised by the Bible's ambiguities regarding the visual are first and foremost of a literary nature. We no longer focus on specific isolated texts to support a doctrinal stance but are more concerned with larger units of narrative or poetry that offer us a more subtle and nuanced understanding of how biblical authors use visual language. We also take into consideration the reader's personal engagement in and reaction to the narrative rather than its doctrinal implications. As Calvino points out, the idea that the God of Moses does not tolerate being represented in images never seems to have occurred to Ignatius of Loyola. On the contrary, he claimed for every believer the grandiose visionary gifts of a Dante or a Michelangelo, the ability to create a picture even from some of the most laconic of biblical verses. But while contemporary literary approaches point us in the right direction, we must extend their boundaries to include the role of the reader's imagination in reading biblical stories, the reader's imagistic consciousness. Calvino argues that we live in an age when 'literature no longer refers back to an authority or tradition as its origin or goal but aims at novelty, originality and invention'.[23] Following the approach of Calvino and in relation to visibility in the Bible, what is important for contemporary scholarship is not the doctrinal debates of the past but how we use the visual (in ways similar to literary approaches) as a way of bringing out the new and unexpected, the hidden and the silenced in the text.

Visuality and Biblical Narrative

The examples that best illustrate the Bible's concern with the visual are found in the Old Testament but several images are carried over into the New and used to appeal to the reader's imagination in ways that expand and develop their original use in Hebrew narrative and poetry. In his commentary on Genesis, Robert Alter frequently draws attention to how the Hebrew language lends itself to creating imaginative visual figures of speech centred on the notion of light and darkness or sight and blindness, images that transfer easily into metaphor.[24] The act of seeing, for example, is often used to denote knowledge and understanding or in other cases belief while blindness

church walls and wealthy homes with scenes from biblical narratives. See Sandys-Wunsch, 'Graven Image', p. 322.
 23. Calvino, *Six Memos*, p. 85.
 24. Alter, *Genesis*, pp. 13, 117.

can denote wilfulness, sinfulness and an unwillingness to understand or obey.[25] Frequently the literal and metaphorical uses of the verb רָאָה, 'to see', are deliberately blurred to give the impression that what we see literally can lead to an internalized understanding of events—sight should lead to insight.[26]

The emphasis that the opening verses of Genesis places on the creation of light, alongside the continuing existence of darkness, anticipates the importance of the theme of light and darkness (as well as the related theme of sight and blindness) throughout the rest of the Bible, expressed through a vast range of intricate similes and metaphors. Genesis 1 establishes those most basic and essential conditions that make it possible to see or that prevent us from seeing—namely, light and darkness. Like any artist conscious of the affects of light and shadow on the way we view animate and inanimate objects around us, so the author of Genesis 1 goes on to describe the nature of the light that illumines the landscapes being created: in vv. 2-5 not only is light (אוֹר) described as something distinct from darkness but four specific points in time, recognizable by their varying intensities of light and shadow, are also named—day, night, morning and evening.

Once light has been created, the author pays detailed attention to its nuances, its hues, its variations and alterations. Light is defined not simply in terms of *non-darkness* but rather as an ever-changing phenomenon: its sources are described in considerable detail in vv.14-18 where the root אוֹר is repeated for emphasis eight times (but yet occurs nowhere else in Genesis), either as a noun or a verb in the *hiphil*:

> Let there be lights (מְאֹרֹת) in the dome of the sky to separate the day from the night...... let them be as lights (לִמְאֹרֹת) in the dome of the sky to illumine (לְהָאִיר) the earth...God made two great lights (מְאֹרֹת), the greater light (מָאוֹר) to rule the day and the lesser light (מָאוֹר) to rule the night—and the stars. God set them in the dome of the sky to illumine (לְהָאִיר) the earth, to rule over the day and over the night and to separate the light (אוֹר) from the darkness.[27]

The luminaries—apart from the stars—are not mentioned specifically as sun and moon, rather it is their function as providers of different kinds of light that is emphasized: the greater light will dominate the day and extend

25. The New Testament follows the same pattern: John the disciple sees and believes (Jn 20.8). Thomas sees, but does not believe (Jn 20.24).

26. In 1 Sam. 3.1-15, Eli 'whose eyesight was dim so that he could not see' is physically blind but can still receive spiritual visions from God.

27. Elsewhere, in the hiphil, the root אוֹר is used in contexts that denote how the visual image of the pillar of fire illumines the path of the Israelites in the wilderness (Exod. 13.21; Ps. 105.39; Ezek. 9.8; Neh. 9.12, 19) but its most frequent use takes the form of a prayer requesting that God will cause his countenance to illumine an individual (Num. 6.25; Ps. 4.6; 31.16; 67.1; 80.3, 7, 19).

everywhere—even in places where the direct rays of the sun do not reach—and the moon will relieve the darkness. Sirach 43.1-12 makes a similar observation on the different forms of light that illumine the earth: the bright rays of the noonday sun blind the eyes (v. 4), the moon's light wanes when it completes its course (v. 7), the new moon is a beacon shining in the vault of the heavens (v. 8) and the stars provide a glittering array of light in the heavens (v. 9). It is the emphasis on light that allows the created world to stand out so visibly against the chaos of darkness, an aspect highlighted in so many paintings and illustrations of Genesis 1, especially those of Blake and Doré.

The way in which the creation of humankind in Gen. 1.26-28 is conceived of in terms of God's image (צֶלֶם) and likeness (דְמוּת)—however we interpret the Hebrew terms—suggests that humanity mirrors or reflects God in some way.[28] Elsewhere the word צלם is used to denote images of gods, crafted visual artefacts (Num. 33.52; 1 Sam. 6.5,11; 2 Kgs 11.18; Ezek. 7.20;16.17; 23.14) and some have argued from this that we are meant to imagine here an external visible likeness.[29] A rabbinic suggestion associates צלם with צל (shadow) 'indicating that one must cleave to the Creator, and follow in his every way as a shadow that faithfully follows the movement of its illuminated form'.[30] (In Ps. 39.7, in a vivid description of the fragility of human life, צלם denotes a shadow, something formed by light and shade.) In the context of Genesis 1, with its emphasis on light, it is easy to see why rabbinic tradition should wish to make the connection between צלם (image) and צל (shadow): the resemblance between humankind and an essentially hidden God can only be visualized in terms of shadow against light. The visual resemblance between humanity and God is, of course, depicted much more explicitly in Christian iconography relating to Genesis 1–2: God the creator is often visualized in the form of the Trinity and humanity (represented by Adam) becomes the mirror image of Christ.

A further instance of the emphasis on visuality in Genesis 1 is the intensive use of the verb רֶאָה, 'to see'. Throughout the chapter, it is always God's seeing that is important: ראה is the third verb, the third activity after creating and speaking, that the author associates with him. God sees the light, that it is good (v. 4), and just as each aspect of creation is brought into existence by his word, so each action ends with God *seeing* that it is good (vv. 4, 10, 12, 18, 21, 31). This is not merely a metaphorical use of the verb: Whybray notes that the repetition of the phrase reflects 'the craftsman's

28. Perhaps in the same way that Seth is the 'image and likeness' of his father, Adam, in 5.3.

29. See Norman Whybray, 'Genesis', in John Barton and John Muddiman (eds.), *The Oxford Bible Commentary* (Oxford: Oxford University Press, 2001), pp. 38-66 (43).

30. Meir Zlotowitz, *Bereishis* (Jerusalem: Mesorah Publications, 1995), p. 71.

visual assessment of his own work, someone with an eye to detail'.[31] But just as importantly, the phrase 'and God saw that it was good' invites the reader, too, to see, to create a mental image of each aspect of the created universe, an invitation that becomes more pressing in the concluding verses vv. 29-31, with the emphatic use of *look!* (הנה) alongside ראה:

> Look! (הנה), I have given you every plant yielding seed that is upon the face
> of all the earth and every tree with seed in its fruit…and God saw everything
> he had made and look! (הנה) it is very good.

The reader should see and acknowledge that the created universe is good, just as God does. Seeing, then, in Genesis 1 is a very positive activity and a source of reassurance—everything we see is good and conversely it is a virtuous and good thing to see, to create a mental image of all the details of the created world.[32]

However, although the verb ראה occurs frequently in Genesis 1 with God as subject, its use becomes more restricted in Genesis 2–3. In 2.9, God causes to grow every tree that is good to see (נחמד הראה), including the tree of the knowledge of good and evil. In 3.4, the serpent tells Eve that, when she eats from the tree, the eyes of Adam and Eve will be opened and they will be like God, knowing good and evil. In 3.6, the author makes a point of repeating the refrain used in relation to God in Genesis 1 ('and God saw that it was good') but now it is the woman who 'saw that the tree was good for food and that it was a delight to the eyes'. Eating the fruit causes Eve and Adam to see for the first time (3.7). This is the first recorded act of human seeing and, unlike its positive associations with God's creation in chapter 1, vision, now in the human sphere, assumes negative connotations. In 3.6, the tree is described as 'a delight to the eyes' (תאוה לעינים).[33] Robert Alter argues that it is highly significant that the eyes should be associated with intense desire (תאוה) and in the same verse translates (להשכיל), normally translated 'to make one wise', as 'to look at', thus drawing attention to the internal parallel in the verse ('lust to the eyes…lovely to look at').[34] It was thus the act of

31. Whybray, 'Genesis', p. 44.

32. In contrast to Gen. 1, the next time God sees (Gen. 6.5, 12) it is the corruption and wickedness on earth that he looks upon (v. 12 intensifies the notion of sight by juxtaposing ראה, 'to see', and הנה, 'look!'). But in Gen. 9.16, when God sees the rainbow, just as he saw human wickedness in 6.5, the sight of the rainbow will remind him of the everlasting covenant between himself and every creature of all flesh.

33. Alter translates תאוה as 'lust'. 'The eyes are linked to intense desire and they will be opened chiefly to see nakedness' (Alter, *Genesis*, p. 12). On תאוה Ramban comments: 'The fruit would awaken desire and cause one to stray after the sight of his eyes' (Zlotowitz, *Bereishis*, p. 119).

34. The Aramaic Targums of Onkelos and Jonathan both translate the word as 'to look at'. See Alter, *Genesis*, p. 12.

seeing that precipitated the plucking of the fruit and anticipated all the consequences attendant on it. Alter translates 3.6-7 in a way that underlines the importance of seeing:

> And the woman *saw* that the tree was good for eating and that it was *lust to the eyes* and the tree was *lovely to look at*, and she took of its fruit and ate, and she also gave to her man and he ate. And *the eyes of the two were opened* and they knew they were naked and they sewed fig leaves and made themselves loincloths.[35]

Rabbinic tradition, too, considers the emphasis on Eve's seeing in 3.6 highly significant: 'the verse does not say that she *heard*…….no, she *saw* of her own volition. The tempter did not *tell* her to eat the fruit….it came from her *seeing*'.[36]

In 3.5,7 the 'opening of the eyes' becomes a metaphor for knowing but it is significant that it is the serpent and not God who points this out:

> God knows when you eat (of the fruit), your eyes will be opened and you will be as gods, knowing good and evil.

In an ironic twist, when the eyes of Adam and Eve are opened, the first thing they want to do is to hide, to conceal themselves, first their nakedness with fig leaves and then themselves from God.[37] The irony is clearly conveyed in Masaccio's depiction (fig. 1): Adam's arm and hand act as an arrow drawing the viewer's attention to his eyes while Eve appears partially sighted, as if opening her eyes for the first time. Yet it is the viewer who clearly observes their state of nakedness and not the characters themselves.

Unlike the positive associations of God's seeing in Genesis 1, the seeing of Adam and Eve in Genesis 2–3, manipulated by the serpent, becomes the means of their downfall.[38] Luther glosses Gen. 3.5, 'your eyes will be opened', with the following comment: '….that is, they will become blind. Before, their eyes were closed but after the Fall they were opened'.[39] The ambiguity and suspicion associated with sight, with what we see and how we see, that continues throughout the Bible are thus dramatically introduced to the reader in its opening chapters.

35. Alter, *Genesis*, p. 12.

36. Zlotowitz, *Bereishis*, p. 119.

37. In the story of the nakedness of Noah in 9.20-23, Ham does his father disfavour by seeing his nakedness and not covering him up. Shem and Japheth, on the other hand, walk backward so as not to see him, a motif that picks up the idea of the nakedness of Adam and Eve.

38. This idea is explored by Penny Howell Jolly in *Made in God's Image? Adam and Eve in the Genesis Mosaics at San Marco, Venice* (Berkeley: University of California Press, 1997), pp. 49-53.

39. *Luther's Works*, 51.38.

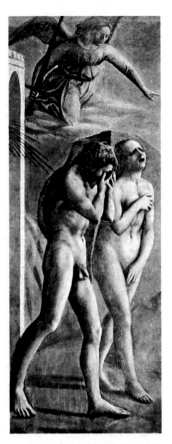

Fig. 1. Masaccio, *Expulsion of Adam and Eve* (1426–27)
Santa Maria del Carmine, Florence.

The Pentateuch closes in Deuteronomy 34 in the same highly visual man-
ner as it begins. With the death of Moses, the reader is given an opportunity
to reflect on past events and to look to the future, to life in the Promised
Land. The chapter opens with a detailed panoramic view of the land that
God shows Moses—and the reader:

> Then Moses went up from the plains of Moab to Mount Nebo, to the top of
> Pisgah, which is opposite Jericho, and the LORD showed him (ראה in hiphil)
> the whole land: Gilead as far as Dan, all Naphtali, the land of Ephraim and
> Manasseh, all the land of Judah as far as the Western Sea, the Negeb, and the
> Plain—that is, the valley of Jericho, the city of palm trees—as far as Zoar.
> The LORD said to him, 'This (הנה) is the land of which I swore to Abraham,
> to Isaac, and to Jacob, saying, "I will give it to your descendants"; I have let
> you see it with your eyes.'

The description recalls the speech of God to Abram in Gen. 13.14-17:

Raise your eyes and look out from the place where you are to the north and the south and the east and the west, for all the land you see to you I will give it and to your seed forever.

The Promised Land, as is frequently the case, is presented in a way that enables us to visualize it just as God allows Moses to see the land 'with his own eyes' (v. 9); very significantly, even at the point of death, Moses' sight is unimpaired (unlike Isaac in 27.1, where the same verb כהה is used). The chapter closes with the phrase 'in the eyes of all Israel'—the reader too is urged to visualize 'all the mighty deeds and terrifying displays of power that Moses performed in the eyes of all Israel'.

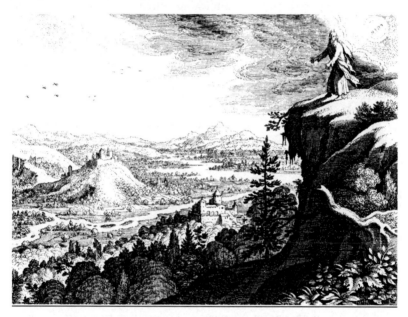

Fig. 2. Merian, Matthaeus the Elder, *Moses Views the Promised Land* (1625–30), Icones Biblicae, Stuttgart

From a visual perspective, then, the author of Deuteronomy 34 achieves two things: first, the topography of the Promised Land is graphically depicted as we anticipate the events that will take place there in the book of Joshua and, secondly, v. 12 acts as a résumé that calls to mind all the miracles of Moses from the past. Whybray states that the point of the concluding verse, v. 12, is to 'stimulate the poetic imagination of the reader'.[40] But it does more than this. The chapter conjures up in the reader's mind dramatic and vivid images from the past in order that we might fully appreciate the point at which the narrative now draws to a close—we are on the very brink of the

40. Whybray, 'Genesis', p. 156.

Promised Land. The reader, who has not been present at these events, must now picture in the mind's eye both the dramatic events of the past and the topography of the land about to be entered.

As well as landscapes, biblical characters too are, of course, often described in visual terms: we know that Sarah and Rebekah, Joseph and David, for example, are 'pleasant to see' (יפה מראה) or 'good to see' (טבת מראה), while, on the other hand, we are told that there is nothing particularly striking visually about the servant in Isa. 53.2. Most of all, the biblical author likes to accentuate the visual when describing memorable encounters between important characters, and it is not a coincidence that some of the best known and most evocative paintings depict biblical meetings, for example, David and Jonathan, Solomon and Sheba, Mary and Elizabeth or Christ and the Samaritan Woman. In his translation of Gen. 24.63-65, Alter brings out clearly the visual aspects of the first meeting between Isaac and Rebekah:

> Isaac raised his eyes and saw and, look! (הנה) camels were coming. And Rebekah raised her eyes and saw Isaac and she alighted from her camel. And she said to the servant 'Who is that man walking through the field toward us?' And the servant said 'it is my master' and she took her veil and covered her face.[41]

Alter makes the comment:

> The formulaic chain, 'he raised his eyes and saw', followed by the 'presentative' *look* (rather like *voici* in French), occurs frequently in these stories as a means of indicating a shift from the narrator's overview to the character's visual perspective. The visual discrimination here is a nice one: in the distance, Isaac is able to make out only a line of camels approaching; then we switch to Rebekah's point of view, with presumably a few minutes of story time elapsed, and she is able to detect the figure of a man moving across the open country.

But this initial encounter must be read in conjunction with their final meeting in Genesis 27. Isaac's keen powers of sight in chapter 24 contrast with his 'dim eyes' and his general inability to see clearly in chapter 27, a theme around which the entire narrative is structured and a weakness that allows him to be deceived by Rebekah and Jacob. With regard to Rebekah, it is significant that, on seeing Isaac, she should take her veil and cover herself for later, in Genesis 27, she will take the garments of Esau and conceal Jacob in them. Her action in concealing herself from Isaac in chapter 24 anticipates how she will conceal the identity of Jacob from him in chapter 27. The emphasis on seeing that marks the first meeting of Isaac and Rebekah in chapter 24 contrasts with the blindness, secrecy and deception characteristic of their final meeting in chapter 27.

41. Alter, *Genesis*, p. 122.

Just as the meeting between Isaac and Rebekah is presented visually, so too are other important encounters, for example the reunion of Jacob and Esau. The same phrase is used of Jacob in 33.1 as of Isaac and Rebekah: 'And Jacob raised his eyes and saw and look! Esau was coming'. In v. 5, Esau raises his eyes and sees the women and children with Jacob and in v. 10 Jacob expresses his intense satisfaction at their meeting by exclaiming that 'to see your face is like seeing the face of God'. In Laban's meeting with Jacob in Gen. 31.51-52, Laban stipulates to Jacob the terms of the treaty between them in language that Alter calls 'the studied repetitions and rhetorical flourishes that characterize Laban's speech throughout'.[42]

> Look! (הנה) this mound and look! (הנה) this pillar that I cast up between you and me. This heap is a witness and the pillar is a witness that I will not pass between this heap and you and you will not pass beyond this heap and this pillar to me, for harm.

The reader must visualize the situation in order to understand the treaty's impact and its mutual obligations illustrated by the pillar and the mound.

In several instances, the biblical author suggests deliberate misrepresentation or deception in relation to what or how we see. It is the physical beauty of Sarah (Gen. 12.10-16) that starts off the process of Abraham's deception of the Egyptians and, similarly, in 26.8-11, Isaac's deception of Abimelech can be traced back to Rebekah's beauty. In the story of Potiphar's wife (39.6b-18), the narrator begins by describing Joseph as 'comely in features and comely to look at'. This causes Potiphar's wife to 'raise her eyes' upon him. Later, her evidence against him is just as visual—it consists only of his garment, the undeniable and damning piece of visual evidence for all to see.[43] When Jacob blesses the sons of Joseph in Gen. 48.8-20, the story is again constructed around seeing. The narrator makes it clear to the reader the positions of the characters in relation to Jacob (the subtleties of which are clearly portrayed in Rembrandt's painting of the scene) but Jacob's eyes are dim with age and, when he crosses his hands to place his right hand on Ephraim's head, Joseph 'saw that his father had placed his right hand on Ephraim's head and it was wrong in his eyes'. Apart from the fact that Jacob and Joseph see the situation from different perspectives, the narrator hints that on his deathbed, Jacob's failing sight may result in mistaking the identity of the rightful heir to God's promises—as was the case with Jacob's father, Isaac, in Genesis 27.

42. Alter, *Genesis*, p. 175.

43. In Judah's lengthy speech during his meeting with Joseph (Gen. 44.18-34) that essentially concerns the making present, the making visible of an absent father, the verb ראה, 'to see', occurs six times (vv. 21, 23, 26, 31, 32, 34).

Even when the author remains deliberately vague as to the precise iden-
tity of a character, the reader is still given sufficient information to form a
visual image of the scene, for example, Abraham's encounter with the three
men in Genesis 18. Alter imagines Abraham 'peering out through the shim-
mering heat waves of the desert noon' overshadowed by the giant oaks of
Mamre.[44] In 18.1, we are told that God makes himself seen, appears to (וַיֵּרָא)
Abraham but from a human perspective in v. 2, Abraham sees only three
men ('He lifted up his eyes and he saw and look! three men…and when he
saw them…'). The focus on vocabulary relating to sight shows how the
author deliberately accentuates the visual but, at the same time, suggests
different perspectives from which the visitors may be seen—it is really God
who appears but we, like Abraham, see only three men. In another encoun-
ter, Jacob wrestling with the angel in Gen. 32.13-32, the initial identifica-
tion of the anonymous adversary as 'a man' is from Jacob's point of view
because all he knows of his adversary is what he sees and what he is able to
make out in the darkness of the night. But in the morning, as the sun rises
on him,[45] Jacob calls the place Peniel (the face of God) because he has seen
the face of God and survived. The narrator succeeds in portraying the mys-
teriousness of Jacob's adversary by situating the episode in the darkness of
night and the obscurity of early dawn.

More mysterious and complex is the process by which the reader engages
with the visual content of dreams. That they cannot always be satisfactorily
interpreted by the narrator only adds to their sense of mystery. Much of the
content of dream narratives in the Bible consists of visual images rather than
verbal content, for example, the dreams of Jacob (Gen. 28.12; 31.10-11),
Joseph (Gen. 37: 5-9), Pharaoh's butler and baker (Gen. 40.9-19), Pharaoh
himself (Gen. 41.1-24) and Daniel (Dan. 7.1-28; 8.1-27). The precise func-
tion of the visual element in dreams has always fascinated commentators.
For example, Macrobius's classification of dreams in the fourth century greatly
influenced mediaeval biblical commentators and in particular Augustine,
who developed two of Macrobius's dream categories, *visio* and *somnium*, and
applied them to dream sequences in the Bible.[46] Macrobius defined *visio* as 'a
dream that comes true' while *somnium* is a dream that 'conceals with strange
shapes and veils with ambiguity the true meaning of the information offered
and requires an interpretation for its understanding'. Augustine subdivided

44. Alter, *Genesis*, p. 77. He also notes (p. 84) that in 19.1 a different atmosphere is
created for Lot's encounter with his visitors who come as darkness falls.

45. Alter, *Genesis*, p.183, makes the point that just as Jacob's flight from home was
marked by the setting of the sun (28.10), so now it is fitting that the rising sun greets him
on his return back to his native land.

46. See Anon., 'Dreams and Visions', in David Lyle Jeffrey (ed.), *A Dictionary of Bib-
lical Tradition in English Literature* (Grand Rapids: Eerdmans, 1992), pp. 213-17.

further the category of *visio* into *visio corporalis* (a sensory and realistic presentation of natural images), *visio spiritualis* (resulting from spiritual powers shaping the imagination by the use of sensory images) and *visio intellectualis* (a revelation without mediation of images appealing directly to the intellect). But later, Vincent of Beauvais was to argue that there can be no dreams (either *visio* or *somnium*) without visual images, thus strengthening the importance and centrality of the visual in dreams such as those of Joseph and Daniel. What is particularly interesting is how mediaeval commentators thought of the dream as a means of suggesting powerful and vivid visual images while at the same time deliberately concealing or obscuring their precise significance.

The art historian Maria Ruvoldt illustrates how, in a Renaissance context, the abandon and abstraction of sleep were understood to provide the ideal conditions for divine union, an experience frequently realized through a dream.[47] Sleep could offer a visual sign for a particular type of intellectual experience carrying implications of divine inspiration. Sleep also inflected the practice of looking, allowing the viewer a contemplative voyeuristic experience rather than a fictive dialogue with an image. Ruvoldt shows how artists of the Renaissance, like the biblical prophets, were considered by Vasari (a sixteenth-century biographer of Italian artists) to be divinely inspired and how this perception was depicted by showing the artist asleep and as a recipient of highly visual divine dreams. Even the imagery of sleep itself in Renaissance art offered a powerful visual sign for a Platonic model of divine inspiration.

But in the highly visual world of biblical literature, the reader must also reflect on the fragility of sight and the prospect of blindness in its varying states.[48] The vision of mortals is at best only partial and limited while God is all-seeing[49] and he can remove or, more significantly, restore sight. Blindness is a stigma sent by God (Deut. 28.28-29) and revoked by God (Ps. 146.8). Those who cannot see are forbidden to take priestly office (Lev. 21.17-23) and nothing blind can be offered as a sacrifice (Lev. 22.22; Deut. 15.21). Blindness is a punishment (Zech. 11.17; 12.4) yet the blind are protected (Lev. 19.14; Deut. 27.18; Jer. 31.8). In the New Testament, the miracles where Jesus restores sight to the blind feature most prominently (Mt. 9.27-31; 20.30-34; Mk 8.22-26; 10.46-52) and when he proclaims he is the light

47. Maria Ruvoldt, *The Italian Renaissance Imagery of Inspiration: Metaphors of Sex, Sleep and Dreams* (Cambridge: Cambridge University Press, 2004), pp. 1-5.

48. See John M. Hull, 'Open Letter from a Blind Disciple to a Sighted Saviour', in Martin O'Kane (ed.), *Borders, Boundaries and the Bible* (JSOTSup, 313; Sheffield: Sheffield Academic Press, 2002), pp. 154-77.

49. God is all seeing, even in secret (Mt. 6.4, 6, 18).

of the world, Jesus speaks in the context of his ability to restore sight (Jn 9.5). Blindness, on the other hand is a metaphor associated with unbelievers and those who lack faith (Mt. 15.14; Lk. 6.39; Jn 12.40; 2 Cor. 3.4; 4.4; Eph. 4.18). In Acts 9.8, although Paul's eyes are open, he can see nothing and yet he is the recipient of an inner vision, the image of Ananias laying hands on him restoring his sight; eventually the scales will fall from his eyes allowing him to see in ways he has not seen before. Subsequently his faith is predicated on seeing heavenly things in a glass darkly (1 Cor. 13.12), walking not by sight (2 Cor. 5.7) but by the evidence of things not seen (Heb. 11.1). Paul concludes in 2 Cor. 4.18 that what can be seen is temporary and what cannot be seen is eternal (v. 18). Indeed, as 1 Jn 2.16 points out, it is merely 'the lust of the eyes' that leads to fascination with things seen.

In the history of interpretation, our very existence is described in terms of blindness and sight. Gregory the Great, commenting on Job 9.25 ('My days are swifter than a runner: they flee away, they see no good') states,

> Man was created for this end, that he might see 'good' which is God; but because he would not stand in the light, in flying, therefore, he lost his eyes; he subjected himself to blindness that he should not see the interior light.[50]

For Augustine, our interior eye has been 'bruised and wounded' through the transgression of Adam who 'began to dread the divine light and fled back into darkness anxious for its shade'.[51] His comment on John 9 notes how 'the blind killed the Light but the Light crucified enlightened the blind',[52] while Jerome argues that 'it is better to have spiritual than carnal vision and to possess eyes into which the mote of sin (Lk. 6.42) cannot fall'.[53] The biblical concern with sight and blindness continues in Bunyan's *Pilgrim's Progress*, where failure to respond to 'the inner light' is a token of the faithlessness of the atheist who is 'blinded by the god of this world' and of Mr Blindman and Mr Hate-Light, who are among the jurors who condemn Faithful at Vanity Fair.[54] Nowhere, however, is the contrast between sight and blindness more pronounced, as we shall see, than in the book of Isaiah, where the harsh command 'to see but not to understand ' in 6.9-10 is tempered by the gradual opening of the eyes throughout the rest of the book (29.18; 35.5; 42.7, 16, 18, 19).

50. Gregory the Great, *Moralia in Iob*, 1.530-31, cited in Ronald B. Bond, 'Blindness', in David Lyle Jeffrey (ed.), *A Dictionary of Biblical Tradition in English Literature* (Grand Rapids: Eerdmans, 1991), pp. 93-95 (94).

51. Augustine, *Sermons on NT Lessons* [Mt. 20.30], cited in Bond, 'Blindness', p. 94.

52. Augustine, *Sermons on NT Lessons* [Jn 9], cited in Bond, 'Blindness', p. 94.

53. Jerome, *Ep. 62*, cited in Bond, 'Blindness', p. 94.

54. Bond, 'Blindness', pp. 93-95.

Sight, Insight and Blindness in the Book of Isaiah

In his introduction to the Twelve Prophets in *The Literary Guide to the Bible*, Herbert Marks brings out clearly the essentially visual nature of prophetic literature.[55] Starting from Longinus's definition of *phantasia* or visualization as 'the situation in which enthusiasm and emotion make the speaker see what he is saying and bring it visually before his audience',[56] he illustrates how in the description of the sack of Nineveh in Nahum 3 'the juxtaposition of moral category and visual image works like a medieval emblem'. According to Maimonides, for whom all prophetic revelation was a form of imaginative vision akin to dreaming, 'the superior imagination, when not receiving and imitating things perceived by the senses, can receive and imitate the intellectually mediated 'overflow' of the divine presence'.[57] Following Maimonides, Marks sees 'prophecy—or at least its rhetorical simulation—as starting from the visual image and proceeding by mnemic images through words to verbal complexes of thought'.[58]

Of all the prophetic books, Isaiah is without doubt the most visual in the sense that the paradox between sight and blindness lies at its very heart. It opens with the superscription claiming that the entire book is a vision Isaiah *saw* concerning Judah and Jerusalem, but it is in the context of his calling in chapter 6 where the paradox between sight and blindness is articulated most forcefully. Isaiah sees a vision of God high above him partly obscured by the seraphim, yet the mission he is given during this dramatic visual experience is to make obscure any knowledge of God or his plans for humans:

> Make the mind of this people dull, stop their ears and shut their eyes so that
> they may not look with their eyes and listen with their ears (6.9-10).

The paradox of 6.9-10,[59] developed and intensified in a series of images throughout the rest of the book (for example, in the image of the closed, sealed scroll in 8.16 and 29.11), preserves and protects the impenetrable

55. Herbert Marks, 'The Twelve Prophets', in Robert Alter and Frank Kermode (eds.), *The Literary Guide to the Bible* (London: Fontana, 1987), pp. 207-33 (227).

56. Longinus, *On the Sublime*, §15, cited in Marks, 'The Twelve Prophets', p. 227.

57. Maimonides, *The Guide of the Perplexed*, 2.36, cited in Marks, 'The Twelve Prophets', p. 228.

58. Marks, 'The Twelve Prophets', p. 227. This same process is explored by Calvino, *Six Memos*, p. 89.

59. John F.A. Sawyer, *The Fifth Gospel: Isaiah in the History of Christianity* (Cambridge: Cambridge University Press, 1996), pp. 120-22, explores how Isa. 6.9-10 lies at the heart of mediaeval Christian iconography that depicts the Jews as 'Blind Synagogue', a downcast blindfolded woman holding a broken piece of one of the tablets of stone on which the Ten Commandments were written.

hiddenness of God and warns readers not to presume that they have fully understood his plans. For Isaiah, God must remain hidden, invisible and inaccessible, yet equally mortals must try and see him, not dramatically and directly, as Isaiah does, but through the perceivable instances of their every-day experience. The emphasis on God's hiddenness challenges the reader to disclose, to reveal, to bring to light the nature of his plans for mortals. No surprise then that Robert Carroll should call Isaiah 'the book of the hidden-ness of Yahweh' and conclude that 'if the text has areas of blindness, it is the reader who must try to make the unseen visible'.[60]

Pierre Sonnet argues convincingly that the reader of Isaiah is not merely an interpreter (a third party) but is the main addressee of the prophetic voice and is given a task: will he or she succeed in seeing and understanding what the people cannot (6.9-10)?[61] The two instances of the closing of a book in 8.16 and 29.11 ensure that we do not come away with the impression that we have already understood or have gained full access to its message; rather we must engage with the book's many ambiguities in order to disclose its mean-ing. Only in this way, can we attempt to reveal the hiddenness of God. The reader can never claim that he or she has already understood. It is a matter of a gradual unfolding of the message; this is the function of the motif of the inability to see and hear that occurs strategically throughout the book.[62] Sonnet argues that the motif of the ability to see, especially from chapter 40 onwards, is presented not as a subsequent, successive or final state that reverses or brings to full circle the enigmatic commission of 6.9-10 but should be seen rather as an expression of how the two states, sight and blindness, are main-tained in an unresolved tension. In other words, the reader may see but there will always be areas in which he or she remains blind. Francis Landy puts forward a similar proposal: although Isaiah 6 suggests that the vision should be concealed (it is too ineffable to be seen or described), the opposite mean-ings possible for הֵשַׁע in 6.10 (it can come from the root שָׁעַע, 'to blind', smear over, or שָׁעָה, 'to gaze') set up a deliberate ambiguity. The 'blinding' or 'smearing over' can also mean 'gaze'[63] The paradox is that the two modes, the

60. Robert P. Carroll, 'Blindness and the Vision Thing: Blindness and Insight in the Book of Isaiah', in Craig C. Broyles and Craig A. Evans (eds.), *Writing and Reading the Scroll of Isaiah: Studies of an Interpretive Tradition* (VTSup, 70; Leiden: E.J. Brill, 1997), pp. 79-93 (85-86). See also his exploration of the theme in *Wolf in the Sheepfold: The Bible as a Problem for Christianity* (London: SCM Press, 1991), pp. 34-61.

61. Jean-Pierre Sonnet, 'Le motif de l'endurcissement (Isa. 6, 9-10) et la lecture d' "Isaïe"', *Bib* 73 (1992), pp. 208-39 (233).

62. For example, 29.18, 23-24; 30.20-21; 32.3-4; 35.5-6; 40.5, 21, 28; 41.20, 26; 42.16; 48.7-8; 52.15; 53.1; 64.3; 66.8.

63. Frances Landy, 'Strategies of Concentration and Diffusion in Isaiah 6', in Frances Landy (ed.), *Beauty and the Enigma and Other Essays on the Hebrew Bible* (JSOTSup, 312; Sheffield: Sheffield Academic Press, 2001), pp. 298-327 (322).

incapacity and the ability to see, are presented as experiences or opportunities that are simultaneous or that can alternate: for the reader, the message of Isa. 6.10 warns that even when we think we have seen and understood the ways of Yahweh, there is still a sense in which his plans and knowledge are concealed and withheld and our sight limited.[64]

The conflict between blindness and sight is intensified by visual images of darkness and light—images that Bernard Gosse considers central to our understanding of the book.[65] The time of 'distress and darkness' in 8.21-22 (צרה וחשכה), he argues, is intended to refer to the time of the prophet; the reader must wait for a future time when 'the eyes of the blind see out of their gloom and darkness' in 29.18 but expressed more vividly in 59.9-10:

> We wait for light and look! (הנה) darkness, for brightness but we walk in gloom. We grope like the blind along a wall groping like those who have no eyes. We stumble at noon as in the twilight.

The book's editor, Gosse argues, is preoccupied with the lifting of scales from the eyes, coming to vision, hoping for a future beyond the time of darkness

> Arise shine: for your light has come...darkness shall cover the earth and thick darkness the peoples ..but the Lord shall arise upon you.... nations shall come to your light and kings to the brightness of your dawn (60.1-3).

But between times, shadows, darkness and obscurity reign. Gosse's interpretation, particularly his emphasis on 'the obscurity of the between times', is insightful and is supported by a series of striking metaphors and other figures of speech in chapters 28–33 that evoke the idea of hiding and sheltering on the one hand and emerging and coming into light on the other. For example, Isaiah 28 opens with the metaphor of drunkenness (v. 1), suggesting confusion, a characteristic that is promptly applied to priest and prophet (v. 7) who err in vision (בראה); their drunkenness withholds their ability to 'see' and to reveal the word of God. In 29.9b the metaphor of drunkenness reappears, juxtaposed between images of blindness and confusion in 29.9a and vocabulary in 29.10 that evokes concealment: the deep sleep (תרדמה) that God has poured on the prophets and seers and the closing of the eyes and the covering of the head. In particular, the deep sleep (תרדמה)—normally associated with inspiration and revelation but here with a state of confusion and blindness[66]—underlines the paradox and tension between seeing and

64. On this point, see Carroll, 'Blindness and Vision Thing', p. 90. He uses the term 'blindsight' (*blindness* and in*sight*) to explore the 'in-sightful readings which this paradox makes possible'.

65. Bernard Gosse, 'Isaïe 28–32 et la redaction d'ensemble du livre d'Isaïe', *SJOT* 9 (1995), pp. 75-82 (81).

66. For example, Gen. 15.12; Job 33.15; Dan. 8.18; 10.9.

understanding on the one hand and blindness and the inability to under-
stand the plans of God on the other.

Images of sleep, dreams and visions of the night underline an atmosphere
of obscurity and mystery present throughout chapters 28–33: their contents,
perhaps, are too ambiguous or too secret to disclose. The shadows and dark-
ness (29.7, 8, 18) contrast with the emphasis on intense light (אוֹר) in 30.26
that anticipates the sudden appearance of God (vv. 27-28); in 30.26, the
healing (רפֿא) of 'his people' is associated with a time when the light of the
moon will be as the light of the sun and the light of the sun will be seven-
fold. The healing in 30.26 recalls that anticipated in 6.10, when the healing
of 'this people' will take place only when they see and come to understand
(בִּין). While darkness symbolizes their unwillingness to hear (29.15, 18),
light symbolizes their ability to reveal the hidden plans and wisdom of God.[67]

The God of Isaiah may remain invisible but what we *can* see, the visual
images from our everyday experience, can reveal and disclose his ways to
humanity. The subtle juxtaposition of images in chapters 28–33 brings out
this point, 29.15-18 providing a particularly good illustration. Isaiah 29.15
rails against those who hide their plans deep, whose deeds are in the dark
and who say 'who sees us?' By v. 18, however, from their gloom and darkness
the eyes of the blind shall see. In other words, the passage moves from a state
of blindness to one of sight and between the two verses, v. 15 and v. 18, two
very striking metaphors exercise the reader's imagination: the first is that of
the potter and the clay and the second that of the fruitful field (Carmel).
Both metaphors use the verb חשׁב, which generally means 'to consider, to
think',[68] but in the context here would appear to have the meaning '*to
imagine*'. The author states that if we imagine (that is, call the visual image
to mind) the process of pottery making, we could not possibly mistake the
role of the clay for that of the potter; in the second metaphor, the author
suggests that we must imagine Lebanon as Carmel (or a fruitful field) and
Carmel as a forest. In their context of 29.15-18, both metaphors illustrate
the point that by *imagining* (or *in our imagination*), when we see everyday
things differently, when we look at the familiar in new ways, we can uncover
new meanings, and not only that but the process can lead to profound
change: seeing the familiar from different angles becomes a metaphor—or
provides an analogy—for seeing and understanding the plans of God in a

67. Light is frequently juxtaposed with themes of blindness, coming to understand and
healing in many texts in Isaiah (2.5; 5.20, 30; 9.1; 10.17; 13.10; 30.26; 42.6,16; 49.6;
51.4; 58.8, 10; 59.9; 60.1, 3, 19, 20).

68. The root חשׁב denotes a creative act: for example, as a noun it can mean 'a deviser,
an artificer especially a weaver in figures of different colours, a damask-weaver'. See
Benjamin Davidson, *The Analytical Hebrew and Chaldee Lexicon* (London: Bagster & Son,
1970), p. 278.

new light. Sight leads to insight and so we leave behind the blindness of
v. 15 and acquire the ability to see in v. 18. In Isaiah, we cannot see God or
directly perceive his plans but the author suggests that the visual images that
our imagination calls up can lead to an understanding of his ways. Similarly,
in other texts, the horticultural images in 28.23-29, the desert crocuses in
bloom and the streams of water springing up in parched lands in Isaiah 35,
the hovering birds of 31.5, all appeal to the imagination and help us visualize
the ways and plans of an invisible God.

Metaphor in the Bible and the Visual Arts

While the Book of Isaiah illustrates clearly how metaphor is a particularly
appropriate form of speech that keeps the conflicting ideas of sight and
blindness in creative tension without arriving at a resolution, two very fami-
liar images recurring throughout the Bible provide further examples, the
mirror image and the representation of shade and shadows. Both convey the
general notion of visibility while at the same time hiding other aspects
implicit in the metaphor: the mirror allows us to see but only very imper-
fectly, while images of shade and shadows accentuate the notion of obscurity
and hiddenness—the object remains visible, however faintly. The metaphor
of the mirror can convey the idea of Wisdom reflecting the glory of God,
while at the same time concealing it from our direct gaze:

> Wisdom is a reflection (or radiance) of eternal light, a spotless mirror of the
> working of God and an image of his goodness (Wisd. 7.26).[69]

Paul notes that 'for now we see only in a mirror dimly, but then we will see
face to face' (1 Cor. 13.12), while, for James, the hearers of the word—
unlike the doers—are like those who look at themselves in a mirror and
immediately forget what they look like (1.23). The notion of hiddenness is
intensified when Paul combines the image of the mirror with that of a veil:

> But their minds were hardened. Indeed, to this very day, when they [the Jews]
> hear the reading of the old covenant, that same veil is still there, since only in
> Christ is it set aside. Indeed, to this very day whenever Moses is read, a veil
> lies over their minds but when one turns to the Lord, the veil is removed...
> and all of us, with unveiled faces, seeing the glory of the Lord as though
> reflected in a mirror, are being transformed into the same image from one
> degree of glory to another...and even if our gospel is veiled, it is veiled to
> those who are perishing. In their case the god of this world has blinded the
> minds of the unbelievers, to keep them from seeing the light of the gospel of
> the glory of Christ, who is the image of God (2 Cor. 3.14-4.4).

69. Job too (37.18), asks: 'Can you, like him, spread out the skies like a molten mirror?'

The point Paul makes is that when Christians read Scripture they can see what the Jews cannot. Yet the reader cannot see the glory of God directly but only as reflected in a mirror; it must remain obscure and indirect and so we cannot see it clearly and opaquely. William Horbury highlights the way the metaphor of the mirror holds a special fascination, for example in the Odes of Solomon (13.1), 'the Lord is a mirror' and in Pseudo-Cyprian (third century): 'through Solomon the saviour is called the spotless mirror of the father, for the holy spirit, the son of God, sees himself redoubled, father in son and son in father and both see themselves in each other'.[70]

Patrick Sherry explores the many instances where God's beauty in the world is expressed through visual metaphors—in terms of light, reflection and the mirror image (and notes that the relationship between God's glory and earthly beauty has always been expressed metaphorically rather than through any philosophical or theological exactitude).[71] In one of his sonnets Michelangelo states that he will love human beauty only because it mirrors God and Thomas Traherne extends the metaphor more widely in one of his *Centuries* when he says, 'The world is a mirror of Infinite Beauty, yet no Man sees it (1.31)'.[72] Mirrors and reflections, according to Sherry, convey the notion of the causal priority of an original. For Plato, followed by Augustine and Aquinas, creatures are copies (or mirror reflections) of ideas in God's mind and Sherry draws out how the likeness between creation and God becomes assimilated to the relationship between a work of art and ideas in the artist's mind.[73]

The importance of the mirror image in works of art was the subject of a special exhibition at the National Gallery, London, in 1998 and several of the paintings included were of biblical subjects.[74] One of these was Robert Campin's *St John the Baptist and Enrique de Werl* (Fig. 3) which depicts John the Baptist drawing the viewer's gaze to the Lamb of God. Behind John the Baptist and directly in front of the viewer hangs a mirror in which we can see the indistinct reflection of two persons looking at the lamb very intently. The mirror represents the attentive gaze that is required of the viewer but it is also suggests the more general New Testament idea of Christ as the mirror image of God—the lamb is depicted in the mirror reminding us perhaps of Christ's second (divine) nature. In this picture the human figure of Christ is hidden from us but his presence is still visible in the form of the lamb; the

70. William Horbury, 'The Wisdom of Solomon', in John Barton and John Muddiman (eds.), *The Oxford Bible Commentary* (Oxford University Press, 2001), pp. 650-67 (659).

71. Sherry, *Spirit and Beauty*, pp. 122-23.

72. Cited by Sherry in *Spirit and Beauty*, p. 122.

73. Sherry, *Spirit and Beauty*, p. 125.

74. The book accompanying the exhibition is: Jonathan Miller, *On Reflection* (London: National Gallery, 1998).

lamb's reflection in the mirror reminds us that it is possible to gaze on the divine but only indirectly. It is also worth noting here the important function of the mirror image in Velázquez's *Christ with Martha and Mary* and how Esler and Boyd have considered it so crucial for an informed understanding of the painting that they have dedicated an entire chapter in their book to discussing the visual technicalities associated with it.[75]

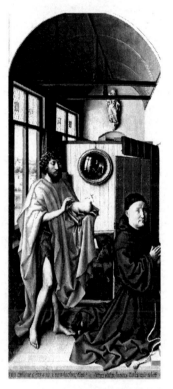

Fig. 3. Robert Campin, *St. John the Baptist and Enrique de Werl* (1438)
Museo del Prado, Madrid.

The metaphor of shade and shadows also suggests an aspect of hiddenness and invisibility since shadow is, in essence, a source of light that has been obscured. Natural elements such as trees, vines and rocks provide shade and cover from the heat and light (Judg. 9.15; Job 40.22; Ps. 80.10; Song 2.3; Isa. 32.2; Ezek. 7.23; 31.3, 6, 12, 17; Hos. 4.13). God provides shade (Isa. 4.6, 25.4; Ps. 121.5) frequently in the shadow of his wings (Ps. 36.7; 57.1; 63.7; 91.1) and often with the connotation of hiding and concealing (as in Ps. 17.8 or Isa. 49.2, and 51.16). In Isa. 16.3, God's shade at noon will be like night

75. See the chapter 'Mirrors and Velázquez', in Boyd and Esler, *Visuality and the Biblical Text*, pp. 117-28.

and so will hide the outcast. The fleeting quality of life is expressed by the simile of the approaching shadow (1 Chron. 29.15; Job 8.9; 14.2; 17.7; Ps. 39.6; 102.11; 109.23; 144.4). In Jer. 6.4, the shadows of the evening lengthen and in Acts 5.15, Peter's shadow, as it falls over the sick, can heal, while the author of Jas 1.17 addresses God as 'the Father of lights in whom there is no shadow or variation'. Such preoccupation with shade and shadow reflects a subtle and nuanced use of the visual metaphors of light and darkness that occur throughout the Bible. For Bonaventure, terms such as vestiges, traces, shadows are used to describe the relationship between earthly and heavenly beauty.[76]

In his book *Shadows: The Depiction of Cast Shadows in Western Art*, E.H. Gombrich draws attention to the importance of shade and shadow in several important masterpieces, many of which are biblical in theme. He notes that 'artists, intent on reproducing appearances, develop a specifically sensitive eye for the modifications of light and shadow'.[77] In *Golgotha*, for example, the artist Gérôme depicts his vision of Golgotha showing just the shadows of the three crosses against a dramatically lit landscape. In *The Shadow of Death* (Fig. 4), Holman Hunt turns the shadow of the youthful Christ into a portent of his ultimate death on the cross. In both paintings, the most significant aspect of the visual narrative (the crucifixion of Christ) is concealed in the shadows and it is up to the viewer to bring to light, to imagine, what is merely implied by the artist.

In terms of visuality in biblical literature, then, the visual metaphor, such as the mirror image or shade and shadow, plays a crucial role. It is metaphor that enables biblical authors to articulate the dichotomy between a highly visual human world and the hidden and invisible world of the divine that we can only 'see' in our imagination, and it is the interactive nature of metaphorical speech that allows the reader to engage creatively with the visual image. Most important of all, the medium of metaphor allows us to draw comparisons between the reader's engagement with biblical texts and the viewer's reaction to biblical paintings, since metaphor functions in essentially the same way in the visual arts as it does in literature. It is the connection—between metaphor in biblical literature and in art—that I want to draw attention to briefly in this concluding section.

One of the key attributes of metaphor, both in literature and in the visual arts, is its ability both to reveal and conceal. In their classic study on metaphor, Lakoff and Johnson emphasize this particular attribute and use the terms *highlight* and *hide* to describe the process whereby the commonplaces

76. Sherry, *Spirit and Beauty*, p. 125.

77. E.H. Gombrich, *Shadows: The Depiction of Cast Shadows in Western Art* (London: National Gallery, 1995), p. 10.

Fig. 4. William Holman Hunt, *The Shadow of Death* (1869–73)
Manchester City Art Galleries.

associated with the vehicle of the metaphor organize, filter and transform
our view of the tenor and either highlight or hide aspects of the subject: for
example, in the metaphor of God as a rock, the vehicle highlights strength
and protection but hides characteristics attributed to God in other speeches,
such as emotion and personality.[78] What are hidden are those aspects of the
tenor that are inconsistent with the vehicle.[79] Similarly, Mieke Bal argues
that metaphors operate as much by suppressing and concealing meaning as
by overtly creating it,[80] while Paul Ricoeur frequently uses the terms *open*
and *covert* to describe the essential processes at work in metaphor.[81] What is
visible is only partial, what remains concealed is what the reader, or viewer,

78. George Lakoff and Mark Johnson, *Metaphors We Live By* (Chicago: University of
Chicago Press, 1980), p. 149.

79. A further related term 'metaphoric extension' means extending previously 'unused'
parts of a metaphor in a figurative or imaginative way. For a more complete presentation
of this aspect of Lakoff's and Johnson's theory of metaphor, see Sarah J. Dille, *Mixing
Metaphors: God as Mother and Father in Deutero-Isaiah* (JSOTSup, 398; London: T. & T.
Clark International, 2004), p. 6.

80. Mieke Bal, 'Metaphors He Lives By', *Semeia* 61 (1993), pp. 185-208 (205-206).

81. Paul Ricoeur, *The Rule of Metaphor: Multi-disciplinary Studies of the Creation of
Meaning in Language* (Toronto: Toronto University Press, 1977), p. 198.

must seek to uncover and reveal. We must use our imagination to see, to bring to light what lies hidden, and so draw out new and original meanings. Hans-Georg Gadamer argues that we can never exhaust all the potential meanings or interpretations of a work of literature or art: what is *with-held* will always be part of our very experience of engaging with an artwork. A painting, for example, reveals particular aspects of its subject—it 'brings something forth from unconcealedness', but 'the emergence into light' is not the 'annihilation of concealedness' but the revelation of 'a continued sheltering in the dark':

> There is clearly a tension between the emergence and the sheltering that constitutes the form of a work of art and produces the brilliance by which it outshines everything else. Its truth is not constituted by its laying bare its meaning but rather by the unfathomable depths of its meaning. Thus by its very nature, the work of art is a conflict between emergence and sheltering.[82]

In other words, a painting, like a text, will always hide or conceal aspects from the reader or viewer and this, according to Gadamer, is precisely what lies at the heart of the intellectual challenge presented by art.

In one of the most important contributions to the topic of metaphor in the visual arts, John W. Dixon in *Art and the Theological Imagination* illustrates how 'art is basically a metaphoric activity, the penetration into the secret life of things to find the bonds between them'.[83] By this he means that human life is too intricate, too varied and complex to receive its definitive statement in any one language. The manifold interconnections between the various elements that make up life constantly interchange and interlock, and so frequently resist being articulated in the language of words, but a work of art, on the other hand, can enable the viewer actively and personally to participate in this 'secret life of things' and make connections that are impossible to communicate in words. Metaphor in art, for Dixon, is 'the linking of apparently different things by some profoundly felt connection between them';[84] the metaphors that comprise much art convey essential meaning which can be conveyed in no other way. Austin, too, argues that, as metaphors, theology and art are intimately linked because their verbal or pictorial codes both derive from the interaction of humans and their environment and of forms in space and time. Both words and painting are essential vehicles for

82. Hans-Georg Gadamer, 'Heidegger's Ways', p. 107, cited in Nicholas Davey, 'Between the Human and the Divine: On the Question of the In-Between', in A. Wiercinski (ed.), *Between the Human and the Divine: Philosophical and Theological Hermeneutics* (Toronto: The Hermeneutic Press, 2002), pp. 88-97 (95).

83. Dixon, *Art and the Theological Imagination*, p. 12.

84. Dixon, *Art and the Theological Imagination*, p. 14.

conveying the meaning that the theologian and painter wish to convey—meanings that they cannot define or encompass but can only suggest.[85]

As in biblical literature, where metaphor functions to hide and conceal, so too there is always a sense in which a painting withholds its meaning from the viewer or discloses itself only in limited and partial ways. The art theorist W.J.T. Mitchell puts it this way:

> We can never understand a picture unless we grasp the ways in which it shows what cannot be seen.[86]

In his review of Boyd and Esler's *Visuality and the Biblical Text*, David Jasper brings out very clearly how crucial it is for the reader of the biblical text and the viewer of a biblical painting to try to reveal what lies hidden or undisclosed, to progress from the visible to what is unseen:

> It is in this revealing of what cannot be seen that the painting enters into dialogue with the biblical text...it is in the seeing what is not seen and imagining what is not written that a genuinely creative dialogue takes place (between a biblical text and painting).[87]

What both Esler and Jasper point to is the role of the reader's or viewer's visual imagination as a means of accessing what cannot be articulated, disclosing what can only be suggested through the medium of metaphor.

Many of the aspects relating to visuality in the Bible introduced in this chapter will be explored in more depth in subsequent chapters but, by way of conclusion, it is important to draw attention here to two considerations that surface frequently throughout the book. The first has to do with the notion of time and space and the second with how we define the role of the imagination. When we explore visuality in the Bible, we give a rightful place to *space* and counterbalance the preoccupation with *time* in traditional biblical interpretation. For example, in the Old Testament our hermeneutic tends to concentrate on the biblical ordering of time, but a hermeneutic situated in the language of the visual can draw on spatial acts as well as temporal.[88] Visual art can define character, intensify or quiet the rhythm of an act; it can clarify an act beyond the possibilities of the verbal story because those things which must be set out in succession in the story can be shown simultaneously in a painting. The rhythm of the event in *time* and the shape of the event in *space* should be considered as being of equal importance. Dixon argues that although artists were always well aware of this, in the work of

85. Austin, *Explorations in Art*, p. 93.

86. W.J.T. Mitchell, *Iconology: Image, Text, Ideology* (Chicago: Chicago University Press, 1985), p. 39.

87. David Jasper, 'Review of Jane Boyd and Philip F. Esler, *Visuality and the Biblical Text* (Florence: Leo S. Olschki Editore, 2004)', ACE 44 (2005), pp. 8-9.

88. See Dixon, *Art and the Theological Imagination*, pp. 29-32.

'the Western Intelligence' the notion of space in all its manifestations was taken too much 'as ornament, as furniture, as a resource and not as central to the intellectual enterprise'. He goes on:

> We live, however, in a world not of words but of sights and sounds and weight and surface, and of lines and colours, of tones and textures, of forms and of space. ...all of our life is lived outside of words. Our life is lived in space with objects and persons: in the world we actually live in, we find all the elements of art—shape, mass, texture, colour, sound rhythm, line, edge, weight, movement, and all the many elements of our sensory world.[89]

With regard to the imagination: as I stated at the start of this chapter, the importance of the imagination in reading biblical texts has never been sufficiently highlighted. We rely on the imagination of artists to provide original and creative afterlives for the text but the reader too must exercise his or her visual imagination in order to appreciate fully, to be persuaded by, the Bible's plots and characters. Austin notes that too often the imagination is identified with the untrammelled, ill-disciplined, irrational part of us. The imagination, he argues, is not opposed to the intellect—it does not go against reason:

> While reason leads us to construct systems and employ arguments, the imagination compels us to paint pictures and tell stories and create myths, to recognize and value apparent disorder.[90]

Patrick Sherry notes that it is for good reason that the cognate term *image* lies at the heart of the word *imagination* (and correspondingly in German, *Bild* in *Einbildung*),[91] since the visual is central to the workings of the imagination, while John McIntyre sees the imagination as something that 'can make the absent present':

> The imagination is our mind working in ways that lead to perception, selection, and integration; in ways that are creative and constructive, cognitive and interpretative; that are empathetic and sustaining and truly communicative; that makes the absent present and distance of little consequence.[92]

But it is Dante (for whom there was a kind of luminous source in the skies that transmits images) who speaks most passionately of the role of the imagination in *The Divine Comedy* (Canto XVII.13-18), paraphrased here by Italo Calvino:

89. Dixon, *Art and the Theological Imagination*, p. 4.

90. Austin, *Explorations in Art*, p. 2.

91. Sherry, *Spirit and Beauty*, p. 110, links imagination with inspiration and points to the liberating and illuminating power of art. Art plays an important role in extending people's imaginative and moral range—it helps them to see things from an unfamiliar point of view and so stimulates them to deeper and richer lives.

92. John McIntyre, *Faith, Theology and Imagination* (Edinburgh: Handsel Press, 1987), p. 1.

Imagination is that which has the power to impose itself upon our faculties and our wills, stealing us away from the outer world and carrying us off into an inner one, so that even if a thousand trumpets were to sound, we would not hear them.[93]

Calvino lists visibility as one of the values he would wish to save in the new millennium and talks of the need for a 'pedagogy' of the imagination that would enable the visual images we encounter in literature to 'crystallize into a well-defined, memorable and self-sufficient form'. In Biblical Studies, too, we have neglected the importance of the visual imagination in our hermeneutical processes and, following Boyd and Esler, we must bring more insights from the world of visual culture to bear on the way we engage with and interpret the biblical text. The chapters that follow are intended to provide a further step in that direction.

93. Calvino, *Six Memos*, p. 82.

2

THE ARTIST AS READER OF THE BIBLE:
VISUAL EXEGESIS AND *THE ADORATION OF THE MAGI*

Increasingly, visual interpretations of biblical texts are included in many con-temporary commentaries, indicative of the rich and varied afterlives these texts have enjoyed.[1] In some cases, they are used to draw out the devotional and doctrinal aspects of a biblical theme envisaged by the artist,[2] in other cases to explore the appropriation of texts in specific historical and political contexts;[3] frequently they offer starting points, or are used as evidence for positions already taken up, in gendered readings of the text.[4] But, given the vast and overwhelming range of visual interpretations now accessible to the contemporary researcher, how does one select images or paintings that shed new insights into the meaning and significance of the text, and, in particular, that foreground those aspects otherwise lost, or insufficiently brought out, in traditional or current literary approaches? Is the selection of paintings used to illustrate the significance of a text merely arbitrary, and limited to the range of paintings familiar to the commentator and to his or her academic or personal interests? In what sense does a 'biblical' painting illumine a biblical text and what credibility or authority does an artist or painting really bring to the task of interpretation?

Some argue that biblical paintings of the traditional art-historical kind do little to support contemporary, inclusive and explorative readings of the text;

1. For example, The Blackwell Bible Commentaries Series emphasizes the influence of the Bible on literature, art, music and film.

2. John Drury, *Painting the Word* (New Haven: Yale University Press, 1999); Martin O'Kane, 'The Flight into Egypt: Icon of Refuge for the H(a)unted', in Martin O'Kane (ed.), *Borders, Boundaries and the Bible* (JSOTSup, 313; Sheffield: Sheffield Academic Press, 2002), pp. 15-60.

3. Richard C. Trexler, *The Journey of the Magi: Meanings in History of a Christian Story* (Princeton: Princeton University Press, 1997).

4. Mieke Bal, *Reading 'Rembrandt': Beyond the Word–Image Opposition* (Cambridge: Cambridge University Press, 1991). See especially her discussion of the story of Susanna and the Elders, pp. 138-76.

others question whether modern art, with its essentially abstract approach, can convey any identifiable cultural afterlife of the narrative, given that artistic subjectivity rather than the biblical iconographical traditions of past centuries is central to its approach.[5] When art is used to enhance, expand or comment on a biblical text, the dynamic between the written text, the visual expression of its subject matter and the viewer comes to the fore, raising in turn issues of a philosophical nature such as the word–image order, the relationship between a text (what is written) and an image (what is seen), and whether it is even possible to reduce what we see in a painting to the level of verbal explication rather than concentrate on its sheer (inarticulable) sensibility.[6] To these considerations, we might add the question of what contribution the analyses of visual expressions of biblical subject matter make to the on-going dialogue between art and the broader theological agenda.

While many biblical commentators now focus on the dynamic that takes place between the written biblical text and its reader,[7] there has been much less interest in engaging with approaches that explore how the involvement of the viewer in the biblical visual image determines its meaning and significance. It is our response as viewers, or the response that the artist intends to elicit from the viewer, that helps us discover unexpected subtleties in the parallel biblical text.[8] Traditionally, the patron, whether church, secular and political authorities or individuals of power and influence, has played a major role in determining how a biblical text should be visually expressed; despite this, however, the patron cannot control or determine the effect a painting has had on its viewers living in different times and cultures.

5. Gesa E. Thiessen, *Theology and Modern Irish Art* (Dublin: Columba Press, 1999), pp. 9-36.

6. Paul Valery warns, 'We should apologize for daring to speak about painting' (cited in Simon Schama, *Rembrandt's Eyes* [London: Penguin Books, 1999], p. i).

7. See D. Marguerat and Y. Bourquin, *How to Read Bible Stories* (London: SCM Press, 1999) for a presentation of a range of approaches used by contemporary commentators in emphasizing the role of the reader.

8. Laurie Edson, in *Reading Relationally: Postmodern Perspectives on Literature and Art* (Ann Arbor: University of Michigan Press, 2001), explores how reading literature in the context of the visual arts enriches our understanding of what texts do and what texts mean. She advocates a practice of reading that directs attention to readers' relationships with texts and to the ways in which our frames of reference and mediating practices shape an object under investigation. By 'reading relationally' across the disciplines of literature and visual art, she sets in motion a series of reverberations between verbal and visual material. Reading relationally, she argues, can shed new light on texts by enabling us to think and see differently and therefore bring different textual details into sharper focus. A verbal text read through the lens of a visual text, constructed according to different codes and interpreted according to different conventions, can unsettle some of the habitual or codified methods of analysis that have governed the mind and eye.

In the light of such considerations, the aim of this chapter is to explore the processes at work in a painting's engagement of its viewer in biblical subject matter. It accentuates the role of the artist as an active reader of the Bible and not merely an illustrator of biblical scenes, the dynamic that occurs in the text–reader process as paradigmatic for the image–viewer relationship and the important role of the developing tradition that felt the need to change or rewrite the biblical story, while at the same time attempting to maintain its continuity with the author's intentions.

The fact that the visual subject matter is biblical makes it appropriate to explore the process in the general terms of hermeneutics and exegesis—if we define hermeneutics as 'the interweaving of language and life within the horizon of the text and within the horizons of traditions and the modern reader'[9] and exegesis as 'the dialectic between textual meaning and the reader's existence'.[10] Understanding the process at work between a biblical painting and its viewer—and seeing this process in parallel terms to what happens between a biblical text and its reader—allows us to appreciate how the painting of a biblical subject presents to the viewer an event in which he or she becomes involved and how different visual instances of the same subject matter broaden the horizons of the viewer.[11]

The starting points for such an enquiry lie in philosophical and art historical perspectives as presented in the works of philosopher Hans-Georg Gadamer and art historian Paolo Berdini. In 'The Question of Truth as It Emerges from the Experience of Art', in his magnum opus, *Truth and Method*, Gadamer sets out the role of hermeneutical aesthetics in understanding the function of art.[12] In his extended theoretical introduction 'Scripture Reading and Visual Exegesis', in *The Religious Art of Jacopo Bassano: Painting as Visual Exegesis*, Berdini deals with the processes at work when an artist paints a biblical scene, and argues that what is visualized is not the text but a reading of the text, a process he calls 'visual exegesis'.[13] Thus, Gadamer's interests focus on hermeneutics, the critical and theoretical reflection on the processes of interpretation, while Berdini's centre on exegesis, the work of interpreting and understanding specific texts as a first order activity. Applying both approaches to the visualization of biblical subject matter illumines the key role given to

9. Anthony Thiselton, 'Biblical Studies and Theoretical Hermeneutics', in John Barton (ed.), *The Cambridge Companion to Biblical Interpretation* (Cambridge: Cambridge University Press, 1998), pp. 95-113 (95).

10. Paolo Berdini, *The Religious Art of Jacopo Bassano: Painting as Visual Exegesis* (Cambridge: Cambridge University Press, 1997), p. 5.

11. See David Brown, *Tradition and Imagination*, pp. 50-52.

12. Hans-Georg Gadamer, *Truth and Method* (London: Sheed & Ward, 1975), pp. 5-150.

13. Berdini, *The Religious Art of Jacopo Bassano*, p. xi.

the viewer in the visual hermeneutical process. For the purposes of this chapter, the biblical text that demonstrates the usefulness of Gadamer's and Berdini's insights is the story of the adoration of the Magi (Mt. 2.1-12), the first public and universal *seeing* of Christ, a subject matter that constitutes one of the most frequently depicted themes in the entire history of biblical art, and that for artists 'has provided the perfect context for involving the spectator in the world of the Bible'.[14] Finally, the chapter concludes by drawing out some areas of common interest between the interpretation of the Bible through its visual expressions and the exploration of modern art as a source in and of theology, advocated by Paul Tillich,[15] and applied to a number of contemporary abstract paintings in a recent study by Gesa Thiessen.[16]

Hans-Georg Gadamer and Hermeneutical Aesthetics

The philosophical hermeneutics of Hans-Georg Gadamer has had significant influence on biblical interpretation. His central notion of the fusion of horizons (*Horizontverschmelzung*) holds that authentic interpretation does not take place by attempting to put oneself in the shoes of the author but rather through a merging of one's horizon with that of the author. His ideas on how understanding a text from the past and applying its meaning to our present circumstances occur simultaneously and not as two separate events have been used effectively in the area of biblical hermeneutics, particularly by Gerhard Ebeling,[17] Anthony Thiselton,[18] and Ulrich Luz.[19] In *Truth and Method*, Gadamer is concerned with three aspects: aesthetic experience, historical consciousness and language. However, since hermeneutics traditionally has placed so much importance on language, especially its written forms, his influence on biblical hermeneutics has generally been restricted to the

14. Dawson Carr, *Andrea Mantegna: The Adoration of the Magi* (Getty Museum Studies in Art; Los Angeles: Getty Museum, 1997), p. 91.

15. Paul Tillich, 'Art and Ultimate Reality', in Michael Palmer (ed.), *Paul Tillich: Main Works* (Berlin: de Gruyter, 1990), II, pp. 317-22.

16. Thiessen, *Theology and Modern Irish Art*.

17. Gerhard Ebeling, *The Word of God and Tradition* (London: Collins, 1968).

18. Anthony Thiselton, *The Two Horizons: New Testament Hermeneutics and Philosophical Description* (Exeter: Paternoster Press, 1980), pp. 293-326.

19. Ulrich Luz, *Matthew 1–7: A Commentary* (Edinburgh: T. & T. Clark, 1989). Ebeling's view that 'the more deeply a person penetrates the interpretation of a subject, the more strongly one's own relation to the subject matter makes itself felt' (Gerhard Ebeling, *The Study of Theology* [London: Collins, 1974], p. 24) has been further developed by Luz in his commentary on Matthew's Gospel, where he devotes discrete sections in each chapter to 'the history of influence' (*Wirkungsgeschichte*) which explores 'what we have become on the basis of the text' (Luz, *Matthew*, p. 96), as actualized in media such as art, hymnody and sermons.

aspect of language, while the application of his perspective on aesthetic experience to biblical visual culture has remained largely unexplored.[20] In brief, Gadamer argues that, in experiencing a work of art, one undergoes something similar to the experience of play in games: the participant is drawn into an event with its own subjectivity and life. We experience truth in art when the work draws us into its play of meaning and allows us to see something previously hidden about the everyday world in which we live.[21]

In a recent volume that explores the centrality of the visual within contemporary critical discourse in which the 'visual field has begun to be explored with a thoroughness and global understanding unique in the history of human self-reflection',[22] Nicholas Davey builds on Gadamer's views on aesthetic experience in *Truth and Method* to present a robust argument for the value of a hermeneutical aesthetic in coming to appreciate what lies in a work of art.[23] His essay provides a useful point of reference since he reflects on Gadamer's views in a contemporary intellectual context that is 'extraordinarily sensitive to the importance of the visual and no less suspicious of its implications'.[24] It also demonstrates how the appreciation of visual interpretations of a biblical subject, far from being a simply subjective experience, is essentially dialogical in that it 'underwrites art's ability to take us beyond ourselves and out of the initial horizons of our present historical circumstance into others'.[25]

Following Gadamer, Davey defines hermeneutical aesthetics as a 'philosophical meditation on what happens to us in our experience of art'.[26]

20. Yet, currently, the application of Gadamer's hermeneutical aesthetics to interpreting visual culture is central to current debates in other disciplines such as critical theory, post-modern philosophy, aesthetic theory, deconstruction and cultural studies—disciplines that 'converge and intersect upon the field of visuality as one of the central terrains of modern critical thought' (Ian Heywood and Barry Sandwell, 'Explorations in the Hermeneutics of Vision', in Ian Heywood and Barry Sandwell [eds.], *Interpreting Visual Culture: Explorations in the Hermeneutics of the Visual* [London: Routledge, 1999], pp. ix-xviii [ix]).

21. For a more complete discussion, see D.E. Klemm, 'Hermeneutics', in John J. Hayes (ed.), *Dictionary of Biblical Interpretation* (Nashville: Abingdon Press, 1999), pp. 497-502 (500).

22. Heywood and Sandwell, 'Explorations', in their *Interpreting Visual Culture*, p. ix.

23. Nicholas Davey, 'The Hermeneutics of Seeing', in Heywood and Sandwell (eds.), *Interpreting Visual Culture*, pp. 3-29.

24. M. Jay, *Downcast Eyes: The Denigration of Vision in Twentieth-Century French Thought* (Berkeley: University of California Press, 1993), p. 588. The comment by Jay refers to Derrida's stance concerning the claim that the Western tradition of thought is dominated by an ideas-led approach to the visual so that we are always striving to 'see-as', to reduce the seen to a level of verbal explication rather than to concentrate on the sheer (inarticulable) sensibility of the visual.

25. Davey, *The Hermeneutics of Seeing*, p. 3.

26. Davey, *The Hermeneutics of Seeing*, p. 3.

Hermeneutics' deep concern with language does not subordinate image to word but applies the sensitivities we acquire from linguistic exchange to reveal how our experience of art is a complex dialogical achievement involving the fusion of the horizons surrounding artist, subject matter and viewer. Davey makes linguistic understanding a paradigm case for grasping the nature of artistic understanding and shows how contemporary philosophical hermeneutics[27] emphasize the ability of the said to point to and reveal the unsaid and argues that what comes to pass in language illuminates the nature of our understanding of art. Language discloses of itself subtleties of association and nuances which logical analysis cannot foresee; consequently, embedded within words are world views capable of supplementing and extending our own, the possibility of alternative meanings which flow from the past into our contemporary world. Gadamer holds that there is no fundamental difference between experiencing the disclosive powers of language and experiencing what art discloses to us.

Hermeneutic aesthetics makes a distinction between the broad subject matter of a work and the very particular way a painting interprets it; it discloses how the subject matter an art work brings to mind is larger than what is shown and, at the same time, reveals the individuality of a work, its particular way of contributing towards its expression.[28] When an art work brings its subject matter to mind, it will bring to mind more than is initially seen. We are led out of the immediacy of our own horizon and brought to consider other ways of seeing and thinking; reacquainting ourselves with previous interpretations of a subject frees us from being compelled to think and feel solely in terms of our present horizon. By recognizing different traditions of art practice and history, hermeneutical experience exposes the (subjective) limitations of our ways of seeing and opens us to a greater objectivity.[29] The subject matter (*Sache*) that a painting expresses can never be exhausted by its particular exemplifications; it is more than any individual expression of it and always susceptible to extension by further interpretation so that no art work can ever be finished.[30]

One of the most important contributions of hermeneutical aesthetics is the argument that, in the experience of art, seeing and understanding are

27. See Martin Heidegger's *On the Way to Language* (New York: HarperCollins, 1982) and Gadamer's *Truth and Method*, pp. 5-150.

28. See Davey, 'The Hermeneutics of Seeing', pp. 14-17.

29. Davey, *The Hermeneutics of Seeing*, p. 3. See Paul Ricoeur's similar idea in relation to the text: 'to interpret is not a question of imposing on the text our finite capacity of understanding but of exposing ourselves to the text and receiving from it an enlarged self' (Paul Ricoeur, *Hermeneutics and the Human Sciences* [ed. and trans. John B. Thompson; Cambridge: Cambridge University Press, 1981], p. 143).

30. Gadamer comments in *Truth and Method*, p. 99, 'all encounter with the language of art is an unfinished event'.

not merely passive. On the contrary, the spectator is a condition of what is held within a work or art coming forth and this can effectively change the subject matter it discloses. Davey emphasizes Gadamer's crucial distinction between representation (*Vorstellung*) and presentation (*Darstellung*) in art. *Vorstellung* implies a re-presenting of something independent of the work, an attempt to represent something 'objectively', for example, the genre of Dutch maritime painting is taken to re-present the seascape; re-presentation suggests that the work is something other than, distinct from, what it re-presents.[31] The notion of *Darstellung*, however, is altogether different; it suggests a placing (*Stellung*) there (*da*). It hints at that which an art work presents or offers up, how an image occasions the *coming forth* of the subject matter, facilitating its epiphany, its coming into appearance. Gadamer is particularly concerned with what happens in our experience of art, with the 'event of being that occurs in artistic presentation', 'what comes to picture' in a painting. The 'appearing' is not secondary to the subject matter but is, on the contrary, a presentation (*Darstellung*) of the essence itself. Gadamer emphasizes that the notion of *Darstellung* is particularly important for understanding religious art since the artist cannot offer 'objective' images of the divine; religious art is not a depiction (*Vorstellung*) but a coming into picture (*Darstellung*) of a divine presence.[32]

Gadamer's perspective helps highlight the important role of visual culture in biblical interpretation. It respects the changing and developing tradition of biblical subject matter, it appreciates its range and variety of visual instances and it merges the horizons of viewer and artist to expand the subject matter itself, while the notion of *Darstellung* is especially applicable to the concept of the Bible as a source of divine revelation. Visual instances of the adoration of the Magi provide a good illustration of the usefulness of Gadamer's approach; as the first public instance of the revealing of the divinity in human form, the subject matter deals essentially with a theological concept that cannot simply be *presented* but must be *re-presented*. Gadamer's notion of the *coming forth* of the subject matter becomes more significant since it corresponds to the biblical narrative's theme of *coming forth* of the Christ child.[33] The particularly rich visual reception history of the story illustrates the variety of ways artists have interpreted its subject matter; its many instances show how a work of art points beyond itself, is larger than what is shown, while

31. Davey, *The Hermeneutics of Seeing*, p. 19.

32. 'If religious iconography is the means whereby the divine appears to us in our terms, such iconography occasions for us a divine presence' (Davey, 'The Hermeneutics of Seeing', p. 28 n. 23).

33. 'In speaking to us, an art work reveals something; it brings something forth from concealedness' (Hans-Georg Gadamer, *Heidegger's Ways* [Albany: New York University Press, 1994], p. 180).

also revealing the individuality of the work. By appreciating a range of expressions of the same subject matter in many different art traditions, we free ourselves from the limits of our present horizon and recognize that no expression of the theme is ever complete, that the subject matter addressed is always more than any individual expression of it.

Paolo Berdini and Visual Exegesis

Paolo Berdini, with specific reference to the late sixteenth-century artist Jacopo Bassano,[34] explores the process and implications of what happens when an artist paints a subject or narrative from the Bible.[35] In the place of traditional art-historical criticism that emphasizes text as *source* and the *function* of the corresponding image, he advocates the notion of textual expansion. What the painter visualizes is not the narrative of the text but its expanded form as it emerges from the painter's reading of it. In other words, 'the complex dynamics of visualization' combines the text with the ideas and images provided by the painter as he or she reads and responds to the text. Painting visualizes a reading and not a text, for the relationship between a text and its visualization has to take into account the circumstances under which that text is read in addition to what makes it the object of the particular interest that might result in its visualization. Painting (and not only Bassano's) thus proceeds by a process Berdini calls 'visual exegesis'. The relationship between text and image is conceived of, not in terms of a correspondence between a narrative and its visual equivalent, but rather in terms of the visualization of an expanded notion of it; following the exegetical model, visualization addresses the discursive status of the text. The notion of 'visual exegesis' thus registers and promotes the crucial move from image to beholder. What visual exegesis describes is the new encounter with the text made possible by the image.

The problem with traditional art-historical notions of source and function, Berdini argues, is that they stop short the process from textual reading

34. Jacopo Bassano (1518–1592) was 'a painter and reader of Scripture. The list of subjects he took from the Bible for his painting is impressive in its number and variety, and includes parables and pronouncement stories that are seldom visually represented. Bassano's engagement with Scripture, though, was hardly limited to such professional expertise. His biographers tell us that, when fatigued by painting, he resorted to scriptural reading. Reading was his virtuous activity' (Berdini, *The Religious Art of Jacopo Bassano*, p. xi).

35. Reviewing Berdini's work, John Marciari affirms the value of Berdini's methodological approach to biblical painting which calls for a re-evaluation of traditional (Panofskian) art-historical methodologies that seek close correspondences between painted image and text. Marciari advocates pursuing similar approaches to other artists. See John Marciari, 'Review of Paolo Berdini, *The Religious Art of Jacopo Bassano: Painting as Visual Exegesis* (Cambridge: Cambridge University Press, 1997)', *Speculum* 75 (2000), pp. 440-41.

to existential significance—they arrest their interplay.[36] Exegesis, on the contrary, valorizes the beholder's role in the existential appropriation of the text. Whereas a function remains an attribute of the image, visual exegesis reveals dimensions of the beholder. Replacement of the notion of source and function is necessary because they prevent acknowledgment of the hermeneutic import of beholding. Reading needs to be recognized as an event that, rather than being subjected to patterns of universal validity, registers at any moment the prerogatives the reader brings to the text.

Since the reader is a painter, it is the relationship between the structure of exegesis and the circumstances of visualization that most interests Berdini.[37] In dealing with the text of the Bible, he argues, the painter enters a cumulative text, a chain of texts; his or her engagement with it proceeds from an understanding of the text's meaning to the assertion of its significance. Textual exegesis has to be structured in such a way as to be able to register the effect of the text on its reader; it guides and disciplines the reader's search for the existential referent implicit in the text and revealed by its reading. This process is similar to what takes place in visual exegesis.

In particular, Berdini emphasizes the *expansive* modes implicit in the process of Christian exegesis in its four traditional stages: narrative, allegory, tropology and anagogy.[38] An awareness of the exegetical process assists the reader in transcending a literal reading of the text and in identifying a moral dimension which can be assimilated to his or her life and, finally, it motivates the pursuit of spiritual proximity with the divine. Exegesis thus fulfils its aims whenever the significance of the text can be ascertained as a dimension of being on the part of the reader. Similarly, Berdini argues, visualization enters into a relationship with the text that constitutes a form of exegesis, 'visual exegesis'—a process that allows the text to reveal multi-level meanings that exceed literality while unveiling the existential conditions of the reader.[39]

Berdini uses the work of the prolific artist Jacopo Bassano, who worked in the Veneto during and after the Council of Trent (1546), to illustrate his approach. Contrary to the case in Reformation Germany, where 'like the word, the image had to be secure in its literality, precluded in its expansion and politicized in its use',[40] visual culture in Italy was intended to play an important role in the expansion of the text. In fact, the most controversial

36. Berdini, *The Religious Art of Jacopo Bassano*, p. 3, and Hans-Georg Gadamer, 'The Play of Art', in Nicholas Walker (ed.), *The Relevance of the Beautiful and Other Essays* (Cambridge: Cambridge University Press, 1986), pp. 123-30.

37. Berdini, *The Religious Art of Jacopo Bassano*, pp. 5-7.

38. Berdini, *The Religious Art of Jacopo Bassano*, p. 5.

39. Berdini, *The Religious Art of Jacopo Bassano*, p. 7.

40. Berdini, *The Religious Art of Jacopo Bassano*, p. 9.

aspect of the debate over the status of religious images following the Council of Trent was the *exegetical* import of images; there was a high degree of concern for the ways in which the image inevitably expands the text. The case of Veronese is an example that *any* artistic invention could not be taken for textual expansion, for, when he was brought before the Inquisition for his depiction of figures extraneous to textual accounts of the Last Supper, he was questioned primarily as a *reader*.[41]

Just as a painter's reading of a biblical text can be shown to function in how an image is visualized, so too the viewer's reading of a painting can function in determining to what degree the work of art is religious.[42] The Gospel parables provide a good example. In representing a parable, the painter has the difficulty of preserving its religious message while at the same time depicting realistically the realm of ordinary existence, the human sphere, in which the action of the parable occurs; the image, not overtly religious, becomes so only in the eyes of the beholder through an exegetical process of reading. It is therefore up to the beholder to determine the degree of 'religiosity' sufficient to make an image religious; the religious status of an image depends on the beholder's reception of it and not simply on the identification of its genre.

Berdini's study demonstrates the importance of the mediating influence on the painter of established and authoritative exegetical traditions. The painter is not painting a text but a *reading* of the text according to exegetical principles; the viewer is guided in reading the painting through the same exegetical process. Since Bassano worked almost exclusively in the rural Veneto, his immediate concern was to address a rural peasant population, and so Berdini chooses in particular to deal with his treatment of the theme of the adoration of the shepherds. However, there are many examples of his *Adoration of the Magi*, a subject matter that also illustrates the notion of textual expansion and one suitable for tracing the exegetical process at work in many of its visual representations. It could be argued that Berdini's approach applies only to mid-sixteenth century Italian painting, but, as we shall see, the same exegetical principles are implied, using different methodology, in Mieke Bal's discussion of Rembrandt's drawing of the *Adoration of the Magi*

41. Veronese was taken to task by his inquisitors for crowding a painting of the *Last Supper* (Accademia, Venice, 1573) 'with such irrelevant and irreverent figures as a buffoon with a parrot on his wrist, a servant whose nose was bleeding, dwarfs and similar vulgarities'. He staunchly defended his right to artistic license: 'I received the commission to decorate the picture as I saw fit. It is large and, it seemed to me, it could hold many figures'. He was instructed to make changes, but the matter was resolved by changing the title of the picture to *The Feast in the House of Levi* (WebMuseum, Paris. www.ibiblio.org/wm/paint/auth/veronese).

42. Berdini, *The Religious Art of Jacopo Bassano*, pp. 123-24.

from seventeenth-century Holland,[43] as well as in Gesa Thiessen's exploration of modern abstract art in Ireland.[44]

The Adoration of the Magi: Development of the Tradition

In Matthew's Gospel, the story of the adoration of the Magi is presented as the first public revealing of Christ. In Christian tradition, as the Epiphany, it quickly became associated with two other early Gospel episodes, the marriage feast at Cana (Jn 2.1-11) and the baptism of Christ (Mt. 3.13-16).[45] By the fourth century, the Magi had come to represent the three ages of humankind (old age, middle age and youth) and the three continents (Europe, Asia and Africa), and were given individual identities as Caspar, Melchior and Balthasar.[46] Compared to its importance in tradition and in the reception history of the New Testament, the narrative and the challenges its many visual instances present have received little attention from contemporary commentators.[47] M.A. Powell has explored the narrative from a reader-response angle, but remains focused on traditional questions such as the identity of the Magi as wise men, kings or magicians, and the implications such identities might have for the story's first readers and for readers today.[48] In a detailed study of the reception history of the story, Richard Trexler concentrates on the implications of presenting the Magi throughout centuries of Christianity as a 'legitimating icon' for power and monarchy and on its potential for social critique,[49] with little attention paid to the devotional

43. Bal, *Reading 'Rembrandt'*, pp. 206-15.

44. Thiessen, *Theology and Modern Irish Art*, pp. 249-83.

45. The conflation is summed up in St Gregory's eighth homily for the Epiphany: 'Today the Church is joined to the divine bridegroom because Christ washes away its sins in the Jordan; the Magi bring wedding gifts and the wedding guests rejoice at the water made wine' (cited in Jeffrey Ruda, *Fra Filippo Lippi: Life and Work* [London: Phaidon, 1999], p. 210).

46. See Trexler, *The Journey of the Magi*, pp. 38-39; Brown, *Tradition and Imagination*, pp. 86-88; Paul D.H. Kaplan, *The Rise of the Black Magus in Western Art* (Ann Arbor: UMI Research Press, 1983), pp. 50-52.

47. Interestingly, the importance of the visual has been stressed in traditional commentaries, for example, Douglas R.A. Hare, *Matthew* (Interpretation Series; Louisville, KY: John Knox Press, 1993), p. 12, states: 'The story of the Adoration of the Magi has often been better understood by poets and artists than by scholars whose microscopic analysis has missed its essence'.

48. M.A. Powell, 'The Magi as Kings: An Adventure in Reader-Response Criticism', *CBQ* 62 (2000), pp. 459-80; 'The Magi as Wise Men: Re-examining a Basic Assumption', *NTS* 46 (2000), pp. 1-20; *Chasing the Eastern Star: Adventures in Biblical Reader-Response Criticism* (Louisville, KY: Westminster John Knox Press, 2001).

49. Trexler, *The Journey of the Magi*.

aspects, a criticism that has been made elsewhere of his study.[50] Larry Kreitzer has explored the theme in literature and film but not in art.[51]

Ulrich Luz in the 'history of influence' (*Wirkungsgeschichte*) section of his commentary finds the apparent lack of correspondence between the text of Mt. 2.1-12 and its afterlives striking and notes:

> The discrepancy between the biblical text and popular piety is especially thought provoking. The history of the influence of our text is also an example of its lack of influence. The exegesis therefore aids in critical examination of popular piety to find the way back from the abuses to the message of the text, without destroying the inherently positive element, namely, the possibility of Christians to identify with the Magi.[52]

David Brown defends the developing tradition as having continuity with Matthew's intentions. The reason behind the re-writings of the story, in particular the development of its characters, was to ensure the concrete realization of the story in the present. In later treatments comes the substitution story that could be experienced as contemporary with the reader's own world. Deliberations on the identity of the Magi as wise men or the significance of the star have receded; the intention now is to speak of a child relevant to every age of humanity and race:

> There is the need to hear in them [i.e. later traditions surrounding the Magi] the transformation of the biblical story into a deeper social critique than Matthew himself offers. Through the use of his imagination, the evangelist set the Church on a particular path, but what arose was no more straight-forward deduction or implication, but itself a creative reworking in the light of later, more developed, Christian self-perception.[53]

Gadamer and Berdini both emphasize the importance of the developing tradition in appreciating different visual instances of biblical subject matter. In the case of Gadamer, the expansion of biblical themes to address contemporary political or social issues, as well as for devotional or doctrinal purposes,

50. In a review of Trexler's book, Thomas F.X. Noble (*History of Religions* 40 [2001], pp. 304-306 [305]) makes the comment: 'My main reservation about this book is that its resolute attempt to interpret the Magian theme is always and everywhere being about power that strips the image of the range of devotional associations that were surely at its heart'. See similar comments made by David Brown (*Tradition and Imagination*, p. 90), where he argues for a very different interpretation of Benozzo Gozzoli's famous depiction, commissioned by the de Medici family for their private chapel in the Palazzo Medici in Florence. Rather than its being a way of glorifying the de Medicis, he argues, the de Medici family are given a subordinate role in the annual procession of the Magi to indicate that they acknowledged where true power and wealth lay.

51. Larry J. Kreitzer, *Gospel Images in Fiction and Film: On Reversing the Hermeneutical Flow* (The Biblical Seminar, 84; Sheffield: Sheffield Academic Press, 2002), pp. 24-44.

52. Luz, *Matthew*, p. 141.

53. Brown, *Tradition and Imagination*, p. 92.

provides examples of how different instances of the same subject matter led to other ways of seeing and understanding. For Berdini, an awareness of the developing tradition informs the viewer of the painter's religious and social priorities in reading, actualizing and visualizing the text for the then contemporary viewer. In biblical visual culture, therefore, it is not the literal correspondence between text and image (or lack of it since the correspondence in most instances is partial) that determines our appreciation of the painting but rather an understanding of how the artist read the text within its developing tradition.

Visual-related Language in Mt. 2.1-12

Before we explore specific visual instances of the story, it is important to appreciate the visually evocative material contained in the text itself, which becomes especially significant if the reader is a painter. Particularly striking in the Greek narrative of Mt. 2.1-12, but rarely noted in commentaries, is the use of vocabulary related to sight.[54] The passage centres around five instances of the verb ὁράω, 'to see', most often with the Magi as its subject (vv. 2, 9, 10, 11) or Herod (v. 16). In the first three cases, it is the star (identified as the star of the Christ child by αὐτοῦ in v. 2) that the Magi see, but in v. 11, the climax of the story, they see 'the child with Mary his mother'. Herod, on the other hand, despite his efforts, sees neither the star nor the child, only that he has been tricked by the Magi (v. 16). Even when he tries to ascertain knowledge of the star in v. 7, it is in its visual appearance (φαινομένου) that he expresses interest rather than in its significance. It is the Magi alone who see both the star and the child and therefore only they can pay him homage (v. 11). The ability of the Magi to see is highlighted for the reader by the interjection (ἰδού) whose verbal root also comes from ὁράω. Normally a term that serves as a narrative technique to suggest urgency and immediacy and often translated as 'look! behold!', its function here is to direct the reader's attention both to the Magi (v. 1) and to the star (v. 9).[55] It serves to conjure up in the mind of the reader visual images of the story's key components, just as elsewhere in the infancy narrative ἰδού introduces the reader to the sudden visual appearance of the angel to Joseph (1.20; 2.13, 19). The reader thus becomes more visually attuned to the story and, with the Magi, sees the

54. David J.A. Clines (*I, He, We and They: A Literary Approach to Isaiah 53* [JSOTSup, 1; Department of Biblical Studies, University of Sheffield, 1976], pp. 40-41), similarly highlights the role of visual language in the Servant Poem in Isaiah 53 and concludes that the poem is 'about modes of seeing'.

55. In Isaiah 53, Clines (*I, He, We and They*, p. 40), explores the use of הִנֵּה (behold!) 'which announces that the poem is about seeing; that is, in what way the servant should and should not be seen'.

child for the first time in 2.11. A further visual aspect of the story is high-lighted by the use of the verb φαίνω 'to shine, give light', its middle and pas-sive forms denoting 'to be seen, to appear'. Like ἰδού, it is used of the appear-ance of the angel to Joseph (1.20; 2.13, 19), and, elsewhere in Matthew, it often signals the visual appearance or revelation of the divine to humankind (9.33; 24.27, 30). Its significance has been retained in tradition by the use of the term 'epiphany', denoting an event that has been made visible.

In this highly visual context, the reader is challenged to create mental images of other objects which are unfamiliar and infrequent elsewhere in the Gospels; in addition to 'the Magi', 'the East', and the 'star', the words 'trea-sure chest', 'gold', 'frankincense' and 'myrrh' evoke visual images that bring the story to its colourful conclusion.[56] But foregrounding the visual goes beyond simply the vocabulary of the passage; the contrast between the blind-ness of familiar characters (King Herod, the chief priests and scribes) and the ability of the unfamiliar (the Magi) to see, to reveal insight, highlights the metaphorical significance of sight throughout the passage. In addition, fami-liar place names such as Bethlehem and Jerusalem, known and 'seen' by the narrator, appear to threaten, while foreign and 'unseen' places, 'the East' and 'their own country', terms that enclose the story in v. 1 and v. 12, are synony-mous with notions of recognition and faith.[57] The fact that Joseph, whose role as the protector of the child and his mother is emphasized in Matthew 1–2, is conspicuously absent from 2.11 allows the child with his mother to stand out iconically; mother and child offer a striking visual image, con-fronted by the Magi.[58] Visually imagining the child with his mother faced with the inquisitive gaze of the Magi helps the reader experience the climax and point of the story. The activity of seeing is central in v. 11 since it is the first time anyone sees the child, either the characters in the episode or the reader; the reader must see the child for the first time through the eyes of the Magi.[59]

56. A number of key words in the story are very infrequent in the New Testament: ἀστήρ occurs four times in the story and elsewhere only in the plural in 24.29 (dependent on Mk 12.24); μάγοι occurs four times in Mt. 2 but nowhere else in the Gospels; ἀνατολή occurs three times in Mt. 2 and elsewhere in the Gospel only in 8.11 and 24.27 where it is used as imagery. Other words occur only once, either in the Gospel or in the New Testament generally, for example, λίβανος, σμύρνα.

57. The idea is similar to that found in 4.16; 8.11-12 and 8.28, the only other instances where ἀνατολή and χώρα appear.

58. The phrase τὸ παιδίον μετὰ Μαρίας τῆς μητρὸς αὐτοῦ in v. 11 occurs nowhere else in Matthew, where the more general phrase τὸ παιδίον καὶ τὴν μητέρα αὐτοῦ is preferred. 'The child *with* his mother' contrasts to 'all Jerusalem *with* him' (Herod) in v. 3, the only use of μετά in Mt. 2.

59. The tradition of identifying the reader or viewer with the Magi is an old one; for example, in his sermon for the Epiphany in 578 CE, St Romanos the Melodos writes: 'We

Foregrounding visual-related language, then, serves to identify a prominent component of the text;[60] moreover, if the reader is a painter, a professional visualizer, an awareness of the process of forming visual images within the act of reading and the dynamics of the reader's visual participation become all the more important.

Visual Instances of the Adoration of the Magi

For the purposes of this chapter, paintings that visualize *devotional*, rather than political or social readings of the text are used to illustrate the approaches of Gadamer and Berdini, since devotional paintings have the additional aim of uniting the experience of the viewer with the spiritual aspects of the subject matter. Paintings by four artists, Mantegna, Lippi, Botticelli and Bassano, are representative of the theme in Italian art in the century before the Council of Trent (mid-fifteenth to mid-sixteenth century); they represent a period when iconographic traditions relating to the theme were well established, yet before the injunctions of the Council relating to the depiction of biblical images came into force. Although working within the same century, each artist came under a range of influences in relation to genre and style, so that these paintings can be seen to offer distinct and unique instances of the same subject matter. I shall also consider a Rembrandt drawing, also a devotional image, from seventeenth -century Holland. It has been used by Mieke Bal as an illustration of how a *narrational reading* of a biblical image offers an added critical dimension to traditional iconographical reading. Bal's critique of this drawing illustrates similarities with Berdini's approach, though expressed through different terminology.

Andrea Mantegna

Mantegna's *Adoration of the Magi* in the Getty Museum is regarded as one of his most innovative and best-known compositions.[61] It is a personalized

are fellow travellers of the Magi. They represent us. the Magi are given for our mimesis. They search, seek and examine but as they retrace their journey, they find deception and blindness'. See Eva Catafygiotu Topping, 'St Romanos the Melodos and his First Nativity Kontakion', *Greek Orthodox Review* 21 (1976), pp. 231-50 (240).

60. Ellen J. Esrock, in *The Reader's Eye: Visual Imagery as Reader-Response* (Baltimore: John Hopkins University Press, 1994), has explored, through a study of Italo Calvino's *Invisible Cities*, the value of the reader's imagistic consciousness, the complex interactions between a text with visually evocative material and the reader's disposition to visualize, and argues that the importance of visual imagery must be recognized and integrated more fully into contemporary literary criticism.

61. This painting differs from his earlier version in the Uffizi, Florence, in that 'the

devotional image—personalized not by depicting the donor but by including the spectator. Mantegna followed closely, in this painting, the guidelines of his contemporary Alberti in his treatise *De pictura* (1435), which recommend that the prime goal of painting should be *historia*, meaning storytelling as moral and intellectual instruction. *Historia*, according to Alberti, should convey a multiplicity of higher meanings.[62] It was not meant to be a pictorial re-creation of an event as it might have appeared to an onlooker; rather it was to be a learned interpretation that would reveal the quintessential meaning of the subject matter to the viewer (in the same sense as Gadamer's *Darstellung*). The ultimate goal of *historia* was the emotional identification of the viewer with the action or moral significance of the scene. Mantegna used Alberti's conception of art as potentially revealing a multiplicity of meanings to exploit the significance of the story of the Magi and to encourage a variety of meditational paths.[63]

The scene (Fig. 5), depicted in half-length format against a dark background (a technique Mantegna derived from classical portraiture), highlights the visually iconic aspects of the biblical narrative, giving it directness and emotional immediacy so that the viewer experiences a closeness to the represented characters. While the Virgin, Joseph and the child wear simple garments, the Magi are dressed in exotic clothing and jewels and bear exquisite gifts. Caspar, bearded and bareheaded, presents the Christ child with a rare Chinese cup, made of delicate porcelain and filled with gold coins. Melchior, the younger, bearded king behind Caspar, holds a Turkish censer for perfuming the air with incense; on the right, Balthasar the Moor carries a covered cup made of agate.[64] Mantegna's posing of a limited number of figures against a dark background is virtually as terse as Matthew's text; the composition is focused and clear and the darkness leaves the setting to the imagination. The figures are large, promoting an even greater sense of physical proximity to the viewer, and are depicted in their traditional allegorical

clear differentiation of characters and the self-conscious inclusion of the viewer evokes the new Renaissance conception of the importance of the individual' (Carr, *Andrea Mantegna*, p. 91).

62. For the importance of Alberti's emphasis on the inclusion of the viewer and of the painting 'holding the eye of the learned and unlearned spectator', see Lew Andrews, *Story and Space in Renaissance Art: The Birth of Continuous Narrative* (Cambridge: Cambridge University Press, 1995), pp. 116-17; David Freedberg, *The Power of Images: Studies in the History and Theory of Response* (Chicago: University of Chicago Press, 1989), pp. 14-17, and John Onians, 'The Biological Basis of Renaissance Aesthetics', in Frances Ames-Lewis and Mary Rogers (eds.), *Concepts of Beauty in Renaissance Art* (Aldershot: Ashgate, 1998), pp. 2-27.

63. Carr, *Andrea Mantegna*, p. 67.

64. Carr, *Andrea Mantegna*, p. 83.

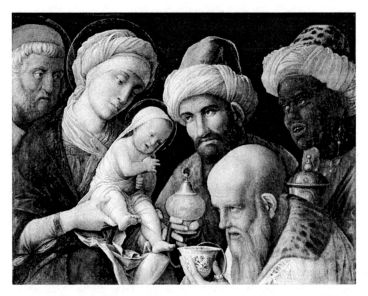

Fig. 5. Andrea Mantegna, The *Adoration of The Magi* (1497–1500)
John Paul Getty Museum, Los Angeles.

capacities as the three ages of humankind and the three continents. The gifts
can be interpreted symbolically too. Gold pays homage to Christ's kingship;
frankincense, used for incense, honours Christ's divinity; myrrh foresees the
death and burial of Christ.[65] The vessels mimic reliquaries and Eucharistic
vessels and Mantegna clearly differentiates each object by shape and size to
underscore the distinct origins of the Magi. In this way, while not stressing
the Magi's kingship, Mantegna presents a series of rich visual icons to the
viewer for meditation.

 Mantegna deliberately abandons any use of setting such as landscape to
concentrate on the psychologies of the scene; every turn of the head, every
glance of the eye, every nuance of gesture is studied for maximum impact. In
this close-up view, his vivid characterizations of the psychological reactions
of the Magi attempt to draw the viewer into similar appropriate action—
worship of the Christ child and meditation on his incarnation. The Magi,
before whom the viewer stands, serve as clear role models; they establish the
appropriate devotional state and, as the 'original' worshippers, could show the
way in contemporary devotion.[66] The Magi do not appear together but as indi-
viduals and are differentiated by their states of awe: at the right, Casper is lost
in ecstatic wonder as he stares at the child with open mouth; Balthasar bends
forward eager to see, while Melchior does not allow his eyes to meet the child.

65. Carr, *Andrea Mantegna*, p. 84.
66. Carr, *Andrea Mantegna*, p. 91.

The Christ child responds to the worship of the Magi with the bestowal of a childlike blessing; the benediction is directed at the viewer as much as the Magi. By having the child use his index and middle fingers, Mantegna turns the child's gesture into the jerking movement of an infant. The gesture becomes a sign of the incarnation itself; the divine child is limited to blessing as a human infant might.[67] The swaddling clothes are slung around his left shoulder, like a toga. In antiquity, the Roman male was shown in this way only if he were a priest acting in a ritual role; as symbolic of Christ as high priest, this form of presentation was suitable for the ritual context of the painting. the Magi not only lead the viewer to worship and wonder but also to receive the blessings given by God in recognition of their faith.

Mantegna's reading of the story highlights the visual imagery already present in the text; in depicting the characters' intense watchfulness, he conveys the text's preoccupation with sight and insight. In the words of Jacques Lacan, applied elsewhere to paintings by Titian,[68] Mantegna's *Adoration* becomes a 'trap for the gaze', the gaze that connects the painted figures and has the quality of arresting movement and of seeming to stop time. As a 'trap for the gaze' the painting engages the viewer in its own time and space.

The composition permits multiple interpretations; the viewer can identify with one of a number of characters, interpreting the event from different perspectives—the old, humble and wise magus, the entranced middle-aged magus or the young astonished black magus—or from the perspective of Joseph, who is not in the biblical text but who appears in the left corner, an outsider as it were, scrutinizing the strangers who appear to reveal a deeper level of insight. The gold coins that fill the rare and precious cup invite the viewer to reflect on the place of material wealth in relation to the blessing the child offers.

Interpreting Mantegna's painting from the perspectives of Gadamer and Berdini makes for a more complete appreciation of it. As an instance of *Darstellung*, it is a presentation and not a re-presentation of the biblical story, a coming into picture, an instance of the subject matter coming forth, an event that takes place in which the viewer participates. It illustrates Gadamer's view that, through art, aesthetic qualities such as intimacy, nearness, directness and inwardness gain a tangibility of presence which, without art's mediation, they would not have.[69] Here, the viewer is drawn into the intimacy of the

67. Carr, *Andrea Mantegna*, p. 84.

68. For a discussion of the Lacanian gaze in painting, see Laurie Schneider Adams, 'Iconographic Aspects of the Gaze in Some Paintings by Titian', in Patricia Meilman (ed.), *The Cambridge Companion to Titian* (Cambridge: Cambridge University Press, 2004), pp. 225-40 (225-26).

69. Clines (*I, He, We and They*, pp. 44-46) points out that the Servant Poem in

scene and becomes part of it. Standing in front of the Christ child, he or she completes the circle of characters and is caught up in their network of gazes so that concept of adoration in Mt. 2.11 now becomes tangible and experiential. Mantegna's *Adoration* illustrates Gadamer's view that each instance of the visualization of a subject matter extends not only the viewer's horizon but also the subject matter itself. In terms of visual exegesis, Mantegna presents a reading of the text that highlights the symbolic, the iconic and that expands the text to offer the viewer a transcendental experience of union with the divine, just as the Magi experience the newborn Christ.

Fra Filippo Lippi

Jack Ruda, discussing the Carmelite priest and artist Fra Filippo Lippi,[70] shows how, in fifteenth-century Italy, biblical images were called upon in a wide range of situations in daily life for many liturgical and didactic needs and were subject to highly variable demands. He suggests that, since, collectively, fifteenth-century viewers were familiar with many lessons from the Bible and tradition, most images were planned to be used as loose frameworks to enable individual viewers to make a (personalized) range of associations. To the extent that they have a parallel in literary structure, he suggests, paintings were more like vernacular hymns and sermons with a loose sequence of ideas than like theological treatises with closely knit arguments. A flexible and intellectually popular system would have suited most of Lippi's likely viewers; the process of composing the imagery for his paintings would have been similar to a sermon. Such an approach offered flexibility to the viewer in determining the meaning the subject matter contained.

Lippi's exceptionally rich association of images in his *Adoration of the Magi* makes it his most sermon-like painting, suitable for the appropriate moral reflection of his viewers, and presents 'a wider range of incident than virtually any other panel painting of the early to mid-fifteenth century'.[71] The imagery depends on well-known sacred texts and commentaries and not on any particular theological argument, so that the painting represents 'an original and sophisticated visual exegesis' in which the expansive modes of reading based

Isaiah 53 lacks any affective terminology: 'of the servant himself, not a single emotion is expressed'. Yet, in traditional and contemporary iconography, it is the emotional response of the viewer that depictions of the subject seek to elicit. On the same point, see Richard Verdi, *Anthony van Dyck: Ecce Homo and the Mocking of Christ* (Birmingham: The Barber Institute of Fine Arts, 2002), pp. 27-28, and Thiessen's discussion of Louis le Brocquy's contemporary *Ecce Homo* in *Theology and Modern Irish Art*, pp. 142-44.

70. Jeffrey Ruda, *Fra Filippo Lippi: Life and Work* (London: Phaidon, 1999). See especially his section 'The Painting as a Sermon', pp. 238-57.

71. Ruda, *Fra Filippo Lippi*, p. 210.

on traditional principles of Christian exegesis come into play.[72] From a literal reading of the text, the artist creates a series of symbols that transcends the story's literality and that points to an experience of and unity with the divine, the final goal of exegesis.

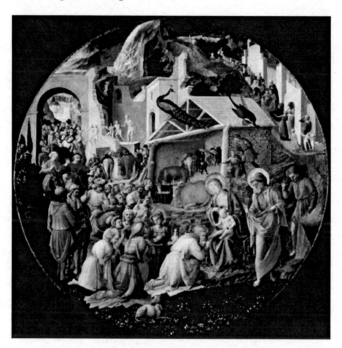

Fig. 6. Fra Filippo Lippi, *The Adoration of The Magi* (1450)
Washington National Gallery of Art.

Lippi interprets Mt. 2.1-12 through a series of other biblical texts, particularly Ps. 72.10-11:

> May the kings of Tarshish and of the isles render him tribute, may the kings of Sheba and Seba bring gifts! May all kings fall down before him, all nations give him service![73]

He expands the traditional association made between the Magi and the kings of Tarshish in vv. 10-11 by recalling more visual imagery from the same Psalm:

> May the mountains yield prosperity for the people, and the hills, in righteousness! (v. 3).

72. Ruda, *Fra Filippo Lippi*, p. 238.
73. Ps. 72.10-11 constituted the Offertory chant for the feast of Epiphany.

May he defend the cause of the poor of the people, give deliverance to the needy! (v. 4).

May he be like rain that falls on the mown grass, like showers that water the earth! (v. 6).

They that dwell in the wilderness shall bow down before him (v. 9).

For he delivers the needy when they call, the poor and those who have no helper (v. 12).

He has pity on the weak and the needy, and saves the lives of the needy (v. 13).

From oppression and violence he redeems their life; and precious is their blood in his sight (v. 14).

May there be abundance of grain in the land! May it wave on the tops of the mountains! May its fruit be like Lebanon and may people blossom in the cities like the grass of the field! (v. 16).

Lippi attempts to portray these sentiments and images from Ps. 72 in his painting. The fruitful landscape described in vv. 3, 6 and 16 is depicted by the grassy hill at the upper centre; while the park-like meadow at the bottom and the trees at the left suggest the fertility of the land. The poor and needy of vv. 4, 12, and 13 are visible among the humble workers in the stable, the ragged shepherds and beggars to either side and the people of the city at the right, including the mother with clinging naked children. The wilderness of v. 9 is depicted by the rocky landscape beyond the gateway.[74]

The semi-nude figures opposite the cypress represent death and rebirth through the sacrament of baptism (for which they are dressed), since Epiphany traditions also commemorated the baptism of Christ. The ruins fit the theme of resurrection in Simeon's prophecy over the infant child in the Vulgate of Lk. 2.34: 'Behold this child is set for the fall (*ruinam*) and rising again (*resurrectionem*) of many in Israel'. Jacobus of Voragine explained this prophecy in terms very close to the imagery found in Lippi's painting: he compared weak humankind to leaning walls that may fall into ruin and God to a mountain or rock of support, while Christ is the sign who appears over a mountain that represents the world. In the painting, followers look up to what may be this sign, while the Christ child and Mary sit on the rock—an allusion to Christ as the cornerstone (Ps. 118.22; Isa. 28.16; Mt. 21.42-4; Lk. 20.17-18).[75]

Other symbols refer to Christ's victory over death. The peacock, looking up, signifies eternity while the pheasant, looking down, represents sin or sloth.[76] The cypress by the gateway is an ancient funerary sign so that the

74. Ruda, *Fra Filippo Lippi*, pp. 213-14.
75. Ruda, *Fra Filippo Lippi*, p. 214.
76. For a discussion of the moral dangers of sloth (seen as the spiritual tepidity and

gate may be the gate of heaven and refer to death and rebirth. The very shape of the tondo enriches its meaning; the circle represents the entirety of creation so that the round shape of Lippi's *Adoration* complements the role of the kings as representatives of the entire community of the faithful, while all elements of the composition—figures, cityscape, landscape—spiral in response to the panel's round shape. As the painting draws on the Psalm along with other biblical sources as a sermon might gather quotations and paraphrases to enrich its discourse, the viewer engages with the symbolism of the images presented—the second stage of exegesis—and is invited to explore the correspondences between them.

Through the extensive symbolism in this painting, the artist's aim is to draw the viewer into the final stage of exegesis—proximity with the divine. The context of the *Adoration* is not a natural landscape but rather a supernatural and other-worldly one; the peacocks symbolizing eternal life and the neophyte's rebirth through baptism point to a scene set in heaven with Mary and the Christ child seated on a throne, receiving the saved as they proceed through the narrow gate of heaven. The viewer is drawn into the intimacy of the meeting of the magus as he touches the foot of the Christ child. The attitude of the magus, his state of recognition and adoration, offers a model for the viewer to imitate in order to gain eternal life.

Sandro Botticelli

Sandro Botticelli's *The Adoration of the Magi* (Fig. 7) was commissioned for the Chapel of the Epiphany in the Florentine church of Santa Maria Novella. Rab Hatfield notes that, 'For an altarpiece in the form of a self-contained narrative picture, it is unprecedented in the elasticity and range of its symbolic content'.[77] As an altarpiece, it presents a very particular type of hermeneutic.

The centre of the picture is taken up by a rock, which is generally believed to derive from that of Lippi's tondo.[78] An impressive classical building, with its style still recognizable and intact, has been placed in the background to the left, where it stands apart from the place of Christ's birth. Hatfield highlights the classical character of the building and suggests that, under the influence

apathy of the believer) in fifteenth-century Italy, see Bernard Aikema, *Jacopo Bassano and his Public: Moralizing Pictures in an Age of Reform ca. 1535–1600* (Princeton: Princeton University Press, 1996), pp. 7-8.

77. Rab Hatfield, *Botticelli's Uffizi 'Adoration': A Study in Pictorial Content* (Princeton: Princeton University Press, 1976), p. 67.

78. Hatfield, *Botticelli's Uffizi 'Adoration'*, p. 65.

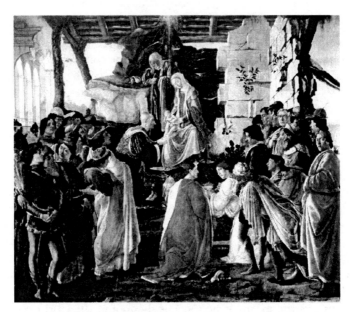

Fig. 7. Sandro Botticelli, *The Adoration of the Magi* (1470–75)
Galleria degli Uffizi, Florence.

of the contemporary theologian Ficino, it symbolizes the cultural excellence
of the ancients, represented by the Gentiles.[79] The jagged corner of wall to
which the shed is attached and which here serves as the altar may refer to
the stone which the builders rejected and which has now become the corner
stone of the Church. This painting may be seen as an allegory of the Church,
rising amid ruins of the ancient religions, to which the Magi come, repre-
senting the nations of the pagan world, while the shepherds, the Jews, are
seen in the background to the left. Many figures portray features of members
of the Medici family: Cosimo the Elder as the old king in front of the child,
his son Piero as the kneeling king with a red mantle in the centre, Lorenzo
the Magnificent as the young man at his right, in profile, with a black and red
mantle. The figure looking out at the spectator is probably the self-portrait of
Botticelli.

In terms of visual exegesis, Botticelli offers a reading of the biblical text
suitable for the purposes of an altarpiece. The symbolic images in this picture
are relatively few and their approximate meanings must have been clear to

79. Ficino argued that the errors of the Gentiles were understandable because they did
not live 'under Grace' but they did possess natural philosophy and religion 'which hold
out the same truth under different guises to all people'. See Stephen M. Buhler, 'Marsilio
Ficino's *De stella magorum* and Renaissance Views of the Magi', *Renaissance Quarterly* 43
(1990), pp. 348-71 (354).

the average worshipper, but it is the manner in which familiar images are interrelated to its function as an altarpiece that sets Botticelli's painting apart. Berdini stresses the function of the liturgical and sacramental in Christian exegesis:

> In Christian exegesis, actual comprehension is achieved only when the quest for explanation is submitted by that state of partial depragmatization of experience, which, being the domain of faith can only be resolved in liturgical practice.[80]

Since this is an altarpiece, the meaning of the painting must be interpreted in terms of the liturgical practice of the Eucharist; it is the symbolism of the body of Christ that lies at the heart of the conceptual structure of Botticelli's painting.[81] Christ's body, once referred to as a temple, is now the body of the Church; as the Eucharist, his body is the nourishment that leads the believer to eternal life. Since it represents a conflation of separate actions, the doctrine of the Eucharist permits a suspension of time and place; it fulfils the past as well as looking to and beyond the end of time. The presence in the painting of so many fifteenth-century Florentines, contemporary with the artist, indicates to the viewer that one may be always present at Christ's first epiphany since he is always present sacramentally in the Eucharist; it provides the answer to the Magi's question, 'Where is he who has been born King of the Jews?'[82]

Jacopo Bassano

Berdini's study of Jacopo Bassano centres on the social and political context of sixteenth-century Veneto, and in particular the role Bassano's paintings play in documenting the religious and political aims of church and state, especially in relation to the status and perception of the peasant.[83] Jacopo

80. Berdini, *The Religious Art of Jacopo Bassano*, p. 5.

81. The hermeneutical aspect of the Eucharist is emphasized by John Drury in connection with Rubens's *Adoration of the Magi* above the altar of the chapel in King's College, Cambridge (*Painting the Word*, p. xiv). See also his section on 'Partakers of the Altar', pp. 107-15. For a similar idea, see David Brown, *Tradition and Imagination*, p. 92. On the importance of the theme of the Magi coming in procession with their gifts to the altar in a range of paintings, see Maurice B. McNamee, *Vested Angels: Eucharistic Allusions in Early Netherlandish Paintings* (Leuven: Peeters, 1998), especially his chapter 'Eucharistic Allusions in Epiphany Scenes', pp. 159-66.

82. Hatfield, *Botticelli's Uffizi 'Adoration'*, p. 67.

83. Aikema, *Jacopo Bassano and his Public*, pp. 52-54, discusses how the peasant was seen as the antithesis of the God-fearing, upstanding civilized burgher, according to the late fifteenth-century text *Alfabeta sopra li villani*: 'the wicked, disagreeable, evil peasant is always destined to work. Goodness does not reign in him or courtesy; only anger, envy,

Bassano produced a large number of paintings of the adoration of the Magi. Two that typify his approach are those now in Edinburgh (National Galleries of Scotland) and Birmingham (the Barber Institute of Fine Arts).[84] Both paintings are naturalistic and make much less use of symbolism than earlier Italian paintings, allowing the viewer to engage with the subject matter in a number of less overtly 'religious' ways.

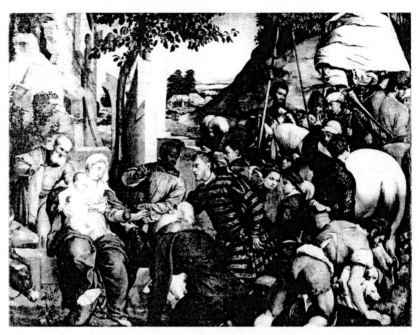

Fig. 8. Jacopo Bassano, *The Adoration of the Magi* (1542)
National Galleries of Scotland, Edinburgh.

In the Edinburgh *Adoration*, Joseph, Mary and the child, along with the three magi, are isolated on the left by massive ruins; within this grouping,

hatred, and thievery. Evil he is filled with and every vice'. The growing number of indigents from the Veneto coming into Venice in the 1520s and 1530s caused great consternation, as did bogus beggars and pilgrims. This is clear from Bassano's *Adoration of the Shepherds* in the Galleria Borghese, Rome. However, as Berdini notes, during and after the Council of Trent a pedagogy emerged that grounded social behaviour on scripture; methods of expanding the text became diversified in order to confront a specific reader in terms of his or her social identity. Humble labour and agricultural activity, it was felt, had to be praised as Christian virtues if the peasant could be emancipated from the image of the ignorant and lascivious and improve his ways (*The Religious Art of Jacopo Bassano*, pp. 14-17).

84. Other depictions of the theme exist in Stamford Abbey, England, and in the Kunsthistorisches Museum, Vienna.

the Magi are kept at some distance from Mary and the child. Melchior and the servant directly behind him form a continuation of the crumbled wall separating the group on the right. Two of the Magi have identified the child and worship him; by taking off his hat, the servant too indicates that he has recognized him. No one in the group to the right pays any heed as they fritter away their time on material and worldly concerns; in particular, there is a marked contrast between the prostrate aged king in adoration and the peasant (the only character dressed recognizably as a peasant). The lone peasant in the distant background is completely oblivious to the event unfolding. His attitude is in marked contrast to that of Caspar, the king, whose position is directly beneath him.

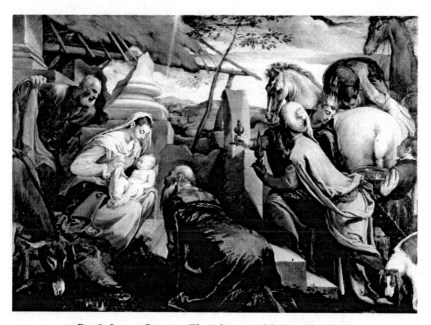

Fig. 9. Jacopo Bassano, *The Adoration of the Magi* (c. 1565)
The Barber Institute of Fine Arts, The University of Birmingham.

In the Barber Institute's *Adoration*, there are subtle changes in the positioning of the characters. The three Magi are now clearly differentiated as individuals, each conveying a different attitude. The elderly king, kneeling with his crown removed, gazes intently at the Christ child. The second king emerges from the right holding out his gift, while the youngest king has not removed his crown. He offers his gift but is distracted by the gold platter held by the servant boy. Mary and the child stand out in pastel colours and are positioned between Joseph and the elderly king—who resemble each other in looks and posture. The group on the left denotes an attitude of deep

contemplation while the group to the right is distracted by commerce and worldly concerns.[85]

In Bassano's naturalist painting, where individuals are not explicitly presented as 'religious' (for example, there are no haloes), it is possible to suspend for a moment the reference to the *Adoration* 'and decline the cultural and contextual invitation to recognize the traditional storyline'.[86] The painting can now be seen in a different way: two elderly men looking intensely, representing old age and imminent death, contemplate birth and new life, represented by a new born child and a youthful mother. The nakedness of the child, which contrasts with the rich fabrics of his mother and the kings, together with the glittering crowns, suggests the vulnerability of life in the face of death (a point strengthened by the setting of decayed buildings and a desert landscape), regardless of one's wealth and prestige. The investigation of the crowns on the ground by the curious donkey suggests that wealth is alien to and inessential in the natural world. The crowded scene to the right, full of activity and commercial preoccupation, denotes a lack of awareness of the brevity of life and what should be regarded as essential. Seen in this way, the painting becomes a meditation on life, its purpose, priorities and its certain and ultimate decay. Bassano's naturalist paintings allow us to offer less 'religious' interpretations; as Berdini points out, the viewer can determine the degree of religiosity present.

A particular technique used by Bassano to suggest to the viewer an added spiritual dimension (Berdini's final stage in the process of visual exegesis) to a natural scene is his use of light.[87] Divine manifestation is signalled by the bodily reception of light. Light is supernatural because the body cannot confront it; it declares its nature only in its reception by the human body. Natural light illuminates a landscape whereas supernatural light modifies a body. In the *Adoration of the Magi*, the contrast between the two sources of light confers a binary structure on the landscape. Appearing over the far horizon, natural light defines an open view by providing a sense of depth and spatial recession. Light in the forefront, as it falls on the flesh of the mother and child, Joseph, the elderly kneeling king and the young king, has direction and purpose; it is a source of supernatural light and is superior to the natural light on the horizon. Light illuminates the faces and expressions of those characters whose attitude the viewer is invited to meditate on, emulate or disregard. In these naturalist paintings with fewer traditional iconographic symbols, the viewer must determine the 'religiosity' they contain and to what extent natural elements such as landscape, light and animals (important in all Bassano's works) convey the significance of the event. Bassano's reading of the text,

85. See Richard Verdi, *The Barber Institute of Fine Arts* (London: Scala, 1999), p. 41.
86. Bal, *Reading 'Rembrandt'*, p. 210.
87. Berdini, *The Religious Art of Jacopo Bassano*, pp. 27-35.

therefore, appreciated through the process of visual exegesis, allows the viewer to interpret the painting on a number of levels, from a naturalist painting to an intensively religious one.

Rembrandt van Rijn

In her analysis of a Rembrandt drawing on the theme of the adoration of a magus, Mieke Bal adopts a *narrational reading* of the image, which, she argues, is a further interpretative step beyond *reading iconographically*. While agreeing that 'in order to appreciate the subject matter and its visualization, the viewer must know the conventional idiom of visual representation, must be literate in visual traditions and must be well read enough to recognize the story and its other details', she argues that viewing images only in this way is limited in that it can be used to ward off threatening interpretations and to fit images into a reassuring tradition.[88]

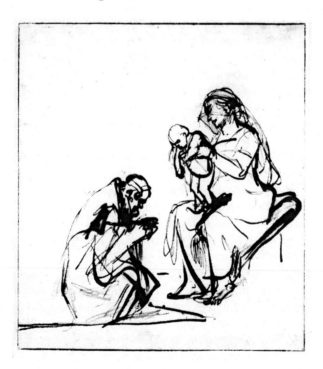

Fig. 10. Rembrandt van Rijn, *The Virgin Showing the Infant Christ to One of the Magi* (1635), Rijksprentenkabinet, Amsterdam.

88. There are few examples of Rembrandt's treatment of the theme, mostly drawings. See Hilda Hoekstra, *Rembrandt and the Bible* (London: Magna Books, 1990), pp. 224-47.

Bal takes for granted that the viewer of Rembrandt's drawing recognizes the story line immediately from its iconographic symbols, and so suggests that we suspend, for a moment, the obvious reference to the Magi; instead, if we link all the diagonal series of elements, we can form a story or *fabula* that is not the standard scene of *The Adoration*, one in which action, and not a still pose, is depicted. The drawing can now be viewed as if Mary has just pulled the child from her womb and presents him to the magus; the infant's feet are not visible—they are still in the birth canal—and the expression on the woman's face suggests that she is actively in labour. The drawing thus becomes a delivery scene. This *fabula* is not congruent with the iconographi-cally recognizable scene, which tends to obliterate rather than emphasize these elements. If we need to bracket the official story temporarily, she argues, it does not mean that we contradict it; in fact, it merely conflates the Nativity with the Adoration by representing the two in one scene that sheds an unexpected light on both. Bal suggests that the infant looks like the magus and that, if the magus were his father, this would reinforce the humanity of Christ, just as his birth does.[89] In handing over the infant to the old man, the woman delivers the child to a representative of those for whom he was incarnated in the first place—the human race, exemplified by this impressed and submissive elderly man. The slight mismatch of the two sides of the scene emphasizes the radical separation between the man who can only receive the child and the woman who is actually producing him, between human and divine personae and between natural and supernatural events. Bal concludes that the dogmatic views of theological or iconographical traditions can blind us to other possible readings, including readings that are acceptable within the context of theology. Tracing motifs back to traditions and sources tends to preclude active interpretation.

For Bal, a narrational reading offers multiple interpretations of the image. It allows for a reading rather than simply recognition of a narrative structure. It is much more than recognizing a motif; it is about interpreting the image in relation to the biblical text (pre-text), the cotext (the interrelationship between symbols) and the context (the viewer). In this way, the further criti-cal potential of the familiar iconographic reference can be developed. Bal's approach, expressed in different terminology, mirrors Berdini's emphasis on the artist as reader and what he calls the 'exegetical trajectory of reading', the notion that visual exegesis fulfils its aims whenever the significance of the image can be ascertained as a dimension of being on the part of the viewer. In contrast to Gadamer, however, who stresses the importance of appreci-ating different instances of the same subject matter and their relationship to

89. Bal, *Reading 'Rembrandt'*, p. 212.

each other, Bal regards the practice of referring an image back to its predecessor as highly problematic. It is 'a consequence of the reluctance to interpret; citing loose elements is eclectic and avoids commitment to specific meanings'.[90] However, in support of Gadamer, it is difficult to appreciate the full impact of Rembrandt's drawing without reference to Rembrandt's predecessor, Rubens, whose style he followed for this theme, especially his *Adoration of the Magi* (1609), from where he derived his inspiration for the naturalistically floppy-spined child.[91]

Conclusion

Different visual instances of the adoration of the Magi show how each artist reveals a different dimension of the subject matter of the text. Mantegna, with his emphasis on classical form, structure and portraiture, highlights the qualities of the individual characters to be imitated by the viewer (Fig. 5). Lippi focusses on the significance of the symbolism traditionally associated with the story and how it impacts on the life of the viewer (Fig. 6). Botticelli in his altarpiece associates the epiphany with the Eucharist, thus actualizing the text sacramentally in the life of the viewer (Fig. 7). Bassano, through his two naturalist paintings (Figs. 8 and 9), presents the viewer with a stark choice of good and evil by depicting his characters within two mutually exclusive groupings. Each painting, therefore, offers the viewer a different perspective, another way of reading the text, in the light of the developing traditions of the story.

The exploration of these paintings supports Berdini's view that the 'correspondence model', the idea that an image simply reflects its corresponding text with greater or lesser accuracy, imposes serious limitations on the role of the beholder. Such a model leaves little room for any understanding of the interpretative nature of the text and denies to the painter a critical role in its reading. Visual exegesis, on the other hand, begins with the awareness that recognition of the subject matter has been exceeded and acknowledges the excess of meaning emerging from the literality of the text 'as it unfolds along a trajectory whose end is the beholder's altered existence'.[92] What makes an image 'religious' is not religious motifs or symbols but the experience of beholding it.

Various traditions through the centuries reflect the need to expand and develop the story of the adoration of the Magi; its range of visual expressions shows that artists were interested primarily in making the story relevant to their times and viewers rather than simply depicting the literal details of the

90. Bal, *Reading 'Rembrandt'*, p. 213.
91. Schama, *Rembrandt's Eyes*, p. 140.
92. Berdini, *The Religious Art of Jacopo Bassano*, p. 126.

corresponding biblical text. Gadamer's concept of *Darstellung*, that the image presents to the viewer an existential event, a *coming forth* of the subject matter, complies with the existential and actualizing role of exegesis. His emphasis on the inability of particular instances of a subject matter to exhaust its significance accords with the process of exegesis that explores different levels of meaning in the text. In short, taken together, Gadamer's hermeneutic aesthetics and Berdini's visual exegesis combine to illumine the central role of both the artist and viewer in extending and appropriating a biblical subject or theme through its visual expressions.

Appreciating different visual instances of the same biblical subject is equally important in contemporary art, as Gesa Thiessen's detailed critique of the relationship between modern art and theology shows. Her starting point is the work of Paul Tillich,[93] and Horst Schwebel.[94] Tillich argues that modern 'profane' works of art can convey issues of ultimate concern—often much more than the so-called sacred art produced for places of worship—while Schwebel's view is that contemporary religious art has now become autonomous and no longer plays a servant function in the church. With regard to depictions of Christ, Schwebel argues, artistic subjectivity rather than Christian iconography of past centuries is central to modern art so that images of Christ do not appear in familiar biblical surroundings. Christ is often featured not as the Christ of the Scriptures but as a human being without those attributes that would immediately reveal his divinity.

Thiessen's reservations about Tillich's approach in particular[95] led her to undertake an analysis of a range of modern abstract paintings with a religious or biblical theme. She concluded that the most meaningful way to appreciate and expand the religious and theological readings of abstract paintings was through the use of theological *writings* (mainly biblical texts and writings of well-known theologians) that suggested themselves to her through the painting. For example, she interprets Louis Le Brocquy's abstract work, *Ecce Homo*, through the biblical text of John 19 as well as through Heidegger's

93. Tillich is regarded as the theologian most concerned with developing the dialogue between theology and modern visual art, summed up in 'Art and Ultimate Reality', pp. 317-22, first delivered as an address at the Museum of Modern Art in New York in 1959.

94. Schwebel is generally acknowledged as the leading scholar in the field of theology and modern art in the German-speaking world. His work, regarded as the most comprehensive theological examination of the image of Christ in twentieth-century European art, is presented in *Das Christusbild in der bildenden Kunst der Gegenwart* (Giessen: Wilhelm Schmitz Verlag, 1980).

95. Thiessen's criticism of Tillich includes his failure to base his views on any detailed study of individual paintings, his underestimation of the important aspect of subjectivity in modern artistic creation and the fact that his narrow definition of what constitutes the 'religious' in art would exclude many important artists, and indeed works with religious content (*Theology and Modern Irish Art*, pp. 17-23).

dialectical notion of truth as disclosure and concealment. The process of applying a range of theological texts (in a subjective way) in order to interpret the abstract painting with the aim of 'seeing differently or in new ways' is derived from Gadamer, who advocates 'using our own preconceptions so that the meaning of the text (the work of art) can really be made to speak for us' since 'interpretation becomes the act of understanding itself'.[96] The abstract painting thus becomes a source (a *locus theologicus*) for theological interpretation; the work of art, like a text, is perceived as a source to be interpreted and re-interpreted.

Thiessen's study shows that Gadamer's perspective can illumine the theological appreciation of contemporary abstract religious art just as it does traditional iconographical biblical painting. In abstract art, traditional biblical iconography is often substituted by symbols or reference points from the artist's impressionistic and subjective experience. Art, like a text, reveals the world, experience and vision of the artist and thus can broaden the viewer's knowledge and transform or intensify his or her vision of the subject. The very selection of artists and works of art a viewer makes confirms the involvement and significance of the viewer's horizons. Gadamer's insistence that all understanding is interpretation warns us that, even before we engage with it, any text or work of art already presents us with the artist's interpretation of his or her experience.

Thiessen's conclusions support Berdini's notion of the artist as reader inasmuch as a contemporary artist's depiction of biblical subject matter will consist of his or her subjective reaction to, and interpretation of, the story as found in the Bible. As he or she engages with it, the viewer may, or may not, find correspondences between the story and the artist's appropriation of it. Hence (and as argued by Berdini) the visual interpretation of a biblical subject is once removed from the way one encounters and interprets the biblical text itself. For Thiessen, this makes it enriching in one sense because of the artist's interpretation of the text (and as Gadamer argues, permits a broadening of the viewer's horizons) but also limiting in that it represents the individual's particularity in his or her rendering of the theme.

Thiessen's study suggests an approach essentially consistent with that of Berdini and Gadamer. Together these approaches help illumine how a wide range of visual instances of a biblical subject, whether traditional or contemporary, can be used to expand the viewer's horizons, encouraging the viewer to think, feel and reflect on a biblical story or text as it becomes 'bodied forth in surprising, gentle, challenging, shockingly immediate or meditative fashion in a work of art'.[97]

96. Thiessen, *Theology and Modern Irish Art*, p. 257.
97. Thiessen, *Theology and Modern Irish Art*, p. 262.

3

THE FLIGHT INTO EGYPT:
ICON OF REFUGE FOR THE H(A)UNTED

Exile is not a material thing,
it is a spiritual thing.
All the corners of the earth
are exactly the same.
And anywhere one can dream is good,
providing the place is obscure,
and the horizon is vast.

Victor Hugo

In this chapter I want to explore the significance of the Matthaean narrative of the flight into Egypt, review some of its artistic representations, evidence of its universal appeal, and conclude by focusing on its particular significance in the twentieth century. The title of the chapter, 'The Flight into Egypt: Icon of Refuge for the H(a)unted', anticipates its conclusions, namely that this narrative, uniquely, offers an image with which many have identified— those who have experienced exile or displacement literally (the hunted), as well as those for whom the experience of exile or diaspora has been, or continues to be, an issue which they must confront in terms of their own personal or communal identity (the haunted).[1]

The flight into Egypt (Mt. 2.13-23), unique in the Gospels to Matthew, recounts the story of a family of refugees who flee the violence of their homeland, find safety in exile in a foreign land and eventually return to live and work in their homeland. Although Matthew's narrative of the episode appears brief and unsatisfactory in its detail, it has received universal recognition and attention far and beyond the limited space it occupies in the Gospel. Artistic representations adorn almost every gallery in the world[2] and its associations

1. See especially, Marc H. Ellis, A Reflection on the Jewish Exile and the New Diaspora (Liverpool: Friends of Sabeel UK, 1998), pp. 2-19.
2. For example, in the 2001 exhibition, The Genius of Rome 1592–1623, held at the Royal Academy of Arts, London, no less that 15 paintings of the theme were included in the catalogue from this period alone.

with Christmas has for many, especially in the West, made it part of the cultural baggage of the Christian world and an image familiar to many from childhood.

The drama and romanticism of the legend ensures that Jesus starts off his career in true heroic style, matching any of the great movers of history; heroes and great people, it would appear, thrive in later life if they have experienced exile or displacement in their youth. Such heroes are not restricted to the Bible, to Abraham, Joseph or Ruth but are celebrated throughout history.[3] While the New Testament heralds the start of Christianity with a story of a fugitive refugee child (φεῦγε εἰς Αἴγυπτον!, Joseph is told), the *Aeneid* prepares for the glory of the Roman Empire by proudly celebrating, in its opening lines, Aeneas's origins as a *profugus*, a fugitive:

> arma virumque cano, Troaie qui
> primus ab oris Italiam fato
> profugus Lavinaque venit
> litora
>
> I sing of arms and the hero
> who first came from the shores of Troy,
> an exile by Fate, to Italy and its Lavinian shore
>
> *Aeneid*, Book 1, lines 1-4

Romulus and Remus, too, start off their lives abandoned and exiled while Odysseus must wander through many perils in strange and hostile territories before reaching home.[4] Although his chief characteristics in the *Odyssey* are his longing for home and his endurance of suffering in order to reach it, there is the constant danger during his ten years' wandering that Odysseus might succumb to the attractions of exile and abandon his determination to return to his homeland.[5] He is warned by the goddess, Circe, of the lure of

3. For a discussion of exile in the Bible as *plot motif* and *character type* see 'Exile', in Leland Ryken, James C. Wilhoit and Tremper Longman III (eds.), *The Dictionary of Biblical Imagery* (Downers Grove, IL and Leicester, England: Intervarsity Press, 1998), pp. 250-51.

4. 'Later Gentile-Christian readers of Matthew's Gospel would have been reminded (when reading Mt. 2.12-23) of the childhood narratives of Cyrus, Cypsalus, Zoroaster and Romulus' (Ulrich Luz, *The Theology of the Gospel of Matthew* [Cambridge: Cambridge University Press, 1995], p. 25).

5. Elazar Barkan and Marie-Denise Shelton, *Borders, Boundaries, Diasporas* (Stanford, CA: Stanford University Press, 1998), p. 1, discuss how in her novel *Le chant des sirènes* (Port-au-Prince, Haiti: Editions du Soleil, 1979), p. 33, the Haitian novelist, Marie Thérèse Colimon allegorizes the modern exodus of Haitians to foreign lands in search of freedom and self-redemption in the light of this episode from the Odyssey. Walter Brueggemann, *Cadences of Home: Preaching among Exiles* (Louisville, KY: Westminster John Knox Press, 1997), pp. 1-3, defines the metaphor of exile as 'not primarily geographical but social, moral and cultural'.

false gods and the seductions of the winds bringing him to foreign shores.[6]
She describes the dangers awaiting Odysseus and his men as they sail past the
Sirens' isle and face the terrors of Scylla and Charybdis:

> First you will come to the Sirens, who bewitch everyone who comes
> near them. If any man draws near in his innocence and listens to their
> voice, he never sees home again, never again will wife and little
> children run to greet him with joy; but the Sirens bewitch him with
> their melodious song. There in the meadow they sit and all round is a
> great heap of bones, mouldering bodies and withering skins. Go on
> past that place, and do not let the men hear; you must knead a good
> lump of wax and plug their ears with pellets.

Circe to Odysseus, *The Odyssey*

Odysseus alone can hear the Sirens' wonderful voices but to enjoy their
song he must have his men tie his body tight to the ship's mast. Circe speaks
to everyone and not just to Odysseus: the moral of the story is that, although
travel may indeed broaden the mind, the ransom of the journey is loneliness,
separation, shattered dreams, madness and forgotten love. The voyager who
has tasted the pleasures or displeasures of exile is often unable to steer the
ship back home.[7]

Events of the twentieth century have left behind many unresolved issues
that centre on the reality of exile: the status of the refugee, the rights of asy-
lum seekers, the voluntary and enforced displacements of ethnic groups and
the cultural identity of diaspora communities. Images of fleeing individuals
and mass departure of families, beamed across the world by the media, remind
us daily of the immediacy of the issues. Reflecting the post-war preoccupation
with exile, Pope Pius XII in 1952 suggested in a celebrated encyclical, *Exsul*

6. James E. Miller , *The Western Paradise: Greek and Hebrew Traditions* (San Francisco:
International Scholars Publications, 1997), pp. 19-21, associates Elysium with the Garden
of Eden. In the Odyssey, Elysium is a land without sorrow across the Ocean-stream associ-
ated specifically with the West Wind (*zephyros*), often considered a favourable and gentle
wind.

7. Patristic exegesis saw the voyages of Ulysses as a 'type' of the Christian's journey;
the ship figures the Church and Christ the invisible pilot. The typology was prevalent
during mediaeval times: 'Navigating through this world as though on the open sea, we
must employ great caution lest we endanger our lives. For often we are deceived under the
appearance of good' (see Franco Mormando, 'An Early Renaissance Guide for the Per-
plexed: Bernardino of Siena's *De inspirationibus*', in John C. Hawley [ed.],*Through a Glass
Darkly: Essays in the Religious Imagination* [New York: Fordham University Press, 1996],
pp. 24-49 [33]). While the exilic experience of Adam's Fall was seen to bedevil all mortal
sojourners, the penitent person could move beyond exile and return to 'the harbour of
salvation'. For a synopsis of the theme of biblical exile in English literature, see Anon.,
'Exile and Pilgrimage', in David Lyle Jeffrey (ed.), *A Dictionary of Biblical Tradition in Eng-
lish Literature* (Grand Rapids: Eerdmans, 1992), pp. 254-59.

Familia, that the flight into Egypt should be seen as *the* symbol of hope to the refugee in every age:

> The émigré Holy Family, fleeing into Egypt, is the archetype of every refugee family. Jesus, Mary and Joseph, living in exile in Egypt to escape the fury of an evil king, are, for all times and places, the models and protectors of every migrant, alien and refugee of whatever kind who, whether compelled by fear or persecution or by want, is forced to leave his native land, his beloved parents and relatives, his close friends and to seek a foreign soil.
>
> *Exsul Familia* 1952

But surely this is an exaggerated claim—is the image of the flight into Egypt to be regarded as such a comprehensive and inclusive symbol? Is the term *archetype* justified?[8] After all, Jesus' status as a refugee is very temporary and he does return to his homeland safely and, in any case, does not the Matthaean narrative simply replicate the exodus/exile experience of the Old Testament? Can the narrative, for example, speak to those who seek exile voluntarily and remain in permanent exile? What the encyclical does bring out clearly, however, is the way in which the biblical story lends itself to a universal consideration of the reality of exile. It raises questions that the contemporary reader might wish to bring to this particular narrative.

The disturbing image of the innocent mother and new-born child fleeing from a dangerous and evil situation ensures that it can be appropriated easily by the refugee. The fact that even a child with divine status can be so vulnerable and find himself at the mercy of the whims of a dictator draws attention more universally to the precarious balance that exists between rootedness and displacement, justice and injustice, good and evil. But this simple, direct and affective image is also full of complex symbolism and, in Matthew's narrative, must be interpreted through the twin filter of the Old Testament exodus and exile and in the light of all the theological associations that accompany both these major biblical themes. Subsequent readers have identified with the Matthaean narrative either literally or metaphorically; for some, the refugee status of Jesus is immediately recognizable in their own experience of displacement, either individually or collectively, while others accompany the holy family spiritually on a type of pilgrimage, reflecting on its significance for their own fragmented lives. It has been in the twentieth century, however, that the paradigm of exile, diaspora and

8. In Ryken, Wilhoit and Longman, *The Dictionary of Biblical Imagery*, p. xvii, an archetype is defined as 'an image or pattern that recurs through literature and life'. Four pages (pp. xvii-xx) illustrate how archetypes are among the chief building blocks for writers of the Bible. The authors explore how 'Christ was the archetype exile: a person who in this life had nowhere to lay his head' (Mt. 8.20) and who in his death 'suffered outside the gate in order to sanctify the people through his own blood' (Heb. 13.12).

return seems to have been invariably connected with the Jewish experience, that the image has been invested with a particular significance and interpreted through the lens of that paradigm.

The gaps in the narrative of Mt. 2.13-23 have been filled most assiduously in the folklore and legends of the Coptic Orthodox Church, which takes pride in associating its origins with the flight into Egypt, preferring to emphasize the positive benefits of the family's exile in Egypt rather than concentrate on the contemporaneous massacre of the innocent in far-off Bethlehem. Like an experienced desert guide, the Coptic Church describes in vivid topographical detail the route taken by the family, being careful to stress the etiological significance of the Arabic place names:

> It is most probable that the holy family avoided taking the usual route at that time after escaping from Palestine to Egypt. They probably joined it after passing through the Sinai Desert, at Farma or Pelusium, which stands between Al-Arish and Port-Said. Their route took them to Basta near the city of Zagazig then to Belbies and on to Ein Shams, now called Al-Matariah, where they rested under a tree, which is still named after the Holy Virgin. Then the holy family headed southward to Babylon, of Old Cairo, where they stayed for some time in the cave which is now part of St. Sergius's church. Later the holy family continued its flight to the site, which is known now as Al-Muharak Monastery. Throughout all the places visited by the holy family, miracles have taken place and faith still shines. Tourists and local visitors throughout the year visit them. A spot of light in a world of darkness.[9]

Whereas one can easily appreciate the simple and striking image of the mother in flight and imagine the vivid, colourful route described by the Copts, the full significance of the powerful metaphor of exile which the Matthaean narrative contains is much more challenging and difficult to unravel. It has not received the same scholarly attention as the metaphor of exile in the Old Testament, where much creative and explorative work has been done, for example, by Brueggemann,[10] Carroll, Davies, Grabbe and Jeppesen in assessing how the notion of exile has been presented historically and ideologically by the authors of the Hebrew Bible and how it seems to permeate the entire literature of the Old Testament.[11] Matthaean commentators generally regard Matthew's allusion to Old Testament exile in a more limited way, as referring to a definite historical event which took place in 587 BCE and as restricted to only one possible theological interpretation. Old Testament scholarship, on the other hand, argues that there were in fact several

9. This description is found in Naim Ateek, 'The Flight into Egypt', *Cornerstone* 13 (1988), pp. 6-10 (9).

10. See for example, Brueggemann, *Cadences of Home*.

11. Articles on the topic by these scholars appear in Lester L. Grabbe (ed.), *Leading Captivity Captive: 'The Exile' as History and Ideology* (European Seminar in Historical Methodology, 2; JSOTSup, 278; Sheffield: Sheffield Academic Press, 1998).

exiles and displacements in the Hebrew Bible and many biblical voices with divergent views all eager to comment on their significance from their own particular standpoint. In other words, the effectiveness of the metaphor of exile in the flight into Egypt pericope has not been fully appreciated because commentators have confined and restricted its significance to the traditional interpretation of the Jewish exile to Babylon in 587 BCE. Contemporary explorative investigations into the many ways in which the metaphor of exile in the Old Testament may be read will inevitably throw new light also on the way we read Matthew's pericope.

There is a further dimension which makes the flight into Egypt an especially rich narrative to investigate. Our reading of it will be influenced not only by whether we ourselves have actually experienced exile but also by our encounter with, and response to, the cultural, especially visual, representations of the passage. J. Cheryl Exum notes:

> It is not simply a matter of the Bible influencing culture; the influence takes place in both directions. What many people know or think they know about the Bible often comes more from familiar representations of biblical texts and themes in the popular culture than from study of the ancient text itself... Not only will our knowledge of the biblical text influence the way we view, say, a painting of a biblical scene, our reading of the biblical text is also likely to be shaped by our recollection of that painting.[12]

More than any other passage in the Bible, it is virtually impossible to read this story without calling to mind a visual representation of it, either in a gallery, a church, or perhaps more implicitly from a television documentary that deals with situations of war, where both the visual imagery and accompanying commentary often intentionally recall the refugee Holy Family in order to increase the emotional impact. Phrases such as 'a refugee crisis of biblical proportions' or families forced to flee a tyrant 'as in biblical days' frequently trip off the tongues of news reporters and resonate with the audience's subconscious familiarity with the biblical story. However, before we can appreciate the rich afterlives of the story, we need first to recognize that the narrative itself contains several ambiguities and subtleties that helped fuel the imagination of its interpreters.

The Biblical Narrative

The flight into Egypt in Mt. 2.13-23 forms a compact and discrete literary unit. It is preceded by an account of the birth of Jesus and the subsequent

12. J. Cheryl Exum, *Plotted, Shot, and Painted: Cultural Representations of Biblical Women* (Gender, Culture, Theory, 3; JSOTSup, 215; Sheffield: Sheffield Academic Press, 1996), pp. 7-8.

visit of the wise men to Bethlehem and their adoration of the child Jesus
(1.18–2.12) and followed by a description of John the Baptist, his ministry
and the baptism of Jesus (3.1-17). The narrative itself forms a chiastic struc-
ture with the massacre of the children (vv. 16-18) at its core:[13]

A (13) Now after they had left, an angel of the Lord appeared to Joseph in a dream and
 said, 'Get up, take the child and his mother, and flee to Egypt and remain there until
 I tell you; for Herod is about to search for the child, to destroy him'.

B (14) Then Joseph got up, took the child and his mother by night, and went to
 Egypt (15) and remained there until the death of Herod. This was to fulfil what
 had been spoken by the Lord through the prophet, 'Out of Egypt I have called my
 son'.

C (16) When Herod saw that he had been tricked by the wise men, he was
 infuriated and he sent and killed all the children in and around Bethlehem
 who were two years old or under according to the time that he had learned
 from the wise men. (17) Then was fulfilled what had been spoken through the
 prophet Jeremiah, (18) 'A voice was heard in Ramah, wailing and loud lamen-
 tation. Rachel weeping for her children; she refused to be consoled because
 they are no more'.

A' (19) When Herod died, an angel of the Lord suddenly appeared in a dream to Joseph
 in Egypt and said, (20) 'Get up, take the child and his mother, and go to the land of
 Israel for those who are seeking the child's life are dead'.

B' (21) Then Joseph got up, took the child and his mother, and went to the land of
 Israel. (22) But when he heard that Archelaus was ruling over Judaea in place of
 his father Herod, he was afraid to go there. And after being warned in a dream,
 he went away to the district of Galilee. (23) There he made his home in a town
 called Nazareth so that what had been spoken through the prophets might be
 fulfilled: 'He will be called a Nazorean'.

Elements A and B of the chiasmus describe the safe passage of Jesus by night
to Egypt while in elements A' and B' the journey is reversed when the family
returns to Israel. At the heart of the narrative is element C in which the
massacre takes place in Bethlehem; v. 16 interrupts the peace and calm of

13. Raymond E. Brown (*The Birth of the Messiah* [New York: Doubleday, 1993], p. 109)
reconstructs a 'pre-Matthean' version which considerably shortens the material within the
chiasmus. In particular, he omits vv. 22-23, which he attributes to Matthew, who added
these verses as his own appended composition, and he argues that this history of compo-
sition, explains the awkwardness of several revelations involved in the return from Egypt.
Ulrich Luz (*The Theology of the Gospel of Matthew* [Cambridge: Cambridge University
Press, 1995], p. 28), sees vv. 22-23 as an addition for similar reasons. Richard J. Erickson
('Divine Injustice? Matthew's Narrative Strategy and the Slaughter of the Innocents
[Matthew 2.13-23]', *JSNT* 64 [1996], pp. 5-27) offers a chiastic structure, similar to the
above, and places the episode of the Slaughter of the Innocents and its fulfilment quota-
tion (Jer. 31.15) at the very heart of the narrative.

the midnight escape, shows that the dramatic flight was indeed justified and leaves the reader relieved that the Christ child has escaped, even though it may also raise ethical questions as to why other children too did not receive a similar warning.[14]

The brevity and intensity of the Matthaean style requires considerable unravelling to appreciate the impact of the episode. First, for whom was the narrative intended? Commentators on Matthew's Gospel agree on its Jewish orientation, one of the central aims being to present Jesus as the fulfilment and culmination of the Old Testament, and most are of the opinion that it was written for a Jewish-Christian audience towards the end of the first century, perhaps shortly after 70 CE.[15] The location of the community is still disputed but several commentators suggest Antioch in Syria as a strong probability.[16] The flight into Egypt is characteristic of the author's attempts to make the background of the infancy of Jesus fit into its Old Testament background and to make it appealing to the reader familiar with Jewish tradition. The geographical sweep from Israel to Egypt (vv. 3-14) and back again (vv. 19-23) reminds the reader of the patriarch Joseph's journey to and stay in Egypt (Exod. 37–50)[17] and the return of Jesus to Israel reminds the reader of Moses' return at the time of the Exodus (Exod. 14–15). Joseph plays the role of Joseph the patriarch and Jesus plays that of the new Moses.[18] The narrative, replete with Old Testament names, places and themes,[19] makes it clear

14. For the ethical issues raised, see Erickson, 'Divine Injustice?', pp. 25-27. Elizabeth Wainwright ('The Gospel of Matthew', in Elizabeth Schüssler Fiorenza [ed.], *Searching the Scriptures: A Feminist Introduction and Commentary* [New York: Crossroad, 1993; London: SCM Press, 1995], p. 644) contrasts the male and heartless despot Herod with the female and compassionate mother Rachel.

15. See Luz, *The Theology of the Gospel of Matthew*, pp. 11-21; Donald Senior, *What Are They Saying about Matthew?* (New York: Paulist Press, 1996), pp. 7-20; and M.A. Powell, *The Gospels* (Philadelphia: Fortress Press, 1998), pp. 71-75.

16. For a range of views, see Powell, *The Gospels*, pp. 73-74.

17. In Isa. 30.1-7 and 31.1-3, the prophet condemns those who 'seek refuge' in Egypt and not in Yahweh. The implication is that they believe the gods of Egypt are more powerful to save than Yahweh. The irony in Matthew is that Jesus himself should have to seek refuge there. See, too, the importance of Yahweh himself as 'refuge' in the Psalms in Jerome F.D. Creach, *Yahweh as Refuge and the Editing of the Hebrew Psalter* (JSOTSup, 217; Sheffield: Sheffield Academic Press, 1996), pp. 106-21.

18. For detailed similarities with Old Testament texts dealing with the childhood of Moses, see Brown, *The Birth of the Messiah*, p. 113.

19. See Brown, *The Birth of the Messiah*, pp. 203-13; Robert H. Gundry, *Matthew: A Commentary on his Handbook for a Mixed Church under Persecution* (Grand Rapids: Eerdmans, 2nd edn, 1994), pp. 35-37 and Augustine Stock, *The Method and Message of Matthew* (Collegeville, MN: Liturgical Press, 1994), pp. 37-39. Erickson ('Divine Injustice?', pp. 13-15) explores points of comparison as does Douglas R.A. Hare, *Matthew* (Interpretation Series; Louisville, KY: Westminster John Knox Press, 1993), pp. 15-17.

that Matthew is much more interested in creating a symbolic journey through
the past for the reader than simply re-telling an historical childhood tradition
associated with Jesus.

But the key to interpreting the narrative and unravelling its symbolism lies
in discovering the function of the three so-called *fulfilment quotations*.[20] Of
the twelve fulfilment quotations in the Gospel, five occur in chs. 1–2 and
three of these are found in the narrative of the flight into Egypt (vv. 15,
18, 23). Matthean commentators, while at odds over the precise sources of
Matthew's fulfilment quotations and his adaptation of them, agree that Old
Testament quotations are not mere embroideries on the Gospel story but are
an integral part of the Gospel's message, placing the story of Jesus in the
broader context of Israel's history.[21] As a literary and editorial technique, the
fulfilment quotation serves the purpose of conveying to the reader the full
significance of events within the narrative; it ensures that the reader is more
aware of their symbolism than the actual characters are within the story.

In the first occurrence, v. 15, Matthew quotes Hos. 11.1, which refers to
the exodus of Israel from Egypt; Jesus relives in his own life the exodus
experience of the Jewish people. In the second occurrence, v. 18, Matthew
quotes Jer. 31.15, where the dead Rachel is imagined to be weeping at
Ramah, the site where the Israelites were gathered for the march into the
Babylonian exile, lamenting their departure. In this fulfilment quotation,
Matthew links the massacre of the children in Bethlehem with the earlier
tragedy of the exile to Babylon.[22] In combining Egypt, the land of the Exodus
in v. 15, with Ramah, the site of the departure for the Babylonian Exile in v.
18, Matthew skilfully offers a succinct history of Israel from exodus to exile
and identifies Jesus with this history; Jesus, the refugee, relives the history of
the Jewish people first in their voluntary exile in Egypt and second in their
enforced exile in Babylon. The two fulfilment quotations in v. 15 and v. 18
draw out clearly for the reader the comparison between both events. Com-
mentators have noted the significance of the association made between Beth-
lehem, Egypt and Ramah. Brown speaks of 'the summing up of the theological
history of Israel in geographical miniature',[23] while Stock notes that 'the ful-
filment citations give us three names (Bethlehem, Egypt and Ramah) evoca-
tive of the great moments of the Old Testament'.[24]

20. For a discussion of this peculiarly Matthaean device, see Gundry, *Matthew*, pp. 24-
25; Luz, *The Theology of the Gospel of Matthew*, pp. 37-41; Powell, *The Gospels*, pp. 69-70;
Senior, *What Are They Saying about Matthew?*, pp. 51-65 and Stock, *Method and Message
of Matthew*, p. 30.

21. Senior, *What Are They Saying about Matthew?*, p. 61.

22. In the genealogy presented in Mt. 1, it is the only specific event to be mentioned
(1.11, 17).

23. Brown, *The Birth of the Messiah*, p. 218.

24. Stock, *Method and Message of Matthew*, p. 41. Luz, *The Theology of the Gospel of*

Although the last fulfilment quotation (v. 23) is very problematic, since it does not actually appear in the Old Testament and the prophet concerned is not cited, it is clear that its purpose is to make a definite association between Jesus and Nazareth.[25] Since Nazareth is in Gentile Galilee, commentators see the purpose of this verse as an attempt to show that Jesus returns from Egypt to the area of the Gentiles where he can begin his mission. By combining the reference to Israel (v. 20) with Galilee of the Gentiles (vv. 22-23), Matthew has Jesus divinely directed to the two groups that make up the Matthaean community: Jew and Gentile.[26] In short, the narrative of the flight into Egypt, the symbolism of which has been interpreted for the reader through three fulfilment quotations, is intended to speak to both Jewish and Gentile readers, presumably in Antioch towards the end of the first century CE, to further their sense of identity with the person and mission of Jesus.

But this conclusion is inherently problematic, first with regard to the Jewish reader and second, the Gentile. Since the Gospel was written after the destruction of Jerusalem in 70 CE, the Jewish-Christian community in Antioch has presumably either left Jerusalem or never lived there in the first place, having been part of an earlier diaspora. Does the narrative of the flight into Egypt, with its emphasis on themes of displacement, exodus and exile at its centre, offer a credible history to the Jew living in Antioch with which he, or she, can identify? The return of Jesus, representing the new people of Israel, to 'the land of Israel'[27] (vv. 20-21), the only use of the phrase in the New Testament, appears reassuring; but it is a less than satisfactory closure to the narrative of Jesus' escape from Herod since his return puts his life in more, not less, danger[28] and also because he cannot return directly to his home in Bethlehem from which he fled since he is diverted away from Judaea to Nazareth in Galilee, a town with no Old Testament associations.

Matthew, pp. 29-30, also emphasizes the importance of the geographical locations for an understanding of the passage.

25. For a discussion of the problems which this fulfilment quotation presents, see Brown, *The Birth of the Messiah*, pp. 207-13 and p. 617. See also Erickson, 'Divine Injustice?', p. 20, for an interesting perspective on the issue.

26. See Stock, *The Method and Message of Matthew*, p. 41.

27. Brown (*The Birth of the Messiah*, p. 206) suggests Matthew's use of the phrase is inspired by Ezek. 20.36-38.

28. Many commentators associate Herod's search for Jesus to destroy him with Jesus' trial and death. For example, they point out that the verb 'destroy' in v. 13 appears in the passion narrative in Mt. 27.20 and the verb 'ridicule' in v. 16 is used for the mockery of Jesus as king in 27.29, 31, 41 (Brown, *The Birth of the Messiah*, p. 204). Stock (*The Method and Message of Matthew*, p. 37) notes that the manner in which Herod reacts to the perceived threat posed by the infant Jesus anticipates the manner in which the religious leaders will later respond to the adult Jesus.

One could argue that, for the reader with a Jewish background, the *symbolism* of Jesus' return would have been immediately obvious.[29] One could also argue that the return of Jesus to 'the land of Israel', even though it resulted ultimately in the death of Jesus, was the event that would bring about salvation. Yet at the same time, Matthew, in suggesting that Jesus' return reverses the Jewish exodus and exile, shows that his concept of exile is a negative and punitive one. Would Matthew's diaspora readership in Antioch, prosperous Alexandria or elsewhere have agreed with his view?

An illuminating perspective from which to appreciate the impact of the geography of the passage is Robert Carroll's discussion of the situatedness of the reader in relation to texts dealing with exile in the Old Testament.[30] Carroll draws attention to the 'narratological obsession' of the Hebrew authors with exodus and exile which act as root metaphors in Hebrew narrative:

> Exile and exodus: these are the two sides or faces of the myth that shapes the subtext of the narratives and rhetoric of the Hebrew Bible. Between these twin topoi is framed, constructed and constituted the essential story of the Hebrew Bible. The narratological structure reflects a constant concern with journeyss.[31]

Carroll argues that although there were many instances of exile and deportations in the Hebrew Bible,[32] the predominant tradition that there was one major exile has come to us through an ideological shaping of biblical history carried out in the service of a Jerusalem-centred ideology:

> From the position of modern readers of the Bible, there can really only be a sense of exile as something propounded by a Jerusalem- or Palestinian-orientated point of view. From a Babylonian Jewish community, an Egyptian Jewish community or even a modern reader's point of view, life in the Diaspora may not have been seen as exilic at all. It is all a question of point of view and perspective… To talk about *the* exile is to take a position following or favouring the Jerusalem-orientated point of view.[33]

It could be argued that in the narrative of the flight into Egypt, constructed around the same twin topoi of exodus and exile, Matthew reinforces for his Jewish Christian audience the same Old Testament perspective of

29. Jacob Neusner, *Understanding Seeking Faith: Essays on the Case in Judaism* (Atlanta: Scholars Press, 1986), pp.137-41, argues that the historical-geographical experience of exile has become paradigmatic for a contemporary understanding of Judaism.

30. Robert P. Carroll, 'Exile! What Exile? Deportation and the Discourses of Diaspora', in Grabbe (ed.), *Leading Captivity Captive*, pp. 62-79.

31. Carroll, 'Exile! What Exile?', p. 63.

32. Brown (*The Birth of the Messiah*, p. 216 n. 8), too, admits 'how difficult it is to decide which exile is meant by Matthew; he may have intended a conglomerate picture of exile'.

33. Carroll, 'Exile! What Exile?', p. 67.

exodus and exile; just as the Old Testament perspective is centralized in Jerusalem, so too Matthew's viewpoint of the exodus and exile is seen from within 'the land of Israel' (vv. 19-20). But can such a viewpoint be shared by Matthew's diaspora community, the gentiles within his community or subsequent readers of his narrative, including the modern reader for whom there is no link either geographically or culturally? For Matthew, there is a *centre and periphery*, with Bethlehem (v. 16) or the land of Israel (vv. 19-20) at the centre and Egypt (vv. 13-15) and Nazareth (v. 23) as peripheral locations in the story. This may be Matthew's ideological view but every reading and every re-reading of the story must be situated and that situatedness of the story is dependent on the location and identity of the reader.[34]

To interpret Jesus' return to the land of Israel as a fulfilment of, and satisfactory conclusion to, the Old Testament events of exodus and exile is problematic. It suggests that exile and diaspora must always be seen as punitive, negative and temporary, a position with which not everyone would agree.[35] Matthew, in the structure of his chiasmus, determines for the reader *his* view of exile, a view that already existed in the Old Testament and which was centred on Jerusalem; the implication is that exile is a state from which people need rescuing—a view not always shared by subsequent interpreters.

The Flight into Egypt and its Artistic Afterlives

From the early Christian centuries, readings of the flight into Egypt focused not on the *centre* of Matthew's pericope, the Massacre of the Innocents,[36] nor on its twin theme of exodus from Egypt and return from exile. Rather, interpreters became more interested in *peripheral* aspects of the narrative, the flight of the family out of Israel and their time of exile in Egypt. In the biblical narrative, the three members of the family, after their flight to Egypt, remain hidden in the background during the massacre of the infants until their eventual re-appearance and return.[37] Their absence, the secrecy of their

34. See Philip R. Davies ('Exile? What Exile? Whose Exile?', in Lester L. Grabbe [ed.], *Leading Captivity Captive*, pp. 128-38) on the importance of identity as a major factor in the discussion.

35. See Davies, 'Exile! What Exile?', pp. 134-35.

36. Erickson, 'Divine Injustice?', p. 8, provides references where the centre of the pericope, the Slaughter of the Innocents, has been used as a platform to speak to such issues as the holocaust, abortion and the Vietnam war.

37. The absence of the Virgin is particularly noticeable in the panel depicting the Slaughter of the Innocents in Duccio's masterpiece, the *Maestà*, painted for the Duomo in Siena in 1317. The Virgin is present in all the narrative panels portraying her life except in the Slaughter of the Innocents which portrays the weeping mothers alone with their injured expressions of grief. See Enzo Carli, *Duccio's Maestà* (Florence: Istituto Fotocromo Italiano, 1998), p. 9.

journey and their unknown destination have exercised the imagination of
many throughout the centuries; the desire to complete the details of the terse
narrative parallels similar attempts to offer closure to other unsatisfactorily
short biblical stories.[38] But it was precisely the brevity and lack of detail that
allowed interpreters, especially artists, to expand the biblical narrative and
to apply it to their own situation and their own particular viewers. Paolo
Berdini,[39] with reference to the religious art of Jacopo Bassano, has shown
how a biblical painting is not just a representation of the text but the artist's
reading of the text, influenced by his, or her, historical or political situation:

> What the painter visualizes is not the narrative of the text but its expanded
> form as it emerges from the painter's reading of it. In compliance with a speci-
> fic mode of reading—Christian Exegesis—the visualization of a text is intended
> to have a specific effect on the beholder. I call the dynamics of visualization
> 'visual exegesis' and suggest that painting visualizes a *reading* and not a text.[40]

Similarly, many artists, informed and inspired by early apocryphal legends,
offered *readings* of the biblical flight into Egypt and highlighted various dis-
tinctive aspects of the journey so that what was originally either peripheral
to or non-existent in the Matthaean account now becomes central, even
taking on a life of its own.[41] The artists' reading of the narrative could also be
inspired by other biblical texts that shared a similar theme, for example, the
exile of Adam and Eve from the Garden of Eden, the Babylonian exile or the
'exile' of Christ as he is condemned to death. Ironically, what Matthew
omits from his text—the context and details of the family's stay in Egypt—
becomes a focus for the artist to suggest, visualize and reflect upon several
divergent aspects of biblical exile.

Early Christian apocryphal legends betray an insatiable interest in the
characters of Jesus, Mary and Joseph and especially in the events of their
journey and stay in Egypt—legends mostly clustered together in *The Gospel*

38. Several writers have shown how biblical narratives have been extended and com-
pleted in art, music, literature and film. See especially, Exum's treatment of the Samson
and Delilah narrative in *Plotted, Shot, and Painted*, pp. 184-88; Bal, *Reading 'Rembrandt'*;
Berdini, *The Religious Art of Jacopo Bassano*; David Curzon, *Modern Poems on the Bible: An
Anthology* (Philadelphia: Jewish Publication Society, 1994); Larry Kreitzer, *Film and Fic-
tion in the Old Testament: On Reversing the Hermeneutical Flow* (The Biblical Seminar, 24;
Sheffield: Sheffield Academic Press, 1994); Martin O'Kane, 'The Biblical King David and
his Artistic and Literary Afterlives', *BibInt* 6 (1998) pp. 313-47.

39. Berdini, *The Religious Art of Jacopo Bassano*.

40. Berdini, *The Religious Art of Jacopo Bassano*, p. xi.

41. For the development of *The Flight into Egypt* iconography, see Gaston Duchet-
Suchaux and Michel Pastoureau, *The Bible and the Saints* (Flammarion Iconographic
Guides; Paris: Flammarion Press, 1994), pp. 149-51; and Peter and Linda Murray, *The
Oxford Companion to Christian Art and Architecture* (Oxford: Oxford University Press,
1996), pp.157-59.

of Pseudo-Matthew.[42] Pseudo-Matthew's embellishments, which focus on the actual escape and subsequent exile, are important because such legends were instrumental in the way artists, especially in the mediaeval period and in later centuries, read the story. Elliott notes that *The Gospel of Pseudo-Matthew* was so influential in the Middle Ages that much mediaeval art is indecipherable without reference to it.[43]

Ps.-Matt. 17–25 corresponds to Mt. 2.13-23 and documents a number of miracles performed by, or because of Jesus. It locates the events two years after the birth of Jesus (*Ps.-Matt. 16*) and describes the journey in colourful and fanciful language. Having found a cave in which to shelter and find rest, Mary is frightened by lions, panthers and various other kinds of wild beasts, but is pacified by Jesus' words and the submission of the animals to him. In fulfilment of Isa. 65.25, the beasts walked with them and yet not one of them was hurt (*Ps.-Matt. 19*). Mary found shelter in the shade of a palm-tree and desired to eat the fruit from the branches which were out of even Joseph's reach. However, on Jesus' command, the branches of the palm-tree stooped low so that Mary could pick enough fruit with which to refresh herself, Jesus and Joseph (*Ps.-Matt. 20*). Jesus commanded the tree to 'open from [its] roots a vein of water which is hidden in the earth and let the waters flow, so that [they] might quench [their] thirst' (*Ps.-Matt. 20*). The tree duly complied and the family had more than enough water from the spring which emerged for themselves and for their animal companions (*Ps.-Matt. 20*). The palm-tree which provided the Holy Family with shelter and refreshment anticipates the palm branches used by the crowds to pave Jesus's way as he triumphantly entered Jerusalem immediately prior to his passion, death and resurrection.

The final miracle recounted by *The Gospel of Pseudo-Matthew (22–24)* is, perhaps, the most dramatic. On reaching Sotinen in Egypt and not knowing anyone there, the family went to the temple. In fulfilment of Isa.19.1, when they entered the temple the 365 idols fell off their plinths and shattered into tiny fragments 'and thus they plainly showed that they were nothing' (*Ps.-Matt. 23*). This single event, the gospel declares, led to the conversion of the whole city because the governor proclaimed that

> Unless this were the God of our gods, our gods would not have fallen on their faces before him, nor would they be lying prostrate in his presence: therefore they silently confess that he is their Lord. Unless we do what we have seen our gods doing, we may run the risk of his anger and all come to destruction.

> (*Ps.-Matt. 24*)

42. J.K. Elliott (ed.), *The Apocryphal Jesus: Legends of the Early Church* (Oxford: Oxford University Press, 1996), p. 3.

43. J.K. Elliott (ed.), *The Apocryphal New Testament: A Collection of Apocryphal Christian Literature* (Oxford: Clarendon Press, 1993), p. 84.

A further legend[44] which developed around the biblical story was that of the sower: being pursued by Herod's soldiers, Mary and Joseph asked a sower, whom they passed by, to tell the soldiers that he had seen them go by at the time of sowing. Immediately, a field of corn grew up, giving the impression that sowing had occurred many months previous. When the soldiers arrived and saw that it was nearly time for the harvest they gave up their search thinking that they were much too late and thereby allowed the family to continue their escape without fear of being caught.

Thus, even at an early stage in the narrative's interpretation, the emphasis on divine protection in perilous circumstances obviously appealed to the reader and the potential of the subject could easily be appropriated by artists to encourage the viewer to identify with the scene.[45] In some cases, the artist simply depicts the embellishments made to the biblical text by the apocryphal stories. For example, *The Flight into Egypt* (National Gallery, London, c. 1515) a panel from a wooden altarpiece by the Master of 1518, is typical of the way the subject was treated in the fourteenth and fifteenth centuries.[46]

Here, the artist depicts, on the right, the plinth from which a pagan idol falls and on the left, the miracle of the wheat field. Painted as an altarpiece, the work was intended to act as a devotional aid and is representative of many similar paintings. Joseph leads the donkey which carries Mary as she suckles the infant Jesus; his gaze towards Mary directs the attention of the viewer to her and especially to the suckling child.

A second and more subtle interpretation is found in stained glass from the early twelfth century above the Royal Portal in Chartres Cathedral in the 'Incarnation Window' which depicts in five narrative panels the flight into Egypt.[47] That so much space in the window was given over to the theme testifies to its importance. Of particular significance is the way in which the family is welcomed at Sotinen in Egypt; the city is represented in great detail with ramparts, streets, turrets and towers, houses with windows and hinged, nail-studded doors and a high red city gate, before which Aphrodisius, the

44. Cited in Maryan W. Ainsworth and Keith Christiansen (eds.), *From van Eyck to Bruegel: Early Netherlandish Painting in the Metropolitan Museum of Art* (New York: Metropolitan Museum of Art, 1998), p. 266.

45. Although there is no recent bibliography specifically on this topic, two biblical commentators from the end of the nineteenth century explore the theme in some depth: H. van Dyke 'The Flight into Egypt', in *Harper's New Monthly Magazine* (December 1889) and Frederic W. Farrar, 'The Massacre of the Innocents and the Flight into Egypt', in *The Life of Christ as Represented in Art* (London: Adam & Charles Black, 1894), pp. 263-70.

46. A detailed description of this painting is given in Anabel Thomas, *Illustrated Dictionary of Narrative Painting* (London: The National Gallery Publications, 1994), pp. 38-39.

47. Malcolm Miller, *Chartres Cathedral* (Andover, Hampshire: Pitkin, 1996), pp. 32-36.

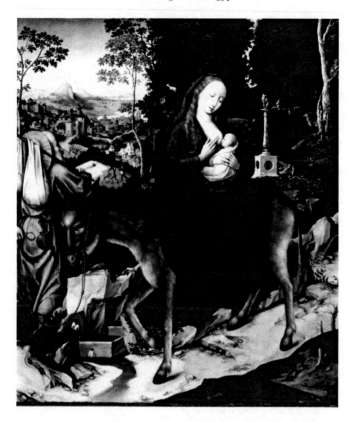

Fig. 11. The Master of 1518, *The Flight into Egypt* (c. 1515)
The National Gallery, London.

governor and a great retinue stand to welcome the Christ child. The detail
and sophistication of the depiction of Sotinen, the city of the Gentiles,
create the effect of stability and security while the warmth of Aphrodisius's
welcome contrasts with the harsh cruelty of King Herod in Bethlehem. But
especially noteworthy is the way in which the place of exile, in Sotinen,
becomes for the viewer the centre and focus of the Matthaean narrative.

Of the very many depictions of the flight into Egypt, those associated
with the liturgical hours of Vespers offer some of the richest interpretations.
They are found especially in the Books of Hours[48] that subsequently had a

48. See Christopher de Hamel, *A History of Illuminated Manuscripts* (London: Guild
Publishing, 1st edn, 1986) and *A History of Illuminated Manuscripts* (London: Phaidon, 2nd
edn, 1994). John Harthan, *Books of Hours and their Owners* (London: Thames & Hudson,
1978) includes three colour plates of *The Flight into Egypt* (pp. 71, 122, 126). See also his
The History of the Illustrated Book (London: Thames & Hudson, 1997), especially 'Section
1: Manuscripts to the Sixteenth Century', pp. 11-58; Robert G. Calkins, *Illuminated Books*

profound influence on Carravaggio's well-known *Rest on the Fight into Egypt*. The mediaeval Books of Hours, 'the late medieval best-sellers'[49] with their devotional decorations and illustrations based on biblical scenes indicated those portions of the day which were to be set aside for religious or business purposes. The contents of the Books were divided into three elements: essential, secondary and accessory texts.[50] One of the essential texts was the *Little Office* or *Hours of the Virgin* in which each Hour was usually illustrated by a full or half page miniature of the following scenes.[51]

Matins	*The Annunciation*
Lauds	*The Visitation*
Prime	*The Nativity*
Tierce	*The Angel's Announcement of Christ's Nativity to the Shepherds*
Sext	*The Adoration of the Magi*
None	*The Presentation in the Temple*
Vespers	*The Flight into Egypt*
Compline	*The Coronation of the Virgin*

In the *Little Office*, the Hours are seen principally as episodes in the life of the Virgin, e.g. at Lauds, Mary visits Elizabeth and at Vespers she flees with the Christ child to Egypt. No doubt the reason for the association of the flight with Vespers was Matthew's report that the journey took place at night. (For this reason, the chronological order of events is disrupted; one would expect the *Flight* to come before the *Presentation* and not after it.) A typical artistic representation of the flight into Egypt which served to introduce the texts of Vespers in the Books of Hours is found in *The Hours of Marguerite de Foix, Duchess of Brittany*.

of the Middle Ages (London: Thames & Hudson, 1983) includes an illustration and brief discussion of the *Flight into Egypt* from the *London Hours* in the British Library from the first decade of the fifteenth century (pp. 261 and 266); Janet Backhouse, *The Illuminated Page: Ten Centuries of Manuscript Painting in the British Library* (London: The British Library, 1997), includes three early representations of the *Flight into Egypt*: first, a surviving leaf from a late-twelfth-century Psalter showing twelve scenes from the Nativity of Christ, centred on the *Flight into Egypt* (p. 47); second, several scenes from apocryphal incidents from the Holkham Bible Picture Book, early fourteenth century (p. 237); and third, a decorated miniature of the Flight introducing Vespers in a Book of Hours, started in 1520 and completed more than a century later in 1643; Nancy Grubb (*The Life of Christ in Art* [New York: Abbeville, 1996], p. 53) includes a depiction from the thirteenth century, *Miniatures of the Life of Christ*.

49. Harthan, *Books of Hours and their Owners*, p. 9.
50. Harthan, *Books of Hours and their Owners*, p. 14.
51. Harthan, *Books of Hours and their Owners*, p. 28.

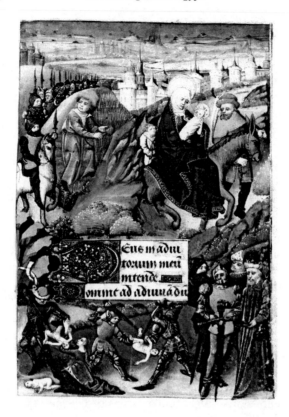

Fig. 12. *The Flight into Egypt* (c. 1470–80) from *The Hours of Marguerite de Foix, Duchess of Brittany*, The Victoria and Albert Museum, London.

In the depiction of *The Flight into Egypt* from *The Hours of Marguerite de Foix*, distant mountains, towers and a river landscape lead the eye down to the walled city of Bethlehem from where the family is fleeing.[52] Immediately behind the mule, an angel stands as if protecting the little group from the soldiers sent in pursuit by King Herod. The peasant cutting corn illustrates the apocryphal Miracle of the Sower in which Mary asked the sower to tell the soldiers that he had seen the family go past at sowing time. The soldiers then abandon the pursuit in the belief that the refugees must now be too far away to be apprehended. Below the text, the massacre of the infants takes place in Bethlehem. Herod stands on the right pointing with his sceptre as the soldiers go about their work. The artist presents the viewer with images

52. The figure of Joseph, without a halo, is thus differentiated from that of the Virgin. This might be explained by a particular devotion that Marguerite de Foix had for the Virgin, the 'immaculate daughter of Anne', which is suggested by a prayer at the end of the book. See Harthan, *Books of Hours and their Owners*, p. 124.

of great immediacy. As well as incorporating accurately the Matthaean nar-
rative of the massacre of the infants at Bethlehem, he includes an apocryphal
legend of *Pseudo-Matthew*. The written text, opening Vespers, imploring God
to come to the reader's help, serves to associate the dangers conveyed in the
miniature with the vicissitudes of his or her own life and, by implication,
commends the reader to pray for divine assistance.

No doubt, the reason for the choice of the flight into Egypt to illustrate the
texts of Vespers was that it offered yet another incident—and a nocturnal
one—in the life of the Virgin. But there is a further explanation. Vespers,
which included five psalms and the Magnificat,[53] was a favourite and an
important devotion. Paolo Berdini emphasizes its importance in the Middle
Ages:

> Regarding the ordinary Christian, the liturgy of the hours provided the struc-
> ture within which the continuity and interplay between the two Testaments
> could be recognized. In particular, Vespers were conceived and perfected as
> evening prayers with the intention of positing clearly the link between cre-
> ation and salvation, between the story of the sinful Adam and the redemptive
> sacrifice of Christ. [54]

Berdini relates the underlying exegetical exercise present in the reading of
biblical texts at Vespers to the interpretation of Bassano's *The Journey of
Jacob* (1578)[55] and suggests that an understanding of the structure of Vespers
offers a rich 'reading' or 'visual exegesis' of that painting. He argues that the
overriding impression of night and darkness in *The Journey of Jacob* reveals
'an exegetical character that can be related to the structure of Vespers'.[56] He
notes that the biblical passages which Vespers contained (from the Psalms
and Genesis) were selected for the purpose of relating the events of creation
to the events of Christian revelation. Light as a divine manifestation was
considered the unifying force of the Old and New Testaments. In the Old
Testament, light signals the beginning of creation; it is the first sign of life
given to Adam, but in the New Testament the light of Christ indicates the
path of salvation itself. Vespers, at the last light of day, provided an oppor-
tunity to reflect on light and darkness, labour and rest. Central to all scrip-
tural selections forming Vespers since early Christianity, Psalm 104 initiated
Christian thanksgiving and introduced night as the time for praying. Psalm
104.20-24 describes a nocturnal landscape where night is broken by the
daylight of labour which lasts until evening. Darkness disrupts labour and
brings rest:

53. Harthan, *Books of Hours and Their Owners*, pp. 16-17.
54. Berdini, *The Religious Art of Jacopo Bassano*, p. 84.
55. The painting can be seen in Berdini, *The Religious Art of Jacopo Bassano*, plate IV.
56. Berdini, *The Religious Art of Jacopo Bassano*, p. 85.

> You make darkness and it is night, when all the animals of the forest come creeping out. The young lions roar for their prey, seeking their food from God. When the sun rises, they withdraw and lie down in their dens. People go out to their work and to their labour until evening (Ps. 104.20-23).

Berdini's method of 'visual exegesis', of applying the same interpretative process to a biblical painting as applied to biblical texts at Vespers, illumines artistic representations of *The Flight into Egypt*. A painting that cannot be fully appreciated unless interpreted as 'Vespers Art' is Michelangelo Merisi da Caravaggio's *Rest on the Flight into Egypt*.

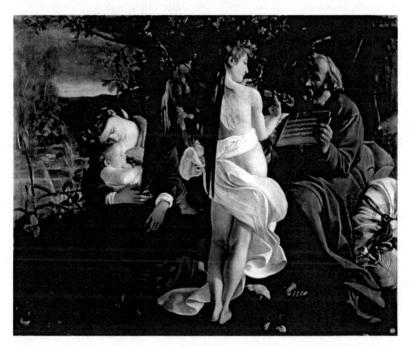

Fig. 13. Michelangelo Merisi da Caravaggio, *Rest on the Flight into Egypt* (c. 1603) Galleria Doria Pamphilj, Rome.

Caravaggio based his work on Jacopo Tintoretto's painting of *The Flight into Egypt* (1583–87), in the Scuola di San Rocco, Venice, which dramatically presents the Holy Family as they furtively and hesitatingly leave Bethlehem. While the theme of *The Flight into Egypt* was common in Italy,[57] *Rest on the*

57. For important and distinctive examples of the theme, see di Buoninsegna (c. 1280), Cathedral Museum, Siena; Giotto (c. 1305), Scrovegni Chapel, Padua (Grubb, *The Life of Christ in Art*, p. 50); Correggio (c. 1515), Galleria degli Uffizi, Florence; Barocci (c. 1528), Pinacoteca Vaticana, Rome; da Fabriano (c. 1400), Galleria d'Arte Antica e Moderna, Florence. The theme in Duccio's *Maestà* is discussed in Carli, *Duccio's Maestà*, p. 27;

Flight into Egypt, on the other hand, was a Northern subject[58] and in Venice there was no major example depicting the family resting along the way. In depictions of the theme in Italy, landscape normally took second place to the central image of the Virgin, to which Joseph and the donkey were generally loosely connected, usually at a distance. Caravaggio subdued the dramatic impact of the family's departure in Tintoretto's painting by showing the family at rest and by making the figures strikingly present to the viewer.[59] He distinguished the landscape according to the adult figures, with the angel positioned as a hinge between the two. A strong geometrical layout divides the oblong space into the barren half occupied by Joseph. Almost incidentally, behind the angel's wings, mother and child appear. Old age on the left hand of the picture is contrasted with youth as the quintessence of eternal

Giotto's version in the Church of St Francis, Assisi is included in Eric Santoni, *La vie de Jésus* (Paris: Editions Hermé, 1990), p. 35 and Carracci's version (1603) in the Doria Gallery, Rome can be found in Susan Wright, *The Bible in Art* (New York: Smithmark, 1996), p. 85; di Paolo's version (c. 1450) in the Pinacoteca Nazionale di Siena is included in Marco Torito, *Pinacoteca Nazionale di Siena* (Genova: Sagep Editrice, 1993), p. 49. *The Flight into Egypt* forms part of Simone Martini's famous frescoes of the Church of San Gimignano, Tuscany: see J.V. Imberciadori, *The Collegiate Church of San Gimignano* (Poggibonsi, Tuscany: Nencini, 1998), pp. 20-21. For a discussion of the painting *The Holy Family* with a Donatrix as Saint Catherine of Alexandria and the psychological intensity of the grouping of the figures, see Carolyn Wilson, *Italian Paintings XIV–XVI Centuries in the Museum of Fine Arts, Houston* (Houston: Museum of Fine Arts, Rice University Press. London: Merrell Holberton, 1996), pp. 350-56.

58. See, for example, de Cock (c. 1520), National Gallery, Dublin; Patener (c. 1520), National Gallery, London; Lastman (1620), National Gallery, London; Poussin (1657), Hermitage, St Petersburg; van der Werff (1706), National Gallery, London; Boucher (c. 1750), Hermitage, St Petersburg. For Lucas Cranach, see Alexander Stepanov, *Lucas Cranach the Elder, 1472–1553* (Bournemouth: Parkstone, 1997), p. 27. For Bruegel, see Rose-Marie and Rainer Hagen, *Pieter Bruegel* (Cologne: Taschen, 1994), p. 93. For Elsheimer (c. 1600), see Jacques Duquesne, *La Bible et ses peintures* (Paris: Fixot, 1989), p. 149. For Patel (c. 1650), see Frances Lincoln, *The First Christmas* (London: The National Gallery, 1992), p. 25. For Doré, see Gustave Doré, *La Bible* (Paris: Ars Mundi, 1998), p. 326. For Rossetti, see Frederic W. Farrar, 'The Massacre of the Innocents', in *The Life of Christ*, pp. 266-77. For Edward Burne-Jones, see Joseph Rhymer, *The Illustrated Life of Jesus Christ* (London: Bloomsbury, 1994), pp. 32-33. For Murillo and Carpaccio, see *The Story of Jesus* (Pleasantville, NY: The Reader's Digest Association, Inc., 1993). Depictions of the theme exist in Islamic art from Isfahan, Iran, from the eighteenth century: Mary and Joseph pass through the desert with Jesus in Bedouin dress with a Bedouin tent in the background (see Na'ama Brosh and Rachel Milstein [eds.], *Biblical Stories in Islamic Painting* [Jerusalem: Israel Museum, 1991], pp. 125-26).

59. See Eberhard König, 'On Deciphering the Pictures of the *Rest during the Flight into Egypt*—a Pastoral or Caravaggio's First Great Work?', in *Michelangelo Merisi da Caravaggio 1571–1610* (Cologne: Könemann, 1997), pp. 88-92. The discussion of the painting in this chapter follows his description and analysis.

life; on the right, the eye is drawn from the stony earth on the left across the world to the distant perspectives of eternity.

The composition fans out from an angel who is playing music and who has his back to the viewer. He divides the picture centrally with the outline of his right side and his left wing, which projects vertically towards the viewer in the foreground picture area. Nothing grows on the stony ground to the left. Joseph, now an old man, sits there beside a travelling bottle and bundle. He wears clothes of earth-colour and is holding a book of music from which an angel is paying violin solo. In setting out violin music for the angel to play, Caravaggio offers a key to the painting's meaning. By painting a meticulous copy of a music book which contains a motet which begins with the letter Q, we can identify a passage from the Song of Solomon (Song 7.6-7) as the text appropriate to the music; the score shows the cantus part of a motet by the Flemish composer, Noel Baulduin, first published in 1519. The quotation forms part of the Vespers of the Virgin Mary and runs:

> Quam pulchra es et quam decora carissima in deliciis. Statura tua assimilata est palmae et uba tua botris.

> How beautiful are you, my beloved, you creature of bliss! As you stand there, you are like the palm-tree and your breasts are like the grapes.

Caravaggio makes such a close association between the story of the flight into Egypt and the liturgical process of Vespers that instead of depicting the fleeing holy family, which is usual in Italy, he chooses to show them resting as befits the hour of sunset (and Vespers) and makes the music a lullaby. Eberhard König points out that the sleep of Mary and Jesus anticipates the death of Jesus—sleep and death being often intimately linked in art. The painting is a Vespers picture, in which Caravaggio seeks to evoke the hours that the Virgin spends with her child, the pastoral character of the angelic music and the nearness of sleep and death. The motet from the Song of Songs, applied to the Virgin at Vespers, suggests that the focus of the painting is on Mary's role not only now, but also at the death of Jesus.

The key to appreciating the painting, then, is an understanding of the process of Vespers, the liturgical separation of work and rest, light and darkness, consciousness and sleep; the angel's wings act as a hinge to highlight the separation. On the left half of the painting, Joseph, the angel and the donkey (with its huge eye) stay awake to celebrate Vespers and watch over Mary and the child on the right as they sleep. The viewer identifies with the left side of the picture and the group who are awake and conscious and not with Mary and Jesus who are unaware of what is happening. The viewer's attention is further attracted to the group on the left because the music score is positioned at such an angle that only the angel and the viewer can read it. As the angel plays the Vespers motet which Joseph holds and as the viewer

reads it, he or she becomes part of the Vespers picture and joins in the devotion to Mary suggested by the text of the Song of Solomon.[60]

The Flight into Egypt as Metaphor for the Journey of Life

Lew Andrews[61] and David Freedberg[62] discuss the importance of internal visual representation from the thirteenth century onwards as an aid to prayer and meditation. Andrews[63] draws attention to the anonymous text, *Giardino di orationi* (Garden of Prayer), written in 1454 and widely available during the fifteenth and sixteenth centuries, which instructed the faithful how best to meditate upon and remember the story of the Passion. It advised them to make a memory place of their own familiar surroundings in order to visualize the successive events of the Passion to be remembered in various locations within that space:

> The better to impress the story of the Passion on your mind and to memorize each action of it more easily, it is helpful and necessary to fix the places and people in your mind: a city for example will be the city of Jerusalem—taking for this purpose a city that is well-known to you...and then too you must shape in your mind some people, well-known to you, to represent for you the people involved in the passion...[64]

Andrews notes that this spiritual exercise was readily translated into paint, the best example being Hans Memling's depiction in Turin of *The Passion*, which is an illustration of the advice of the handbook. The episodes within the picture act as *aide-mémoires* to the viewer's recall as well as dazzling the eye:

> Their illusionistic brilliance spurs both the imagination and memory, permitting the viewer to enter the painting's fictive world, to move through the picture's space as though traversing the imaginary room or houses of the ancient treatises or the familiar environments of the devotional handbook. Viewing or looking is presumed to be an active process, a kind of devotion.[65]

Freedberg, too, discusses how the painter was 'a professional visualizer of the holy stories' and how his pious public, were practiced in spiritual exercises

60. Helen Langdon (*Caravaggio: A Life* [London: Chatto and Windus, 1998], pp. 123-26 [125]) emphasizes the 'passionate eroticism' of the Song of Songs in the motet which is transferred to the 'sweetly erotic' angel.

61. Andrews, *Story and Space in Renaissance Art*.

62. David Freedberg, *The Power of Images*.

63. Andrews, *Story and Space in Renaissance Art*, pp. 29-33.

64. Cited in Andrews, *Story and Space in Renaissance Art*, p. 29.

65. Andrews, *Story and Space in Renaissance Art*, p. 33.

that demanded a high level of visualization of the central episodes in the life of Jesus.[66] As an example, he cites the detailed instruction of *The Flight into Egypt* in *The Meditations of the Life of Christ* from the mid-thirteenth century by Pseudo-Bonaventure:

> ... Jesus was carried to Egypt by the very young and tender mother, and by the aged saintly Saint Joseph, along wild roads, obscure, rocky and difficult, through woods and uninhabited places—a very long journey....they are said to have gone by the way of the desert which the children traversed and in which they stayed for 40 years... Where did they rest and spend the night?.... Have pity on them...accompany them and help to carry the child Jesus and serve them in every way you can...here there comes a compassionate meditation...make careful note of the following things: Do they live or did they beg? ...you must contemplate all these things...enlarge on them as you please..be a child with the child Jesus! Do not disdain humble things for they yield devotion, increase love, excite fervour..and raise hope.[67]

Freedberg demonstrates, with illustrations from *The Passion of Christ*, how the imaginative intensity of such tracts was greatly increased by painters 'to arouse the empathetic responses necessary for successful meditation'.[68] Two paintings of *The Flight into Egypt* illustrate Freedberg's point.

In *The Rest on the Flight into Egypt*,[69] Gerard David was inspired by two late mediaeval works of literature: *The Life of Christ* by Ludolph of Saxony and the *Meditations on the Life of Christ* by Pseudo-Bonaventure. Popular expanded versions of the latter contemporary with David's painting present the Flight in terms of a pilgrimage on which the reader should accompany the Holy Family. They describe the arduous journey of the aged Joseph and Mary carrying the child Jesus 'through dark and uninhabited forests, and by very long routes past rough and deserted places to Egypt'.

66. One might also note here how the popular thirteenth-century Franciscan tract, the *Meditations on the Life of Christ*, stressed the defencelessness of the Holy Family, alone in a strange land. See I. Ragusa and R.B. Green (eds.), *Meditations on the Life of Christ* (Princeton, NJ: Princeton University Press, 1961), p. 67.

67. See Ragusa and Green (eds.), *Meditations on the Life of Christ*, p. 67.

68. The spirituality of van Gogh too, stemmed from the mediaeval traditions of an inward piety which taught that the spiritual journey is interior and intensely personal. It is expressed in Thomas à Kempis's *The Imitation of Christ* which had a profound effect on van Gogh in the early years. See Kathleen Powers Erickson, *At Eternity's Gate: The Spiritual Vision of Vincent van Gogh* (Grand Rapids: Eerdmans, 1998), pp. 42-49.

69. David painted two versions of the subject. The second is in the Washington Art Gallery. Both paintings inspired numerous replicas and versions: for example, the copy of the Metropolitan *Flight* now in the Prado, Madrid. For detailed descriptions of both, see Ainsworth and Christiansen, *From Van Eyck to Bruegel*, p. 308, which I follow in my description of the two paintings.

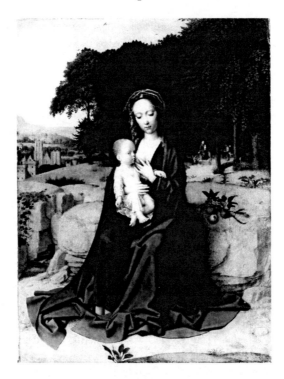

Fig. 14. Gerard David, *The Rest on the Flight into Egypt* (1510)
The Metropolitan Museum of Art, New York, The Jules Bache Collection, 1949.

A tiny scene in the right middle ground shows the family emerging from
the woods to the broad open plain where Mary nurses the child. In the centre
image as in the forest scene, David has recalled the description of Ludolph of
Saxony: 'the eye of devotion observes the little Jesus who sweetly drinks at
the breast of the glorious...what could be more pleasant or delightful to see?'
At the left a spring has opened near Mary's feet to quench their thirst since
they were refused water along the way by the inhabitants of Materca. Just as
the Virgin provides the child with her milk, so in turn Christ nourishes the
faithful with his own body and blood. This is indicated by the posture of the
baby Jesus who turns towards the viewer, as if extending an invitation. It is
shown in details directly below the child: the glimpse of the Virgin's under-
dress which is red (the colour of Christ's passion) and the broad leaf plan-
tain, popularly known for its medicinal value as a stancher of blood. The ivy
on the left is a symbol of salvation and the bough with the apples to the
right of the Virgin are a reminder of the sin and subsequent exile of Adam.
 David draws the viewer into the painting in a number of ways: for exam-
ple, the way in which the Virgin and child tower, in a pyramid-like shape,
over the viewer with whom the child establishes eye contact and through

the many symbols which anticipate the death of Jesus, interpreted as a saving activity. But, most importantly, the journey of the family becomes the individual's own journey through life. Drawn into the painting, we now accompany the refugee family—their journey becomes our journey. A painting by the so-called Master of the Female Half-Lengths provides a second example, showing how the viewer is drawn into the scene.

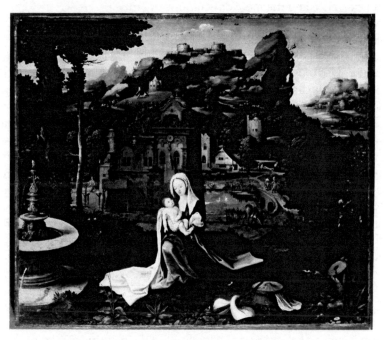

Fig. 15. The Master of the Female Half-Lengths, *The Rest on the Flight into Egypt* (c. 1515), The Metropolitan Museum of Art, New York, H.O. Havemeyer Collection; bequest of Mrs H.O. Havemeyer, 1929.

The details of this painting[70] have been inspired by *Pseudo-Matthew* and includes many of the episodes mentioned there. The subject of the flight into Egypt, which at first glance seems to be merely the pretext for the creation of a charming landscape,[71] is in fact discreetly referred to in motifs and scenes

70. The artist was inspired by a contemporary of Gerard David, Joachim Patiner, whose two surviving depictions of the themes are in the Prado, Madrid and the Gemälde-galerie, Berlin. See Ainsworth and Christiansen, *From Van Eyck to Bruegel*, p. 266.

71. The landscape in depictions of *the Flight* is never without significance. It may at first glance suggest the idealized and artificial world of Arcadia, the perfect pastoral world free from concern and danger. However, it can also suggest the Garden of Eden from which humankind experienced their first exile and banishment and act as a reminder that Christ is the new Adam restoring this lost world. In discussing the landscape in Bassano's

scattered in the foreground and background. The painting was conceived of as a type of *Andachtsbild* in which a worshipper might follow the story from scene to scene during private devotion, travelling the various paths of the landscape. The journey was understood by contemporary viewers as a meta-phor for pilgrimage, in particular the pilgrimage of every human life, con-fronting at each step along the way the choice between the easy path of a sinful existence and the more difficult one of virtue.[72]

Mary is seated on the ground, surrounded by flowering plantain, a lowly plant that symbolizes the well-worn path of the faithful who seek Christ. The fountain to the left suggests the refreshment provided by a miraculous spring of water. The broken figure suggests the idols that were toppled off their pedestals. In the foreground are a traveller's basket and saddlebags wrapped around a pilgrim's staff. The wheat field behind conveys the story of the wheat which, in *Pseudo-Matthew*, sprang up miraculously. The most promi-nent feature of the middle distance is the architectural fantasy that is sur-rounded by water and approached over a footbridge by an elegant woman in a long pink robe. No doubt the viewer is intended to journey along from image to image reflecting on the significance of each episode. The elegant lady in pink corresponds to the image of the Virgin. It has been suggested that the castle in the middle distance is common in paintings of this period and intended to address the increasingly secularized middle class.[73] The viewer is invited to contrast the lady with the Virgin—the wealthy lady entering her castle with Mary, the homeless and refugee mother.

The landscape situates the episode for the viewer: it is not the landscape of Egypt but a familiar one, situated within the viewer's own experience. The viewer enters into the painting and is urged to join in the journey—the pilgrim's staff and clothing at the forefront of the painting may suggest that we take on this journey with some urgency.

The theme of the flight into Egypt also offers the viewer an opportunity to reflect on the passion of Christ. Orazio Gentileschi's version (unlike many depictions of the scene which are characterized by a sense of serene romanti-cism),[74] captures the harsh realism suggested by the story; stripping away the

Journey of Jacob, Berdini (*The Religious Art of Jacopo Bassano*, p. 86) states that 'man and the created world are still a multitude of survivors in need of leadership and salvation'. This is reflected in *The Journey of Jacob* in the disordered and discordant landscape.

72. See Ainsworth and Christiansen, *From Van Eyck to Bruegel*, p. 266.

73. Ainsworth and Christiansen, *From Van Eyck to Bruegel*, p. 266.

74. The theme was a favourite of Gentileschi. Other versions are found in the Louvre (see Santoni, *La vie de Jésus*, p. 36) and in the Paul Getty Museum in Malibu. In the Louvre version, the donkey is omitted. Some suggest that this makes the image more uni-versally applicable to any refugee family since the inclusion of the donkey links the image unmistakably to the Holy Family.

idealism of other depictions, he leaves the viewer with 'a family exhausted in their human ordinariness from their nocturnal journey'.[75]

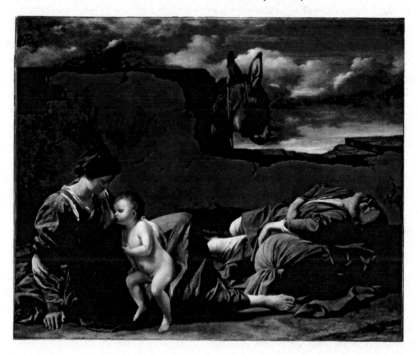

Fig. 16. Orazio Gentileschi, *Rest on the Flight into Egypt* (1628)
Birmingham Museums and Art Gallery.

He situates the episode in a setting which highlights the bleakness, isolation and poverty of the refugee family; there is no natural landscape, no source of food or water; instead a large decaying wall covers almost a third of the canvas. Their worldly possessions are contained in one small sack. The menacingly tempestuous sky is symbolic of the violent drama which is unfolding in Bethlehem and from which the family has escaped. From just above the lower part of the wall, on the left of the painting, a glimmer of light emerges, heralding a new dawn.

The painting anticipates the death of Jesus in a number of ways.[76] First, the donkey, whose head seems extraordinarily large and prominent in the

75. Wendy Beckett, *The Gaze of Love: Meditations on Art* (London: Marshall Pickering, 1998), p. 19.

76. For a description of the development of the traditions which associated the infancy of Christ with his passion and death, see Anne Derbes, *Picturing the Passion in Late Medieval Italy: Narrative Painting, Franciscan Ideologies, and the Levant* (Cambridge: Cambridge University Press, 1998), pp. 1-11.

centre of the painting,[77] reminds the viewer of the journey to Jerusalem at the beginning of Christ's passion in Mt. 21.1-11. Beckett[78] suggests that the donkey symbolizes the divine protection which appears to be absent on first viewing in Gentileschi's painting, but which is much more immediately obvious in the paintings of Giotto di Bondone and Caravaggio in the form of choirs of angelic hosts. Second, as Joseph collapses with fatigue, his motion-less body[79] is reminiscent of artistic portrayals of the body of Jesus taken from the cross, *The Deposition*, a common theme in Renaissance art. Third, the Christ child, feeding at the breast of Mary, may anticipate the giving of his body as food in the Eucharist. Gentileschi invites the viewer to enter the scene, beckoned by the gesture of Jesus' right arm and encouraged through his eye contact. The wall clearly protects the family (and the viewer who stands on the same side) from everything that happens in the world beyond it, symbolized by the tempestuous sky. From this vantage point, the viewer is invited to reflect on where safety, rest and security lie in a storm-filled world and to reflect on the passion and death of Jesus.

Thus, even a brief review of artistic representations of the flight into Egypt indicates that artists were attracted by both the literal and metaphorical aspects of the story. The stark image of the fleeing family obviously provided the artist with opportunities to depict a scene of pathos and tragedy as well as to display their skills in depicting landscape and characterization. But artists almost invariably depict exile as a potentially positive and life-giving experience. In some cases, the journey takes on the connotations of pilgrim-age, inviting the viewer to travel with the family on a journey of personal and spiritual enrichment; the dangers of the journey are seen as providing an opportunity to strengthen one's faith. For other artists, the rest on the flight was invested with the same liturgical significance as Vespers. Artistic reflec-tions on *The Flight into Egypt* encourage the viewer to consider the experience of exile, be it physical or metaphorical, and its causes and effects. Alan Mintz uses the phrase 'primal speaker' to refer to those who re-present the experi-ence of exile as something positive:

> The primal speaker first represents the catastrophe and then reconstructs, replaces, or redraws the threatened paradigm of meaning, and thereby makes creative survival possible. [80]

77. The point is discussed by Richard Harris in *A Gallery of Reflections: The Nativity of Christ* (Oxford: Lion Publishing, 1995), p. 80.

78. Beckett, *The Gaze of Love*, p. 98.

79. Note his red tunic—symbol of the passion in other paintings.

80. A. Mintz, *Hurban: Responses to Catastrophe in Hebrew Literature* (New York: Col-umbia University Press, 1984), p. 2.

Artists, too, can be included in this term because when artists take on the role of 'primal speaker', they often acknowledge the catastrophe by including an image of the massacre of the infants or of King Herod but they also replace the danger of Bethlehem with the security of Egypt and they reconstruct by including symbols that anticipate the passion and death of Jesus which they present as a source of new life. The donkey which takes the family to Egypt anticipates the entry of Jesus to Jerusalem at the beginning of his passion; the apple which Jesus holds indicates that he is the new Adam reversing the fall; the red of the garments anticipate his death; the posture of Joseph as he sleeps anticipates the deposition of Jesus from the cross. In short, artists, in their depictions of the narrative, suggest that through danger and death, there comes the possibility of hope and new life. The artist is less interested in portraying the safe return of the family to Bethlehem as a satisfactory closure to their current plight than in suggesting new interpretations of the catastrophe and in reconstructing, in Alan Mintz's words, 'a new paradigm of meaning'. The situation of exile becomes an opportunity to rebuild and reconstruct.

The Twentieth Century and Marc Chagall

The desire to give visual expression to the notion of exile and alienation in the twentieth century[81] is seen in an early work of Pablo Picasso. Picasso's *Poverty* (1903), painted during his so-called 'Blue Period' that was characterized by his preoccupation with the poor and destitute of society, anticipates the importance given to the theme throughout the rest of the twentieth century.[82] In *Poverty*, painted with palettes of blue, the frail and destitute family bear a strong resemblance to the Holy Family on the flight to Egypt.[83] The sense of despair in much of his work at this time, has been associated with the grief Picasso felt at the suicide of his friend Casegames in 1901. Mortality is communicated by the skull-like appearance of the heads of both mother and baby.

81. In the twentieth century, photography became a popular means of capturing the plight of the refugee. See Josef Koudelka, *Exiles* (London: Thames & Hudson, 1997). He is described in *The Times* as 'the most potent and powerful photographer alive today', his images 'sum up the alienation and disconnection of the twentieth century'. For a recent twentieth-century painting, see *The Flight into Egypt* by He Chi in 'Image', *Christ and Art in Asia* 76 (September 1998), p. 5. The painting symbolizes for the artist the alienation of the Chinese Christian at the end of the millennium.

82. Richard Verdi (ed.), *Art Treasures of England: The Regional Collections* (Catalogue of 1998 Exhibition; London: The Royal Academy of Arts, 1998), p. 317.

83. For other twentieth-century depictions of *The Flight into Egypt*, see Nicholas Usherwood, *The Bible in 20th Century Art* (London: Pagoda, 1987), pp. 6, 49, 99.

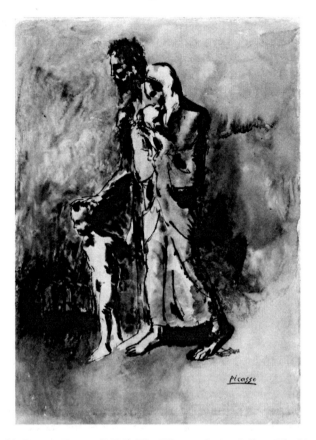

Fig. 17. Pablo Picasso, *Poverty* (1903), The Whitworth Art Gallery, The University of Manchester, © Succession Picasso / DACS 2006.

The simplicity of the image with its figures' slow death-like movements suggests that exile can be internal as well as external. As Brueggemann aptly notes, 'Exile is not primarily geographical but rather social, moral and cultural'.[84] His observation is particularly appropriate for the nineteenth century when many British and French artists, painting scenes of destitution to arouse the national social conscience, used the motif of the flight into Egypt to depict the poor or evicted rural and urban family.[85] But it is Marc Chagall in the twentieth century who identified most personally with the biblical story and who offered some of the most original and innovative visual interpretations of the passage.

84. Brueggemann, *Cadences of Home*, p. 2.
85. For example, Hubert von Herkomer, *Hard Times*, 1885 (Manchester City Art Galleries) and William-Adolphe Bouguereau, *Charity*, 1865 (Birmingham Museum and Art Galleries).

Images depicting fleeing mothers and children, alongside other biblical images, were commonly used before, during and after World War II by Jewish artists, to depict the horror and intensity of the suffering of the Jews.[86] The defencelessness of the mother and child is conveyed by the conspicuous absence of the father in many of the Holocaust works and their innocence and purity by implied Christian overtones of images such as the *Madonna and Child* and *The Flight into Egypt*, associations which Chagall exploited to the full.

Chagall used three basic symbols to depict the Jew fleeing into exile, or to depict the refugee. The first was that of the *Wandering Jew*, the second the *Jew carrying the Torah* and the third the *Mother and Child*; but frequently all three themes were combined.[87] With regard to the latter, he sometimes used the *static* Madonna and child image especially in his early career (1920s and 1930s), while from 1941 he concentrated on the *fleeing* mother and child. Chagall emphasized the similarity of this theme to the flight into Egypt, a comparison not pursued by most other Jewish artists of the time. After his flight from Europe in 1941 and while seeking a self-image as a refugee, he found in *The Flight into Egypt* an autobiographical precedent for his present state and an image that clearly suggested the fact that he had been *saved* while others had not. It is this creation of an intensely personal iconography of the refugee mother and child that really differentiates him from other contemporary Jewish artists who used the theme.[88] In a very distinctive way, Chagall stressed the Christian overtones of the theme to arouse the sympathy of his Christian audience in a more direct way than could be achieved by either of his specifically Jewish refugee types; his purpose was to call attention to the plight of the Jews in Europe by addressing Christians in their own language of images.[89] The flight into Egypt, with its long history in Christian iconography, its associations with the Christian liturgy and its cultural and sentimental links with Christmas, was an ideal image to express to Christian Europe the plight and suffering of the Jewish people.

86. For a survey of Jewish artists' depiction of Holocaust themes, see Ziva Amishai-Maisels, *Depiction and Interpretation: The Influence of the Holocaust on the Visual Arts* (Oxford: Pergamon Press, 1993). My section on Chagall follows substantially her assessment of Chagall's work.

87. For the importance of the Bible as a source of inspiration for Chagall, see his introduction in 1973 to the then newly opened Musée National Message Biblique Marc Chagall in Nice in Anon., *Marc Chagall 1887–1985* (Nice: Musée National Message Biblique Marc Chagall, 1998), p. 7.

88. Chagall was especially inspired by icons of the Madonna and he had a personal interest in the process of birth and motherhood which came to the fore especially in connection with the birth of his daughter, Ida (see Amishai-Maisels, *Depiction and Interpretation*, p. 23).

89. Amishai-Maisels, *Depiction and Interpretation*, p. 24.

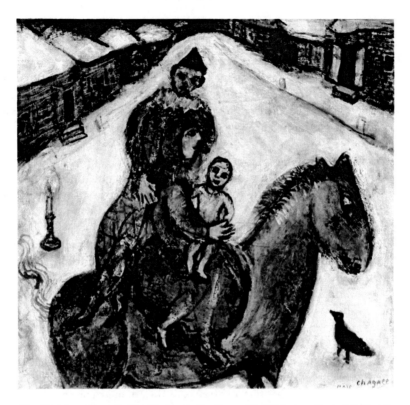

Fig. 18. Marc Chagall, *The Harlequin Family*, or *The Flight into Egypt* (1942–44)
Indianapolis Museum of Art, Gift of Mrs James W. Fesler,
© ADAGP, Paris and DACS, London 2006.

In *The Harlequin Family* (1942–44), also called *The Flight into Egypt*, the
mother and child ride out of the deserted snow-covered village on the tradi-
tional donkey with Joseph the Harlequin perched precariously behind them.
The image is similar to traditional iconography of the flight into Egypt; to
the Christian viewer, the painting is reminiscent of a Christmas card scene
with its background of snow. In *The Yellow Crucifixion* (1943),[90] the same
motif appears in the foreground where the Wandering Jew replaces the Har-
lequin in the role of Joseph. In preparation for this painting, Chagall drew a
sketch forming a rich tapestry of biblical imagery which he adapted and
applied to the situation of the Jews in Central Europe. In the original sketch,
the sacrifice of Isaac and the Massacre of the Innocents played an important
part alongside Christ, the Crucified Jew. During the war, the figure of Jesus,

90. The title may well be an ironic homage to the more tranquil and religiously conven-
tional *Yellow Christ* painted by Gauguin in 1889 (see Monica Bohm-Duchen, *Chagall*
[London: Phaidon, 1998], p. 245).

for Chagall, was predominantly a symbol of Jewish martyrdom,[91] an image which he constantly combined with his other two Holocaust motifs, the Mother and Child and the Wandering Jew. Later, Jesus came to symbolize the artist himself. The message he had originally intended to convey through these desperate images was that everyone is finally sacrificed—Abraham, Isaac, the ram and all the other innocent victims. However, in the painting itself he simplified the imagery and preferred to use the crucifixion as the most comprehensible image of a sacrifice which had taken place. To underline Jesus' Jewish identity, Chagall juxtaposed a Torah scroll to the Crucifixion and placed a phylactery on the head of Christ.[92]

The Yellow Crucifixion relates to the sinking of the ship, the Struma, in 1942. In it, both Jewish and Christian elements are strongly emphasized. Jesus wears phylacteries as well as his prayer shawl/loincloth and an open Torah scroll covers his right arm to form a single image. The scroll, in which the original sketch had depicted slaughtered children and the Sacrifice of Isaac, is now empty and is illuminated by a candle held by an angel who blows a ram's horn, the symbol of salvation. But redemption is still far away; the cross is planted in the burning shtetl from which Jews try to escape while the fleeing mother and child below connect these refugees to the theme of the flight into Egypt. But at present there is no escape: the refugees move left to join those on the sinking Struma. His personal identification with the theme can be seen in his sketch for *The Yellow Crucifixion* in which he wrote his name and that of Vitebsk on the open Torah in Hebrew. Two images in this painting refer to Christ: the Crucified Christ and the Christ child fleeing. Chagall's style, in organizing his pictures by balancing the two 'semi-autonomous episodic fragments within a shallow visual setting',[93] may imply further desperation: just as the Christ child—even though he escaped Herod—will ultimately die as an innocent victim, so too although the Jewish refugee may escape the present calamity, his or her future remains similarly threatened. Will the place of exile be significantly better than the destruction from which the refugee flees?

91. 'For me, Christ has always symbolized the true type of Jewish martyr. That is how I understood him in 1908 when I used this figure for the first time, it was under the influence of the pogroms. Then I painted and drew him in pictures about ghettos, surrounded by Jewish troubles, by Jewish mothers, running terrified with little children in their arms' (Chagall in 1977, cited in Amishai-Maisels, *Depiction and Interpretation*, pp. 184-85).

92. This description is taken from Amishai-Maisels, *Depiction and Interpretation*, p. 168.

93. The phrase is adapted from Stephanie Barron (*Exiles and Emigrés: The Flight of European Artists from Hitler* [Los Angeles: Los Angeles County Museum of Art, 1997], p. 115) where she sums up Chagall's artistic style, 'Chagall dispensed with conventional rules of spatial and narrative unity and instead organized his pictures by balancing semi-autonomous episodic fragments within a shallow visual setting'.

In *Christmas 1943*, a sketch done for *Vogue Magazine*'s Christmas issue of 1943[94]—the drawing appeared opposite an appeal to donate to various charities over Christmas—Chagall depicted a terrified woman carrying a worried child, fleeing under the direction of an angel instead of the happy Madonna and Child one might expect. The drawing reflects his preoccupation with the theme during his American years and his desire to keep the image before the Christian West, especially at Christmas.

Chagall's personal identification with the image of the flight into Egypt emerges in *Obsession* in 1943. Here the mother and child are in a wagon hitched to a blue horse as they escape from a building burning in Russia, which he symbolized by the green-domed church and the men bearing a red flag at the upper right. This image is based on two illustrations from Chagall's autobiography: visually it derives from the drawing of a cart driving away from a house; thematically, it was inspired by the story of Chagall's mother being removed on her bed from the house which burned down at the moment the artist was born. *Obsession* symbolizes the darkest days of the war and parallels the crushing of the Warsaw Ghetto revolt.[95] Here the whole world goes up in flames and a green Jesus lies helpless in the streets of the burning ghetto, mourned by the matriarch, Rachel, in the blazing sky above. Beside him, a bearded Jew holds aloft the candelabrum normally used to illuminate the cross but now one of its branches, the green one which parallels the green Christ, totters, its flames darkened, symbolizing a life that has been extinguished. On the right, Chagall sets his symbols of hope, the mother and child fleeing from the burning house but their grinning satanic mule refuses to move so that their escape is blocked and the child—Chagall himself—realizing this, covers his face with his hands. Above them the Red Army comes to the rescue but these few staggering soldiers are unarmed and they too seem consumed by the flames.

In *Obsession*, Chagall powerfully and dramatically subverts traditional Christian iconography of the flight into Egypt by means of his characteristic style of using semi-autonomous episodic fragments, drawn from biblical or Christian imagery. In traditional iconography of the flight into Egypt (for example, The Master of 1518; see Fig. 11), Joseph is usually depicted leading the donkey and protecting Mary and the child; on their journey, in many paintings of the theme, pagan idols fall from their pedestals as the Christ child approaches. Often too, the background reflects a unified composition of a peaceful and serene landscape which invites the viewer to reflect and meditate on the order and stability of the world, particularly in Vespers

94. Amishai-Maisels, *Depiction and Interpretation*, p. 24.
95. Amishai-Maisels, *Depiction and Interpretation*, p. 184.

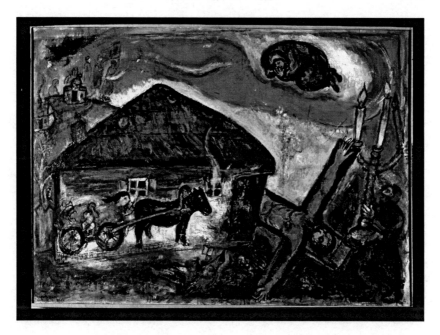

Fig. 19. Marc Chagall, *Obsession* (1943)
Private Collection, © ADAGP, Paris and DACS, London, 2006.

pictures. Frequently, the family is guided by angels and so are divinely protected. In *Obsession*, however, such imagery is deliberately subverted: the absence of Joseph is particularly noticeable, leaving the mother and child especially vulnerable. It is not the pagan gods, who tumble in front of the mule blocking its way, but the crucified Christ, the Christian symbol of the saving power of God, who falls down so helplessly—the colours of the lifeless body implying that he is well and truly dead, beyond revival and so powerless to defend. The background, far from suggesting a unified landscape of peace and calm, is literally on fire, the flames about to envelop the mother and child. Rachel, not included in Christian iconography, floats above the scene and mourns as she does in Matthew's account of the episode. By using familiar Christian symbols (and by adding the mourning Rachel) from the biblical narrative,[96] Chagall speaks to Christian viewers of the plight of the Jews in easily identifiable visual imagery. Jesus is both the martyred innocent Jew but also represents the powerlessness of the Christian God; not only is he a fallen, ineffective idol but his lifeless body even blocks the escape for the Jewish family. Chagall's implied comment is that the Christian West, like their God, is either powerless or lacks the will to save the Jews in their plight.

96. The only time that Rachel is mentioned in the New Testament is Mt. 2.18. Only in Matthew, too, is Jesus born in a *house*, which Chagall paints as being on fire.

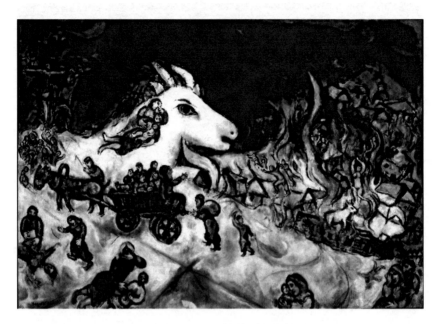

Fig. 20. Marc Chagall, *War* (1964–66)
Kunsthaus, Zurich, © ADAGP, Paris and DACS, London, 2006.

The autobiographical connection of the fleeing mother with his birth, and hence with his own fate as a refugee, also explains his Russianization[97] of the theme at this time by a sleigh instead of a cart. In the large painting *War* (1943), the mother and child flee in a sleigh from a snow-covered village alight with flames and inhabited only by a corpse. They abandon both the Wandering Jew who escapes in a different direction and the horse and wagon which seems to have been bogged down in blood.[98] The theme was repeated in a later version, *War* (1964–66) (Fig. 20). The mother and child also flee on *The Flying Sleigh* (1945), accompanied by a Russian. The sleigh is now drawn by a creature which is half horse and half rooster and thus will have no difficulty in escaping.[99]

97. For Chagall's early Russian themes see Ruth Apter-Gabriel (ed.), *Chagall: Dreams and Drama* (Jerusalem: Israel Museum, 1993), pp. 13-18.

98. The sketch for *War* (1943), now in the Musée National d'Art Moderne, Paris, depicts an even more horrific image of a desperate mother and child in flight; see Jacob Baal-Teshuva, *Marc Chagall* (Cologne: Taschen, 1998), pp. 160-61.

99. Amishai-Maisels, *Depiction and Interpretation*, p. 24.

Chagall and the Narrative of Matthew

More closely than any other artist, Chagall mirrors the detail of the Matthaean story of the flight into Egypt and, in addition, both he and the Gospel writer share a common aim—namely to address both a Jewish and Christian audience. A number of similarities may be drawn between the situation of Matthew, the first-century author of the flight into Egypt and that of Chagall, the narrative's twentieth-century artistic interpreter. First, Matthew created the story to speak to his first-century Jewish-Christian audience in a language and with symbols with which they might identify. In his narrative, he defines the future role of Jesus in terms of exodus and exile and interprets his narrative through three Old Testament fulfilment quotations; Old Testament history has been fulfilled in the person of Jesus (the Jew *par excellence*), a fulfilment centred on his return from exile in Egypt. From its Jewish roots and heritage, Matthew's community develops into a Christian church.

Chagall, too, speaks to both Jews and Christians and uses symbols from both traditions. Early in his career, fearing that using exclusively Jewish themes might be too parochial, he gradually developed his use of Christian symbols, the best example being *The Crucified Jew* which to many Jews proved controversial.[100] But Chagall especially wanted to confront and accuse Christians/Gentiles using their own language and symbolism with regard to the plight of his fellow Jews. Just as Matthew, in the flight into Egypt, used Jewish-Old Testament imagery to speak to Jews in the first century about Christ and his identity, so Chagall used Christian-New Testament imagery to speak to Christians in the twentieth century about Jews and their identity. The immediacy and poignancy of the episode in Matthew, which in the mediaeval period had lost something of its sharpness and focus due to a reliance on florid apocryphal embellishments, are aspects emphasized again and again by Chagall in the very real, life–death, situation of World War II. This was helped by the strong autobiographical factor in Chagall's paintings. More than any other artist who depicted the theme, Chagall was especially keen to include himself in his paintings and to identify personally with the subject, which he was to use as his self-image of exile. This, coupled with his personal identification with Christ, whom he saw as the perfect martyred Jew, ensured that he shared much of Matthew's own perspective.

It is Chagall's explicit self-identity as an exile and his reading of the flight into Egypt *from the point of view of an exile* which makes us return to the issue of the *situatedness* of the reader of the Matthaean account, discussed in the first section of this chapter. Matthew centred his story in Bethlehem and structured his literary account from the point of view of 'the land of Israel';

100. Baal-Teshuva, *Marc Chagall*, p. 161.

the episode is resolved and closed by Jesus returning there. But, subsequent readings in the apocryphal traditions, in paintings and in the Books of Hours emphasize the exile, the stay in Egypt and not the return. Chagall's depictions of the theme raises the question of 'centredness' again; born in Russia, working in Paris and exiled in the United States, Chagall highlights his *unsituatedness*—he is the person floating around in his paintings or the child being rushed away by a terrified mother. For, Chagall and for the Jews of Eastern Europe for whom he speaks, exile is a continuous experience because there is nowhere to return to:

> The man in the air in my paintings…is me… It used to be partially me. Now it is entirely me. I'm not fixed *any place. I have no place of my own…* I have to live *some place.*[101]

Even in the post-war years and with the establishment of the State of Israel, Chagall never depicts the return of the holy family to the land of Israel.[102]

Conclusion

The flight into Egypt which Matthew portrays as temporary and negative and in which he focused on the family's return, has, ironically, been most often interpreted as potentially a rewarding, even spiritual, experience. In the apocryphal legends, the episode provided the opportunity to emphasize the miraculous powers of Jesus so that the Gentiles of Egypt acknowledge him. In the stained glass of Chartres, the details of his sojourn in Egypt are more important than those of his return. The Holy Family is frequently depicted as resting in a lavish landscape which provides the viewer with an opportunity to reflect and meditate. In fifteenth- and sixteenth-century paintings, many characteristics of the passion and death of Jesus are subtly brought together; the flight into Egypt allows the viewer to anticipate the various elements of the Passion. Chagall emphasizes the flight and departure of the family, with no reference to their return.

Ironically, in the context of yet another exile in the latter half of the twentieth century, Marc Ellis, in his essay on reconstructing a meaning and identity for diaspora life, compares and contrasts the Jewish experience to the post-1948 displacement and subsequent diaspora of the Palestinians. His view that 'a condition of exile becomes an opportunity and its pain an affirmation'[103] echoes many interpretations of the theme of the flight into Egypt in art. Naim Ateek, Palestinian Christian and Director of *Sabeel* Ecumenical

101. Amishai-Maisels, *Depiction and Interpretation*, p. 22.
102. For Chagall's paintings and political views in the post-1948 period, see Amishai-Maisels, *Depiction and Interpretation*, pp. 324-26.
103. Ellis, A *Reflection on the Jewish Exile*, p. 5.

Liberation Theology Centre, in his Autumn 1998 newsletter, places Jesus the Palestinian refugee at the centre of his theology; the return of Jesus to 'the land' justifies the hope of return for all Palestinians in exile. There is remarkable irony in the fact that a story, originally written by Matthew to encourage and affirm the Jewish heritage of his community, could have been used in the mid-twentieth century by Chagall to accuse Christians in Europe of the persecution of his fellow Jews and, subsequently, by a Palestinian Christian in Jerusalem to accuse Jews, who have returned to the land, of making *his* fellow Palestinians into refugees and exiles.[104] Ateek's theology mirrors the details of Matthew's narrative; unlike the artistic representations discussed above which view the story from the standpoint of exile, Ateek reads the story from the same geographical centre (Jerusalem) as Matthew; and just as in the text the story is resolved in the return of Jesus to the land, Ateek also sees the plight of the Palestinian exiles resolved in their right of return:

> It is paradoxical that in Jesus' day, there were more open borders than at the end of the twentieth century. The Holy Family was able to return from Egypt to Palestine. The repatriation of refugees is a right and not a courtesy.[105]

In Ateek's theology the centre of the narrative has returned to Jerusalem, and just as Chagall used the image powerfully and effectively in twentieth-century Europe, visual images of the flight into Egypt can be seen, but now with a different emphasis, in the art galleries of East Jerusalem and Ramallah where it depicts Jesus, the Palestinian, expelled and banished from his homeland.

After some 2,000 years, the flight into Egypt continues to be appropriated in the Arts. In a recent play, *La fuite en Egypte*,[106] first performed in January 1999, the modern Parisian playwright, Bruno Bayen, dramatizes part of the life of Io from Greek mythology. Zeus fell in love with Io, the daughter of Inachus, king of Argos, and turned her into a heifer to conceal her from the jealousy of Hera. But Hera sent a gadfly to persecute Io and forced her to undergo long wanderings in the course of which she came to Egypt. Here Zeus came to her and changed her back into a woman and by touching her body with his hand begot his son Epaphus. Epaphus ruled Egypt and Africa and was eventually worshipped as a god; Io was worshipped thereafter by

104. Another 'political' interpretation is evident in a Spanish colonial folk artist's interpretation of the theme where the Holy Family is given a local guide to lead them in their exile; the implication is that the family, fleeing from the motherland, are welcomed and sustained by those living in the colonies. See Anon., *The Story of Jesus* (Pleasantville, NY: The Reader's Digest Association, Inc., 1993), p. 64.

105. Ateek, 'The Flight into Egypt', p. 2.

106. Bruno Bayen, *La fuite en Egypte* (Paris: L'Arche, 1999).

the Egyptians as Isis.[107] In the play, set in Egypt after her arrival there, Io is presented as the 'same age as the Virgin Mary at the birth of her son'.[108] She reflects with her young daughter and another character about her fate, driven as she is by the mercy of the gods, by her continual wanderings and by divine prophecies.[109] The fate of Io and that of the Virgin Mary are implicitly compared: both have sons fathered by Zeus and God and their two sons are gods also. In his introduction, Bayen notes that the story of Io and her metamorphosis has been told differently by Aeschylus, Ovid and Herodotus and the accounts of her journeys and the number of her children is never agreed upon. Furthermore, her story has been culturally assimilated and interpolated so many times by Western authors and painters that one is led to ask whether she has *a* story at all or whether her life is simply a 'geography and constellation of Mediterranean legends.'[110] There is no *one* way of looking at her life.

Perhaps the same observation applies to the narrative of the flight into Egypt. It has been depicted in so many ways by so many interpreters from different ages and backgrounds that the original significance of the story has become unimportant; but the fact that it has inspired so many artists in every age is a testimony to its power to inspire the artistic imagination in every century, offering consolation to those who have been displaced forcibly (the hunted) as well as to the exile and émigré who have left voluntarily, yet remain haunted by the memories and love of their homeland.

107. Paul Harvey, *The Oxford Companion to Classical Literature* (Oxford: Oxford University Press, 1986), pp. 222-23; Michael Grant and John Hazel, *Who's Who in Classical Mythology* (London: Routledge, 1996), pp. 186-87.

108. Bayen, *La fuite en Egypte*, p. 9.

109. Farrar (*The Life of Christ in Art*, p. 266) includes two paintings that associate the Virgin with Io (Isis). The first is *In the Shadow of Isis* by Luc Olivier Meeson from the end of the nineteenth century. The second, *Anno Domini* by Edwin Long, depicts the arrival of the family in Egypt and their encounter with the slave who offers for sale a tray of Egyptian gods, Isis, Osiris and Thoth (p. 268).

110. Bayen, *La fuite en Egypte*, p. 7.

4

THE DECEPTION OF ISAAC (GENESIS 27): MATTHIAS STOM'S *ISAAC BLESSING JACOB*

Text and Image

A glance at recent book reviews in academic journals across a range of disciplines in the Humanities confirms the surge of interest in the cultural interpretation of biblical themes in art, music, literature and film. They illustrate how some of the most exciting, engaging and creative insights into biblical narrative—especially concerning the representation of biblical characters—now come from authors and researchers based not in traditional Theology-related disciplines but in the areas of Literature, History of Art, Music and Media Studies.[1] They show how our reading and understanding of biblical stories are frequently influenced by our encounter with and response to the cultural, and in particular the visual, afterlives of the narrative. Cheryl Exum notes:

> It is not simply a matter of the Bible influencing culture; the influence takes place in both directions. What many people know or think they know about the Bible often comes more from familiar representations of biblical texts and

1. See, for instance, the autobiographical novel by Jean-Paul Kauffmann, *Wrestling with the Angel: The Mystery of Delacroix's Mural* (London: The Harvill Press, 2003), where he explores how the famous mural in the Church of Saint-Sulpice reveals new and unexpected insights into the mysterious episode from Genesis. For studies relating to visual culture, see Bal, *Reading 'Rembrandt'*; Berdini, *The Religious Art of Jacopo Bassano*); Michael Camille, 'Seductions of the Flesh: Meister Francke's Female "Man" of Sorrows', in Marc Müntz (ed.), *Frömmigkeit im Mittelalter: politisch-soziale Kontexte, visuelle Praxis, körperliche Ausdrucksformen* (Munich: Fink, 2002), pp. 243-59; Richard Cocke, *Paolo Veronese: Piety and Display in an Age of Reform* (Aldershot: Ashgate, 2001); James C. Harris, 'Art and Images in Psychiatry: *Still Life with Open Bible* and Zola's *La joie de vivre*', *Archives of General Psychiatry* 60, (2003), p. 1182; Nissan N. Perez, *Revelation: Representations of Christ in Photography* (London: Merrell Publishers, 2003); Deborah Kuller Shuger, *The Renaissance Bible: Scholarship, Sacrifice and Subjectivity* (Berkeley: University of California Press, 1994).

themes in popular culture than from the study of the ancient text itself... Not only will our knowledge of the biblical text influence the way we view, say, a painting of a biblical scene, our reading of the biblical text is also likely to be shaped by our recollection of that painting.[2]

It is virtually impossible to read or listen to a familiar biblical passage, from either the Old or New Testament, without calling to mind a visual representation of it in a church, an art gallery or a film (and of course access to a wide variety of 'biblical' paintings from all ages and places has now been made possible by the ever increasing number and quality of art websites).[3] Often, the lack of detail in a terse biblical narrative invites us to expand or enhance the story in our imagination and we look to the artist's expansion and interpretation of a theme or story to fill out and complete the details of the unsatisfactorily short narrative. The artistic afterlives of biblical characters provide opportunities to question the text and the motives of its author and encourage us to read the passage again more imaginatively and acknowledge the range of possibilities and different perspectives from which the text may be 'seen' and interpreted.

Throughout Christian tradition, to separate the biblical word from the visual image was simply unthinkable for both believer and artist. Lew Andrews[4] and David Freedberg[5] highlight the importance of internal visual representation of biblical scenes from the thirteenth century onwards as an aid to prayer and meditation. Andrews[6] draws attention to the anonymous text, *Giardino de orationi* (Garden of Prayers), written in 1454 and widely available during the fifteenth and sixteenth centuries which instructed the faithful how best to meditate upon and remember the story of the Passion. It advised them to make a memory place of their own familiar surroundings in order to visualize the successive events of the Passion to be remembered in various locations within that space:

> The better to impress the story of the Passion on your mind and to memorize each action of it more easily, it is helpful and necessary to fix the places and people in your mind: a city for example will be the city of Jerusalem—taking for this purpose a city that is well-known to you...and then too you must shape in your mind some people, well-known to you, to represent for you the people involved in the passion...[7]

2. Exum, *Plotted, Shot, and Painted*, pp. 7-8.
3. For an excellent guide to important paintings in regional UK galleries, many of which have been inspired by the Bible, see Verdi (ed.), *Art Treasures of England*.
4. Andrews, *Story and Space in Renaissance Art*.
5. Freedberg, *The Power of Images*.
6. Andrews, *Story and Space in Renaissance Art*, pp. 29-33.
7. Cited in Andrews, *Story and Space in Renaissance Art*, p. 29.

Andrews notes that this spiritual exercise was readily translated into paint (as indeed was the case in many Renaissance paintings), the best example being Memling's depiction of *The Passion* in Turin, which is, in effect, an illustration of the advice of the handbook. Creating a visual continuous narrative of Gospel events that corresponded to the lives of an illiterate faithful was of the utmost importance. The episodes within the picture acted as *aide mémoires* to the viewer's recall of Gospel events as well as having the effect of dazzling the eye:

> Their illusionistic brilliance spurs both the imagination and memory, permitting the viewer to enter the painting's fictive world, to move through the picture's space as though traversing the imaginary room or houses of the ancient treatises or the familiar environments of the devotional handbook. Viewing or looking is presumed to be an active process, a kind of devotion.[8]

Freedberg discusses how the painter was 'a professional visualizer of the holy stories' and how his pious public was practised in spiritual exercises that demanded a high level of visualization of the central episodes in the life of Jesus. He demonstrates, with illustrations from the Passion of Christ, how the imaginative intensity of such tracts was greatly increased by painters 'to arouse the empathetic responses necessary for successful meditation',[9] particularly through artists' attempts to depict the psychological and emotional traits of individual characters.

The propensity for visualizing characters is deeply embedded within the Christian, especially the Catholic, consciousness. For example, saints have always been given a central place within the tradition; their lives have been held up as models to be imitated and their strengths and weakness reflected upon for centuries in countless hagiographies. In artistic representation, the distinction between Christian saints and biblical characters is frequently blurred so that the artist becomes as interested and curious about the details of the life of Moses or Daniel as about those of Saint Sebastian or Saint Catherine. The viewer is expected to gain as much, in terms of the ethical and moral direction of his or her life, from an engagement with a painting or fresco of a biblical character as from the depiction of the lives of real 'flesh and blood' saints with whom the original viewer may have been more inclined to identify.

The visual emphasis on character, most evident perhaps in the art of the Italian Renaissance, relates easily to contemporary literary approaches to the Bible that explore the place and role of characters not only in the plot of the

8. Andrews, *Story and Space in Renaissance Art*, p. 33.
9. Freedberg, *The Power of Images*, p. 168. See also Kathleen Powers Erickson, *At Eternity's Gate: The Spiritual Vision of Vincent van Gogh* (Grand Rapids: Eerdmans, 1998), pp. 42-49, in which she illustrates the influence of the spirituality of Thomas à Kempis (*The Imitation of Christ*) on Vincent van Gogh in his early years.

canonical story but frequently too in the detail of their rich cultural after-lives expressed in apocryphal literature and in art, literature and music. Nevertheless, as Rabbi Adin Steinsalt remarks, in spite of the considerable attention given to it in contemporary scholarship, the essential concept of *character* and its importance in the Bible remains unacknowledged and the stereotypes associated with it often go unchallenged:

> The characters and heroes of the Bible are without doubt some of the best-known figures in history. Even people not well versed in the Scriptures and who do not read the Bible regularly know at least the names of some of the major personalities. We encounter them again and again directly and indirectly in art, in literature, in speech or in folklore. And yet these men and women remain among the most elusive, enigmatic and least understood of any heroes. This lack of knowledge and understanding is not necessarily a function of ignorance but stems rather from the fact that the biblical personae are so familiar, so 'famous' that they have become almost stereotyped. They have fallen victim to accepted patterns of thinking, been fitted into conventional moulds and subjected to unquestioning assumptions that have prevented any attempt at a deeper understanding. It is not uncommon for the very thing that 'everyone knows' not to receive the attention it deserves.[10]

Visual representations, on the other hand, serve to question and challenge the stereotypes and assumptions often made about characters in so many biblical commentaries. In paintings of biblical scenes, it is the artist's handling of the complexities of the key characters that makes the painting so compelling and this is certainly true, for example, of Rembrandt's *Bathsheba* or Rubens's *Delilah*, as Cheryl Exum has so well illustrated.[11] Genesis 27, with its range of contrasting characters, its many ambiguities and portrayal of the more disturbing sides of human nature, provides a further example of an Old Testament text that held a universal and irresistible appeal for artists, especially in the seventeenth century.[12]

The dramatic story of the deception of Isaac reflects the skill of the biblical author in profiling four important characters—Isaac, Rebekah, Jacob and Esau. The literary subtleties of the story have been brought out clearly by Robert Alter,[13] in particular the way in which the author succeeds in drawing the reader into the story; indeed, the careful delineation of characters has provided the inspiration for many subsequent authors and writers to elaborate on

10. Adin Steinsalt, *Biblical Images* (Northvale, NJ: Jason Aronson, 1994), p. ix. See also Stephen Prickett's exploration of biblical character in 'The Idea of Character in the Bible: Joseph the Dreamer', in O'Kane (ed.), *Borders, Boundaries and the Bible*, pp. 180-93.

11. Exum, *Plotted, Shot, and Painted*, pp. 30-43, 189-96.

12. For a survey of iconography associated with Genesis 27, see Duchet-Suchaux and Pastoureau (eds.), *The Bible and the Saints*, pp. 183-84.

13. Alter, *Genesis*, pp. 137-45.

the subject through the centuries.[14] Its popularity among artists was high-
lighted in an exhibition entitled *Isaac Blessing Jacob*, at the Barber Institute
of Fine Arts (The University of Birmingham) in 1999–2000 that centred
around one of the collection's masterpieces, Mathias Stom's *Isaac Blessing
Jacob* (c. 1633–40) (Fig. 24). In the exhibition catalogue, Richard Verdi,
Director of the Barber Institute, provides a most informative survey of how
the theme was portrayed repeatedly by artists such as Terbrugghen, Stom
and the pupils of Rembrandt and he explores the techniques used by these
artists to draw the viewer into the psychological undercurrents of the plot.[15]
Of all the paintings associated with the exhibition, however, it is the version
by Stom that is most effective in revealing the many ambiguities implicit in
the text and that compels the viewer to return to the biblical story and re-
assess some of the troubling ethical issues the narrative raises.

Genesis 27: Literary Features

Genesis 27 oscillates dangerously between the stark realities of death and life.
At the start of the chapter, Isaac is on the brink of death (v. 2) and, at the
end, Jacob's life is seriously threatened by Esau (v. 41). Rebekah reflects that
her life will 'be of no good to her' if Jacob marries a Hittite woman (v. 46).
But the theme of life is also present through the promise of the blessing
(ברכה, mentioned seven times), a blessing given by Isaac to Jacob that
'should be understood as vitality that is passed on by the one who is departing
from life to the one who is continuing in life'.[16] Life and blessing are associated
with Jacob to whom God gives the dew of heaven and the fatness of the earth
(v. 28) while death or oblivion are reserved for Isaac, Esau and Rebekah.

The author of Genesis 27 creates a plot involving four characters who
either perpetrate, or are the victims of, an intricate web of deception: the
patriarch Isaac, his wife Rebekah and their twin sons, Esau and Jacob. The
context of the story makes the deception even more poignant considering
that Rebekah is introduced to the reader in Genesis 24 in one of the most
imaginative and romantic stories in ancient literature and is a popular subject
in art, for example, Giovanni Castiglione's *Rebekah Led by the Servant of
Abraham* (Fig. 21), in which the artist depicts Rebekah turning her back,
literally, on her own people to embrace the life and people of Isaac.

14. For a survey of the influence of Genesis 27 in English literature, see David Lyle
Jeffrey (ed.), A *Dictionary of Biblical Tradition in English Literature*, pp. 385-87.
15. Richard Verdi, *Matthias Stom: Isaac Blessing Jacob* (Birmingham: The Barber Insti-
tute of Fine Arts, 1999).
16. Richard J. Clifford and Roland E. Murphy, 'Genesis', in Raymond E. Brown, Joseph
A. Fitzmyer and Roland E. Murphy (eds.), *The New Jerome Biblical Commentary* (London:
Geoffrey Chapman, 1990), pp. 8-43 (29).

Fig. 21. Giovanni Castiglione, *Rebekah Led by the Servant of Abraham* (1650)
The Barber Institute of Fine Arts, The University of Birmingham.

By the end of the chapter there is no doubt in the reader's mind but that
Rebekah is indeed a most suitable wife for Isaac:

> Then Isaac brought Rebekah into his mother Sarah's tent. He took Rebekah
> and she became his wife; and he loved her (v. 67).

When it is apparent that she is barren, he prays to the Lord for her (Gen.
25.19) and their affection for each other is highlighted in 26.8 where Isaac is
seen 'fondling his wife'. In the story of deceit in Genesis 27, however, there is
no direct or immediate contact between them. In a chapter full of dialogue,
only in the very last verse does Rebekah address her husband (v. 46)—and
only here to expresses her concern about finding a wife for Jacob. This is the
last we see or hear of Rebekah and the episode brings the reader full circle:
just as Rebekah came from Paddan-aram, so a wife must be found for Jacob
from the same place. That Rebekah's final appearance in Genesis should
involve such an act of deception contrasts sharply with the way she is first
introduced. The optimism and romanticism of Genesis 24, underscored by
the central motif of a journey and the setting off into a future of promise and
hope, are replaced by the manipulation, partiality, deceit and treachery of
Genesis 27, underscored by the setting of a deathbed scene—yet another
departure, but this time to death and eternal separation.

Whereas Rebekah is portrayed as powerful and manipulative, Isaac is por-
trayed as weak and ineffectual.[17] Alter refers to him as:

> manifestly the most passive of the patriarchs. We have already seen him as a
> bound victim for whose life a ram is substituted; later, as father, he will prefer
> the son who can go out to the field and bring him back provender, and his one
> extended scene will be lying in bed, weak and blind, while others act on him.[18]

Laurence Turner describes him as a 'pathetic figure, a duped, senile passive
character unaware of what is taking place outside his tent and confused about
what takes place within it'.[19] He draws out clearly the parallels between Isaac
as victim at the start of his life in Genesis 22 and as passive victim at the end
of his life in Genesis 27—manipulated by his father in his youth and by his
wife in his old age.

Isaac is presented as an old man about to die. The theme of old age and
famous last words are commonplace in the Hebrew Bible, Jacob (Gen. 48–
49), Moses (Deut. 33) and David (1 Kgs 1–2) providing especially good
examples. These venerable old men on their deathbeds are given famous last
words to utter that are both dignified and authoritative and earn the respect
of those around them—including the reader. The aged Isaac, on the other
hand, is feeble and devoid of any sense of authority and the fact that he does
not appear to be able to distinguish between his own sons seems at best far-
cical and at worst culpable (an aspect that may explain, as we shall see later,
Rembrandt's reluctance to paint the scene). To the reader, his blindness
seems to suggest not only a physical but also a moral disability.

Jacob is presented as a liar whose only anxiety is that his deceit might be
uncovered (v. 12). Gerhard von Rad points out that the deception by means
of a pelt on Jacob's arms and neck is rather ridiculous and is a coarse carica-
ture of his unkempt brother.[20] To exploit his father's blindness was not only
prohibited on grounds of humanity, God himself was supposed to watch over
the dealings of the blind and the deaf (Lev. 19.14; Deut. 27.18). The calcu-
lating and deceptive nature of Jacob (Gen. 25.29-34) contrasts with the
openness and spontaneity of the character of Esau (Gen. 25.30; 27.38). From
their youth, Isaac favoured Esau while Rebekah favoured Jacob (Gen. 25.27-
28). The reader is thus presented with a dysfunctional family, full of division
and partiality, a family that by the end of Genesis 27 is torn apart. Isaac has
been made a fool of by his wife and son while Esau has been cruelly deceived

17. For a discussion of the characters of Isaac and Jacob and their interrelationship, see
R.W.L. Moberly, *Genesis 12–50* (Old Testament Guides; Sheffield: JSOT Press, 1992),
pp. 26-33.

18. Alter, *The Art of Biblical Narrative*, p. 53.

19. Laurence Turner, *Genesis* (Sheffield: Sheffield Academic Press, 2000), p. 117.

20. Gerhard von Rad, *Genesis* (Philadelphia: Westminster Press, 1972), p. 227.

by his mother and brother and let down by his father; Esau wants to kill his brother Jacob who is forced to flee and Rebekah is not given any opportunity to re-appear in Genesis to restore her reputation or to justify her actions.

In Genesis 27, the interaction between the four characters is presented in dialogue form—and always between only *two* of the four characters. The reader alone is privy to all the dialogue and, thanks to the author's effective use of dramatic irony, therefore knows more than any of the characters. There is a series of seven interlocking dialogue scenes: Isaac–Esau (vv. 1-4), Rebekah–Jacob (vv. 5-17), Jacob–Isaac (vv. 18-29), Isaac–Esau (vv. 30-39), Rebekah–Jacob (vv. 42-46), Rebekah–Isaac (v. 46) and Isaac–Jacob (28.1-4).[21] As Alter points out, it is hardly a coincidence that there are seven scenes and the key word blessing (ברכה) is repeated seven times. The first two scenes set out the opposing pairs: the father and his favourite son, then the mother and her favourite son. Husband and wife are kept apart until the very last verse of the chapter and there is no dialogue at all between the two brothers (sundered by the plot of the narrative) or between Rebekah and Esau.

The narrative is brilliantly constructed not only in the psychological portrayals of its characters but equally in its deliberate silences and the many unanswered questions it raises for the reader: how can Isaac, as part of the patriarchal trio, Abraham, Isaac and Jacob, be regarded by posterity with the same respect as Abraham and Jacob when he is presented here in such a weak and ineffectual manner? How can Esau, as the first-born, be treated so unfairly? Is Rebekah, the only female in the narrative, presented in a negative way simply to ensure the continuation of the biblical stereotype of the woman as seductress and deceiver?[22] But most of all, how can God act through such deceit to bring about his plans? Does such a worthy end as delivering the promise and blessing to Jacob justify the deceitful means by which it is brought about? How can God manipulate human relationships in such a cynical manner to achieve his ends?[23] How can he leave a family in such ruins to bring about his plan? Roland E. Murphy points out that Augustine's famous dictum that the transference of the blessing to Jacob was 'not a lie but a mystery' does little justice to the pathos of the story: Jacob *is* a liar but he is also the bearer of the promise and the blessing.[24]

A person who remains silent or who is required to keep a confidence when an act of deceit is practised on another is automatically implicated in the crime. In Genesis 27, the narrator insinuates the reader, an innocent

21. Alter, *Genesis*, p. 137.

22. See, for example, Dorothée Sölle, Joe H. Kirchberger, Herbert Haag (eds.), *Great Women of the Bible in Art and Literature* (Grand Rapids: Eerdmans, 1994), pp. 58-73.

23. God is largely absent from the story except to approve Jacob's success in the deceit (v. 20) and to give Jacob 'the fatness of the land' as a blessing in v. 28.

24. Clifford and Murphy, 'Genesis', p. 29.

bystander, into the narrative by inviting him or her to identify with the characters of the plot. The character with whom the reader identifies most closely will depend on the experience that she or he brings to the narrative: for example, the reader may identify with one of the characters on grounds of age, gender, family role or personality type, whether the reader has experienced deception or exclusion by family or friends or indeed whether she or he has practised deceit on the grounds that the end gain is regarded as essential and so the deception is morally justified.

The appeal of the narrative lies in its ability to bring out universal traits of human nature with which everyone can identify. One of the ways in which the narrator draws the reader into the story is by creating a plot that is centred around the five senses. This ensures that the story has an immediate and universal appeal and that the reader is brought close to the characters in a very tangible way—she or he can almost see, hear, touch, feel and smell them. Isaac cannot see (v. 1) and so he must rely on his other senses of taste (vv. 4, 25), touch (vv. 21, 22, 26, 27) and smell (v. 27), but yet ignores the evidence from what he hears (v. 22). Rebekah's success, on the other hand, comes from her sense of hearing: she listens in to Isaac's conversation with Esau (vv. 5-6) and she urges Jacob to listen to her advice and plans (vv. 8, 13, 43). The reader, of course, listens in to all seven dialogues in Genesis 27. As well as an appeal to the senses, the emotions of the characters are brought into play. Jacob expresses fear that he may be caught (vv. 11-12), Isaac trembles violently when Esau returns (v. 33), Esau cries out and weeps (vv. 34, 38), he is furious with rage (v. 45) and hates his brother (v. 41). While the appeal to the senses makes the characters credible and the scene almost tangible, the detailed reporting of such emotional anguish demands our spontaneous reaction and judgment on the scene — the emotions experienced by the characters are transmitted to the reader. Such drama, passion and pathos, as we shall see, translated easily from literature into painting.

Christian tradition, however, has consistently interpreted the chapter in ways that stereotype the characters and has removed much of the immediacy and pathos we should experience as we read it.[25] God's partial, one-sided view expressed in Rom. 9.13 ('I have loved Jacob but hated Esau') lays out clearly Paul's interpretation and explanation for the deceit that has influenced much subsequent tradition. Rebekah is the one through whom God chose to fulfil the promise (Rom. 9.10) and from earliest times commentators sanctioned and defended her conduct. Rabanus Maurus sees Rebekah as the 'sancta Ecclesia'—in directing Isaac's blessing to Jacob, she is a figure of the Holy Spirit guiding God the Father. John Chrysostom argued that her

25. For a summary of the way Rebekah has been viewed in tradition, see Russell A. Peck, 'Rebekah', in Jeffrey (ed.), *A Dictionary of Biblical Tradition in English Literature*, pp. 656-57.

act in Genesis 27 was praiseworthy because she did it in response to God's wishes expressed in Gen. 25.23, 'the elder shall serve the younger'. For Ambrose, the mystery overweighed 'the tie of affection' in the mind of the pious mother. In consecrating Jacob to be the first-born, she was making a sacrifice that she knew would separate him from herself.

John Cassian classifies her deception of Isaac with Hushai's deception of Absalom (2 Sam. 17), saying that Jacob 'received gains of blessing and righteousness because he was not afraid to acquiesce in his mother's instigation since the saints have sometimes with a righteous purpose used dissimulation as an allowable remedy for deadly disease'—Cassian implies that the disease in Isaac's case was his shortsighted preference for a hunter's food. [26] Augustine (followed by Aquinas) argues strongly that the deception was not a lie; rather, Jacob's assertion that he was really Esau was spoken 'in a mystical (or figurative) sense'. He made use of this 'figurative' form of speech (his statement that he was Esau and not Jacob) because he was moved 'by the spirit of prophecy' to do so. From the Middle Ages onwards, the rivalry between Jacob and Esau came to symbolize that between Christians and Jews. This was the interpretation given to it by both Luther and Calvin, the latter regarding the biblical story as a classic example of the doctrine of predestination, citing Gen. 25.23 in support of his interpretation. Rather than being seen as a wife who deceives her husband, she was regarded as an agent of the Lord, whose deception 'flowed from no other source but her faith'. Calvin observed that 'the inheritance promised by God was firmly fixed in her mind. She knew that it was decreed to her son Jacob.'[27]

Artistic Representations of Genesis 27

The theme of *Isaac Blessing Jacob* appears occasionally in early Christian, Byzantine and mediaeval art but it comes into prominence only in the Renaissance and seventeenth century, the most famous Renaissance treatments of the subject being Lorenzo Ghiberti's relief on the doors of the Baptistery in Florence (c. 1439) and Raphael's fresco in the Loggia of the Vatican (1518–19).[28] From earliest times, Rebekah is included in the scene of the blessing although, strictly speaking, she is absent from this specific episode in the biblical narrative (Gen. 27.18-24). In a late-sixteenth-century representation of Genesis 27, the drawing by Ercole Setti (Fig. 22), the determined Rebekah is given the pose of a prophetess offering her favourite son who appears somewhat reluctant to play his part.

26. Peck, 'Rebekah', p. 656.
27. Cited by Verdi, *Matthias Stom*, p. 23.
28. Verdi, *Matthias Stom*, p. 20.

Fig. 22. Ercole Setti, *Isaac Blessing Jacob* (1570), Ashmolean Museum, Oxford.

This is one of the most elaborate of all treatments of the theme, inspired by Raphael's famous fresco of the subject, and depicts Isaac blessing Jacob on the extreme right. Aided by Rebekah, Jacob hands his father the meal and receives the blessing. In the background, Esau descends a flight of stairs bearing the carcass of a deer and is greeted by a male servant while two other figures converse at the top of the stairs. The scene is completed by various domestic motifs, including a female servant working in another room, a sleeping dog under an arch and a table laid out with an elaborate meal. The drawing presents a visual narrative of the whole chapter divided into its different episodes and, like most sixteenth-century paintings, depicts Rebekah in a benevolent light. The viewer is invited to engage with *all* the episodes of Genesis 27 presented as a continuous narrative and not simply with the single moment of Isaac's deception. The downside, of course, is that we are removed from the emotional intensity of any of the individual scenes because we do not see any character in close-up.

The manner in which artists interpreted and depicted the story changed radically, however, in the seventeenth century. Not only did they tend to concentrate on the very specific episode of the blessing (v. 27) but, more often than artists of any other age, they were much more inclined to interpret the story generally on purely human terms, as one of sibling rivalry, guile and deception.[29] Verdi offers three reasons for this: the greater availability of

29. Similarly in popular tradition, her name becomes synonymous with 'rebekke', a strident pear-shaped stringed instrument, see Peck, 'Rebekah', p. 657.

a large number of illustrated Bibles from previous centuries provided artists with a wealth of new subjects that invited translation into painting. Second, there was an awakening of interest in themes from the Old Testament generally and particularly in stories from the Pentateuch where the victory of the Israelites over the Egyptians was often compared with the struggles of the Dutch against their Spanish oppressors. But the most important reason for the subject's popularity in the seventeenth century was Rembrandt's fascination with it and, although he himself devoted only a handful of drawings to the topic, it is highly likely that he instilled an interest in it in a great number of his pupils because of its psychological complexity and striking emotional contrasts. We know that by the mid-seventeenth century the followers of Rembrandt had produced more that two dozen paintings and drawings of it (almost half of the depictions of the subject known from this period).[30]

Seventeenth-century artists devised a radically new way of portraying the theme from their predecessors and adopted a more immediate and concentrated approach from, say, that of Setti. Gone now is the traditional full-length, long-distance view of the action with its elaborate setting, anonymous onlookers and domestic detail. Instead, all three characters (Rebekah, Isaac and Jacob) are shown at close range filling the picture field and in direct proximity to the viewer. The space is usually shallow and barely defined; still-life elements (for example, the meal) are reduced to a minimum and the episode of Esau returning from the hunt is usually eliminated. All this serves to focus the attention of the viewer on the psychological undercurrents of the action but particularly on the character of Rebekah who, for many artists of the period, now becomes a more coercive and conspiratorial figure, one who is clearly psychologically implicated in the action and not a mere bystander as in earlier sixteenth-century portrayals.[31]

Rembrandt, however, while fascinated by the drama of the subject, had reservations about the message it seemed to present. In his drawing, *Isaac Blessing Jacob* (Fig. 23),[32] he depicts the moment of blessing itself but excludes the episode of the presentation of the meal, the touching of Jacob's hands and the connivance of Rebekah.

30. Verdi, *Matthias Stom*, p. 23.

31. Although Caravaggio never depicted the scene, 'the prototype for any number of Rebekahs which abound in seventeenth-century art would appear to be the wise and wizened crones found in such paintings as *Judith and Holofernes* (Galleria Nazionale dell'Arte Antica, Rome) or *Salome with the Head of John the Baptist* (National Gallery, London)'; see Verdi, *Matthias Stom*, p. 25.

32. One of only two drawings of *Isaac Blessing Jacob* unanimously given to Rembrandt.

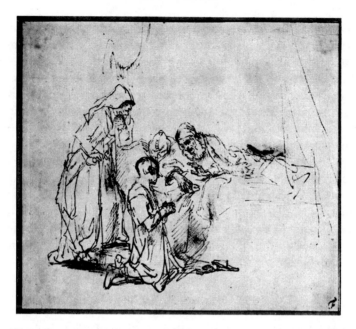

Fig. 23. Rembrandt van Rijn, *Isaac Blessing Jacob* (1652), Devonshire Collection, Chatsworth. Reproduced by permission of the Duke of Devonshire and the Chatsworth Settlement Trustees. Photograph: Photographic Survey, Courtauld Institute of Art.

Jacob kneels by his father's bedside, his hands clasped in prayer, and his head bowed down. Isaac turns and blesses his son Isaac in a reverential manner and behind them stands Rebekah, her eyes rooted to the spot as she silently anticipates the success of the scheme. In contrast to nearly every other artist of the age, Verdi notes, Rembrandt avoids portraying any of the protagonists in an emotionally or physically ambivalent state: Isaac is not at all doubtful, Jacob is not in the least fearful nor is Rebekah manipulative. Instead he presents three figures that embody benevolence, humility and guile, penetrating to the human essence of the scene.[33] Rembrandt evokes the sacredness of the scene by drawing the attention of the viewer to the blessing from God that Isaac bestows on Jacob while the guile of Rebekah, though present, is subtly kept in the background.

Surprisingly, though, Rembrandt never actually painted the episode and when depicting a patriarchal blessing from the Old Testament, he chose instead the subject of Jacob blessing the sons of Joseph (Genesis 48).[34] The reason for this choice, Verdi argues, is that Rembrandt preferred to present

33. Verdi, *Matthias Stom*, p. 60.
34. This well-known masterpiece is now is in the Gemäldegalerie Alte Meister, Staatliche Museen, Kassel.

the character of the idealized Old Testament patriarch in a positive and reverential way; in Genesis 27, the aged father Isaac is deceived as a result of his blindness and infirmity, but in the story of Jacob blessing the sons of Joseph in Genesis 48 the venerable patriarch Jacob is gifted with superior knowledge and intuition when he chooses to bless Ephraim rather than his brother Manasseh. While the underlying theme of the first subject is the frailty and vulnerability of old age, in the story of Jacob blessing Joseph's sons, the patriarch's wisdom and spiritual insight are revealed.

However, other painters of the period were much less concerned to protect the character of Isaac and less reticent to portray the deceitful nature of Rebekah. Of all the painted versions of this subject, Verdi argues that Stom's *Isaac Blessing Jacob* is 'the most emotionally charged and compelling'.[35] In addition, it remains the only canvas of this subject in which the viewer is directly insinuated into the action through the admonishing figure (and finger) of Rebekah.

Matthias Stom, Isaac Blessing Jacob (c. 1633–40)

Very little is known about Matthias Stom, an almost invisible figure in the annals of the history of art, except that he was a prolific seventeenth-century Dutch artist who worked mostly in Italy and that of his nearly 200 paintings that survive, three-quarters depict biblical subjects.[36] Virtually all his paintings are characterized by two very distinct features: the first is his technique of posing all his figures close to the picture plane and providing them with little (if any) setting, a device that intensifies the boldness and immediacy of his art, and the second is his tendency to align his figures parallel to the confines of the frame in rigidly constrained poses. His style also shows the clear influence of Caravaggio in its dramatic play of light and shade and in the use of warm colours and lack of domestic detail—all these characteristics have the effect of increasing the tension of his compositions and further enhance their dramatic impact. Stom also likes to group his figures together in close intimate settings while at the same time endowing each of his characters with a sense of great individuality and distinctiveness.

In *Isaac Blessing Jacob* (Fig. 24), which purports to depict very specifically the moment of deception (Gen. 27.21-23), the arrangement of the characters is such that the viewer, standing in front of the painting, is effectively drawn into the event and the emotional intensity of the scene.

35. Verdi, *Matthias Stom*, p. 60.
36. Verdi, *Matthias Stom*, pp. 121-22.

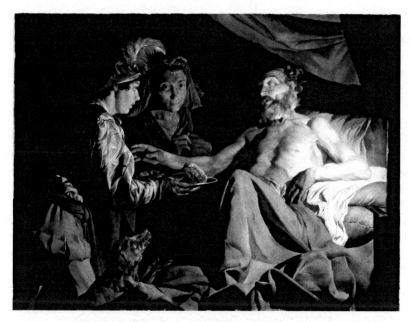

Fig. 24. Matthias Stom, *Isaac Blessing Jacob* (c. 1633–40)
The Barber Institute of Fine Arts, The University of Birmingham.

The setting consists of a bed upon which the aged Isaac reclines surrounded by Jacob and Rebekah; it is illuminated from the right by a shaft of light which floods the scene, poignantly emphasizing the blind old man who seems oblivious to it. Disconcerted with Jacob's voice, Isaac has beckoned to him to come closer so that he might feel his hands and assure himself that they are those of Esau. His suspicions allayed, the frail Isaac prepares to bestow the blessing. Rebekah raises her finger warning the viewer not to divulge the deceit:

> Emerging from the shadows between the ignorant Isaac and the fearful Jacob, her scheming countenance appears to hold the entire proceedings in its sway and constitutes the emotional centre of the picture.[37]

Jacob's fear is portrayed through his anxious expression and divided pose for although his hands move forward with the meal his feet appear rooted to the ground; this ambivalent attitude summarizes his eagerness to receive the blessing, yet his fear of detection. Even the leaping dog may be interpreted as part of the conspiracy—it may be intended as impersonating one of Esau's hunting dogs, thereby clinching the deception. Isaac is presented as a gaunt and wasted figure who gropes poignantly into space seeking to establish contact with his son. His semi-nakedness adds to his vulnerability and contrasts

37. Verdi, *Matthias Stom*, p. 25.

with the costumes of Rebekah and Jacob: Rebekah wears an elaborate head-
dress decorated with pearls while the overdressed Jacob sports a red waistcoat
and silver doublet tied with blue ribbons, slashed red breeches and a magnifi-
cently plumed hat. Verdi points out that although this provides a pictorial
flourish, it also imparts an ironic meaning: although Rebekah is dressed like
an Old Testament prophetess, 'she is behaving like a guileful old woman
whose capacity for inflicting retribution on the viewer seems unbounded'.[38]
Through his attire, Jacob openly declares to the viewer (but not to his father)
that he has donned a disguise[39] since Genesis describes him as 'a plain man
living in tents' (25.27). The semi-nude Isaac, in contrast, is presented with-
out any suitable bedding and is given only a plain black background. This,
combined with the omission of the meal and the lack of any other domestic
detail, serves to remove the story from its Old Testament context and ele-
vates it to a more timeless and symbolic realm.

Stom, like the biblical author, implicates the viewer in the deception.
The depiction of the three biblical figures in a semi-circle suggests a certain
incompleteness—only when the viewer closes the circle is the act of decep-
tion accomplished. The viewer stands in close proximity to the three figures
and directly opposite Rebekah who stares back and raises her finger, urging
us not to alert Isaac to the crime being perpetrated. The curtain pulled aside
suggests the darkness and secrecy of the deed to which only the viewer is
privy—one feels that were the curtain to fall behind the viewer, he or she
would become even more complicit in the secrecy of the crime. As in the bib-
lical narrative, the senses are highlighted: in particular, the sense of sight—
Rebekah holds the viewer in a fixed stare while Jacob's eager but fearful eyes
are contrasted with Isaac's lack of sight. The emphasis on the sense of touch
is almost tangible: Jacob's hands covered with goatskin are within reach of
the viewer but it is the movement of Isaac's arm as he reaches over to touch
Jacob that particularly catches the eye. Isaac's arm, stretching across the
centre of the painting and just below Rebekah's finger of deception, unites
the figures of Isaac and Jacob. This has the effect of focussing the viewer's
attention on the two characters—father and son, old age and youth, one
blind and one with vivid sight, one partially naked and one fully and magni-
ficently clothed. Even though the faces of Rebekah and her favourite son are
in very close proximity, suggesting a commonality of purpose, the stretched
arm of Jacob creates a more formal unity for the viewer to contemplate. In
several other paintings, one frequently finds that the hand or arm acts as an
arrow directing the viewer's attention to the most important feature or

38. Verdi, *Matthias Stom*, p. 25.
39. The viewer becomes involved in the painting in that he or she is the only char-
acter who can actually see—and be impressed by—the fine colours of the clothes of
Rebekah and Jacob, since the blindness of Isaac prevents him from doing so.

theme of the painting. In this case, the eye follows Isaac's arm and rests on the character of Jacob. The viewer listens to the words that Isaac speaks concerning him:

> May God grant you
> from the dew of the heavens and the fat of the earth.
> May peoples serve you,
> and nations bow before you.
> Be overlord to your brothers,
> may your mother's sons bow before you.
> Those who curse you be cursed,
> and those who bless you, blessed (vv. 28-29).[40]

Seen within this perspective, the theme moves from one of human deception to contemplation of a wider divine plan. Jacob is no longer seen as the deceiver of his aged, frail father but as the inheritor of the promise, the leader now entrusted to take over from him. His magnificent clothes now remind the viewer of a prince, a nobleman in whom divine authority is invested.

The figure of Jacob as one invested with divine authority is further highlighted if we consider the two paintings that were originally intended to accompany this one. *Isaac Blessing Jacob* was one of three paintings commissioned by an unknown patron, probably in Naples in the 1630s, and together with *Tobias Healing his Father's Blindness* (Fig. 25), executed by an unidentified Italian artist who was a collaborator of Stom's, it was intended to flank a centrepiece *Christ Disputing with the Doctors* (Fig. 26). All three paintings originally formed a devotional narrative triptych. *Isaac Blessing Jacob* and *Tobias Healing his Father's Blindness* each contain three figures and *Christ Disputing with the Doctors*, seven. The composition of the first two canvases is comparable, both in the broad disposition of the figures—with the fathers at the right and youths at the left—and in the motif of the leaping dog. The theme of the triptych, according to Verdi, is the confrontation between old age and youth, illustrated by three examples taken from the Old and New Testaments and the Apocrypha: it concerns the dependence of old age upon youth, either for perpetuation (Jacob), instruction (Christ) or healing (Tobias)[41] and the passing of authority and power from old age to youth.

The contrast between *Isaac Blessing Jacob* and *Tobias Healing his Father's Blindness* is striking. The figure of Tobit to the left of the picture resembles that of Isaac, Tobias resembles the figure of Jacob and the angel Raphael initiating and guiding the process of healing replaces the figure of Rebekah and her plot to deceive. The leaping dog in *Isaac Blessing Jacob* serves to link

40. The translation is Alter's (*Genesis*, p. 140).

41. The theme may have had some private significance for the patron; see Verdi, *Matthias Stom*, p. 37.

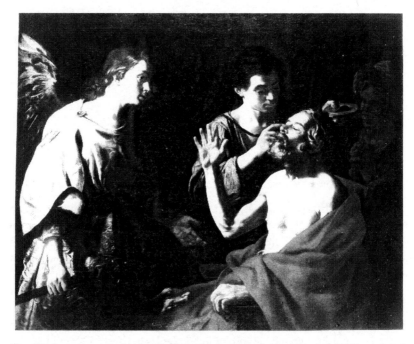

Fig. 25. Anonymous Italian, *Tobias Healing his Father's Blindness* (mid-17th century)
Private Collection.

the story with that of Tobias (Tob. 6.2). Rather than taking advantage of an
old man's blindness as Jacob does, Tobias displays his compassion in seeking
to restore his father's sight:

> Then Tobit got up and came stumbling out through the courtyard door.
> Tobias went up to him, with the gall of the fish in his hand, and holding him
> firmly, he blew into his eyes, saying, 'Take courage, father'. With this he
> applied the medicine on his eyes, and it made them smart. Next, with both
> his hands he peeled off the white films from the corners of his eyes. Then
> Tobit saw his son and threw his arms around him, and he wept and said to
> him, 'I see you, my son, the light of my eyes!' Then he said, 'Blessed be God,
> and blessed be his great name, and blessed be all his holy angels. May his holy
> name be blessed throughout all the ages. Though he afflicted me, he has had
> mercy upon me. Now I see my son Tobias!' So Tobit went in rejoicing and
> praising God at the top of his voice (Tob. 11.10-15).

The hand of Tobit is held up in recognition and gratitude as the scales fall
from his eyes while Isaac's hand flounders in darkness, ignorance and con-
fusion. The two paintings, on either side of the centrepiece, offer contrasting
aspects of the relationship between a father and son and the obvious com-
parison between Tobias and Jacob serves to make Jacob's crime appear even
more heinous.

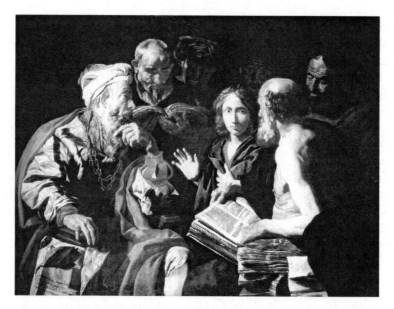

Fig. 26. Matthias Stom, *Christ Disputing with the Doctors* (c. 1630–40)
The Detroit Institute of Arts, Collection of Mr A. Alfred Taubman.

In the centrepiece of the triptych, *Christ Disputing with the Doctors*, Stom depicts how the aged Jewish scribes are astonished by the young Christ's understanding and answers (Lk. 2.42-52). A close and heated debate is suggested by the compact grouping of all the elders around Christ, three of whom hold massive tomes, symbols of the old law which has now been surpassed by the new dispensation. At the centre of the picture, Christ's authoritative raised right hand is highly visible and contrasts with the devious right hand of Jacob, cleverly concealed by the clothing of Esau. The aged doctor of the law to the right who disputes with Christ is the mirror image of the blind Isaac while the young Christ takes the place of Jacob. As in *Isaac Blessing Jacob*, the light emanating from the right that falls on the old man and on the young Christ heightens the emotional intensity of the scene. The many similarities between the two paintings permit us to interpret one in the light of the other and highlight how the old scribe, surrounded by (and in spite of) the large volumes of the law remains as blind figuratively as Isaac is blind physically. In *Christ Disputing with the Doctors*, there are other implicit links that connect it with *Isaac Blessing Jacob*. Lk. 2.48-49 describes the ambiguity surrounding the relationship between Christ and his father: in v. 48, Mary says: 'your father and I have been looking for you with great anxiety', to which Christ replies in v. 49: 'I must be about my father's business'. Christ's ambivalent relationship with his earthly father, Joseph, mirrors Jacob's attitude towards his father Isaac and helps justify Jacob's blatant disrespect. Two

of the books held up by the doctors of the law are positioned intriguingly by Stom directly in front of the viewer—only the viewer can see them fully.[42] Why is this? Could it be that, for Stom, these books represent the Old Testament and that the pages lie open at Genesis 27, indicating that the subject of the heated dispute is, in fact, how the troublesome story of Jacob's deceit of his father should be interpreted? If this is the case, then Stom is suggesting that the viewer, too, must reflect on the dilemma that Genesis 27 presents—and that is so graphically depicted in the painting that hangs alongside.

In *Isaac Blessing Jacob*, the flaws in Jacob's character are set out clearly and unambiguously but it would also seem that his character is partially rehabilitated when we view this painting alongside the two others that make up the triptych. The young Jacob is seen alongside the young Tobias and the young Christ and just as the plans and designs of God are kept hidden from the aged Tobit and the aged doctors of the law, so too his plans are concealed from Isaac. God's affirmation of the young Tobias and the young Christ reminds us of his choice of Jacob, reflected in his elegant clothing that bestows on him the presence and aura of a prince, someone who is worthy of the authority and trust that God invests in him.

Conclusion

First impressions of Stom's *Isaac Blessing Jacob* might suggest that the artist is interested in portraying only the human psychological drama of the biblical narrative of Genesis 27, by appealing chiefly to the senses and emotions; but the painting also allows us to move from character to character evaluating their role not only in this scene but also in the roles that history has given them. It allows us to explore the interrelationship between the characters: Rebekah's relationship with her favourite son, Isaac's relationship with his successor Jacob, and the final stages of the relationship between Isaac and Rebekah that had begun so romantically but ends so deceptively. While Jacob's characters may be partially rehabilitated by a comparison with Tobias and Christ in the other two paintings, this is certainly not the case for Rebekah. She is portrayed as an instigator of deceit and, with her finger directed towards the viewer, she attempts to implicate us too in her crime—her deceitful role is brought into sharper focus when we contrast her with the role given in the second picture, to Raphael with whom there is a direct correlation in the grouping of the figures and especially with the young Christ in the third. Just as she holds centre stage and gazes directly at the viewer, so too in *Christ Disputing with the Doctors* Christ stands at the centre

42. Van Gogh employs a similar technique in his *Still Life with Open Bible*.

and also looks towards the viewer with his hand raised like Rebekah—but not to implicate us in deceit but to explain authoritatively the ways of God. Unlike Jacob, there is no attempt in this triptych to rehabilitate the reputation of Rebekah.

On the surface, there is nothing positive or wholesome in this painting; bedridden old age and a scheming mother and son. But the painting does raise several searching questions: where and how in this peculiar set of relationships is God present? How God can act through deceitful ways? How does God act in the complicated web of human relationships that make up life? The lack of any background objects and the focus on light and darkness suggest that such questions relate not only to this painting but are applicable to all times and places. The Bible speaks with many voices and unsatisfactory or inexplicable episodes have not been censored or excluded. It lets us see all sides to life—the uncomfortable and darker sides of human nature as well as the more exalted and heroic. Biblical literature, like painting, exposes us to the raw reality of life and encourages us to deal with it in all its complexity. However, the placing of this particularly troubling episode from Genesis 27 within a triptych that features scenes from apocryphal and New Testament literature tones down the negative implications of Genesis 27 by counterbalancing the character of Jacob against two positive images—that of Tobias and Christ. The intention, perhaps, is to encourage the viewer to balance negative aspects of human nature alongside more positive ones and to justify, especially where God is concerned, why the end really does justify the means.

5

IMAGING THE 'MAN OF SORROWS': ISAIAH 53 AND ITS VISUAL AFTERLIVES

Spurned and withdrawing from human society,
he was a man who suffered;
pain was his close acquaintance.
Like one who must hide his face from us
he was despised;
we held him of no account.[1]

Isa. 53.3

Visualizing the Servant in Isaiah 53

Isaiah 53,[2] the poem celebrating a mysterious and unknown servant from the Hebrew Bible who suffers on behalf of the sins of others, has been the subject of much scholarly debate over many decades, debate that has focused on questions relating to his identity, the reasons for and nature of his suffering and whether his eventual martyrdom is envisaged.[3] The fact that the male servant became associated with Christ from earliest New Testament times accounts for the enormous attention given to Isaiah 53 (to the neglect, many would argue, of the female servant who appears at the start of the following chapter)[4] and has assured him iconic status not only literally, in his depiction

1. The translation is by David J.A. Clines, *I, He, We and They: A Literary Approach to Isaiah 53* (JSOTSup, 1; Department of Biblical Studies, University of Sheffield, 1976), p. 12.
2. The term Isaiah 53 is a convenient, though loose, heading for the poem Isaiah 52.13–53.12.
3. For a summary of traditional views on the servant in Isaiah, see R.N. Whybray, *Second Isaiah* (Old Testament Guides; Sheffield: JSOT Press, 1983).
4. See John F.A. Sawyer, 'Daughter of Zion and Servant of the Lord in Isaiah: A Comparison', *JSOT* 44 (1989), pp. 89-107; Marjo Korpel, 'The Female Servant of the Lord in Isaiah 54', in Bob Becking (ed.), *On Reading Prophetic Texts: Gender-Specific and*

on scores of early Byzantine icons, but also through the later incarnations of his chiselled, Herculean, naked and frequently erotic body of the Italian Renaissance. That he was a *man* would clearly appear to be as significant in his visual afterlives as the *sorrows* the servant experienced.[5] In this chapter, I want to explore some of these visual afterlives and show how they enrich our understanding of the poem's literary dynamic, even though the servant-figure from the Hebrew Bible is most often mediated through Christian perspectives. I would argue that in several instances we can suspend traditional iconographical readings of the Man of Sorrows as Christ in order to let the visual image interact directly with the Hebrew poem itself and so facilitate more creative and unexpected readings.[6] Frustratingly, art historians invariably inform us that the image of the Man of Sorrows 'relies on' or 'refers to' Isaiah 53 but never quite explain how the underlying concerns of the poem surface in the painting; thus the need to let the literary qualities of the poem interact more creatively with, and account for, some of the quite striking aspects of the visual image.

Related Studies in Memory of Fokkelien van Dijk-Hemmes (Leiden: Brill, 1996), pp. 153-67; Peter Quinn-Miscall, *Reading Isaiah: Poetry and Vision* (Louisville: Westminster John Knox Press, 2001), pp. 200-203.

5. Phyllis Trible (*Texts of Terror: Literary-Feminist Readings of Biblical Narratives* [London: SCM Press, 1992,], p. 2), interprets women's stories (Hagar, Tamar, the Daughter of Jephthah) through Isaiah 53: 'Women, not men, are suffering servants and Christ figures'. Shuger (*The Renaissance Bible*, pp. 115-16) discusses how images of the tortured and agonized Christ illustrate 'a peculiarly Renaissance nightmare of emasculation, the loss of power, autonomy, strength and status'.

6. Bal (*Reading 'Rembrandt'*, pp. 207-209) argues that the dogmatic views of theological or iconographical traditions can blind us to other possible readings, including readings that are acceptable within the context of theology; simply reading images iconographically is limited in that it can be used to ward off threatening interpretations and fit images into a reassuring tradition. Laurie Edson (*Reading Relationally: Postmodern Perspectives on Literature and Art* [Ann Arbor: University of Michigan Press, 2001]) explores how reading literature in the context of the visual arts enriches our understanding of what texts do and what texts mean. She advocates a practice of reading that directs attention to readers' relationships with texts and to the ways in which our frames of reference and mediating practices shape an object under investigation. By 'reading relationally' across the disciplines of literature and visual art, she sets in motion a series of reverberations between verbal and visual material. Reading relationally, she argues, can shed new light on texts by enabling us to think and see differently and therefore bring different textual details into sharper focus. A verbal text read through the lens of a visual text, constructed according to different codes and interpreted according to different conventions, can unsettle some of the habitual or codified methods of analysis that have governed the mind and eye.

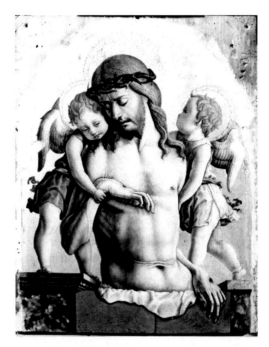

Fig. 27. Carlo Crivelli, *The Dead Christ Supported by Two Angels* (c. 1494)
The National Gallery, London.

In his now classic literary analysis of Isaiah 53, David Clines argues convincingly that what is fundamental about the poem is not the 'factual' information it can provide but rather the reader's response and reaction to the figure of the servant. Pointing to its many ambiguities, he stresses that the poem's most striking aspect is the way it conceals as much as it reveals:

> The force of the poem—to say nothing of the poetry of the poem—lies in its very unforthcomingness, its refusal to be precise and to give information, its stubborn concealment of the kind of data that critical scholarship likes to get its hands on.[7]

All that can be said with any certainty, he proposes, is that the poem revolves around four key personae, identified only by the pronouns 'I', 'he', 'we' and 'they'; the movement of the poem is wholly occupied by them and by the various connections that exist between them.[8] In particular, the 'he' (the servant) stands in the centre of the nexus of relationships and the poem is almost entirely taken up with the relationships in which 'he' figures. At

7. Clines, *I, He, We and They*, p. 12.

8. The use of pronouns offers greater potency in the poem. See Clines, *I, He, We and They*, p. 37, and C. Westermann, *Isaiah 40–66: A Community* (Louisville, KY: Westminster John Knox Press, 1969), pp. 256-57.

the start, the 'we' express an attitude of disgust towards the servant but as the poem proceeds, however, their attitude changes very markedly from rejection to acceptance and recognition. The change of attitude provides the only clear *before* and *after* in the poem since there is nothing else that entitles us to structure a temporal sequence of past, present and future. As matters of time and place are absent and questions of identity are out of focus, Clines argues that the poem lends itself easily to multiple interpretations and that we only come to appreciate it fully through the situations to which we apply it.[9] Following the hermeneutical approach of Gadamer,[10] he proposes that we let the poem become a 'language-event', let ourselves be taken hold of its creative language in order to 'enter' its alternative world:

> The poem exists to create another world, a world that is recognizably our own, with brutality and suffering and God and a coming to see on the part of some but not a world that simply existed and is gone for good. The poem's very lack of specificity refuses to let it be tied down to one spot on the globe or frozen in history: it opens up the possibility that the poem can become true in a variety of circumstances—that is its work. The poem is free to do its work by its very lack of specificity; its subject matter becomes true in a variety of circumstances.[11]

Isaiah 53 can create a variety of meanings; for example, in Acts 8, when Philip discusses the poem with the Ethiopian eunuch, it is not a question of a *re-application* of an ancient prophetic text that once meant something quite different in an original setting, but only one of a vast array of meanings the text itself can create. Later, we shall see that Gadamer's hermeneutical aesthetic works in exactly the same way for the visual arts, allowing the image to create an unlimited range of meanings through its visual expression. First, however, I want to draw attention to two key (but, to me, contradictory) aspects of the poem highlighted by Clines: the first relates to the use of highly visual language and the second to the absence of affective terminology that evokes feelings of sympathy or compassion on the part of the reader.[12]

The absence of speech in Isaiah 53 and the silence of its characters tell us that the poem is about seeing, not hearing; it is about vision rather than verbal communication and how the servant should and should not be seen.[13]

9. Clines, *I, He, We and They*, pp. 33-37.

10. Hans-Georg Gadamer, *Truth and Method* (London: Sheed & Ward, 1975), pp. 1-150.

11. Clines, *I, He, We and They*, p. 61. Robert Alter (*The Art of Biblical Poetry* [Edinburgh: T. & T. Clark, 1985], p. 161) highlights 'the impulse [of Hebrew prophetic poetry] to realize the extreme possibilities of the themes it takes up'.

12. Clines, *I, He, We and They*, pp. 40-46.

13. Michael Camille ('Mimetic Identification and Passion Devotion in the Later Middle Ages: A Double-sided Panel by Meister Francke', in A.A. MacDonald, H.N.B. Ridderbos and R.M. Schlusemann [eds.], *The Broken Body: Passion Devotion in Late-Medieval Culture* [Groningen: Egbert Forsten, 1998], pp. 183-210 [204]) notes: 'More than texts,

The initial words (הנה) 'look! behold!' in 52.13 introduce the servant to the reader while his visual appearance is described in 52.14. In 52.15, 'they' see what has not been told them. The reaction of the 'we' is expressed in visual language: he had no 'form or splendour to make us look at him and no appearance that we should desire him'. The 'we' look away from his disfigured appearance. The attitude of the 'we' and the 'they' to the servant is symbolized by the way they see him and for the servant, seeing symbolizes his future and the fruitfulness of his suffering. Other visual aspects of the poem that appeal to our imagistic consciousness include the elevation of the servant in 52.13 and the revealing of God's arm in 53.1. Finally, seeing throughout the poem is conceived of as an activity parallel to understanding in 52.15 and to contemplating and reflecting in 53.3-4. Seeing is used, then, in a metaphorical sense as a coming to an awareness, a realization of, as well as simply the physical act of seeing.[14]

With regard to the lack of affective terminology: God does not say how he feels about the servant and, of the servant himself, not a single emotion is expressed. Various translations have sought to make amends for the psychological vacuum by making him a 'man of sorrows and acquainted with grief' in 53.3 but the Hebrew terms used (איש מכאבות וידוע חלי) refer to physical pain, not emotion, and so leave the servant's inner state undisclosed. The initial reaction of the 'we' to the servant is expressed in affective terms, 'he had no beauty that we should desire him' in 53.2 and 'he was despised' in 53.3, but these are emotions that the 'we' have rejected and the change in attitude is characterized precisely by language entirely free of emotion. Clines suggests that the lack of affective language is deliberate: the servant moves in silence so as not to divert the reader from what goes on in the poem by the use of adjectives or emotive speech.[15]

In comparison to the next chapter, Isaiah 54, which simply resonates with vocabulary expressing emotion, the lack of affective language in ch. 53 becomes even more striking. John Sawyer notes that 'the differences in language and imagery [between the two chapters] are compelling' and draws

images have the far more pervasive potential to redefine the servant's body in relation to the beholder's body. The distance between words and flesh is greater than that between the viewer and the person in the image who always stands as the mirror image of that viewer.'

14. Ellen J. Esrock (*The Reader's Eye* [Baltimore: John Hopkins University Press, 1994]) has explored through a study of Italo Calvino's *Invisible Cities* the value of the reader's imagistic consciousness, the complex interactions between a text with visually evocative material and the reader's disposition to visualize; she argues that the importance of visual imagery must be recognized and integrated more fully into contemporary literary criticism.

15. Clines (*I, He, We and They*, p. 46) cites Genesis 22 as an example where Abraham moves in silence so as not to divert attention from the story line.

attention to the masculine imagery of ch. 53 and the distinctively feminine imagery in ch. 54,[16] in particular the 'gendered' rewards given to the two servants: while the male servant shares the spoils of war with the strong (53.12), the female servant story ends ultimately in a description of childbirth and the joy of contentment of a mother with her children (Isaiah 65–66). The way God acts in the two servant stories is different: in the first, he is like a judge or a king eager to demonstrate his power, while in the second he empties himself of exalted status and, almost on bended knee, expresses his love as a man for a woman and speaks intimate words of affection (54.4-5). It may be that the male servant is presented in a detached, impersonal way deliberately in order to heighten the emotional impact of God's attitude towards the female servant. But I shall return to this point later and here merely point out that the 'maleness' of the servant, so significant in the poem's visual afterlives, is also relevant to reading the poem in its literary context of Isaiah 53–54.

That the reader should be introduced to the male servant in Isaiah 53 in highly visual language and expected, along with the 'we' of the poem, to register and acknowledge a change of attitude towards his suffering and rejection in language that avoids evoking empathy, pity or compassion seems a contradiction in terms. If the poem is 'to interpret the reader' and 'create a range of meanings',[17] how can it become 'an event for the reader' without an appeal to the emotions? Is it possible to *see* the servant without *experiencing* sympathy or sorrow? Is it part of the poem's enigma and challenge, part of its concealing and revealing, that the reader must infuse the poem with the feeling and emotion it lacks? In complete contrast, a visit to any museum or art gallery shows that the most striking aspect of any painting or image with the title, *Man of Sorrows*, is not the reticence or detachment of the servant—it is the opposite, we are struck by the image's highly emotive quality, its ability to transfix the viewer and evoke an immediate and empathetic response. How can we explain the deliberate and noticeable absence of affective language in the poem and reconcile it with the intensely emotional content that characterizes its visual afterlives?

16. Sawyer ('Daughter of Zion', p. 92) notes: 'The feminine imagery of Isaiah 54 creates a story or picture as consistent and convincing as that of the Servant of the Lord in chapter 53'. Quinn-Miscall (*Reading Isaiah*, pp. 200-203) comments: 'Both poems reveal the surprising treatment that one specially chosen by God may have to undergo. That they are anonymous means that they can present patterns of the ways of God in the world and not just the Israelites. Both poems reveal the tensions and even the contradictions that exist between expectation and mercy. The poems of Isaiah 53–54 with the enigmatic portrayals of the servant and the woman remind us that God's ways are not so simple and that the world is not so clear-cut.'

17. Clines, *I, He, We and They*, pp. 60-61.

The Servant and his Visual Incarnations

Christian interpretations of Isaiah 53 where Christ is identified as the Man of Sorrows have ensured that visual representations of the servant retain a central place in the iconography and culture of Western Europe. Despite their mediation through Christian perspectives, however, they can still illumine the way the servant is presented within the literary dynamic of Isaiah 53 and, as we shall see, it is possible (and desirable) to extricate the figure of the servant from his almost exclusive identification as Christ. The tradition of Christ as the Man of Sorrows does not spring from any specific incident or episode in the Gospels but stems directly from the Vulgate translation of Isaiah 53.3, the *vir dolorum*. It is striking, as John Sawyer notes,[18] how art commentators always underplay the role of the servant in interpreting the visual image of the Man of Sorrows; it is not the Gospel narrative that created the figure but Isaiah 53 and therefore it is the dynamics arising from that text that illumine the visual image and, conversely, the image that can help us appreciate the text.

The most essential characteristic of the visual image of the Man of Sorrows is its removal from any narrative context in the gospels; unmoored from specific incidents associated with the Passion of Christ, it becomes free to express the sentiments of Isaiah 53 more ambiguously. Traditionally, the function of any devotional image was to inspire the viewer to contemplation and empathetic involvement with those depicted and so artists, following the pattern of icon makers, often removed the biblical figure from the distraction of a narrative context in order to promote a more intense interaction with the viewer. By focussing on the figure of the Man of Sorrows alone, isolated from any identifiable narrative context, the artist could concentrate on evoking an atmosphere of intimacy and immediacy. The iconography of the image becomes very restricted and there are few, if any, symbols that refer to Christ's divinity,[19] thus encouraging the viewer to engage with the human suffering of this pitiful figure. If we see the Man of Sorrows not (or not only) as Christ but as an unidentified suffering individual, it allows us to interpret the image more imaginatively as an expression of Isaiah 53. Several examples show how the image could be interpreted quite flexibly, especially in the late Middle Ages when the popularity of the image was at its height and the viewer could impose different identities on the figures it contained;

18. John F.A. Sawyer, *The Fifth Gospel: Isaiah in the History of Christianity* (Cambridge: Cambridge University Press, 1996), p. 86.

19. The image I am dealing with in this essay is derived from types of the *imago pietatis*, which is quite distinct, although not unrelated to, other images such as *Ecce Homo* and those depicting the *arma Christi*, the instruments of Christ's torture.

Michael Camille notes the artistic practice of depicting a uniform facial format on which the pious beholder could impose his or her personal detail, 'more particularly but less structured than what the painter offered'.[20] With regard to gender, Caroline Bynum has shown how mediaeval mystics and devotional viewers generally were 'always mixing up their genders and associating Christ's fleshiness in the image with the feminine'.[21] The image could also be associated with motifs from classical literature that resembled those of Isaiah 53, for example, Giovanni Bellini's *Man of Sorrows* (c. 1470, Brera Gallery, Milan). An inscription below the painting states:

> Haec fere quum gemitus turgentia lumina promant
> Bellini poterat flere Joannis opus
>
> As these swollen [from weeping] eyes produce sighing,
> the work of Giovanni Bellini was able to weep

Based on a quotation from an elegy of Propertius,[22] the inscription suggests that the painting has the same rhetorical power as antique poetry, as well as obviously drawing attention to the skill of the artist. It claims that Bellini's painting of the Man of Sorrows can evoke the same empathy and compassion from the viewer as Propertius's elegy, which relates a story of suffering and self-sacrifice similar to Isaiah 53, can evoke from the reader.[23] There was, then, considerable scope for the imagination when viewers contemplated the image before them since they were expected to identify personally and imaginatively with the Man of Sorrows so that the power of the image could effect a change and transformation in their lives.

 Clines's point that the literary dynamic of the poem, with its intentional lack of specificity, frees it to become meaningful in a variety of circumstances is even more true for the image. Extending Gadamer's application of hermeneutical aesthetics from literature to the visual arts, we can argue that the subject-matter of a work of art (in this case, the servant) can never be 'finished': it is always more than its individual expressions since no art work can ever exhaust its subject matter, even though a work may exert its own merits in contradistinction to previous examples of its type. An art-work

20. Camille, 'Mimetic Identification', pp. 197-98.

21. Cited in Michael Camille, 'Seductions of the Flesh: Meister Francke's Female "Man" of Sorrows', in Marc Müntz (ed.), *Frommigkeit im Mittelalter: politisch-soziale Kontexte, visuelle Praxis, körperliche Ausdrucksformen* (Munich: Fink, 2002), pp. 243-59 (257).

22. 'Quid nostro gemitu turgentia lumina torques?' (Propertius, Book 1, no. 21). 'Why bend a swollen-eyed glance aside at the sound of my groaning?' Translation taken from R. J. Baker, *Propertius I* (Warminster: Aris & Phillips, 2000).

23. See Bernhard Ridderbos, 'The Man of Sorrows: Pictorial Images and Metaphorical Statements', in MacDonald, Ridderbos and Schlusemann (eds.), *The Broken Body*, pp. 146-81 (151).

occasions the 'coming forth (Gadamer's *Darstellung*) of its subject matter, facilitating its epiphany, its showing, its coming into appearance' in the life of the viewer.[24] Thus the importance of suspending the notion, at least partially, that the Man of Sorrows always has to be Christ (since this is only one manifestation or afterlife of the servant of Isaiah 53) in order to allow a more imaginative range of interpretations of both the image and the poem.

The Imago Pietatis

The *imago pietatis* (image of piety) depicting Christ as the Man of Sorrows became one of the most popular of all devotional images throughout mediaeval and early Renaissance Europe.[25] It depicts Christ wounded, bleeding and dead in the tomb, yet paradoxically alive, upright and suffering, animated by a mysterious life force.[26] The widespread popularity of the image is explained in part by the account given of its origins; it is said that as Pope Gregory the Great (c. 540–604) celebrated Mass in the church of Santa Croce in Gerusalemme in Rome, he had a vision of the Man of Sorrows appear from his tomb on the altar before him, surrounded by the instruments of his torture (Fig. 28).[27]

The vision was recorded in a painting which was revered as the original *imago pietatis*, now in the church of Santa Croce. In reality, this image was not a sixth-century painting but rather a mosaic icon that had found its way from Constantinople to Rome in around 1380, a 'passion portrait' developed in conjunction with the Good Friday liturgy of the Eastern Church; its function was liturgical—to draw the worshipper into an affective relationship with Christ in his suffering (Fig. 29). An indulgence of 20,000 years was available

24. 'All encounter with the language of art is an encounter with an unfinished event' (Gadamer, cited in Nicholas Davey, 'The Hermeneutics of Seeing', in *Interpreting Visual Culture: Explorations in the Hermeneutics of the Visual* [ed. Ian Heywood and Barry Sandwell; London: Routledge, 1999], pp. 3-29 [15]).

25. Ridderbos ('The Man of Sorrows', pp. 145-49) argues (after Erwin Panofsky and Hans Belting) that the image was used for liturgical purposes in Byzantium and when it came to Italy was expanded to include one or more figures.

26. Ridderbos ('The Man of Sorrows', p. 147), together with Belting, interprets this 'living-dead' position of Christ as evidence that the early function of the image was to disclose antithetical theological concepts.

27. In the narrative context of the vision, the underlying relationship between the body of the Man of Sorrows and the Eucharist is clearly highlighted. While the chalice stands on the altar, the bread of the Eucharist does not: the bread has been substituted by Christ, the Man of Sorrows. Implied is that those who partake of the Eucharist become physically united with the body of the Man of Sorrows. For a description of Christ's physical body as it appears in standard images of the Mass of Pope Gregory, see comments on the focus on the body in the *gregorymass* in Neil MacGregor, *Seeing Salvation* (London: The National Gallery, 2000), p. 150.

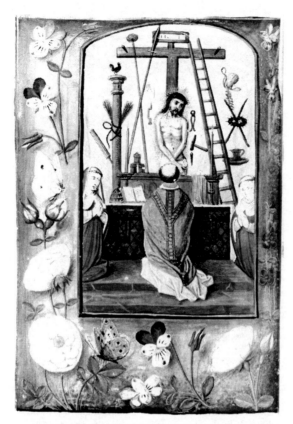

Fig. 28. Follower of Simon Bening, *Mass of St. Gregory the Great* (c. 1500) Museum Meermanno Westreenianum, Den Haag 10 E 3, folio 190V.

to those who prayed before the icon of Santa Croce and this was extended by Pope Urban IV (1328–59) to apply equally to licensed copies so that in time the indulgence increased to 45,000 years. The 'discovery' of the icon also coincided with the gradual institution of the feast of *Corpus Christi* that re-affirmed the presence of the physical body of Christ in the Eucharist.[28]

Thus, a combination of circumstances catapulted the *imago pietatis* into widespread popularity, and in particular, allowed artists the scope to stage a range of devotional responses to the suffering of the Man of Sorrows as well as the opportunity to include a wide range of eucharistic allusions.[29] (The

28. Influenced by the teachings of Bernard of Clairvaux and Francis of Assisi who encouraged an affective spirituality that concentrated on the passion imagery of Christ.

29. See Mitchell B. Merback, 'Reverberations of Guilt and Violence, Resonances of Peace: A Comment on Caroline Walker Bynum's Lecture', *German Historical Institute Bulletin* 30 (Spring 2002), pp. 37-50 (38-39).

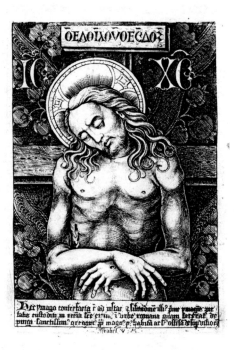

Fig. 29. Israhel van Meckenem, *Vera Icon* (c. 1490), Staatliche Museen, Berlin.

[The Latin inscription reads: 'This image was made after the model and likeness of the well-known image of the first *imago pietatis* in the Church of Santa Croce, Rome, which the holy Pope Gregory the Great ordered to be painted according to the vision he had had from above'.]

association made between the Eucharist and the physical body of the Man of Sorrows is a crucial one because of the emphasis it brought to bear on ensuring that depictions of the servant fully reflected his physical and human attributes). The *imago pietatis* had an immense variety of manifestations: while paintings of the image were restricted to wealthy households, rather crude woodcuts of the image were affordable to all. Prints were hawked at pilgrimage shrines and fairs or sold by itinerant peddlers travelling around the countryside and so were widely disseminated. Once purchased, they could be attached to chimney-mantels for all the members of a family to see, or pasted into Books of Hours or private prayer books. We cannot, therefore, overestimate the influence of the image as a cultural icon nor its flexibility in offering a range of different ways of *seeing* the servant; just as the poem invites us first to create a mental picture of the servant and then to reflect on the meaning of his suffering, so too the image engages the viewer in an intense visual contemplation of his suffering and rejection.

It was the art historian, Erwin Panofsky, who first stressed that the power of the *imago pietatis* lay in its isolation from any biblical narrative associated with Christ's passion or any other reference to time and place. In the *imago pietatis*, Christ is usually shown alone, an isolated and rejected human figure lacking any divine attributes, sometimes upheld by two angels who present him to the viewer. Detached and frozen in time, the image transfixes the beholder in what Caroline Bynum describes as a 'simultaneity of opposites'.[30] On the one hand, the figure's pathetic state appeals directly to our sense of pity and compassion and on the other denounces the viewer as a perpetrator of crimes against the just and innocent man. The *imago pietatis* with its pitiful yet reproving gaze was frequently inscribed with the text of Lam. 1.1—'Look and see if there is any sorrow like my sorrow which was brought upon me, which the Lord inflicted on the day of his fierce anger'. An exchange of gazes establishes an atmosphere of intimacy between the Man of Sorrows and the viewer whose sympathy for the rejected figure is aroused by the vivid and often lurid depiction of physical suffering and wounds.

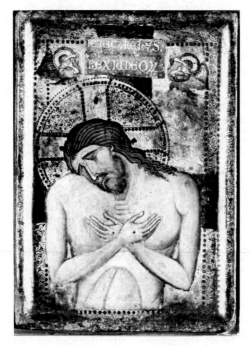

Fig. 30. Unknown Umbrian Master, *The Man of Sorrows* (c. 1260)
The National Gallery, London.

30. Caroline Walker Bynum, 'Violent Imagery in Late Medieval Piety', *German Historical Institute Bulletin* 30 (Spring 2002), pp. 3-36 (6).

We can draw several parallels between the literary dynamic in Isaiah 53 and its affect on the reader and the way in which the Man of Sorrows is presented to the viewer through the *imago pietatis*; the parallels can be illustrated with reference to an early version from c. 1250 by the unknown Umbrian Master (Fig. 30). This painting derives its style from types of Byzantine icon which show Christ, the Man of Sorrows, as a suffering human victim with eyes closed, furrowed brow and drooping head. The figure is emaciated with spine and ribs visible and his imminent death is suggested by the sombre and shadowy outline of his flesh. In both the image and the poem, there is a deliberate lack of spatial and temporal detail and no context that explains the reasons for the suffering. Just as the presentation of the servant in Isaiah 53 is seen in terms of his relationships with others (particularly the relationship between 'he' and 'we'), so too the focus of the image centres on the relationship between the figure and its viewer, the 'he' and 'we' of the poem.[31] The change in attitude, the transformation, the coming to awareness of the significance of the servant's suffering on the part of the 'we' in the poem are reflected in the viewer's change of attitude, in the spirit of penitence that the artist hopes an affective engagement with the Man of Sorrows will bring about. As in the poem, the subject-matter of the image concerns the breaking in of a new vision of the servant in the life of the viewer. The 'seeing' in both the poem and the painting refers to more than physical seeing; it refers also to pondering, contemplating and understanding. Like the servant in the poem, the Man of Sorrows in the image is passive, indicated by the crossing of his arms; there is no indication of his inner state or attitude and he is deathly silent. We should not think of this image as a 'copy' of a template or a 're-application' of an ancient prophetic text but rather as one of a vast array of meanings the text itself can offer and powerful evidence of the poem's capacity to create. In the language of Gadamer, each instance of the subject-matter (the servant) extends the subject-matter itself; to all who see the image, it presents the servant as an event, a 'coming forth' and an opportunity to create new meanings.

Turning to the visual appropriation of two specific themes in the poem, the suffering of the innocent man on account of the sins of others and the servant's disfigurement and repulsiveness, we see how the visual image can expand the meaning of the poem creatively and imaginatively. In the Book of Isaiah and in the rest of the Hebrew Bible, there is no hint that God will accept the suffering of the innocent and righteous in place of the punishment of the guilty and wicked. Individuals may suffer unjustly or excessively

31. Sawyer (*The Fifth Gospel*, p. 83) notes how the emphasis on the pronoun 'we' gave the Church from earliest times the opportunity to identify with the suffering of the servant.

but not in place of the deserved punishment of others.[32] Whybray interprets the transfer of sin from others to the servant in a Christian sense suggesting that 'through the servant's own unmerited suffering, he enabled others to escape the divine punishment that they deserved'.[33] In terms of the reader, Clines proposes that if one accepts that the suffering of the innocent is in any way because of, or for the sake of, or on behalf of oneself who deserves to suffer, then one has joined the ranks of the 'we'. Identification with the 'we' puts one within the world of the poem.[34] The notion of transfer of suffering is even more central to an appreciation of the dynamic of the *imago pietatis* where it is developed and expanded from the poem. The viewer is drawn into the image by the pitiful gaze of the Man of Sorrows who stares out at us; but his demeanour of innocence and suffering becomes a reproach to the viewer and his distressed state engenders a sense of guilt; it is the sins of the viewer that have caused his suffering. Mediaeval scholars have argued that it is precisely this notion of the transfer of suffering from the 'we' to the innocent servant that made the *imago pietatis* an image of violence. Merback claims that, as an archetype image of sacrifice and suffering, it stakes its rhetorical power on several basic stereotypes of visual violence, a violence that lay at the heart of mediaeval religiosity.[35] Caroline Bynum notes that the graphically violent art evidenced in the popularity of the ubiquitous figure of the Man of Sorrows is central to mediaeval scholars' understanding of the 'violent tenor of life' in the fourteenth and fifteenth centuries. She argues that it is the paradox of the image that gives it its violent potential: the half dead body in the coffin expresses not solution or resolution but a 'simultaneity of opposites' that affirms life in spite of death, glory in spite of agony and salvation in spite of sin. Detached from any narrative the image transfixes the viewer with a spectacular surplus of blood, wounds and pain as objects for contemplative immersion, unbearable to behold, yet salvific.[36] It suggests a religiosity of blame and self-reproach as well as ecstasy and love and calls for vindication of, as well as empathy with, the Man of Sorrows: the figure

32. Quinn-Miscall, *Reading Isaiah*, p. 198.

33. Whybray, *Second Isaiah*, p. 77.

34. The 'we' of the poem corresponds to the 'we' or 'I', the viewer of the image, depending on the image's cultic (plural) or devotional (singular) setting.

35. 'The Man of Sorrows was a trigger of pilgrimage, persecution and progrom' (Merback, 'Reverberations of Guilt', p. 42; see also his subsequent exploration of the influence of the image in terms of a Freudian perspective on violence, pp. 42-47).

36. In particular, Bynum ('Violent Imagery', p. 18) highlights the role of the *arma Christi*, the instruments of his Passion that floated around Christ, 'visual triggers' to remind Christians what God had suffered for them. 'Non-narrative and scattered around the picture field with no regard to perspective or proportion the *arma* functioned as signs heaping up detail to encourage pious adherents to meditate in a random manner that could be different—every recourse to the image hence was ever challenging and ever new'.

was an aching revelation of one's own guilt and encouraged a blaming of one-self and a call to repentance.[37] Contemplation of these images unleashed a violence of guilt and self-accusation, ultimately of condemnation. The excess of guilt engendered by the gaze of the Man of Sorrows cried out for transfer and turned from the blaming of self to the blaming of others: unbelievers, the damned, the Jews, in a spiral of scapegoating and self-castigating.[38] As 'a simultaneity of opposites', the Man of Sorrows became a 'living god of recon-ciliation and an atavistic icon of bloody persecution',[39] an ambiguity and ten-sion that remained unresolved, as is evident from the literature of mediaeval hagiography.

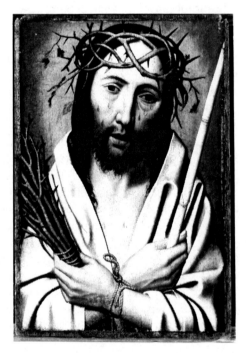

Fig.31. Style of Jan Mostaert, *Christ as the Man of Sorrows* (c. 1520)
The National Gallery, London.

In a painting by the school of Jan Mostaert (Fig. 31) entitled *Christ as the Man of Sorrows*, the accusatory nature of the figure is clearly seen. The artist includes the *arma Christi*, the instruments of Christ's suffering, the crown of thorns, the reed thrust on him by the Roman soldiers and the birch with

37. One mediaeval tract cites Gerhard of Cologne, 'We are the new Jews' (quoted in Bynum, 'Violent Imagery', p. 27).
38. Bynum, 'Violent Imagery', p. 28.
39. Merback, 'Reverberations of Guilt', p. 47.

which he was flogged, to encourage the viewer to reflect more intensely on the sufferings of the Passion of Christ.[40] However, if we disregard the Passion iconography that identifies the Man of Sorrows as Christ, that is, remove it from its narrative context and see the figure as the servant of Isaiah 53, the painting illustrates how, in this context too, his gaze engenders a sense of guilt in the viewer: tears stream from his face in large crystal beads as he looks directly at us, lips slightly parted as if about to speak words of reproach and disappointment. The artist has used every means to induce feelings of compassion and contrition in the viewer, from the small scale of the image which already assumes intimacy to the catchlights in the tear-filled eyes. The drooping of the figure's shoulders reflects the plaintive character of the painting. This was undoubtedly an image for private contemplation and in the privacy of prayer it was intended to elicit tears.[41] Not only does the painting present us with graphic detail of the servant's suffering but it also allows the servant to see us, thus ensuring that 'seeing' is a reciprocal activity—the servant interprets *us* as much as we interpret *him*, a point that will be developed later in relation to Meister Francke's *Man of Sorrows*.[42]

The second aspect of the poem, in the context of the Hebrew Bible, is its description of a servant of God as physically unattractive, even repulsive. 'He had no beauty, no splendour to attract us, no grace to charm us...like one who must hide his face from us, he was despised' (53.2-3). As Claus Westermann notes, the servant in this aspect is quite unlike other handsome biblical heroes such as Joseph (Gen. 39.6) and David (1 Sam. 16.18) where a prerequisite of their story—and their importance—is their 'beauty and splendour'. In the Hebrew Bible, the beauty of the person is associated with a blessing: Joseph's beauty indicates that he is blessed and will prosper; but of the servant in Isaiah 53 it is said that there was nothing beautiful about him. He is, therefore, a man without a blessing and no regard will be paid to him.[43] However, later instances of the *imago pietatis*, especially in the Italian Renaissance, depict the Man of Sorrows as physically attractive, often erotic.[44]

40. The artist may have been influenced by the spiritual movement in the Netherlands known as the *devotio moderna* that sought to make faith more accessible to lay people and encouraged a greater spiritual and emotional engagement with the person of Christ. See MacGregor, *Seeing Salvation*, p. 118.

41. MacGregor, *Seeing Salvation*, p. 118.

42. A history of the first Dominicans written before 1269 by Gerard de Frachet reveals that 'in their cells they had before their eyes images of the Virgin and of her crucified Son so that while reading, praying, sleeping, they could look upon them and be looked upon by them with the eyes of compassion' (cited in Hans Belting, *The Image and its Public in the Middle Ages: Form and Function of Early Paintings of the Passion* [New Rochelle, NY: A.D. Caratzas, 1990], p. 57).

43. Westermann, C., *Isaiah 40–66* (London: SCM Press, 1969), p. 261.

44. For views on the eroticizing of Christ, see Richard Trexler, 'Gendering Christ

Michael Camille refers to 'the southern chiselled, Herculean, neo-classical body, triumphant in its homo-erotic masculinism'.[45]

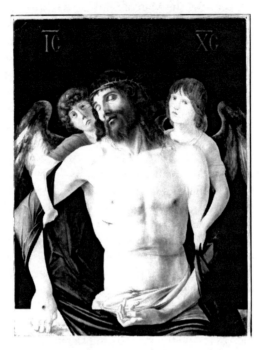

Fig. 32. Giovanni Bellini, *Dead Christ Supported by Two Angels* (c. 1465)
The National Gallery, London.

We can see an example of a somewhat erotic visualization of the Man of Sorrows in Bellini's *Dead Christ Supported by Two Angels* (Fig. 32) where the dead Christ is held up to the viewer by two androgynous angels whose looks insinuate the viewer into the scene. The unbloodied and exquisitely delineated torso of the Man of Sorrows reminiscent of an heroic figure, such as David, can present something of a paradox to the viewer. In Mantegna's *The Man of Sorrows with Two Angels* (Fig. 33) his body, now full length whereas generally it is depicted in half length, is propped up on the end of a sarcophagus by two angels for the admiration and contemplation of all. The blessings associated with physical beauty elsewhere in the Hebrew Bible now appear embodied in this Man of Sorrows; his victorious nature is hinted at through the elegant portrayal of his body. But the paradox we might find in portraying the Man of Sorrows in this unexpected way may be connected to

Crucified', in Brendan Cassidy (ed.), *Iconography at the Crossroad* (Princeton: Princeton University Press, 1996), pp. 107-19.
 45. Camille, 'Seductions of the Flesh', p. 259.

another paradox in the painting suggested by the landscape: to emphasize the division between death and resurrection, the landscape is delicately bisected to evoke an important pivotal moment between crucifixion and resurrection. The Man of Sorrows is frozen in the anguish of death, to his left Calvary is seen in the light of the setting sun, to the right the landscape lightens to evoke the dawn, yet he is alive with eyes open imploring the viewer.[46] The victory and future vindication of the Man of Sorrows is mirrored in his perfected body; his success is reflected in the depiction of a body that has been elevated to the status of heroic. Ridderbos shows that one of the rhetorical functions of the *imago pietatis* was that of disclosing 'antithetical theological concepts' to the viewer especially concerning death and life; the Man of Sorrows can be alive while dead, he can be a 'living dead'.[47] The physical perfection of his body, its sensuousness, assures the viewer that this is a living and desirable body and not a body of wounds, suffering and decay.

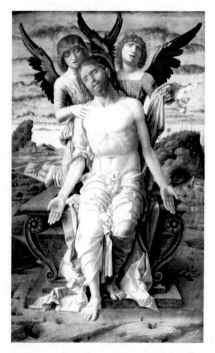

Fig. 33. Andrea Mantegna, *The Man of Sorrows with Two Angels* (c. 1470)
Statens Museum for Kunst, Copenhagen.

46. For a discussion of this painting see Dawson W. Carr, *Andrea Mantegna: The Adoration of the Magi* (Getty Museum Studies in Art; Los Angeles: Getty Museum, 1997), pp. 47-50.
47. Ridderbos, 'The Man of Sorrows', pp. 178-80.

Eroticizing the Man of Sorrows was not restricted to Renaissance Italy. Although sixteenth-century Calvinist literature recoils from the visual and affective piety of southern Europe, the pathetic iconography re-enters Calvinist representations in the next century when Hall and Heinsius, as well as several English preachers, dwell on the horrific agony of Christ's tortured body.[48] They tend, however, to betray a certain discomfort with the figure of abject vulnerability and so in passages describing the Man of Sorrows they intersperse two radically different images: the lover of the Song of Songs and the youthful knight. The bruised and deformed figure of the Man of Sorrows is suddenly reconfigured and becomes beautiful and virile. The images of the grotesque and erotic bodies are very closely juxtaposed: Heinsius exclaims, 'Behold the Man of Sorrows…behold him that was the fayrest among men, being both white and ruddie …his cheekes as a bed of spices, as sweet flowers…he lyeth now disfigured with wounds, weltring and panting in a crimson river of his own bloode'.[49] The juxtaposition maps the erotic body of the young lover onto the disfigured figure of the Man of Sorrows evoking erotic overtones of a body in pain. In an early theological dialogue, Erasmus observes that the agonies of the Man of Sorrows makes him desirable (*amabilis*).[50]

That the *imago pietatis* was intended to evoke an emotional response from its viewers resulting in a spirit of penitence has been illustrated in paintings discussed so far. Mediaeval literature describes how viewers were moved by the image to great extremes of grief and guilt, often resulting in a desire to experience the same suffering and anguish as the Man of Sorrows.[51] With particular reference to Meister Francke's *Man of Sorrows* (1420), Michael Camille highlights the mimetic role of the *imago pietatis* as an object structuring the beholder's psychological identification and empathy with its central figure and emphasizes the scope and flexibility viewers had in their efforts to identify personally and imaginatively with the Man of Sorrows.

Meister Francke was a Dominican monk-painter[52] in the Netherlands to whom only a handful of works can be attributed. Of these, two versions of the *Man of Sorrows* are considered his most important and depict the theme in quite different ways.

48. Shuger, *The Renaissance Bible*, p. 95.
49. Shuger, *The Renaissance Bible*, p. 99.
50. Shuger, *The Renaissance Bible*, p. 100.
51. Camille ('Mimetic Identification', p. 183) quotes at length from the diary of the mystic Dominican nun Margaret Ebner, who went through so many paroxysms of pain and somatic transformations while contemplating the image that she lost all bodily control and had to be supported by others.
52. Camille ('Mimetic Identification', p. 185) argues that this is very significant, considering the importance of the Dominican Order in the promulgation of the theme of the Man of Sorrows and other related Passion themes.

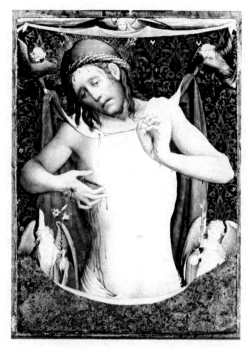

Fig. 34. Meister Francke, Man of Sorrows (c. 1420s), Kunsthalle, Hamburg.

The version now in Hamburg (Fig. 34) depicts a muscular and active figure against a background containing iconographical references to the Last Judgement when flesh will reclothe the body (the red inner lining suggests the notion of being reclothed in flesh) and depicts Christ at the end of time as a 'paternalistic, judging and male God'.[53] The angel to the left carries a branch of lilies and to the right a second angel carries a sword suggesting a judgment tempered by mercy. Camille argues that in the second version now in Leipzig, which he calls 'the female Man of Sorrows', Francke deliberately re-engendered the image to suggest a figure that was more open to projection and less self-contained and triumphalist than the first.

The Leipzig Man of Sorrows (Fig. 35) is a tiny panel painting (16 by 12 inches); the space depicted in the panel is claustrophobic, so shallow in fact that the figure's flesh, pressed out by the great dark wings of the angel, seems about to spill over into our world. He seems paralysed and his limp arms so weak that they have to be manipulated by two tiny angel puppeteers who thrust the (ridiculously inadequate) instruments of his torture between his

53. Camille, 'Mimetic Identification', p. 206.

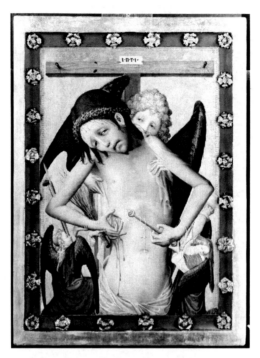

Fig. 35. Meister Francke, *Man of Sorrows* (c. 1430)
Museum der bildenden Künste, Leipzig.

feeble fingers. Unlike other instances of the *imago pietatis* (for example, Fig. 33), there is no tomb: the Man of Sorrows is not on the other side of death but is suffering in our presence as a living exemplar—his eyes are not closed, he is not dead, he is not a corpse. The angel's eyes lead our own to the figure and his languid look meets ours. The fact that his eyes are open and that he is alive gives the image a timeless quality; it is 'a never-ending and continually repeated spectacularization of suffering'.[54] The remaining two nails on the cross have not been removed, and so emphasize the idea of an extended agony and disrupt any notion of narrative temporality and specific location in order to make his suffering ever present as a fact. Francke's *Man of Sorrows* receives no divine approval for his suffering within the image itself and must look to us for validation of his ongoing agony.[55]

Camille notes that when any character in a painting looks directly at us, conscious not only of being observed but also observing us, this crucially breaks the illusion of reality that has been constructed. The internal gaze incorporates the viewer within the scene. Francke's *Man of Sorrows* asks that

54. Camille, 'Mimetic Identification', p. 206.
55. In other paintings by Francke, the presence of God the Father gives divine approval.

we return his gaze, that we look at him as piteously as he looks at us; the painting thus produces a viewing subject in a highly interactive and imaginative dynamic. Camille highlights three aspects that affect the way the viewer responds to this image: its size and the infantile and feminine attributes of the figure, making him appear weak, childlike and female. He argues that these aspects are intentional in order to encourage new responses, to reconstruct its devotional viewers and to broaden its appeal. The effect, he argues, is to create a more empathetic Man of Sorrows, weaker and more sexually ambiguous, more open to projection than the ubiquitous closed, self-contained and masculine image of the Italian Renaissance. In the shallow space in which this body is squeezed out to us, the figure's wounded hand can make only the tiniest of movements. The figures seem to press right up against our retina and seem too close to our bodies. The bodily proportions of the figure, its smoothness and weightlessness, just a head and a tube with no backbone, contrast with other instances of the *imago pietatis* and suggests a body too flimsy to have been broken or crucified.

As for the child-like proportions of the body, Camille argues that these are evident in the facial features where the eyes, with their sockets pushed almost vertical and meeting at the centre, carry much of the movement and empathetic effect. It is a hairless body, a baby's body. In the late Middle Ages, the infantilization of the body crossed gender boundaries and gave both men and women access to a body that could be contemplated, since it appeared neutral and asexual and 'outside gender'. Camille argues that Francke has also staged a feminine presence in this painting, in that the Man of Sorrows is given the delicate outline of the ideal female type in early fifteenth-century culture (the same spidery arms and long tube-like torso can be found in court art of the same period); he suggests that the wound on the figure's side, to which he himself draws attention with his fingers, should be seen as symbolizing the vagina. Infantilization and feminization of Christ in late mediaeval imagery were modes of avoiding explicit sexual suggestiveness;[56] the image plays with gender but it does not do so in order to exclude one gender or the other but to emphasize the lack of boundaries between them.[57]

Camille's analysis of the panel depicting a Man of Sorrows with weak, childlike and female qualities and the fact that the painter had already painted a more 'masculine' version underline the gender issues implicit in the image. Meister Francke succeeded in visualizing Isaiah 53 in new and

56. Shuger (*The Renaissance Bible*, p. 115) notes how Erasmus suggests the Christ's female temperament might provide a physiological explanation for his terror and fear: people with 'cold, scanty blood and thinned spirits—characteristics of female bodies— were more likely to suffer fear than those of hotter constitutions'.

57. Camille, 'Seductions of the Flesh', pp. 245-50.

unexpected ways by drawing attention to the stereotyped 'maleness' asso-
ciated with it. However, a female presence was also clearly important in
earlier versions of the *imago pietatis*: Ridderbos[58] and Camille[59] point out that
the function of the Virgin or Veronica (with whom the Man of Sorrows
frequently formed a diptych, as in Fig. 30, or who was painted on the reverse
of the panel as in Fig. 35) was to draw the viewer's attention to his sufferings
and so intensify the sense of empathy. Centuries later and for different rea-
sons, Vincent van Gogh was to conceive of a female Man of Sorrows too, by
bringing together the male and female servants of Isaiah 53 and 54 in a way
that reflects contemporary biblical scholarship.

Vincent van Gogh's Still Life with Open Bible *and* Sorrow

Vincent van Gogh throughout his life identified with the servant in Isaiah 53
both personally and artistically and referred to 'the man of sorrows and
acquainted with grief' (usually writing this quotation in English) many times
in his letters.[60] The notions of earthly suffering and self-sacrifice in the service
of others, to be followed by eventual recognition, made the Man of Sorrows
from Isaiah 53 a powerful and attractive symbol to van Gogh both as a per-
son and as an artist and he regarded his own sufferings, and suffering in gen-
eral, as something that should not just be endured but celebrated. But while
he depicted several lonely, isolated and vulnerable men and women,[61] these
did not include figurative representations either of the servant of Isaiah 53 or
of Christ as the Man of Sorrows and, apart from his two versions of the Pietà,
executed after a work by Delacroix, he did not paint explicit images of bib-
lical figures, preferring instead to incorporate them through allusion.[62]

In his painting of the text of Isaiah 53, *Still Life with Open Bible* (Fig. 36),
van Gogh consciously imitated the still life and *vanitas* genre of the seven-
teenth century, found especially in Rembrandt, in which still-life objects
were considered symbols of mortality in contrast to the eternal nature of the

58. Ridderbos, 'The Man of Sorrows', pp. 166-67.
59. Camille, 'Mimetic Identification', pp. 206-10.
60. This is clear from his letters to his brother Theo and especially in his general
correspondence from 1877 and 1878. See Joan E. Greer, '"Man of Sorrows and Acquain-
ted with Grief": The Christological Image of the Artist in Van Gogh's *Still Life with Open
Bible*', *Jong Holland* 3 (1997), pp. 30-42.
61. For example, *At Eternity's Gate* or *Old Man with his Head in his Hands*.
62. Greer, '"Man of Sorrows and Acquainted with Grief"', p. 30. He wrote to artist
Emile Bernard, criticizing Bernard's painting of overt Christian themes: 'You can give the
impression of anguish without aiming straight at the historical garden of Gethsemane; it
is not necessary to portray the characters of the sermon on the mount in order to produce
a consoling and gentle motif' (cited in Harris, 'Art and Images in Psychiatry' [2003],
p. 1182).

Christian faith. The painting portrays a large Bible[63] open at Isaiah 53[64] and set on a table with a burnt-down candle in the background. In the foreground to the side of the open Bible, is a copy of a novel, *La joie de vivre* (1884), by the contemporary French author Emile Zola.[65] The pages of the Bible are clean and well cared for whereas those of the novel are torn and tattered. Reminiscent of Rembrandt's style, van Gogh has given the painting a dark background, with pale yellow highlighting the foreground while the cover of the novel is deep yellow, a colour that for him signified life. The protagonist of Zola's novel, Pauline Quenu, orphaned at the age of ten, leaves Paris to live with her aunt, uncle and cousin in an impoverished fishing village. The small fortune she arrives with is squandered by her dishonest aunt who increasingly turns against the girl, making her life miserable. In the face of her problems, however, Pauline Quenu remains devoted to loving and serving those around her, including the village children. She remains very human—suffering with each new pain, experiencing profound feelings of doubt, anger, jealousy and despair—but somehow finding strength and even joy in these circumstances. She is clearly presented as an example of self-sacrifice and service to others; Zola describes her as the 'incarnation of renunciation, of love for others and kindly charity for erring humanity'.[66]

Van Gogh positions the open text of Isaiah 53 directly in front of the viewer so that we become both reader and interpreter. But the presence of Zola's novel *La joie de vivre*, placed strategically between text and reader, ensures that we interpret the poem through the novel and, in particular, through the character of the selfless Pauline Quenu. A deliberate association is established between the servant and the young girl in that both experience personal anguish, yet assume the sufferings of others. The irony of the novel's title *La joie de vivre* is that she should find joy and satisfaction in her suffering and selflessness in the same way as the servant does (Isa. 53.11). The painting suggests that Zola, through his heroine, can convey the signifi-cance of the servant to a contemporary audience much more meaningfully than the institutional Church structures in which the same biblical text is preached—the yellow cover of the novel suggests life and fulfilment while the sombre dark colours of the Bible and the snuffed-out candle convey the

63. Generally agreed to be his father's Bible and a symbol perhaps of the latter's rather conventional faith and strict way of life as pastor in the Dutch Church. See Anton Wessels, '*A Kind of Bible'*: *Vincent van Gogh as Evangelist* (London: SCM Press, 2000), p. 79.

64. The French title *Isaïe* appears at the top right of the page and CHAP LIII is high-lighted in black in the right column.

65. Van Gogh urged his brother, Theo, 'Read as much Zola as you can; this is good for one and makes things clear' (cited in Jared Dockery, *Emile Zola's Influence upon van Gogh* [www.vangoghgallery.com/visitors/009.htm]).

66. Harris, 'Art and Images in Psychiatry', p. 1182.

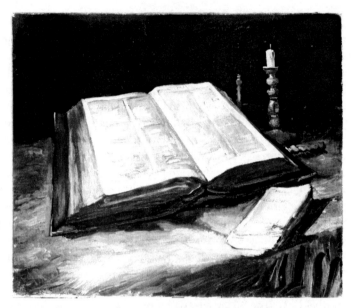

Fig. 36. Vincent van Gogh, *Still Life with Open Bible* (1885) van Gogh Museum
(Vincent van Gogh Foundation), Amsterdam.

sense of empty ritual and death.[67] The painting suggests that only when the
reader becomes involved and engages with the poem can it create new
meanings: it therefore supports Clines's literary analysis when he concludes
that 'meaning resides not in the text but in what the text has become for the
reader'.[68] The open Bible reveals the story of the servant that is powerful and
relevant for all times, but it remains incomplete and unfulfilled, becoming
meaningful only in its specific applications. On the other hand, the fact that
Zola's novel is closed suggests that, while Pauline Quenu represents an
embodiment of the servant that is relevant to Parisian life in the 1880s, this
interpretation will prove limited and irrelevant in other times and places; in
the words of Clines, 'the servant poem exists to create another world, one
that is recognizably our own and that questions who and where is the servant
for oneself'.[69] Beholding van Gogh's painting, the viewer is expected to cre-
ate, to author, a new meaning and setting for the message that the poem con-
tains—just as the three creators, or authors, in the painting have already
done: van Gogh, Zola and the prophet-poet.

67. Kathleen Powers Erickson (*At Eternity's Gate: The Spiritual Vision of Vincent van
Gogh* [Grand Rapids: Eerdmans, 1998], pp. 95-96) explores how van Gogh, having aban-
doned the institutional Church, was seeking a new form, a modern context in which to
express his values in a more meaningful way.
68. Clines, *I, He, We and They*, p. 60.
69. Clines, *I, He, We and They*, p. 61.

Unlike the various instances of the *imago pietatis* with their evocations of pity and sorrow, this largely symbolic painting does not evoke an immediate affective reaction on the part of the viewer except through the human and touching character of Pauline Quenu. That the heroine of the book is female and that she should be closely identified with the male servant of the poem is most significant; the identification of the Man of Sorrows as a young teenage girl concealed in the pages of a contemporary novel contrasts sharply with his ubiquitous 'maleness' from the Renaissance. The image of God preferred by van Gogh in his letters (and in his art as well) was not male but more often that of an idealized, compassionate, maternal figure who, through devoted care, brought joy to humanity; much of his imagery came from Isaiah, for example 49.15 where God is compared to a nursing mother—'Can a woman forget her nursing child or show compassion for the child in her womb? Even these may forget, yet I will not forget you.' It was also to the image of woman that he turned to explore notions of sorrow and suffering[70] and to one woman in particular, Sien Hoornik. Sien was a prostitute and alcoholic who was pregnant and already had a small daughter and been abandoned by her husband when van Gogh began to live with her. He described her, in language reminiscent of Isaiah, 'withered—literally like a tree which had been blasted by a cold dry wind, its young green shoots withering'.[71]

Sien was his model for the dejected and abandoned woman depicted in *Sorrow* (Fig. 37) where the image of the young withering shoots form the background. The theme of the abandoned woman is highlighted at the bottom of the drawing in the reference to the novel *La femme* by the contemporary writer Michelet:

Comment se fait-il qu'il y ait sur la terre une femme seule-delaissé?

How can there be on earth a woman so alone and so abandoned?

Van Gogh intended that the drawing should express more than the plight of Sien and stated that it refers to 'the struggle of life' in general. I would

70. For a discussion of this and other images of 'sorrowing women', of how van Gogh relates to the widespread late nineteenth-century fantasy of rescuing 'fallen women' and of his understanding of Michelet as a moral authority on women and family, see Carol Zemel, 'Sorrowing Women, Rescuing Men: Van Gogh's Images of Women and Family', *Art History* 10.3 (1987), pp. 351-68.

71. Albert J. Lubin, *Strangers on the Earth: A Psychological Biography of Vincent van Gogh* (New York: Da Capo Press, 1972), p. 4. The correspondence between the landscape and the imagery of Isaiah is reflected in a letter of van Gogh, 'I tried to put the same sentiment into the landscape as I put into the figure: the convulsive, passionate clinging to the earth, and yet being half torn up by the storm. I wanted to express something of the struggle for life in that pale, slender woman's figure as well as in the black, gnarled and knotty roots'.

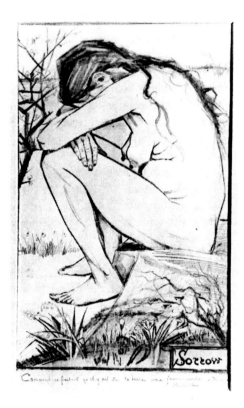

Fig. 37. Vincent van Gogh, *Sorrow* (1882)
The New Art Gallery, Walsall, The Garman-Ryan Collection.

propose that the figure in *Sorrow* should be associated with the unidentified
and abandoned woman at the start of Isaiah 54 whose future happiness God,
in language of compassion and affection, re-affirms. In supporting and caring
for Sien, van Gogh frequently used the image of God as a compassionate
husband from Isa. 54.5. The image of Sien, symbolizing the 'struggle of life'
in general, is intended to evoke a reaction of pity and compassion from the
viewer and to address situations of sorrow and suffering in society; it is the
figure of Sien with her sad demeanour, sorrowful posture and look of dejec-
tion that evokes the response one might have expected had van Gogh pro-
duced a figurative portrayal of the Man of Sorrows, considering his close
identification with that text. Joan Greer suggests, in the light of the depic-
tion of Pauline Quenu as a modern day Man of Sorrows in *Still Life with Open
Bible* and Sien as an image of sorrow, that we look at the two images together
to get a better appreciation of the artist's work. Juxtaposing these images also
corresponds to contemporary ways of reading Isaiah 53 and 54 where com-
parisons are drawn between the roles and fates of the two servants. Peter

Quinn-Miscall notes that both poems reveal the surprising treatment that one chosen by God may have to undergo and the tensions that exist between expectations of justice and mercy. Van Gogh in *Still Life with Open Bible* depicts a female 'Man' of Sorrows concealed in Zola's closed novel; on the other hand, in *Sorrow* we have a figure that speaks to us powerfully and eloquently of rejection, abandonment and suffering and that visualizes the plight of the male servant of Isaiah 53 as much as the female figure of Isaiah 54.

Patrick Hall, The Tale Is Told That Shall Be Told
A final painting, from the late-twentieth century, that offers the viewer an opportunity to engage with the dynamic of Isaiah 53 is by the contemporary Irish artist, Patrick Hall, *The Tale Is Told That Shall Be Told* (Fig. 38). The title of this highly symbolic and enigmatic work makes no reference to the Bible and the artist did not have the biblical poem particularly in mind when painting it.[72] But Gesa Thiessen notes that the less obvious the religious matter of a modern work of art is, the more open and personal the interpretation can be and that abstraction and symbolism, instead of figuration, encourages this response even further.[73] The importance of symbolism lies in its mysterious powers of disclosing and revealing, its stirring the imagination and its transforming effect. In modern art, artistic subjectivity rather than Christian iconography of past centuries is central; the subjective-existential moment of the artist is its point of departure and so the modern work of art through symbol and imagery can be an expression and interpretation of the artist's religious experience. To appreciate, then, the impact of the symbolism of *The Tale Is Told That Shall Be Told* and before we can relate it to Isaiah 53, we need first to outline some of the personal factors and perspectives that influenced Patrick Hall's work.

Patrick Hall was born in Ireland in 1935. Thiessen describes him as a deeply introspective and private person whose experience of life has been one of difficulties and complications that have been somewhat alleviated since becoming a practising Buddhist. He stresses the importance of contemplation and the Four Noble Truths that recognize the existence of suffering as well as the possibility of liberation from it. Living the eight-fold path leads

72. Hall states, 'Where my particular version of the Book comes from would be hard to say. It has all sorts of visceral resonances and texts that haunt the imagination...and I suppose there is meaning but I think the image is above meaning and myth' (personal correspondence from the artist, Autumn 2004). With regard to Isaiah 53, he considers it 'one of the loveliest chapters in the whole Bible'.

73. I am grateful to Gesa Thiessen for points of clarification with regard to Patrick Hall's background and painting style. The information in this section on the artist and his painting comes from her analysis of his life and work in *Theology and Modern Irish Art*, pp. 112-19, 232-34.

him to compassion and love, the main points of comparison, he feels, between Christianity and Buddhism. He strongly rejects the idea of perfection as it does not allow for weakness: 'art is about human weakness, in fact increasingly so today when man is weakened by social and personal alienation'. Acknowledging weakness basically affirms the truth about oneself, it is the raw material of one's life; neither the great prophets nor mystics nor Jesus were perfect, 'they worked with what they had'. Hall admired Grünwald's syphilitic Christ as filling one with wonder and admiration and not disgust. With regard to the Bible, he sees biblical stories as archetypal, as touching something primitive: 'the Bible speaks about the simplest things, it's about feeling, it's about saying the truth about something…it's so simple that its stories become universal'. Like van Gogh, Hall stresses the social and ethical obligations of the artist: 'It's taking on a responsibility to question humanness, meaning and meaninglessness. Painting must serve the interests of human beings…it must contribute to the harmony and the peace of the universe and to the energy of the universe.' For Hall, his work as an artist has a profoundly ethical dimension.

Fig. 38. Patrick Hall, *The Tale Is Told That Shall Be Told* (1989), Private Collection.

John Hutchinson notes that 'Hall's awkward and sometimes difficult works gain their vitality through their tension and ambivalence and their sense of turmoil at the edge of disaster',[74] and this is true of the painting here. Its title is the slightly altered first line of Bartok's opera, *Bluebird's Castle*, 'the tale is old that shall be told' and for the artist, its meaning implies 'dealing

74. John Hutchinson, *Patrick Hall* (Catalogue of Exhibition; Dublin: The Douglas Hyde Gallery, 1995), p. 7.

with fate and fatalism'. The painting presents the viewer with an open book in bright red; the spine of the book, reminiscent of the spine and rib cage of a human, dominates the painting. The red of the open book contrasts sharply with its grey-black background and is partly surrounded by a circle that resembles a halo. A candelabrum is placed on either side of the book with lit candles while little red strokes resembling blood or fire emerge from the book. The bottom of the painting is decorated by a nervous zigzag line (the same red as the writing in the book) that creates an unsettling effect, particularly if the zigzag effect is seen as joining up with the swirling circle that surrounds the book; the same red in this line and in the lines of the book invites us to read something disturbing into the book's contents. The open book, the prayer shawl and the candelabra provide a 'consciously Jewish' aspect that Hall was keen to give the work,[75] probably symbolizing the Hebrew Scriptures, the shawl with which the Torah is held in synagogue worship and the Jewish menorah (notwithstanding the two candles instead of seven). The red dabs on the fringes of the shawl (above the book) convey the idea of blood, an allusion to the blood sacrifices of animals carried out to effect atonement for the offerer (for example in Lev. 1–7). Hall explained that the blood refers to 'all the people who died of the law' and Thiessen suggests he had capital punishment in mind, particularly capital punishment as expressed in the Hebrew Bible (for example, Exod. 21.12-14; Num. 35.29-34). The lit candles at the side and the halo suggest reverence for and contemplation of the written word and the red dabs below the book may symbolize blood that drops from the book (or human rib cage) or fire from below that threatens to destroy the book, its thoughts or its author.

Despite its title, a single narrative or a simple tale is not offered in this painting. Thiessen describes it as 'something of a religious epiphany'; it has a strong feeling of mystery, ritual, worship and adoration, yet because of the grey black background it touches on something sinister.[76] The book or human rib cage, a living yet bleeding intellect or body, enhances this feeling of ambivalence or even darkness. What is the tale that the painting tells? Thiessen suggests an interpretation that accords with Hall's concerns with book censoring through the ages: 'it is the story of the victims whose thoughts die precisely through those who perceive themselves as the ones responsible for the proper handing on of truth'.[77]

When I first saw this painting, it brought to mind some striking aspects of the images included in this chapter: the figure of the Man of Sorrows of the *imago pietatis* with its visible spine and rib-cage (Figs. 29 and 30) often

75. On Hall's love of Jewish symbolism and culture, see Thiessen, *Theology and Modern Irish Art*, p. 232.

76. Thiessen, *Theology and Modern Irish Art*, p. 233.

77. Thiessen, *Theology and Modern Irish Art*, p. 233.

saturated with blood, and van Gogh's *Still Life with Open Bible* (Fig. 36).
However, unlike the latter, there is no indication of a scriptural reference,
no clue (such as Zola's novel) as to how we should interpret the significance
of the open book; here, we encounter a more intensified and abstract sym-
bolism. As viewers, we are invited to project a text, a narrative, on to the
blank pages of the book; the Jewish symbols of the painting, together with
the subjective concerns of the artist suggest, to me, the text of Isaiah 53. It
represents a contemporary and symbolic expression of the visual tradition
associated with the Man (or Person) of Sorrows; the servant, symbolized by
the spine, tries to emerge, to struggle free from the book, blood signifying his
or her atonement for the sins and wrongdoings of others. We witness the
destruction of the servant as he, or she, is sacrificed before our eyes, the halo
that encompasses the book suggesting the innocence of the just person who
suffers for others.[78] Like van Gogh, Hall recalls the still-life or *vanitas* tradition
that urges the viewer to reflect on life's priorities, frequently by reference to
death; here, however, the intensity of the symbolism of fire and flames (the
candles are lit and not extinguished as in the van Gogh painting)[79] suggest a
cataclysm, a final conflagration. The contents of the book become more enig-
matic and unsettling and we can almost feel the dripping blood as we are
drawn into the painting's symbolism.[80] If we look at Hall's painting with the
imago pietatis and *Still Life with Open Bible* in mind, it offers a contemporary
visual reading of the biblical poem which merges the text and servant as one:
the figure of the servant *is* the text, conveyed by the spine that symbolizes
both the rib-cage of a human person as well as the binding or spine of the
book.

The Artist as Reader of the Bible

Finally, I want to return to the point made in the introduction as to how art
historians, when commenting on images of Christ as the Man of Sorrows,
underplay the role of Isaiah 53 as if the artist were simply an illustrator of
biblical scenes and not an active *reader* of the Bible interested in facilitating
new and unexpected meanings emerging from the text. Exceptionally, Paolo
Berdini, with specific reference to the late sixteenth-century artist Jacopo
Bassano, has explored the process and implications of what happens when an

78. Van Gogh stated: 'I want to paint men and women with that something of the
eternal which the halo is used to symbolize and which we seek to convey by the actual
radiance and vibration of our colouring' (cited in Wessels, 'A *Kind of Bible*', p. 81).

79. In Zoppo's *Dead Christ Supported by Saints*, c. 1475 (National Gallery, London), a
version of the *imago pietatis*, the artist includes two burning candles.

80. Thiessen suggests that because of Hall's adherence to Buddhism, the sacred text
may also refer to the Buddhist scriptures.

artist paints a subject or narrative from the Bible.[81] In the place of traditional art-historical criticism that emphasizes text as *source* and the *function* of the corresponding image, he advocates the notion of textual expansion. What the painter visualizes is not the narrative of the text but its expanded form as it emerges from the painter's reading of it. Painting visualizes a *reading* and not a text, for the relationship between a text and its visualization has to take into account the circumstances under which that text is read, in addition to what makes it the object of the particular interest that might result in its visualization. Painting (and not only Bassano's) thus proceeds by a process Berdini calls 'visual exegesis'. Following the exegetical models of scripture, visualization addresses the *discursive* status of the text: the notion of 'visual exegesis' thus registers and promotes the crucial move from image to beholder.

The artists who depicted the Man of Sorrows in the selection of images in this chapter succeeded in addressing the discursive nature of Isaiah 53 and engaging the viewer in the subject matter of the painting. The images draw the viewer into the alternative world of the servant in a very direct and striking way either through the eyes of the figure that transfix the viewer, or by placing the servant's story on the pages of an open book for the viewer to read. In engaging us empathetically with the servant, each image creates a unique meaning for the biblical poem, or, in the words of Gadamer, each visual instance of the Man of Sorrows extends and expands the world of the servant; it facilitates a coming forth, an epiphany of the poem and its concerns in our lives. This is more than a philosophical reflection: in today's world, we can probably assume that the majority of people who are introduced to, and engage with, the poem do so through one of its hundreds of visual expressions in galleries and churches around the world rather than through a liturgical reading or explicitly religious reading of the text and, as many will choose to interpret the image from outside the Christian tradition, it will continue to create ever new, unexpected and challenging meanings for its viewers. It also challenges the professional biblical commentator to 'read' the Bible through its visual expressions, just as the artist van Gogh challenged his father, pastor and professional interpreter of the Bible:

> I too read the Bible just as I read Michelet, Balzac or Eliot but I see quite different things in the Bible from what Father does, and what Father in his little academic way gleans from it I cannot find at all.[82]

81. Jacopo Bassano (1518–92) was 'a painter and reader of scripture. His biographers tell us that, when fatigued by painting, he resorted to scriptural reading. Reading was his virtuous activity' (Berdini, *The Religious Art of Jacopo Bassano*, p. xi).

82. Ronald de Leeuw, *The Letters of van Gogh* (London: Penguin, 1997), p. 115.

6

BIBLICAL LANDSCAPES IN THE ISRAEL MUSEUM

Visualizing Biblical Landscapes

The landscapes and terrains of Jerusalem and the Holy Land and the cultural diversity of their inhabitants have proved irresistible to artists, painters and photographers for many centuries; one of the fascinations the land holds for them is, of course, the association of the various topographical sites in the region with the corresponding texts from scripture that locate momentous and spectacular episodes in the interweaving narratives of Judaism, Christianity and Islam, and that create such vivid and colourful environments, appropriately dramatic for the founding fathers of great faiths.[1] But the pictures we see are never really 'neutral' images showing the place or site 'as it

1. Recent publications that evoke the visual landscape of Jerusalem and the Holy Land include the works of French-Jewish artist Abel Pann (*The Five Books of Moses: Abel Pann* [Jerusalem: Mayanot Gallery, 1996]), the black and white prints of the early Dominican Fathers of the Ecole biblique et archéologique française de Jérusalem (Jean-Michelle de Tarragon [ed.], *Al-Quds Al-Sharif: Photographies 1890–1925, patrimoine musulman de la Vielle Ville de Jérusalem* [Jerusalem: Ecole Biblique, 2002]) and the collection of the famous Armenian photographer Elia Kahvedjian (Kevork Kahvedjian [ed.], *Jerusalem through my Father's Eyes* [Jerusalem: Elia Photo Service, 1998]). In addition, see Naomi Beecham, *Jerusalem and its Surroundings through the Ages* (Jerusalem: Palphot Press, 1984), Elaine Wilson and Motke Blum, *Jerusalem: Reflections of Eternity* (London: Shepheard–Walwyn Publishers, 1990), Brosh and Milstein (eds.), *Biblical Stories in Islamic Paintings*, Nisan N. Peres (ed.), *Visions d'orient* (Jerusalem: The Israel Museum, 1995), 'Terre Sainte', a special edition of *Le monde de la Bible* 100 (1996), Dan Bahat and Shalom Sabar (eds.), *Jerusalem—Stone and Spirit: Three Thousand Years of History and Art* (Jerusalem: Matan Arts Publishers, 1997), Ellen Frankel, *The Illustrated Hebrew Bible* (New York: Stewart, Tabori & Chang, 2000) and John Keane, *The Inconvenience of History: Paintings from Gaza and the West Bank* (London: Christian Aid, 2004). Dictionaries of iconography, on the other hand, include only very sparse entries on the biblical Jerusalem in iconographic tradition and concentrate instead on the New Jerusalem of Revelation; see for example, Duchet-Suchaux and Pastoureau (eds.), *The Bible and the Saint*, p. 145.

is' because they invariably reflect a wider context or a more specific interest, perhaps an atmosphere the artist wants to generate or a religious or political purpose that the image intentionally promotes. Today, visual images of Jerusalem and the Holy Land tend to be used in the media and other popular reportage to bring home the ironies involved in the horrors of the Israel–Palestine situation that take place 'in the land of the Bible', with reporters conjuring up biblical-like phrases to accompany such images in order to make the apparent irony more explicit. But the associations they wish to make, as they invite the viewer to identify personally and affectively with visual images of Jerusalem and the Holy Land, are nothing new and have to do with the longstanding notion that the sites depicted are scriptural and so justify the claim that, if we actively engage with them, they have the potential to disclose something divine to us, just as the scriptural text itself does.[2] The implication is that the viewer in identifying in some way with the biblical site is benefited spiritually; no surprise, then, that viewers in all ages have sought to find in the image familiar, recognizable features that would make their association with the place it depicts more tangible and real. Before moving to the main topic of this chapter (how a specific collection of Old Masters' paintings depicting well-known biblical themes in the Israel Museum is arranged and how this arrangement influences the way we see and interpret individual works in the collection), I want first to set the scene by drawing attention to the overwhelming desire throughout history to make pictorial representations of biblical sites that reflect specific spiritual, cultural or political viewpoints in order to intensify the intimacy and strengthen the emotional bond between a divinely appointed site and the life of the believer. Some of the most striking examples come from the late Middle Ages and nineteenth-century Europe and America.

In late-mediaeval and Renaissance manuals of prayer, the ability to visualize places associated with important events in the Bible was considered central to prayer and meditation. The *Giardino de orationi* (The Garden of

2. This is especially evident in travelogues from the latter half of the nineteenth century. W.M. Thomson begins his 1880 volume 'The land where the Word made-flesh dwelt with men is, and must ever be, an integral part of Divine Revelation' (*The Land and the Book* [London: T. Nelson & Sons, 1880]). Charles Kent, Professor of Biblical Literature at Yale University at the start of the twentieth century notes: 'Biblical geography is the first and in many ways the most important chapter in divine revelation which was perfected through the Hebrew race and recorded in the Bible. Through the plains and mountains, the rivers and seas…the Almighty spoke to men as clear and unmistakably as he did through the voices of his inspired seers' (Charles F. Kent, *Biblical Geography and History* [New York: Charles Scribner's Sons, 1900], p. 5, cited in Burke O. Long, 'Reading the Land: Holy Land as Text and Witness', in Fiona C. Black, Roland Boer and Erin Runions [eds.], *The Labour of Reading: Desire, Alienation, and Biblical Interpretation* [Semeia Studies, 36; Society of Biblical Literature, Atlanta: Scholars Press, 1999], pp. 141-59 [143]).

Prayers, 1454) instructs the faithful how best to meditate on the story of the Passion by making a 'memory place' of their own familiar surroundings that corresponds to the topography of the biblical story:

> The better to impress the story of the Passion in your mind…it is helpful and necessary to fix the places and people in your mind: a city for example will be the city of Jerusalem—taking for this purpose a city that is well-known to you. In this city find the principal places in which all the episodes of the passion would have taken place—for instance a palace with a supper room where Christ had the last supper with the disciples, and the house of Anne and that of Caiaphas, with the place where Jesus was taken in the night, and the room where he was brought before Caiaphas and mocked and beaten. Also the residence of Pilate where he spoke with the Jews, and in the room where Jesus was bound to the column. Also the site of Mount Calvary where he was put on the cross and other like places…and then too you must shape in your minds some people, well-known to you, to represent for you the people involved in the Passion.[3]

This spiritual advice was readily translated into paint and Memling's *Scenes from the Passion* (Turin, Sabauda Gallery, 1470–71) is virtually an illustration of the passage just cited: the events of the Passion are located in various sites distributed throughout what appears to be a familiar city, representing Jerusalem.[4] Like the manual of prayer, Memling's imaginative depiction of places associated with the Passion encourages the viewer

> to enter the painting's fictive world, to move through the picture's space as though traversing the imaginary room or houses of the ancient treatises or the familiar environments of the devotional book. Viewing or looking [at places associated with the Passion] is presumed to be an active process, a kind of devotion.[5]

In nineteenth-century Europe, the desire to associate important sites in the Bible with the readers' own world and the need for 'pictorial aids' that corresponded to how readers imagined these sites to be are evidenced by the quantity (and variety) of illustrated Bibles from that period. They demonstrate the popular demand for the visualization of biblical sites (and characters) that conformed to readers' own varying religious and cultural backgrounds;

3. Cited in Andrews, *Story and Space in Renaissance Art*, p. 29.

4. M. Baxandall notes (*Painting and Experience in Fifteenth Century Italy* [Oxford: Oxford University Press, 1972], p. 45, cited in David Freedberg, *The Power of Images*, p. 168): 'The painter was a professional visualizer of the holy stories but what we easily forget is that each of his pious public was likely to be an amateur in the same line, practiced in spiritual exercises that demanded a high level of visualization—at least of the central episodes of the New Testament'.

5. Andrews, *Story and Space*, p. 32. In one of Dürer's engravings, the New Jerusalem stands as sixteenth-century Nuremberg.

sketches and maps of the 'holy places' included in early guide-books and other literature show how nineteenth-century Europeans were drawn particularly to romantic and reassuringly 'oriental' images of the Holy Land. For example, the lithographs of the nineteenth-century Scottish engraver, David Roberts, illustrate the popularity of images that highlighted 'Eastern' aspects of biblical sites for Western viewers; some present-day editions of his prints that set his nineteenth-century depictions alongside actual images of the sites today show just how romanticized his drawings actually were.[6] Frederick Bohrer, in *Orientalism and Visual Culture*, where he applies a Saidian approach to the visual arts, shows how artists in the nineteenth century felt the need to 'orientalize' biblical places and people to conform to the expectation of their viewers in Europe. The best example, he argues, is Delacroix's *Death of Sardanapalus* (Paris, Louvre, 1827–28) depicting the fall of Assyria, but he also recounts how Tissot, who visited Palestine frequently in order to complete his illustrations of the Old Testament, described his disappointment at the pitiful size of the actual mountain he was shown as Calvary, and how he subsequently exaggerated his depiction of it so as not to disappoint his viewers.[7] William Turner produced twenty-five illustrations for William and Edward Finden's *Landscape Illustrations to the Bible* (1836) that promised to be 'the most accurate and authentic information that could be obtained', yet they clearly reveal his naturalistic attempts to construe the contemporary biblical landscape.[8] The assertion of Michel Thevouz, made in the context of French Orientalism, sums up perfectly the attitude and approach of artists (and their patrons) to the pictorial representation of biblical places and people:

> If Orientalism deserves its name, it is not for having irradiated European painting with the colours of the Orient, but to the contrary, having 'orientalized' them according to the romantic dreams of Paris.[9]

With regard to nineteenth-century American art, John Davis observes that the 'geo-scriptural fusion of writ and region' that had come to determine American attitudes towards the Holy Land by the end of the century is summed up by Arthur Bird's optimistic delimitation of the borders of the United States as 'bounded on the North by the North Pole, on the South by the Antarctic, on the East by the first chapter of the Book of Genesis and on

6. Nachman Ran (ed.), *The Holy Land: 123 Coloured Facsimile Lithographs of David Roberts* (Jerusalem: Terra Sancta Arts, 1982).

7. Frederick Bohrer, *Orientalism and Visual Culture: Imagining Mesopotamia in Nineteenth-Century Europe* (Cambridge: Cambridge University Press, 2003), pp. 12, 54. See also, on the *Death of Sardanapalus*, Gérard-Georges Lemaire, *The Orient in Western Art* (Cologne: Könemann, 2001), pp. 204-206.

8. Bohrer, *Orientalism*, pp. 60-61.

9. Michel Thevoux, *L'académisme et ses fantasmes: le réalisme imaginaire de Charles Gleyre* (Paris: Editions de Minuit, 1980), cited in Bohrer, *Orientalism*, p. 19.

the West by the Day of Judgement'.[10] The metaphor of the United States as a new Israel meant that the actual landscape of Palestine and Syria could be invoked to suggest the notion of America as heir to the sacred topography.[11] But when artists from the United States actually found themselves in the Holy Land, they did not turn their attention to conventional European orientalist genre scenes (since they regarded these, particularly the figures they contained, as having been tainted by corrupt French and Italian influences) but preferred instead to focus on depicting the 'pure' landscape; it was popularly believed that figural scenes that obscured the 'purity' of the landscape, even if taken from scripture, would not be tolerated by the market. The author and painter Thomas G. Appleton emphasized the point thus:

> As historic landscape, Palestine is full of those suggestive sites, those eloquent battlefields and homes of kings and prophets which do not need the help of mere beauty to give them interest. This charm hangs over the whole land and no artist can fail to feel that his subject is inadequate if, besides the faithful rendering of sacred scenes, he should manage to give with it that sentiment of the place to which no beholder can be indifferent.[12]

Despite this advice to concentrate on the 'purity' of the landscape, by the turn of the century the skill and ability to depict biblical sites had come to be understood as residing in the artists' minds rather than in any particular regional terrain. When they did go to Palestine, their painting was less influenced by what they saw than by the cultural and religious beliefs they carried with them.[13]

But this chapter is primarily concerned not with how viewers living in Europe or North America might wish to interpret visual images of biblical sites and their reasons for doing so, but rather the opposite: it is concerned with how viewers situated in Jerusalem and the Holy Land (even if only temporarily) might view depictions of biblical scenes in a series of Old Masters' paintings permanently housed in the Israel Museum, and whether the geographical (or perhaps geopolitical) context of the collection informs and influences our interpretation of it. I am not suggesting that because we are in the Middle East, we are, somehow, culturally in the 'Orient' looking westwards—

10. Arthur King, *Looking Forward: A Dream of the United States of the Americas in 1999* (New York: L.C. Childs & Son, 1899), p. 7, cited in John Davis, *The Landscape of Belief: Encountering the Holy Land in Nineteenth-Century American Art and Culture* (Princeton: Princeton University Press, 1996), p. 4.

11. Davis, *The Landscape of Belief*, p. 5.

12. Thomas G. Appleton, *Syrian Sunshine* (Boston: Robert Brothers. 1877), p. 165, cited in Davis, *The Landscape of Belief*, p. 5.

13. See Davis, *The Landscape of Belief*, pp. 209-10, for this and other conclusions he draws from his study of American artists Miner Kellog, Frederic Church, James Fairman and John Banvard.

the cultural identity of Jerusalem is far too complex for that. But, in theory at least, by virtue of our location, we are more likely to interpret the paintings in the light of the topography of the city and against the landscapes of the wider region, conscious of the fact that it is precisely these same physical features that provide the 'geographical' structure, or narrative markers, to large swathes of biblical literature. As viewers in Jerusalem, we bring to the image a greater awareness of, and sensitivity to, the importance of the topographical details included in a biblical painting and in the corresponding narrative. Second, in a city sacred to three faiths and where 'culture' is defined in terms of Jewish, Christian and Islamic tradition, our interpretation of the paintings should be illumined not only by the predominant Judaeo-Christian narrative through which most of Western biblical art is normally filtered but also by important aspects of Islamic tradition. Notwithstanding how compatible or conflicting their interpretation may be, the biblical episodes that have given rise to such divergent religious traditions are presented to us graphically and affectively in this collection in Jerusalem.[14]

The importance of *place* in interpreting literature and art has been discussed elsewhere: Geyer-Ryan explores how the topography of Venice 'unsettles not only the bonds of love, of nation and of race but all the delusions of grandeur' that we associate with Venice in the arts,[15] and Zemel illustrates how unique photographic collections depicting Jews in the 1920s and 1930s in the so-called 'Pale of Settlement' that stretched from the Baltic to the Black Sea look very different today when seen from the viewpoint of Jewry in America or Israel.[16] But the most pertinent example in this regard is to be found in the distinctive and very beautiful paintings of the French-Jewish Zionist artist, Abel Pann (1883–1963), or rather in the ideological inflection given to his work in the published volume of his paintings that illustrate the Hebrew text of the first five books of Moses (published in Jerusalem in 1996). Gideon Ofrat steers the viewers of the paintings along definite ideological lines relating to place, to the land:

> Inspired by his 1913 stay in Palestine (to where he moved permanently in 1920), Pann resolved to give the world its first authentic graphic version of the Bible, the only version that would ring true—for his paintings would be executed in the land where the Bible evolved, where the events it related had taken place…the virgin landscapes of the land of Israel in the early twentieth

14. For a detailed exploration, see the classic study by Francis E. Peters, *Jerusalem* (Princeton: Princeton University Press, 1985).

15. Helga Geyer-Ryan, 'Venice and the Violence of Location', in Mieke Bal (ed.), *The Practice of Cultural Analysis: Exposing Interdisciplinary Interpretations* (Stanford, CA: Stanford University Press, 1999), pp. 143-50.

16. Carol Zemel, 'Imagining the "Shtetl": Visual Theories of Nationhood', in Bal (ed.), *The Practice of Cultural Analysis*, pp. 102-21.

century offer the perfect setting for events that take us back to the dawn of mankind: by peopling them as he does with his characters, Pann demonstrates a spirit akin to that of the pioneers whose efforts made the land fruitful... Pann's art is profoundly Jewish, imbued with the spirit of the land and characteristic of the art that evolved there—a feeling of immanence pervades his paintings, transforming Abraham, Moses, Sarah, Rachel and other biblical figures into primordial forces of nature while the spiritual presence of the creator permeates every stone and shrub.[17]

Ofrat's points are reinforced by Rabbi A. Hazan and Teddy Kollek who stress the Zionist ideology relating to the land, the only true perspective from which Pann's paintings can be fully appreciated:

They reflect and indeed radiate the majesty of the landscapes of Israel as they appeared in the 1920s. Against this background and in the landscapes of our beginnings, Pann visually traces for us the original characters—and character- istics—of our forefathers. Pann is privileged to fulfil the blessing of Genesis: 'God enlarged Japhet and he shall dwell in the tents of Shem'. Which is to say: in order to reside within the tent of Israel, the visual arts must be divinely inspired, and thus be in the spirit of Shem.[18]

Rabbi A. Hazan

Abel Pann was among the first of the Zionist artists whose work gave expres- sion to the vision and reality of the Jewish people's return to its land. His works combine the abstract and realistic while uniting East and West. Abel Pann came to Jerusalem bearing Western Culture, but there he imbibed images of the East and its special atmosphere. His offering to the West was ancient Jewish orientalism, charged with the strength of primeval power, reinforcing the ancient message, 'From Zion goes forth the Torah'.[19]

Teddy Kollek

The problem with such a narrow interpretation is that Pann's paintings— which indeed certainly do offer some of the most imaginative and evocative visual illustrations of the biblical narrative—are construed as offering a nar- rative that supports only the political aspirations of Zionism. If, on the other hand, Pann's paintings are seen alongside other collections from 1920s and 1930s Palestine, for example the photographic collections of the early Fathers of the Ecole Biblique or the Armenian collection of Elia Kahvedjian from the same period,[20] the visual narrative becomes more inclusive: viewing other collections contemporary with Pann's work, we become more aware of the distinctiveness and subtlety of his paintings. In any case, the way Pann's work has been interpreted, almost exclusively within the political perspective of

17. Pann, *The Five Books of Moses*, Introduction.
18. Pann, *The Five Books of Moses*, Introduction.
19. Pann, *The Five Books of Moses*, Introduction.
20. See footnote 1.

Zionism, serves as a reminder that visual images of the Holy Land are rarely neutral—they come to us filtered through the lens of religious or political ideologies.

Clearly, Ofrat's claims concerning Abel Pann's work cannot extend to the collection of European paintings in the Israel Museum from the seventeenth century (mostly French and Dutch)—they depict well-known biblical scenes originally intended for a Christian viewership—nevertheless, in their present location in a Jewish state within the wider Arab Middle East, these paintings bring to the fore several aspects that would have remained hidden or at least less explicit, had we first seen them in a gallery in France or Holland; they bring to the surface disturbing aspects and introduce sensitivities that we might otherwise have considered quite insignificant. Since the collection has been intentionally arranged as a gallery of *scripture* paintings, I want to explore how the paintings interact *with each other* in drawing out unexpected meanings from biblical narratives; what is striking in this gallery is precisely the way the characters in the paintings seem to converse with each to create a larger, more unified story than what the individual fragmented episodes in each separate painting might suggest. Generally, my approach follows that of Mieke Bal[21] in that I interpret this collection as a continuous visual *narrative* (as opposed to a range of individual paintings), keeping in mind that for Bal 'there is no narrative that does not entail particular selections and omissions, emphases and evasions'.[22] The visual narrative that emerges from the present arrangement of paintings leads the viewer to interpret the subject matter from within very definite boundaries (ideology, perhaps) that corresponds to Bal's notion of 'focalization'; in addition, her exploration of how the juxta-position of paintings ('when one happens to end up next to another so that you see the one out of the corner of your eye while looking at the other')[23] produces challenging and unexpected interpretations also provides a useful

21. Mieke Bal, 'Memories in the Museum: Preposterous Histories for Today', in Mieke Bal, Jonathan Crewe and Leo Spitzer (eds.), *Acts of Memory: Cultural Recall in the Present* (Hanover, NH: University Press of New England, 1999), pp. 171-90, and 'On Show: inside the Ethnographic Museum', in Mieke Bal (ed.), *Looking In: The Art of Viewing* (Amsterdam: G+B Arts, 2001), pp. 117-60.

22. Mieke Bal, 'On Show', p. 12.

23. Mieke Bal, 'On Grouping: The Caravaggio Corner', in Bal (ed.), *Looking In*, pp. 161-90. Her essay relates to two of Caravaggio's paintings that hang side by side in The Gemäldegalerie, Berlin. It is interesting that the curator of the *Musée Message Biblique Marc Chagall* in Nice should use almost identical language in describing how Chagall's biblical paintings are arranged: 'L'accrochage des œuvres du Message Biblique est resté tel que l'artiste l'a imaginé, non pas dans l'ordre chronologique de l'histoire biblique, mais comme une composition d'ensemble. Ainsi le visiteur, l'œil attiré par une domaine chromatique ou un thème, peut-il flâner d'une œuvre à l'autre' (Jean-Michel Foray, *Message biblique Marc Chagall* [Paris: Réunion des musées nationaux, 2000], p. 25).

perspective from which to critique the museological layout of this gallery. But my focus differs from that of Bal in that I am interested primarily in how the visual narrative suggested by the collection of paintings interprets or nuances the parallel literary narrative of the Bible. The reason why I began this chapter by noting the tendency of both artist and viewer in nineteenth-century Europe and North America to use the background and landscape of biblical paintings as a mirror that reflected their own world is that, in contrast, when viewing Old Masters paintings in Jerusalem, I want to allow the topography of the region, so important in biblical narrative, to interact with, or illumine, the painting's own background and landscape. Seen in this light, the painting's background no longer mirrors the world of the artist or his original viewers but now becomes a window, as it were, through which we observe the biblical terrain and horizon beyond the museum. I want to argue that what unites the different subject matter of the paintings into a continuous visual narrative is the sacredness of place that each painting evokes through its topographical detail, and that what unites the viewer with the painting, with its subject and characters, is precisely the sharing of that same sense of place,[24] since the physical location and situation of the viewer now correspond to the biblical landscape depicted in the painting itself.

A Gallery of 'Biblical' Art in the Israel Museum

In the Israel Museum, in a wing that houses collections of impressionist and abstract paintings and beside eighteenth-century French and English drawing rooms that have been restored to their original elegant European style, there is a small but unique gallery devoted exclusively to paintings that depict scenes and characters from the Bible. With the exception of Poussin's *The Destruction of Jerusalem*, and two works that depict St Peter, all the paintings refer to texts from the Hebrew Bible that play a central role in Judaeo-Christian, and to a lesser extent Islamic, tradition. Although it is the intention of the museum to display and present these paintings as 'scripture', pragmatic considerations such as the genres and quality of the works held in the museum and the space available within the gallery for hanging them precludes, as one might expect, any claim that the collection offers a comprehensive visualization of the Hebrew Bible; as the collection grows, it is planned to add more paintings to extend the range of New Testament themes and to remove some existing works to other display rooms but at the same

24. Interestingly, J.A. Wylie, in 1883, stated that the purpose of his book was 'to make the land a commentary on the Bible and a witness for it, by employing the light of its landscapes to illuminate the histories of the Old and New Testaments' (*Over the Holy Land* [London; James Nisbet & Company, 1883], p. 6).

time, however, it is proposed that this will continue to be a discrete, if incomplete, collection inspired by biblical events and characters. Apart from Poussin's masterpiece, most of the other paintings are of early- to mid-seventeenth-century Dutch provenance and represent some of the best works of the very considerable Dutch collection that the museum owns. Unlike many temporary exhibitions set up around themes relating to the Bible, both in the Israel Museum and the adjacent Museum of Bible Lands, this is a permanent display of 'scripture' paintings and so regionally, within the Middle East, it is highly improbable that any other highly focused and permanent collection like it exists. Those most likely to visit the collection are Israelis, both religious and secular, especially children as part of education programmes, some Palestinians, both Christian and Muslim, and 'pilgrims' from the Judaeo-Christian tradition from all over the world, drawn to Jerusalem and to the Holy Land to 'see' places associated with their scriptures. A superficial glance at the paintings might suggest that, with authoritative figures such as Abraham, Isaac, Ishmael, Sarah, Hagar, Jacob, Moses, David and Peter well represented (and many of them held in the same high regard by all three faiths), they should appeal equally to all, but considering that viewers come from disparate backgrounds and cultures, there is no doubt that the responses the collection evokes from its viewing public will be considerably diverse.

It is important to get an idea of how the paintings are currently displayed and how this impacts on the way we view them. In the centre, a large panel has been placed half way across the room to provide more wall space and this panel partially divides the room in two. On one side of this panel facing the entrance to the collection hangs the most significant painting, a very large canvas of Poussin's *The Destruction and Sack of the Temple of Jerusalem*, which dominates the entire room. It is the largest, the most valuable and the most accomplished artistically; it is the first we see and it registers an immediate impact on the viewer, so that its dominant subject-matter effectively spills over into the other paintings in the collection and influences the way we interpret them. Opposite the Poussin, at the entrance to the room, side by side, hang two depictions of Abraham in *The Dismissal of Hagar* and *The Sacrifice of Isaac*. Beside them is a painting of *David and Jonathan* and further along, two that depict St Peter. The layout of the gallery is therefore such that the viewer always has to stand *between* the Poussin and the other paintings, suggesting that he or she is being called upon to play a mediating role, as if *The Destruction of Jerusalem* interprets the other paintings *through* the viewer or in its shadow. In the second section of the room, the reverse of the central panel is dominated by the story of David and displays *The Triumph of David* and *The Death of Absalom*; they are positioned across from *David with the Head of Goliath, Jacob Wrestling with the Angel* and *Balaam and the Ass*. To the left hang *The Crossing of the Red Sea* and *Hagar in the Wilderness*. Finally,

three huge tapestries, depicting *Jacob's Dream*, *Moses Giving the Ten Commandments* and *The Sacrifice of Isaac*, dominate the large exit wall.

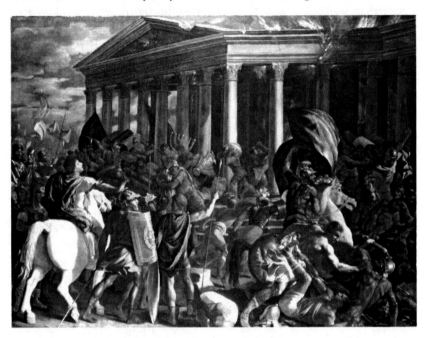

Fig. 39. Nicholas Poussin, *The Destruction and Sack of the Temple of Jerusalem* (1625–26), Gift of Yad Hanadiv in memory of Sir Isaiah Berlin, The Israel Museum, Jerusalem.

Strictly speaking, Poussin's *Destruction and Sack of the Temple of Jerusalem*[25] (Fig. 39) is not based on any subject from the Bible although the fall of the city and destruction of the temple in 70 CE were, of course, important watersheds in emerging rabbinic Judaism and in the history of early Christianity, resulting in both Jews and Christians leaving the city; the event is often presented in New Testament scholarship as a defining moment of crucial

25. The beginning of Poussin's early Roman period includes a group of biblical battle pieces: *The Battle of Joshua against the Amalekites at Refidim* (St Petersburg, Hermitage Museum), *The Battle of Joshua against the Amorites* (Moscow, Pushkin Gallery), *The Battle of Gideon against the Midianites* (Rome, Pinacoteca Vaticana). In his battle scenes, the violent actions and crowded compositions contrast sharply with the serene mood and the carefully balanced lucid compositions of his mythological paintings from the same period. *The Destruction of Jerusalem* belongs to his series of early Hebrew Bible battles. See Avraham Ronen, 'Poussin's *Destruction of Jerusalem* and his Early Years in Rome', in Anna Barber (ed.), *Nicholas Poussin: A Rediscovered Masterpiece* (Jerusalem: The Israel Museum, 1999), pp. 13-15.

importance, the 'parting of the ways' between Judaism and Christianity. In Jewish literature of the period, the event is seen in terms of the fall of Jerusalem and the destruction of the first temple in 587 BCE, and 'spawned reflection about the ways of God and soul-searching about the human condition'.[26] The subject matter of Poussin's painting focuses on a particular episode from 70 CE and is based on a description in *The Jewish War* of Flavius Josephus, a Jew who went over to Rome at the time of the first Jewish rebellion. As the official chronicler accompanying the Roman army, he describes how Titus, the Roman general, sought to save the Temple from total conflagration:

> A runner brought news to Titus as he was resting in his tent after the battle. He leapt up as he was and ran to the Sanctuary to extinguish the blaze. He shouted and waved to the combatants to put out the fire; but his shouts went unheard as their ears were filled by a greater din and his gesticulations went unheeded amidst the distraction of battle and bloodshed. As the legions charged in, neither persuasion nor threat could check their impetuosity; passion alone was in command.[27]

In spite of Titus's renewed efforts to extinguish the fire, the Roman soldiers were caught up in 'their fury, their detestation of the Jews and an uncontrollable lust for battle' (*The Jewish War*, VI.254): the fanaticism of the Jewish rebels led to their downfall and to the tragic chain of events that could not be avoided, as all sides were caught up in the fateful turmoil of war and destruction.[28]

Although Poussin's painting evokes the destruction of Jerusalem following Josephus's account, it is clearly more concerned with Rome than with Jerusalem: the focus is on an enlightened Titus, the Roman who seeks to minimize the violence and bloodshed and whose depiction was inspired by a famous statue of the Roman equestrian Marcus Aurelius, a prime example of Roman virtue and wisdom. The depiction of the fighters derive from reliefs found on Roman sarcophagi, the façade of the Temple resembles the Pantheon in Rome and the menorah was modelled after the well-known image on the Triumphal Arch. The painting's connections with Rome are further underlined by the factors surrounding the painting's commission: shortly after Poussin arrived in Rome from Paris in 1624 the painting was commissioned by Cardinal Barberini, the Pope's nephew, after he had failed in his role as papal intermediary and peace-maker between the two warring Catholic countries, Spain and France. Poussin wanted to draw a parallel between Titus who represented

26. George W.E. Nickelsburg, *Jewish Literature Between the bible and the Mishnah* (London: SCM Press, 1981), p. 280.

27. Josephus, *The Jewish War*, VI.254, cited in Yigal Zalmona, 'A Rediscovered Masterpiece Reaches Jerusalem', in Barber (ed.), *Nicholas Poussin*, pp. 4-6 (5).

28. Zalmona, 'A Rediscovered Masterpiece', p. 5.

the enlightened authority of Rome during the events of 70 CE and Barberini who represented the papal authority of Rome in contemporary Europe. Like Titus, Barberini embodied the forces of moderation and wisdom but, also like Titus, failed—or came too late—to prevent a scene of massacre and bloodshed. The painting depicts human fallibility, the fruits of violence and the notion that, in the end, war and destruction may simply be the inevitable lot and fate of humanity.[29]

Poussin painted a second version of this subject for Barberini in 1638 (Vienna, Kunsthistorisches Museum) and, again, rendered the historical event as if it took place in Rome. Verdi describes this version, now in the gallery in Vienna, as 'one of the most uncompromising and visually discomforting works of his entire career'.[30] Cardinal Barberini gave this painting to the imperial ambassador of the Austrian Empire as a gift for the emperor and probably intended it as political propaganda for the papacy at the Austrian Imperial Court, comparing his own wisdom and tolerance to that of Titus. By this time, he had given the first version (now in the Israel Museum) to Cardinal Richelieu of France so that by 1638 the two versions of the destruction of Jerusalem were to be found in the capital cities of the rival warring nations, France and Austria. The reasons why he did this are speculated upon by the art historian, Anthony Blunt:

> It would be interesting to know why he [Barberini] chose this particular subject [the Destruction of Jerusalem] as a theme for the paintings to be presented to the most powerful—and rival—figures in the European power struggle of the Thirty Years' War. Was it to flatter them with the thought that Emperors—and even Ministers—can sometimes carry out God's will as Titus did in destroying Jerusalem as a punishment on the Jews for having caused the death of Christ? Or did he want to remind them that the Pope, his uncle, was the heir of the High Priests of the Temple, and that his authority was greater than theirs and was received directly from God?[31]

Originally, then, *The Destruction of Jerusalem* had, in fact, little to do with Jerusalem, the plight of the Jews or the destruction of the Temple; these were merely aspects that provided a backdrop against which Poussin could

29. Richard Verdi draws attention to the insights offered by Poussin's paintings into his essentially stoical outlook on life. See Richard Verdi, *Nicholas Poussin 1594–1665* (London: The Royal Academy of Arts, 1995), p. 28. He notes how in *The Death of Germanicus* (described by Tacitus), Germanicus' death becomes an exemplar for the tragic fate that may befall even the noblest of beings and how in his famous depiction of the seven sacraments, his intention was to 'equip the believer with protection against the wayward workings of fortune.'

30. Verdi, *Poussin*, p. 214.

31. Anthony Blunt, 'Poussin at Rome and Düsseldorf', *The Burlington Magazine* 120 (1978), pp. 423-24, cited in Verdi, *Poussin*, p. 215.

depict the futility of a warring Catholic Europe. Josephus's description of violence and destruction, and the role of Titus representing a benevolent and restraining Roman authority, provided powerful images that evoked the excess of bloodshed between the warring Catholic nations and suggested the peace-making role that the Roman papal authority felt it could assume. It is, therefore, important to note that it is not the historical event of 70 CE that is of primary significance in this painting but rather the message and symbolism it sent to the contemporary Europe of Poussin.

For many years, the whereabouts of *The Destruction of Jerusalem* was unknown and it has only recently been acquired for the museum.[32] The reasons for its purchase and its appropriateness for the gallery, for Jerusalem and the State of Israel are emphasized by the museum's director, James Snyder:

> For the Jewish people, the State of Israel and the city of Jerusalem, the subject of the painting has enormous significance, endowing *The Destruction and Sack of Jerusalem* (1625–26) with a meaning well beyond its stature as a masterpiece... *The Destruction and Sack of Jerusalem* makes an addition of enormous importance to the Israel Museum and to its continuing efforts to present works of European Art of the highest quality for the benefit of the Israeli public. It is a radiant work and now that it has come home for the first time to its most appropriate home, it will surely grow even more radiant and full of meaning. Its acquisition also adds in a profoundly important way to the cultural patrimony of the State of Israel... Our first viewing of the painting with all of its power and special connection with Jerusalem remains unforgettable... The designation of the gift of the painting as a gift in memory of Sir Isaiah Berlin, a committed Zionist, and a humanist who saw in art the highest accomplishment of human endeavour, completes perfectly the circle of the painting's journey to the Israel Museum and to Jerusalem.[33]

In the museum's booklet describing the painting, much attention is given to the 'the complex story of its loss and rediscovery'. The story of its 'loss', 'rediscovery' and 'coming home' to Jerusalem suggests that the painting had been in a state of exile just as the Jewish people had been. Following its diaspora-style wanderings around Europe, it has now been cleansed, restored, renewed; it has returned home and has been assimilated into the story of the Jewish people and the State of Israel.[34] Lord Rothschild expresses similar sentiments:

32. For the provenance and history of the painting see Denis Mahon, *Nicholas Poussin: Works from his First Years in Rome* (Jerusalem: The Israel Museum, 1999).

33. Barber, *Nicholas Poussin*, p. 2.

34. David M. Gunn analyses how *Jerusalem* is presented on the Israel Foreign Ministry Home Page of the nation's website and how the narrative of the story of Jerusalem is repeated throughout along these lines: 'The Jewish people and culture are born in the Land. However, they are forcibly exiled from the Land. They endure vicissitudes in far off lands. Then after long centuries, the Zionist Movement begins to forge for them a Return

Poussin, as a young artist newly arrived in Rome, had captured the power and pathos of the Temple in flames, a scene of Jews being slaughtered and of looters fleeing with the holy vessels. We were looking at a cataclysmic event in our history [70 CE], one which began a two-thousand-year exile for the Jewish people. Was it appropriate that a depiction, however distinguished, of such a tragic event in the history of the Jews should find its home in the Israel Museum, just five kilometres from the scene of the destruction?... In the end, we all felt that we should, given the historical significance of the subject matter to Jerusalem and the fact that this early masterpiece by Poussin would greatly enhance the quality of the Museum's collection of Old Master paintings.[35]

Lord Rothschild stresses how the painting recalls the historical event of 70 CE and notes the irony that it should now find its home only a few kilometres away from where the event took place. He associates the 'return' of the painting with the ending of the two-thousand-year exile for the Jewish people. Just as the painting depicts the beginning of exile, its acquisition for Israel now signals the end of exile, he suggests. Viewed in this light, certain aspects of the painting, insignificant up to now, are given a new meaning: the menorah, hitherto identified as the menorah on the Triumphal Arch in Rome, is now identified as a symbol of the State of Israel, the depiction of Jerusalem in flames and the Jewish people as victims serve to remind the viewer that this situation has now been reversed; Jerusalem has been rebuilt and the people are no longer victims but victors. This interpretation differs markedly from that found in catalogues that discuss the significance of Poussin's second version of the subject now in Vienna (which depicts even more gruesomely the fate of the Jews in 70 CE): in the latter case the interpretation focuses on Rome and the situation in seventeenth-century Europe and on how the destruction of Jerusalem was simply a motif taken from Josephus that enabled the artist to depict the futility of war in the contemporary situation of Europe, indirectly and implicitly. But now that the first version is in the Israel Museum, it is described in terms relating to the return of the Jewish people to Jerusalem and to a reversal of Jewish fortunes. It is as if by recalling the trauma and 'memory' of 70 CE the present situation can be seen as a contrast, a reversal of past fortunes or, in the words of Bal, it shows how 'the memorial presence of the past can be used to reshape the present, how the interaction between present and past is the stuff of cultural memory'.[36]

to their ancestral home... What we have here might be described as a 'foundation myth' (Lemche) or a 'master commemorative narrative' (Zerubavel)' (David M. Gunn, 'Yearning for Jerusalem: Reading Myth on the Web', in Black, BOer and Runious [eds.], *The Labour of Reading*, pp. 123-40 [125-26]).

35. Barber, *Nicholas Poussin*, p. 3.

36. Bal, *Acts of Memory*, pp. vii-viii. Acts of memory are 'something we perform even if not wilfully contrived'.

Not only is the subject matter of Poussin's painting important in interpreting this entire collection, as we shall see, but equally illuminating is an understanding of how Poussin saw his role as an artist. Influenced by the Neapolitan poet, Marino, who advocated a close relationship between literature (*pittura parlante*) and painting (*muta eloquenza*), Poussin became adept at interpreting different genres of literature and poetry and translating them into painting: he was erudite in ancient and contemporary literature and developed, we are told, a critical understanding of the classics and the Old and New Testaments.[37] In particular, he became a leading interpreter of the *pittura filosofica*, that is, depicting a literary description of an event but suggesting a contemporary parallel—*The Destruction of Jerusalem* is his first example of this genre where Josephus's description is translated into painting with the express purpose of conveying a political and spiritual message to the then contemporary Europe. Poussin's 'philosophical' approach to biblical painting is illuminating because it offers a paradigm as to how a text becomes a painting, how a literary narrative evolves into a visual narrative and how painting, like scripture, invites the viewer to explore the universal or contemporary. In this gallery, we can extend Poussin's notion of philosophical painting and use it as a way of interpreting the other works too, since all take their subject matter from literature (the Bible) and their background landscapes, their topography, and establish a connection with the viewer that is spontaneous and immediate—an aspect that is important for Museum Director James Snyder:

> The paintings [in the European section, generally] are important not only as Old Masters pieces but also in terms of the iconography for us in Jerusalem.[38]

The arrangement of paintings in the gallery corresponds broadly with the order in which the stories they depict are found in the Hebrew Bible and this is the same order, more or less, in which the viewer encounters them as she or he passes through the gallery. In my discussion of the paintings below, I concentrate on characterization since this is an aspect central to both literary and visual narratives.

Abraham and Isaac, Hagar and Ishmael

The dominant position of *The Destruction of Jerusalem* draws attention to several aspects the painting has in common with Jan Victors's *The Dismissal of Hagar* (Fig. 40) and Gabriel Metzu's *The Sacrifice of Isaac* (Fig. 41) which

37. See Francesco Solinas, '*The Destruction and Sack of Jerusalem* in its Cultural and Political Context', in Barber (ed.), *Nicholas Poussin*, pp. 7-12.

38. Shelley Kleiman, 'Museum and Vision. Interview with James Snyder', in *Ariel: The Israel Review of Arts and Letters* 114 (2002), pp. 45-49 [47].

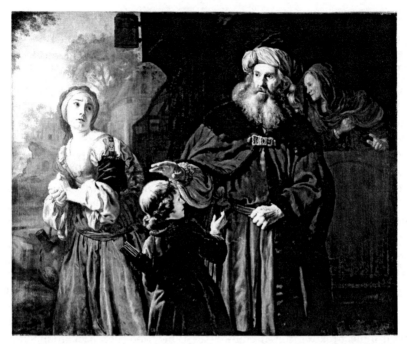

Fig. 40. Jan Victors, *The Dismissal of Hagar* (1650), Gift of Emile E. Wolf to the American Friends of the Israel Museum, The Israel Museum, Jerusalem.

hang opposite. The impotence of the virtuous Titus unable to stop the destruction, seemingly ordained by fate, is mirrored in the depiction of the perplexed Abraham, powerless to stop the victimization of Hagar and Ishmael by Sarah and dominated by a divine command to sacrifice his other son Isaac; the exodus of Jews from Jerusalem, triggered by the events of 70 CE depicted by Poussin, is reflected in the expulsion of Hagar and Ishmael, another enforced departure. The image of the temple in flames and the city's destruction suggests the ending of an era, a conclusion, while the aetiological association of Mount Moriah with Jerusalem in the story of the sacrifice of Isaac (Gen. 22.2, 14) evokes the beginnings of a city, a city with a future, where Solomon will build his temple (2 Chron. 3.1). The emphasis given to *place* in the museum's description of *The Destruction of Jerusalem* draws out for the viewer the importance of the biblical locations associated with Ishmael and Isaac in these two paintings, an important aspect that tends to be overlooked when interpreting other visual depictions of these two episodes found elsewhere.[39]

39. Two essays dealing with the iconography of the two episodes pay little or no attention to the importance of location or landscape either in the biblical narrative or the corresponding paintings; see Phyllis Silverman Kramer, 'The Dismissal of Hagar in Five Art

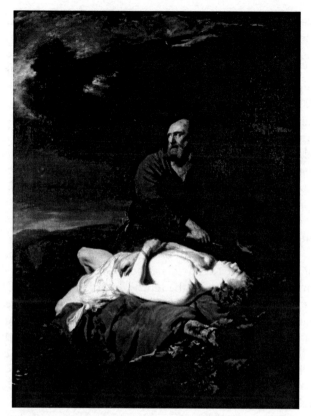

Fig. 41. Gabriel Metzu, *The Sacrifice of Isaac* (17th century), Gift of Emile E. Wolf through the American-Israel Cultural Foundation, The Israel Museum, Jerusalem.

Indeed, the biblical narratives that underlie the two pictures are imbued with a sense of place, geographical reference and a specific concern for 'the land'. First, *The Dismissal of Hagar*: the story of Hagar in its two variants (Gen. 16.1-16 and 21.9-20) occurs in a literary context concerned with the promise guaranteeing the future of Abraham's progeny and securing their destiny (15.2-4; 17.1-8). The land will be given to Abraham's descendants and it is described as stretching from Egypt to the Euphrates (15.18) while in 17.8, God will give all the land of Canaan as an everlasting possession to Abraham and his descendants after him (17.8).[40] But the promises of the

Works of the Sixteenth and Seventeenth Centuries', in Athalya Brenner (ed.), *Genesis: A Feminist Companion to the Bible* (Sheffield: Sheffield Academic Press, 1998), pp. 195-217, and Edward Kessler, 'The Sacrifice of Isaac (the *Akedah*) in Christian and Jewish Tradition: Artistic Interpretations', in Martin O'Kane (ed.), *Borders, Boundaries and the Bible* (JSOTSup, 313: Sheffield: Sheffield Academic Press, 2002), pp. 74-98.

40. Virtually nothing is said in the Koran about Israelite acquisition of land and the

land of Canaan are directed towards Isaac; Alter highlights the subtleties of language in these chapters that reveal a predominant concern to show how the promise of land becomes more and more definite until Isaac is born.[41] Hagar and Ishmael, on the other hand, are associated with Egypt and Arabia: Hagar is Egyptian (16.1, 3)[42] and her son Ishmael will marry an Egyptian (21.21). When she flees from Abraham and Sarah, she flees away from the land of Canaan[43] towards Egypt (Shur in the Negev in 16.7), she wanders in the wilderness of Beersheba (21.14) and the account of God's appearance to her provides an aetiological explanation in 16.14 for the place name Beer-la-hai-roi that lies 'between Kadesh and Bered'. Ishmael will live in the wilderness of Paran (21.20) and his descendants will dwell 'from Havilah to Shur which is opposite Egypt in the direction of Assyria' (25.12-18).

With regard to the second painting, *The Sacrifice of Isaac*: in Jewish tradition the site is identified as Mount Moriah, the place of the future temple in Jerusalem, while in Islamic tradition it is generally identified as a rock in Minā near Mecca (in the Koran, it is suggested that Ishmael and not Isaac is the victim), although as late as the tenth century there were Muslim commentators who placed the story in Jerusalem.[44] The rabbis observed that the phrase that introduces Gen. 12.1—'go to the land I will show you'—should be associated with the phrase at the start of Gen. 22.2—'go to the land of Moriah'—inviting the reader to make a link between the two chapters.[45] The land that Abraham is promised in 12.7 ('to your descendants I will give this land') is connected with the land of Moriah in 22.2 and the site of the sacrifice of Isaac.

Of course, Victors and Metzu probably did not have the slightest interest in Middle Eastern landscape as a backdrop to their paintings, preferring instead a Dutch background with which their patrons and viewing public could identify; in many instances, they reduced or minimized the landscape

period of the Judges; see Herbert Busse, *Islam, Judaism and Christianity: Theological and Historical Affiliations* (Princeton: Markus Wiener Publications, 1998), p. 104.

41. Alter, *Genesis*, p. 66.

42. Rulon-Miller argues that Hagar *is* Egypt. She represents for God, the Israelites and their narrators, 'the foreign land' that is 'a geographical correlative for...sheer female otherness'. See Nina Rulon-Miller, 'Hagar: A Woman with an Attitude', in Philip R. Davies and David J.A. Clines (eds.), *The World of Genesis: Persons, Places, Perspectives* (JSOTSup, 257; Sheffield: Sheffield Academic Press, 1998), pp. 60-89 (62).

43. According to the first account, Abraham is living in Canaan (16.3), and in Gerar, near Gaza (20.1) according to the second, when Hagar is driven out.

44. Busse, *Islam, Judaism and Christianity*, p. 83.

45. See Jonathan Magonet's chiastic reading of Gen. 12–22, arising from the rabbinic observation that לך לך 'go for yourself' only occurs in Gen. 12.1 and 22.2, thus inviting a reading that links the two chapters together; see Jonathan Magonet, *Bible Lives* (London: SCM Press, 1992).

in order to highlight psychological aspects of the characters in the foreground. But now that the paintings are located in this collection in Jerusalem the topography and background do become important for viewers because they bring to mind contemporary and unresolved issues surrounding the same landscape as the subject matter of the paintings refers to. If the iconography is to become important 'for us in Jerusalem' (Snyder), then the viewer must engage with the different interpretations that their location in an Israeli gallery makes possible. For example (and in line with Bal's idea of the importance of 'cultural recall' of past traditions for the present), the museum description implies that *The Destruction of Jerusalem* becomes a source of satisfaction and re-assurance for Israelis in that the situation depicted has now been reversed: the victims are now the victors. But equally, might not the depiction of Hagar and Ishmael's expulsion recall memories just as distressing for Palestinians?

The hanging of *The Dismissal of Hagar* and *The Sacrifice of Isaac* side by side draws out the parallels between the story of the dismissal of Ishmael in Genesis 21 and the sacrifice of Isaac in Genesis 22 more strikingly than if we were to see each picture separately in different galleries.[46] It also means that iconographical traditions normally associated with *The Sacrifice of Isaac* that struggle to express what exactly is going on in this narrative theologically become less important here as we become more preoccupied with comparing Isaac's fate to Ishmael's. For instance, the sacrifice of Isaac is a central motif in the iconography of the Holocaust since it offered a wide range of possibilities for artists to explore theologically God's relationship with the threatened and sacrificed Jewish community, represented by Isaac.[47] But here Ishmael's fate hangs in the balance as much as Isaac's, offering a new and unexpected perspective from which to interpret the scene. Both pictures highlight the role of Abraham as father and show that there is something essentially dysfunctional in his relations with both his sons,[48] and they recall Rashi's commentary on Gen. 22.2 where Abraham plays for time, thinking, perhaps, that he can get away with sacrificing Ishmael instead:

46. It is possible to see from this position another painting, Pieter Lastman's *Hagar and the Angel in the Wilderness*, emphasizing further the pathos of the character of Hagar.

47. Holocaust artists wanted to express the idea that the Holocaust had taken place and that no ram had been substituted for Isaac. Most obvious is Chagall's 1942 highly complex sketch for *The Yellow Crucifixion* where everyone is sacrificed—Abraham, Isaac, Christ, the ram and all the other innocent victims. In Terna's painting of the subject, the angel guides the knife towards, not away from, Isaac. See Amishai-Maisels, *Depiction and Interpretation*, pp. 167-72.

48. Alter, *Genesis*, p. 106, notes the configuration of parallels between the two stories. Each of the sons is threatened with death in the wilderness, one in the presence of his mother and the other in the presence and by the hand of his father. In each case, the angel intervenes at a critical moment. At the centre of the story, Abraham's hand holds

Rashi on 22.2: *Your son:* He said to Him: 'I have two sons'. He said to him: *Your only son:* He said: 'This one is an only one to his mother and this one is an only one to his mother'. He said to him: '*Whom you love*'. He said to him: 'I love them both'. He said to him: '*Isaac*'.[49]

The rejection of Ishmael may be implied in the Hebrew Bible—although God blesses Ishmael and will make him a great nation, it is with Isaac that he will establish his covenant (Gen. 17.20-21)—but it is Paul, in Galatians 4, who provides the explicitly negative interpretation of the Hagar and Ishmael story which has largely determined the way Christians have viewed it over the centuries and which is, again, centred on *place*:

For it is written that Abraham had two sons, one by a slave woman and the other by a free woman. One, the child of the slave, was born according to the flesh; the other, the child of the free woman, was born through the promise. Now this is an allegory: these women are two covenants. One woman, in fact, is Hagar, from Mount Sinai, bearing children for slavery. Now Hagar is Mount Sinai in Arabia and corresponds to the present Jerusalem, for she is in slavery with her children. But the other woman corresponds to the Jerusalem above; she is free, and she is our mother... Now you, my friends, are children of the promise, like Isaac. But just as at that time the child who was born according to the flesh persecuted the child who was born according to the Spirit, so it is now also. But what does the scripture say? 'Drive out the slave and her child; for the child of the slave will not share the inheritance with the child of the free woman.' So then, friends, we are children, not of the slave but of the free woman (Gal. 4.22-31).

Rulon-Miller argues that Paul leaves for posterity a reading of Genesis that is 'infected' and leaves an 'attitude' towards Egypt and Arabia that persists today. Galataians 4.29 is the source of the popular belief of Ishmael's torturing of Isaac that appears nowhere in the Hebrew Bible. Paul perpetuates and promotes the enmity between Arab and Jew incited by Yahweh through Sarah but he goes further and classifies the two women according to their nationalities: Sarah and Isaac (or Israel) are exalted while Hagar and Ishmael (or Arabia) are despised and rejected.[50]

the knife and Hagar is enjoined 'to hold her hand' on the lad. In the end, each of the sons is promised to become a progenitor of a great people.

49. Rashi, cited in Alter, *Genesis*, p. 103. Alter sees the use of יחיד (only one) here (and repeated in vv. 12, 16) as very significant: in Abraham's mind—there really was only one son.

50. Rulon-Miller, 'Hagar', pp. 79-82. Graham Stanton suggests that Paul's main interest is the contrast between the two 'Jerusalems': the earthly Jerusalem refers to the Jerusalem Christian leaders while the heavenly Jerusalem (an image taken from Ps. 87; Isa. 50.1) is intended to include both Jewish and Gentile Christians. See G.N. Stanton, 'Galatians', in Barton and Muddiman (eds.), *The Oxford Bible Commentary* (Oxford University Press, 2001), pp. 1152-65 (1162).

Elsa Tamez notes how the story of Hagar appears to 'complicate the story of salvation' in the Judaeo-Christian tradition and how Genesis would read more neatly without her and her son.[51] Just as she appears to complicate the history of salvation, she also complicates the rhetoric of Genesis 12–22, as many scholars have noted, in particular Magonet who has shown how the two versions of Hagar interrupt what is otherwise a perfect chiastic arrangement of material in Genesis 12–22, where the centre stage belongs to Isaac.[52] But Goldingay argues that the way her appearance interrupts the narrative and the fact that her expulsion is related twice is a deliberate ploy—the text keeps the anomaly of Hagar and what she represents before our eyes, it will not let her or Ishmael go away or be elbowed out.[53]

The same is true of Victors's sympathetic and sensitive portrayal of Hagar in this collection; it raises questions about the Hagar and Ishmael tradition that will not go away, and without it, the collection would read in a very different way. She is the only woman represented here and both Victors's painting and Lastman's *Hagar and the Angel in the Wilderness*, further along, confront the viewer with a tradition that sits uneasily with the founding myths of the Judaeo-Christian tradition that this gallery seeks to portray. To correct the popular imbalance between the way Isaac and Ishmael are popularly perceived, Goldingay argues, it is not the *text* of Genesis that needs rewriting but its *interpretation* because the narrative's interpreters have been middle-class, male, Euro-American and committed Jews and Christians[54]— perhaps the commentators on this collection fall into the same category but nevertheless the presence of two paintings that depict Hagar's and Ishmael's plight must surely strike a discordant note in this gallery that raises the unresolved and uncomfortable question:

> At the centre of a story ostensibly about universal blessing (Gen. 12.3) lies a family conflict that will lead to a conflict between their descendants as nations and as it happens, between religions also. Why do Gentile readers not want to identify with Ishmael, even if not substituting him for Isaac, as the Muslims?[55]

51. Tamez argues that by distancing herself from the reading that the text invites and by looking at it from the perspective of third-world women, she is able to understand the significance of the Hagar story more acutely. See Elsa Tamez, 'Ishmael', in J.S. Pobee and B. von Wartenberg-Potter (eds.), *New Eyes for Seeing* (Quezon City, Philippines: Claretian, 1987), pp. 5-17, cited in John Goldingay, 'The Place of Ishmael', in Davies and Clines (eds.), *The World of Genesis*, pp. 146-49 (148).

52. Hagar's expulsion (Gen. 21.9-20) interrupts the narrative describing how King Abimelech of Gerar offered land to Abraham (20.15) and the subsequent legalization of that land (21.22-33).

53. Goldingay, 'The Place of Ishmael', pp. 148-149.

54. Goldingay, 'The Place of Ishmael', p. 149.

55. Philip R. Davies, in the preface to Davies and Clines (eds.), *The World of Genesis*, p. 14.

Images of Jacob

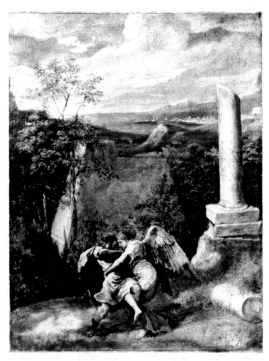

Fig. 42. School of Poussin, *Jacob Wrestling with the Angel* (17th century), Gift of W.A.
Harris van Leef Vevey, Switzerland, The Israel Museum, Jerusalem.

Two images of Jacob, *Jacob Wrestling with the Angel* (Fig. 42) and *Jacob's
Dream*, continue the theme of God's preference of one son over another and
extend the family story and its preoccupations from Abraham and Isaac to
Jacob. They depict two episodes from Genesis (28.10-17; 32.24-29) that take
place between the story of Isaac's deception in Genesis 27 (and the sub-
sequent separation of Jacob and Esau) and the reconciliation of the two
brothers in Genesis 33. Both episodes therefore take place during the pro-
longed absence of Esau from the narrative, leaving the reader to concentrate
exclusively on Jacob; but, in spite of this, Esau's memory still haunts both the
literary narrative and these two paintings of Jacob. The omission of Esau from
the narrative calls to mind the treatment meted out to his father's brother,
Ishmael, depicted in *The Dismissal of Hagar*.

The story of Jacob's ladder has inspired a rich iconographical tradition
largely due to the typological association of Jacob with Christ: the Church
Fathers saw in Jacob a prefiguration of the church of the Gentiles open to
pagans while Esau stood for the Jews alone and more generally the Jewish peo-
ple itself. The rungs of the ladder were compared to the different degrees of

human virtue by St Benedict who saw the ladder as the prototype of the *scala humilitatis*, the 'ladder of humility', whose twelve rungs the virtuous man must climb. But from the sixteenth century onwards it is the background landscape that is highlighted in depictions of the scene and several good examples illustrate the imaginative range of backgrounds that could be included in the scene: Feti, early-seventeenth century, Accademia, Venice; Rembrandt drawing, mid-seventeenth century, Louvre, Paris; Chagall, 1973, Private Collection.[56] The landscape depicted in the tapestry here may reflect a late-sixteenth-century Flemish style but its context in this gallery highlights the importance of the topography of the biblical narrative from which it is taken, since the story of Jacob's dream in Gen. 28.10-17 is constructed around the idea of *place*: the words of God to Jacob are focused on the promises of the land to Jacob and the story ends with the founding of the sanctuary of Bethel where God becomes associated with a specific earthly location:

> And the LORD stood beside him and said, 'I am the LORD, the God of Abraham your father and the God of Isaac; the land on which you lie I will give to you and to your offspring; and your offspring shall be like the dust of the earth, and you shall spread abroad to the west and to the east and to the north and to the south; and all the families of the earth shall be blessed in you and in your offspring. Know that I am with you and will keep you wherever you go, and will bring you back to this land; for I will not leave you until I have done what I have promised you.'

Alter notes that the repetition of a term is usually a thematic marker in biblical narrative and that the repetition of the word 'place' six times in the story shows that it is a tale of the transformation of an anonymous landscape into Bethel, a house of God.[57] That Jacob is addressed as 'son of Abraham and Isaac' in the narrative depicted in this tapestry and that the promise of land is made to his descendants after him makes us return and take a second look at the depiction of his ancestors, Abraham and Isaac. Their various depictions constitute a visual narrative that takes us through the ancestral line starting from the founding fathers. Whybray, somewhat ambiguously, suggests that in Jacob's response to God in this episode 'he clearly speaks as a representative of a future Israel'.[58] The absent Ishmael, on the other hand, becomes identified with Edom, a nation that is presented negatively in the Hebrew Bible in terms of its history of conflict with Israel. King David subjugated it, forcing it to pay tribute (2 Sam. 8.14), Obadiah speaks of its violence 'towards your brother, Jacob' (v. 10) and Ezekiel condemns Edom for

56. See Duchet-Suchaux and Pastoureau, *The Bible and the Saints*, p. 184.
57. Alter, *Genesis*, p. 148.
58. R.N. Whybray, 'Genesis', in Barton and Muddiman (eds.), *The Oxford Bible Commentary*, pp. 38-66 (56).

'giving the people of Israel over to the power of the sword' (Ezek. 35.6). As in the case of Ishmael, Paul makes clear for Christians God's preference of Jacob over Esau in Rom. 9.13: 'As it is written, "I have loved Jacob, but I have hated Esau"' and by the time we reach Heb. 12.16, the negative reputation of Esau has been firmly established:

> See to it that no one becomes like Esau, an immoral and godless person, who sold his birthright for a single meal.

The backdrop to *Jacob Wrestling with the Angel* is the ford by the River Jabbok (Gen. 32.22), a tributary of the River Jordan running from East to West. Esau is coming north from Edom to meet Jacob while Jacob has been travelling south from Gilead. So the significance of the Jabbok for the story is important, setting the scene for the brothers' meeting in ch. 33. Esau's presence can be felt in this painting. Following the midrash, Nahum Sarna identifies the wrestler as the spirit of Esau and Alter notes that the man is 'obviously in some sense a doubling of Esau but also a doubling of all with whom Jacob had had to contend'. The picture evokes Jacob's wider association with 'wrestling', the struggling that is implicit throughout his story: in his grabbing Esau's heel as he emerges from the womb, in his striving with Esau for birthright and blessing, in his rolling away the huge stone from the mouth of the well, and in his multiple contendings with Laban.[59] Now, in this culminating moment of his life story, the characterizing image of wrestling is made explicit and literal. Of all the patriarchs, Jacob is the one whose life is entangled with moral ambiguities, yet he is the one who always manages to win out. The first time the word Israel (32.28) and Israelites (28.32) occur in the Bible is here and it is in association with the wrestling, the struggling of Jacob. The NRSV translates:

> You shall no longer be called Jacob, but Israel, for you have striven with God and with humans, and have prevailed.

Alter sees God as the subject in the word 'Israel' and translates 'God will rule' or 'God will prevail'. The association of the 'struggling' and 'overcoming' of Jacob is the aetiological explanation given for the name Israel and the dietary prohibition observed 'to this day' marks a direct identification, or reverence for, the ancestor who wrestled throughout the night.[60] The aspect of struggling in *Jacob Wrestling with the Angel* brings out the visually explicit violence in many of the other paintings here: for example, in *The Destruction of Jerusalem*, *The Crossing of the Red Sea*, scenes from the life of David but also instances of familial violence evident in *The Dismissal of Hagar* and *The*

59. Alter, 'Genesis', p. 180.
60. Alter, 'Genesis', p. 182.

Sacrifice of Isaac. The aspect of violence that the image highlights in this context contrasts with other visual expressions of the story elsewhere: perhaps the best-known depiction of the subject is a mural by Delacroix that was especially commissioned for a niche in the Church of St Sulpice in Paris. The importance of its location (in the context of other paintings in the church and against the background of nineteenth-century Paris) in appreciating the significance of this mural has been conveyed insightfully and imaginatively by the novelist Jean-Paul Kauffmann, who interprets the mural alongside Delacroix's depiction of *Heliodorus Driven from the Temple* (2 Macc. 3.13);[61] it shows us how a specific place and context can bring to the fore latent meanings in a painting. The 'struggle' of Jacob is clearly much more ominous and threatening in the context of the other paintings in this gallery than is Delacroix's in the more tranquil setting of the church of St Sulpice.

Bastiaan Wielenga brings out a number of interesting post-colonial readings of the struggle of Jacob and the reconciliation between Jacob and Esau in Genesis 33, in particular, how the text can act as a motive for reconciliation in a number of contemporary conflict stories across the world. The Bible, he argues, invites us to understand such bloody conflicts in terms of battles between brothers, as struggles over claims and rights, over the proper share in God's blessing—in the story of Jacob and Esau, there is only one blessing and it must be inclusive:

> Brothers can kill each other as we know from the Cain–Abel story: but they are meant to be reconciled with each other as Jacob and Esau were. Think of Israelis and Palestinians today—peace becomes possible if the parties concerned are able to reflect self-critically about the past. That is what Israel does in exile. The Genesis stories about the patriarchs reflect in their present form such a critical retrospect. The experience of having been deprived of God's blessing, having lost the land, brings the self-critical insight that one has tried to deprive the other of their share. This is the promising alternative to the uncritical glorification of one's own history which is one of the so solid obstacles on the way to peace between hostile peoples.[62]

The arrangement of paintings in the gallery focuses our attention on the theme of brothers, Isaac and Ishmael, Jacob and Esau. It also highlights the omission of Esau and encourages the kind of self-critical reflection suggested by Wielanga.

61. Jean-Paul Kauffman, *Wrestling with the Angel: The Mystery of Delacroix's Mural* (London: Harvill Press, 2003).

62. Bastiaan Wielenga, 'Experiences with a Biblical Story', in R.S. Sugirtharajah (ed.), *The Postcolonial Bible* (Sheffield: Sheffield Academic Press, 1998), pp. 189-98 (196).

Moses and Balaam

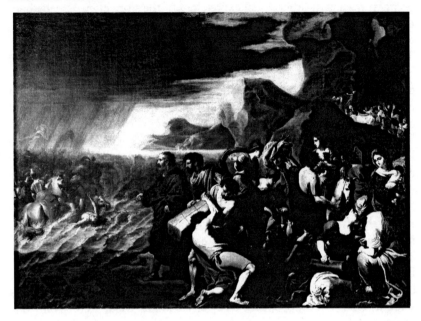

Fig. 43. Jan Miel, The Israelites Crossing the Red Sea (17th century), Gift of Lila and Herman Shikman, The Israel Museum, Jerusalem.

Two images depict well-known scenes from the Book of Exodus, *The Israelites Crossing the Red Sea* (Fig. 43) and *Moses Receiving the Ten Commandments*, both central to the Judaeo-Christian tradition: God's presence and power are permanently promised to Israel in 29.45-46 and he demonstrates his commitment to the Israelites in his delivery of Israel from slavery in Egypt, an episode that is commemorated in the Jewish feast of Passover. Christians, too, identify with the Israelites led through the Red Sea by the hand of God, and the experience of the Sea has been associated with the Resurrection, as in John of Damascus's Easter Hymns, or with baptism (1 Cor. 10.1-5).[63] *The Crossing of the Red Sea* vividly depicts the scene from Exodus 14: the Israelites are delivered and the Egyptians destroyed by God's power. Whether he uses the natural elements or the hand of Moses he triumphs in person over the enemies of Israel, who are his own enemies. But God also acts for his own sake and for his own self-regard 'so that the Egyptians shall know that I am Yahweh' (7.5) and his need to achieve a resounding victory leads him to manipulate Pharaoh into fruitless opposition (7.6–11.10). The painting depicts the contrast between God's choice and protection of

63. Walter Houston, 'Exodus', in Barton and Muddiman (eds.), *The Oxford Bible Commentary*, pp. 67-91 (67).

Israel and his destruction of the Egyptians: as God deliberately entices Pharaoh out to recapture the Israelites and as the Egyptians sink to their death, he asserts that now the Egyptians must know that he is God and the Egyptians must submit: 'Let us flee from before Israel for the Lord fights for them against Egypt' (14.25). Houston describes the literary purpose of the Book of Exodus in terms similar to Bal's idea of how 'cultural recall' from the past informs and strengthens a group or individual's identity in the present:

> The Book of Exodus is Israel's foundation story, their identity document, telling them where they have come from and showing them their place in the world under God's sovereignty…it was being developed when the nation's continuing existence as a distinct community was in prolonged doubt and written to strengthen national feeling and support national identity…it can be seen as imaginatively re-creating a people's past so that they can understand themselves in the present.[64]

I have argued earlier that in the booklet accompanying *The Destruction of Jerusalem* the painting is interpreted along very similar lines—as an element of a collective memory of past events that have now been reversed. Within its context in this gallery *The Crossing of the Red Sea* recalls a founding myth of the nation that inspires confidence in the present. In *The Destruction of Jerusalem*, Jews are victims but in *The Crossing of the Red Sea*, Israelites are victors, a polarity that draws attention to how biblical Israel's identity is defined, at least in this gallery, in relation to its struggle against the Other,[65] Rome, Pharaoh and Egypt, while further along it is Goliath and the Philistines. In addition, external struggles are reflected in internal and familial strife: the dismissal of Hagar and Ishmael and Jacob's wrestling with the angel. It is striking how the outstretched hand of Moses to part the waters in *The Crossing of the Red Sea* draws our attention to the prominence of the raised or outstretched hand[66] in several other paintings: Abraham holds up his hand to kill Isaac, Jacob holds up his hand to wrestle, Balaam holds up his hand to strike the ass (and the angel to prevent him), Absalom's hands cling desperately to the tree for life, David's hands hold the blood-stained head of Goliath, Hagar holds up her hand to protect herself in the wilderness. Titus holds up his hand to stop the bloodshed (by the hands of the Roman soldiers) and Abraham, somewhat ambiguously, stretches out his hand over Ishmael, either to send him away or to bless him. The violence conveyed by

64. Houston, 'Exodus', p. 69.

65. A polarity and division apparently sanctioned by God himself in Exod. 8.23: 'I will put a division between my people and your people'.

66. The stretching out of the hand (especially in the case of God, Moses and Joshua) is almost always directed against Israel and the enemies of Israel in the Hebrew Bible (Exod. 3.20; 7.5, 19; 8.5; 9.22; 10.12, 21; 14.16, 26; Josh. 8.18; Ezek. 6.14; 14.9,13; 25.13, 16; 30.25) or other personal enemies (Ps. 138.7; 144.7).

the outstretched hand is brought into sharp relief by the one painting where the hand is raised to heal: in Strozzi's *Peter Performing a Miracle*, Peter holds up his hand to heal the illness of his daughter Petronella following the New Testament tradition of the laying of hands as a healing process (Mt. 12.13; Mk 3.5; Lk. 6.10; Acts 4.30).

Houston suggests that 'what Exodus means is, in the end, up to the reader… contemporary readings should be welcomed as powerful tests of the validity of the far-reaching claims that the book makes, for example, those who have identified with groups who are marginal to it'.[67] He also notes that the situation from which it is read is important. Looking at this painting, we are more attentive to the theme of Egypt's humiliation and defeat because of where we are than, say, liberation readings in Latin America in the 1970s and 1980s that identify exclusively with oppressed Israel in the Exodus event, or in post-war Jewish iconography where the crossing of the Red Sea is used to reflect the dilemma of displaced Jews in war-torn Europe, as in Segall's two versions of *Exodus*. In his first version of 1947, the composition, inspired by the crossing of the Red Sea, with mist replacing the waves on either side, has no movement and is entirely static: the figures are supposedly in the process of Exodus, but it is not clear where they come from, and they have no place to go and no will to get there. It is only in *Exodus II* (1949) (São Paolo, Museo Lasar Segall), after the creation of the state of Israel, that Segall's survivors begin to move forward—they are still weak and bent with suffering but a place of refuge has now been opened for them in Israel and they move off slowly through the mists and waves towards this haven. There is a development in the iconography with the establishment of the state of Israel—the refugees are now shown on dry land rather than drifting on the sea. But in its context in this gallery, *The Crossing of the Red Sea* encourages us to question the omissions, the silences of the victims absent from traditional interpretations of the Exodus event and to give more thought to the role of Egypt—just as the Hagar and Ishmael paintings (they, too, are associated with Egypt) help us question the interpretation normally accorded to them.

The large tapestry, *Moses Receiving the Ten Commandments*, continues the narrative of the Exodus event: the biblical episode begins with Yahweh's self-introduction 'as one who brought the Israelites out of the land of Egypt' (Exod. 20.2) but the background against which it is set is Mount Sinai and, seen here, it evokes the association between the land and the law according to which the Israelites must live—but also the negative association made between Mount Sinai and Hagar in Gal. 4.22.

The subject of Pieter Lastman's *Balaam and his Ass* may well have appealed to the artist because of the dramatic nature of the fable but in terms of a visual

67. In particular, Houston ('Exodus', p. 69) notes the work of Exum, Fewell and Clines.

narrative of scripture, the painting in its present context highlights the aspect of place and location important in the corresponding biblical narrative. In Numbers 22–25, the Israelites are encamped by the Jordan and, like Pharaoh and the Egyptians, Balak and the Moabites too dread Israel as being numerically superior (22.3-5). There are three encounters between Balaam and the donkey that anticipate a pattern in the following oracles in which Balaam progressively 'sees' Israel's history and God's promises, moving from the past through the present to a more and more specific future: election from among the nations (23.9), promise (and fulfilment) of many descendants (23.10), blessing (24.9), exodus (23.22; 24.8), God's presence among them and his care for them in the wilderness (23.21). Balaam anticipates a successful conquest of the land as both Israel and God are imagined as lions (22.23-24) and the rise of monarchy and other specific conquests are also referred to (24.7, 17-19). The overall scene for Balaam is 'a powerful people, numerous, confident and flourishing'.[68] The viewer here does not see the painting as an isolated fable but interprets it as part of the wider visual narrative.

The Life of David
On the reverse side of the wall supporting *The Destruction of Jerusalem* hang two quite large panels depicting events in the life of David: *The Triumph of David* (Fig. 44) in which Michal with timbrels appears to the left, a young David with the head of Goliath in the centre and Saul in his chariot to the right, and *The Death of Absalom*, both by Giacinto Gimignani. Opposite them hangs a version of *David and Goliath* by Gerard van Kuÿll. A fourth painting, *David and Jonathan* by Ferdinand Bol some feet away (next to *Jacob Wrestling with the Angel*), depicts a meeting in which Jonathan seems to regard David with some trepidation and fear. Together they represent four episodes in the life of David. In the enormous iconography devoted to David through the centuries many aspects of his character are represented, including his image as shepherd or musician, or his relationship with Bathsheba and Michal, or as a repentant old man, all of which portray different sides to a well-rounded character.[69] Here we see David exclusively as a warrior. Three of the paintings refer to episodes from 1 Samuel 17–18, the slaying of Goliath, the triumph of David and the meeting with Jonathan, and relate to the beginning of his career. David is successful in all his undertakings because God is with him.

68. Terence E. Fretheim, 'Numbers', in Barton and Muddiman (eds.), *The Oxford Bible Commentary*, pp. 110-34 (128).
69. O'Kane, 'The Biblical King David', *BibInt* 6, pp. 313-47, and Erich Zenger, 'David as Musician and Poet: Plotted and Painted', in J. Cheryl Exum and Stephen D. Moore (eds.), *Biblical Studies, Cultural Studies* (JSOTSup, 266; Sheffield: Sheffield Academic Press, 1998), pp. 263-98.

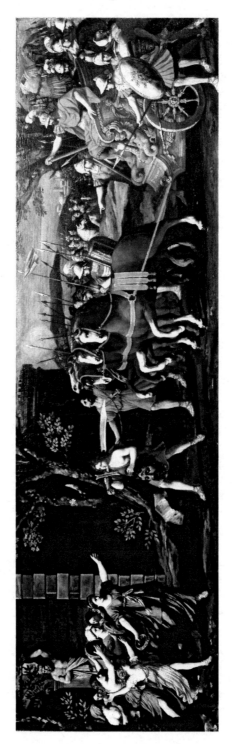

Fig. 44. Giacinto Gimignani, *The Triumph of David* (17th century)
Gift of Jan Mitchell, through the American-Cultural Foundation, The Israel Museum, Jerusalem.

He has triumphed against Goliath the Philistine, the troops of Israel and Judah purge the Philistines (the account gives us detailed place names) and David brings the head of Goliath to Jerusalem:

> So David prevailed over the Philistine with a sling and a stone, striking down the Philistine and killing him; there was no sword in David's hand. Then David ran and stood over the Philistine; he grasped his sword, drew it out of its sheath, and killed him; then he cut off his head with it. When the Philistines saw that their champion was dead, they fled. The troops of Israel and Judah rose up with a shout and pursued the Philistines as far as Gath and the gates of Ekron, so that the wounded Philistines fell on the way from Shaaraim as far as Gath and Ekron. The Israelites came back from chasing the Philistines, and they plundered their camp. David took the head of the Philistine and brought it to Jerusalem (1 Sam. 17.50-54).

The Death of Absalom, depicting the violent and inglorious death of Absalom from 2 Sam. 18.9-10, shows how the threat to David's kingship has been taken away and focusses not on how David famously mourned for his son but on how this episode heralds another victory for David. In portraying the gory deaths of both Goliath and Absalom side by side, the paintings extend the narrative of the defeat of those whom God does not favour from the nearby *The Crossing of the Red Sea*: just as he was on the side of Moses and the Israelites against their enemies the Egyptians, now he supports the Israelites against Goliath and the Philistines. Goliath and Absalom are further spectacular, if lurid, examples of those who must be marginalized so that the narrative of Abraham, Jacob, Moses, and now David can continue unhindered. But the struggle with Israel's external enemies is also reflected within the family—the theme of David's problematic relationship with his son Absalom reminds us of Abraham's difficulties with his sons Ishmael and Isaac.

Portraits of Peter

Finally, two paintings of Peter hang side by side. Rembrandt's *St Peter in Prison* is a psychological portrait of Peter in which his outward portrayal reflects his inner attitude of trust and patience in God. The reference is most likely Acts 12.5 where Peter has been imprisoned in Jerusalem—it represents one of his final appearances in the Bible; he fades out of the picture shortly afterwards and tradition places his death in Rome. The second painting by Strozzi, *St Peter Performing a Miracle*, refers to a tradition in the Golden Legend in which Peter cures his adopted daughter Petronella of a fever.[70] The picture stands out because it is the only one (with the exception of Titus who raises his hand to stop the slaughter) where a stretching out of the hand

70. For the tradition of Petronella, see Duchet-Suchaux and Pastoureau, *The Bible and the Saints*, pp. 276-77.

implies healing or curing and not destruction; it contrasts with the nearby image of Abraham raising his hand to kill Isaac. The background of Peter in prison (in Jerusalem) at the hands of Herod Agrippa associates the painting with *The Destruction of Jerusalem* and the consequences of Roman domination for both Jews and early Christians at this period. Peter, with his keys denoting his future authority, stands amid the Jewish patriarchs in this gallery; in his depiction as an old, bearded man in the same non-descript grey-brown garments as Abraham and Moses, he could almost be mistaken for one of them and so fits acceptably into the Judaeo-Christian narrative. In terms of the topography behind the story of Peter in prison: this is the final scriptural episode that refers to Peter, as he is spirited away out of Jerusalem (Acts 12.17), since from now on tradition associates him with Rome.[71] Indeed, the theme of departure from, and arrival into Jerusalem or into the land is a striking theme throughout this collection: Jews are expelled from Jerusalem in the Poussin painting, as are Hagar and Ishmael in the Victors painting and Peter in the Rembrandt painting. Then, as we progress through the gallery, we encounter Jacob–Israel who receives a promise that the land is exclusively for Israelites, Balaam who foresees that the Israelites will prosper in the land, Moses who brings them towards the land and David who triumphantly enters Jerusalem with the head of Goliath. Seen in this way, the collection narrates not only stories of departure from Jerusalem and the land but also represents the theme of return and re-population.

From Literary to Visual Narrative

No one claims that this collection is complete or comprehensive—the inclusion of paintings from other rooms may well change the focus of the narrative that it now offers. Apart from the museum commentary on the Poussin painting, there is as yet no written guide to the rest of the art works in this room and once art historians have studied these individual paintings they may suggest very different interpretations from those I have put forward here. Nevertheless, in spite of any particular traits specific paintings may have, the visual narrative they present collectively is really very striking and discloses images of God, the founding ancestors of the Judaeo-Christian tradition and the 'promised' land in ways that cannot fail to perplex and disturb the viewer. What one notices immediately is the violence vividly portrayed in nearly all the paintings: the slaughter or capture of the Jews in the Poussin painting, the drowning of the Egyptians, the defeat of the Philistines, the lurid deaths of Goliath and Absalom, the sacrifice of Isaac and the dismissal of Hagar and

71. Loveday C.A. Alexander, 'Acts', in Barton and Muddiman (eds.), *The Oxford Bible Commentary*, pp. 1028-61 (1043).

the imprisoned Peter. The outstretched hand or arm raised to perform brutal actions and the depiction of spears, swords, shields, clubs, arrows and knives in almost all the paintings of the collection add to the overall violent effect. Fear and terror are graphically portrayed on the faces and by the defensive actions of the characters against whom much of the violence is directed: Hagar, Isaac, Absalom, Peter and even in the aggression perpetrated against Balaam's donkey.

In the present arrangement of paintings, the position (and the museum's interpretation) of Poussin's *The Destruction of Jerusalem* acts effectively as the key to the way we view the rest of the collection. If we see this scene (as I feel we are intended to) as depicting the beginning of the Jewish diaspora, a crucial period in the 'middle' of Jewish history (just as the painting stands right in the middle of the room), then we interpret the rest of the paintings that depict momentous occasions in the light of it: for example, Jacob's wrestling with the angel recalling the episode in which the name Israel emerges, the several episodes relating to the promise of the land to the patriarchs, the crossing of the Red Sea recalling the journey to the land and David's military associations with Jerusalem depicting an ancient past that continues into the present. When we look at this painting now in the Israel Museum, we are guided by the museum's commentary to think of it has having 'come home' to Jerusalem; the expulsion of Jews from the city depicted in the painting has been reversed now that the Jewish people have returned and the ancient city has been restored. *The Destruction of Jerusalem* invites the viewer not only to contemplate an ancient Israel of the past but also to make the vital connection with the Israel of the present.

The visual narrative created by the arrangement of the collection also, unintentionally, highlights aspects of the Bible's literary narrative that have been emphasized or omitted in Judaeo-Christian interpretation (what Bal calls 'the selections and omissions, the emphases and evasions'). For example, Victors's psychological depiction of Hagar and Ishmael in this large canvas makes it impossible for us to avoid reflecting on their role that 'interrupts the narrative of Genesis and salvation history',[72] it makes us question their marginalization in Western Christian tradition and helps highlight their pivotal role in Islamic tradition and the Koran. The emphasis on how God sides with the Israelites and fights on their behalf raises the issue of how divine violence is perpetrated against the Other—Pharaoh and the Egyptians, the Philistines—and even how a father must act with violence towards his son (Abraham and David). The absence of Sarah in *The Sacrifice of Isaac* is striking because of the prominence given to Hagar in the painting that hangs alongside it and reflects the problematic omission of Sarah from the narrative

72. See Goldingay, 'The Place of Ishmael', p. 148.

of Genesis 22. (Indeed, the absence of women generally from the collection reinforces the notion of patriarchy throughout the narrative). But most poignantly of all, the collection brings out the notion of *place*, it highlights the landscape and topography of biblical stories that we tend to ignore when viewing 'biblical' art in other galleries or other cities. In Jerusalem the land-scapes, both of the paintings and the corresponding biblical narratives, become alive and real and they come to the fore in a way they do not elsewhere. There are a number of reasons for this: the visit to this gallery may be part of a tour that involves looking at biblical topographical sites in Jerusalem and the Holy Land and so we want to seek out the artist's impres-sion of the site and his portrayal of the characters' reactions to the events that took place there, or we may want to reflect on the function of biblical locations as a source of divine disclosure; but the viewer also brings with him or her a painful awareness of the claims and counter-claims relating to land in the Israel–Palestine dispute and how these claims are justified by an appeal to the promises of land made in the Hebrew Bible.[73] The viewer, acutely aware of the importance of place, land and territory in the Holy Land today will be especially attentive and sensitive to any topographical reference whether in the museum programme, in the painting or in the parallel biblical narrative and will tend to use it as an interpretative key in engaging with the works in the collection.

It is interesting to compare the overall effect of this 'scripture' gallery with that of the *Musée Message Biblique Marc Chagall* in Nice; in spite of the fact that both collections focus on depictions of the Hebrew Bible, there is a vast difference between the moods they create. Chagall did not want his biblical paintings arranged in the chronological order of biblical history but as a 'composition d'ensemble'[74] so that the viewer can follow a theme of his or her choice and move from one painting to another as he or she responds creatively to the works, in order to construct his or her own narrative(s) as suggested by the paintings and their subject matter. While the viewer is encouraged by the Nice collection to engage creatively with the paintings— their arrangement provides a number of starting points and parallel story lines—the arrangement of the paintings in the Jerusalem gallery, on the other hand, appears more concerned with presenting an ideology, with inter-preting the paintings for the viewer within definite parameters. What we can learn from this is that it is not only the artist's intentions and historical milieu that inform how we interpret a biblical painting, equally important is the context in which we now see it; museological factors, such as the paintings

73. See, Michael Prior, *Zionism and the State of Israel: A Moral Inquiry* (London: Rout-ledge, 1999).

74. Jean-Michel Foray, *Message biblique Marc Chagall* (Paris: Réunion des musées nationaux, 2000), p. 25.

chosen to hang alongside it and the particular classification or collection to which a painting is assigned, can bring out new and unexpected meanings and can frequently draw our attention to 'the selections and omissions, the emphases and evasions' of the parallel biblical narrative that the artists so graphically and colourfully portray.

7

THE FOUR SEASONS:
NICOLAS POUSSIN'S BIBLICAL LANDSCAPES

The French artist Nicolas Poussin (1594–1665) is perhaps best known for his formal landscape paintings and the nobility and grandeur of his figures—'formal mastery' and 'intellectual depth' are the attributes typically used to describe his work—but many other aspects of his oeuvre reveal his profound and abiding interest in the Bible as a source of artistic inspiration. Of his surviving works consisting of some two hundred paintings and four hundred drawings, by far the majority treat themes from the Bible or ancient history; he was fascinated by the links between the Bible and mythology; in several instances his biblical characters take on the qualities of Greek and Roman heroes while in other cases a subject or scene from the Bible is presented in a totally novel way as a type or exemplar of the human condition. Unique among artists of his day, Poussin regarded literature, and especially poetry, as an inspirational 'sister art' that inspired and ennobled the visual arts. Since the number of biblical subjects he painted was vast and we know from his correspondence that he reflected at length on how stories from classical and biblical literature—and especially those he felt carried a moral—might best be expressed visually, an exploration of his final cycle of paintings, *The Four Seasons*, provides a fitting conclusion to this book which has as its overall theme the interrelationship between text and image. In setting out to paint *The Four Seasons*, Poussin consciously thought of this cycle as his swansong, his final artistic testament and the summation of his life's work in which he wanted to express not only how he saw in retrospect the meaning of his own life but also the effect of the passing of time on all human life. 'They say a swan sings more sweetly when it is close to death', he notes in his letters.[1]

In what sense did Poussin see this cycle of paintings as a visual expression and interpretation of the very essence and meaning of life? Although his

1. C. Jouanny, *Correspondance de Nicolas Poussin* (Paris: Archives de l'art français, 1911), p. 445.

career is well-documented and we know the enormous effect that his own outlook had on his choice of paintings, there is still some disagreement as to what were the most formative influences with regard to his personal beliefs and piety. Some would argue that towards the end of his life, by the time he painted this cycle, he had now become atheistic, or more accurately perhaps, pantheistic, while others argue that during his very extended periods in Rome he had come under the influence of Jesuit spirituality.[2] But Poussin's work shows little sympathy with the fervent and emotive Catholicism of his day. Richard Verdi is probably nearest the mark when he suggests that although he accepted the basic teachings of Christianity, the dominant influences in Poussin's life were the doctrines and morality of the Stoic philosophers of antiquity and of the sixteenth and seventeenth centuries, such as Montaigne and Charron, whom Poussin regularly paraphrased in his letters and correspondence.[3]

Another major influence in his life was the Neapolitan poet, Marino, who advocated a close relationship between literature, the image that speaks (*pittura parlante*), painting and the silence that is eloquent (*muta eloquenza*). From the early years of his career, Poussin repeatedly refers to himself as following a profession of 'things mute'. The artist became adept at interpreting different genres of literature and poetry and translating them into painting; he was erudite in ancient and contemporary literature and developed, we are told, a critical understanding of the Old and New Testaments as well as the classics.[4] In particular, he became a leading interpreter of the *pittura filosofica*, that is, depicting a literary description of an event but suggesting a contemporary parallel—*The Destruction of Jerusalem* is his first example of this genre where Josephus's description of the fall of the city is translated into painting with the express purpose of conveying a political and spiritual message to the then contemporary Europe.[5] For this reason, his early biographers used the phrase 'the painter for people of intelligence' to convey the intellectual depth of his paintings. Unlike many other artists of his day, such as Caravaggio, Rubens or Velázquez who were restricted and constrained in their choice of subject matter by their patrons, Poussin had a much wider say in his choice of themes. At most, his patrons generally stipulated that the painting should depict a scene from religion or mythology and left the rest to the artist's own devising; Poussin claimed that 'the painter should himself choose the exact

2. See Verdi, *Nicolas Poussin*, pp. 19-25.
3. Verdi, *Nicolas Poussin*, p. 28.
4. See Francesco Solinas, 'The Destruction and Sack of Jerusalem', pp. 7-12.
5. See Solinas, 'The Destruction and Sack of Jerusalem', p. 9.

subject to be represented and avoid those that contained nothing'.[6] Conse-
quently, as Richard Verdi points out, his paintings and choice of themes
frequently reflect the artist's personal outlook on life and, more generally,
how he saw the role of struggling humanity within the natural world in
which we live.[7]

Poussin's distinctive treatment of biblical themes, then, can be attributed
to two main factors: first his own essentially stoical attitude to life and sec-
ond, his professional aim as an artist which was to give expression to the
richness of ancient literature (in this case, the Bible) through the 'silent elo-
quence' of his paintings, following the advice of the poet Marino. It is these
two major influences on the artist that make his visual interpretation of bib-
lical stories so intellectually challenging and less dominated by traditional
Christian symbolism or theological considerations than were other paintings
of his day. In addition, the fact that he had relative freedom to choose his
own biblical subjects allowed him to include autobiographical aspects in the
stories he painted.

Poussin brought several characteristics of Stoic philosophy to bear on his
interpretation of biblical stories, the most important being the unpredicta-
bility of life. This was an underlying subject throughout Poussin's entire
career and he chose in particular the theme of the birth and nurturing of a
future hero to express it. From classical mythology he chose *The Birth of
Bacchus* and *The Saving of the Infant Pyrrhus*, but it was *The Finding of Moses*
(Exod. 2.2-6), a scene he painted five times, that he felt conveyed most effec-
tively the notion of fate and our inability to control destiny.[8] The hero, Moses
or Pyrrhus, becomes an exemplar of how essentially unpredictable life is and
acts as a type for the struggles of life that may befall even the most exalted of
beings. Not only in birth but also in death can fate deal a cruel blow: *The
Death of Germanicus* depicts the young noble hero Germanicus, adopted son
of Emperor Tiberius, on his deathbed and surrounded by his family. He has
been poisoned by the emperor who was jealous of his prowess and success on
the battlefield. The painting depicts the last words of the hero to his wife and
children begging them 'to submit to cruel fortune'. The Stoic, Charron, regu-
larly cited by Poussin, commented:

> If a man shall call to mind the history of all antiquity, he shall find, that all
> who lived and carried themselves worthily and virtuously have ended their
> course either by exile or prison or some other violent death.[9]

6. Cited in Verdi, *Nicolas Poussin*, p. 19.
7. Verdi, *Nicolas Poussin*, p. 19.
8. Poussin painted eighteen canvases illustrating episodes from the life of Moses, his
favourite biblical hero.
9. Cited in Verdi, *Nicolas Poussin*, p. 34.

The fate of these heroes, Moses and Germanicus, and the incidents surrounding their birth and death, epitomize the uncertain nature and course of human destiny. Fortune mixes the good with the bad. Poussin regarded it as the greatest injustice to die outside one's native land (perhaps because he himself had been uprooted from his native France to Rome) and used the story of Moses as an illustration: born in Egypt and though guided by God and struggling to reach the Promised Land, he was forced by fate to die on its borders.

A second aspect of Stoic philosophy, much in evidence in Poussin's work, is the triumph of virtue over vice and the attainment of wisdom which is acquired only through living in accordance with reason. Nature, according to the Stoics, is the source of all reason because it rules all things and reflects the divine will of the creator. A state of virtue is achieved only through living in harmony with nature, an aspect brought out clearly in so many of Poussin's landscape paintings. Virtue and good living bestow the ability to rise above the accidents and misfortunes of life—but virtue has its opposite, namely the forces of evil and destruction. All human life must remain forever subject to nature's weal and woe. The fruits of virtue and the punishment of vice are portrayed many times by Poussin who saw reason and virtue as the only means of protection against 'the assaults of mad, blind fortune', but even these might prove powerless at times against the randomness of fate. Virtue is represented by two biblical subjects: *Eliezer and Rebekah* (Gen. 24.42-46) which he painted three times and by *Moses and the Daughters of Jethro* (Exod. 2.15-21). The former suggests for Poussin a key moment of virtue and kindness when Rebekah quenches the thirst of Eliezer and his servants, strangers in the land; through her kind and virtuous actions she reveals that she is the chosen one. In the centre of the picture, the presence of a young woman with a pitcher on her head, departing for a village in the background, serves to draw attention to those who draw water only for themselves and unlike Rebekah, will not be divinely selected.[10] The male counterpart to this story is the painting in which Moses protects the daughters of Reuel (or Jethro), as they come to draw water at the well, from a group of shepherds and, in return for his virtue, is given Zipporah, daughter of Reuel, in marriage (Exod. 2.15-21). Both biblical stories are used to illustrate the blessings to be gained from acts of virtue. For Poussin, it is virtue alone that is capable of confronting the vicissitudes of life; he chooses to interpret and depict both biblical stories in ways that accord with his own philosophy, ignoring the traditional exegesis of the passages that emphasizes a hidden, divine providence guiding the events of humans towards their predestined end.

Evil, on the other hand, is represented by two different biblical stories: The Adoration of the Golden Calf (Exod. 32.1-6), which the artist painted

10. Verdi, *Nicolas Poussin*, p. 156.

twice and The Plague at Ashdod[11] (1 Sam. 5.1-6). Both episodes concern instances of idolatry, but Poussin uses the story of the golden calf to illustrate the innate greed of humankind and the story of the sudden plague among the population of Ashdod to depict graphically the suffering that acts as punishment for humanity's wickedness and immorality. The artist draws the viewer into the scene and makes the events of the narrative appear frighteningly real and dramatic by compressing all the different actions of the story into a single moment. He combines successive stages in the action, placing the principal figures in the middle distance and reserving the foreground for a group of anonymous actors, representative of ordinary humanity, whose reactions to the event are intended to appeal directly to the viewer.[12] The purpose of this technique is to underline the universality of the story—in Poussin's own words, this narrative painting style was intended to be 'read' by the viewer so that the lesson and moral of the biblical story could be more easily appropriated. In The Adoration of the Golden Calf, the excesses represented by the vast array of gold objects and the consequences of the people's worship of them serve to remind the viewer of the more worthwhile stoic virtues of moderation and detachment, while The Plague at Ashdod suggests that the sufferings and misfortunes of life are nature's punishment for humanity's lack of virtue.

When commissioned to paint a series of *The Seven Sacraments* by his patron, Pozzo, along very specific lines, Poussin implied that, even in this overtly Christian theme, he conceived of the series as a set of moral lessons intended to equip the believer with protection 'against the wayward workings and tricks of Fortune'.[13] Five of the seven episodes he took from the Bible—something quite unprecedented: for *Baptism* he used the biblical episode of John the Baptist baptizing Christ, for *Penance*, Mary Magdalene washing Christ's feet, for *Ordination* Christ giving the keys to Peter, for *Marriage*, the marriage of Mary to Joseph and for *The Eucharist*, he used the scene of the last supper. For *Extreme Unction*, Poussin did not use a biblical episode but instead he used his earlier *Death of Germanicus* to depict the inevitability of death and how the dying man surrounded by his family faces it stoically. Even though these biblical subjects may have represented to the devout Christian various stages along the pathway of life from birth to death, the fate of all these biblical characters merely confirmed for the artist the uncertain and unpredictable nature of human destiny. Poussin used the series of seven paintings as a philosophical reflection on the passage of life from birth to death, the rites of passage through life and the inevitability of death. In his correspondence, he states how he intended to follow up the series with

11. This celebrated canvas is in the Louvre, Paris.
12. Verdi, *Nicolas Poussin*, p. 191.
13. Jouanny, *Correspondance*, p. 33.

another set of pictures taken from biblical subject matter to depict the wisdom and virtue needed to stand up against 'the blind folly of fortune'.

Poussin frequently uses symbols from biblical literature to express important aspects of his stoical approach to life. For example, the serpent becomes an agent of evil or death, as in *Landscape with a Man Killed by a Snake*, in which a youth who approaches the water's edge to drink is suddenly strangled by a serpent, or in the two paintings that vividly portray Eurydice's sudden death by snakebite. These, along with a series of other works, always portray the snake or serpent lurking in a tranquil and idyllic landscape where it serves as a reminder of the omnipresence of death. It provides an archetypal instance of the unpredictability of fate and represents a blind and malevolent force that can suddenly undo the lives of unsuspecting people.[14] The single exception is *The Four Seasons* where Poussin places the serpent in the episode of the violent Flood and not in the idyllic landscape of the Garden of Eden as one would have expected.

The artist was also preoccupied with water as a symbol and it plays a central role in more than fifty of his paintings—which represent almost a quarter of his entire work. He was especially drawn to biblical themes or episodes where water features prominently as in *The Finding of Moses*, *The Crossing of the Red Sea*, *Moses Striking the Rock* and *The Baptism of Christ*. There are many paintings that are focused on a well: for example, his three versions of *Eliezer and Rebekah*, *Christ and the Woman of Samaria* and *Moses and the Daughters of Jethro*. In some of these, a journey to, or across, water clearly symbolizes the initiation to new or higher life or denotes ritual purification, but the artist's own preoccupation with depicting water in its many different contexts may be explained by the fact that water, as a universal symbol of the flowing course of life, was particularly appropriate to an artist pre-eminently concerned with the theme of human destiny with its unstoppable flow. Poussin frequently depicted the destructive power of water as part of a violent storm or tempest, influenced by Stoic belief that the workings of fortune bring meteors and tempests into one's life; he himself refers many times in his letters to the terrible havoc that stormy weather can wreak on both humans and nature.[15] In *Landscape with Pyramus and Thisbe*, the tragic deaths of Pyramus and Thisbe take place in the midst of a violent storm, despite the fact that Ovid himself sets the scene on a moonlight night. In *Landscape with a Storm*, the devastating effects of a raging storm upon a group of anonymous travellers forms the subject of the picture.

Finally, Poussin appears preoccupied with two other themes from the Bible: that of the imperilled child and the power relationships between male and female figures. The first theme is evidenced in several of his paintings,

14. Verdi, *Nicolas Poussin*, p. 45.
15. Jouanny, *Correspondance*, pp. 120, 163.

for example, his many depictions of *The Massacre of the Infants*, *The Flight into Egypt*, *The Judgment of Solomon* and *Hagar, Ishmael and the Angel*. Richard Verdi notes that the relationship between the sexes is a particular concern of the artist's final works. In his early career, Poussin had often portrayed scenes in which a male appears subject to the powers of a goddess, princess or sorceress but in his later career this relationship is reversed in a whole series of images in which a male figure of authority presides over a female, for example, *Esther and Ahasuerus*, *Christ and the Adulterous Woman*, *Christ Appearing to Mary Magdalene* and the meeting between Ruth and Boaz in *The Four Seasons*.

The Four Seasons

Poussin concluded his career immersed in exploring the parallels between the course of human life and the cycles of nature. Such interest already underlies his earlier work where the theme of life and death is set against a background landscape of transience; for example, glimpses of the landscape can be seen in some of *The Seven Sacraments*, in particular *Baptism* and *Ordination*. From 1648 onwards, however, he dedicated himself to exploring how the forces of nature could be employed to reflect the character or mood of important themes from ancient literature that particularly appealed to him. His final years became occupied exclusively with *The Four Seasons*, executed for the Duc de Richelieu between 1660 and 1664, and such was his determination to complete this last cycle of paintings that he abandoned all other works including an elaborate *Apollo and Daphne*.

The cycle is regarded as Poussin's most pantheistic and most stoical work and derives directly from the philosophy of Ovid, summed up in a passage from *Metamorphoses*:

> Do you not see the year assuming four aspects, in imitation of our own lifetime? For in early spring, it is tender and full of fresh life, just like a little child; at that time, the herbage is young, swelling with life, but as yet without strength and solidity, and fills the farmers with joyful expectation. Then all things are in bloom and the fertile fields run riot with their bright-coloured flowers; but as yet there is no strength in the green foliage. After spring has passed, the year, grown more sturdy, passes into summer and becomes like a strong young man. For there is no hardier time than this, none more abounding in rich warm life. Then autumn comes, with its first flush of youth gone, but ripe and mellow, midway in time between youth and age, with sprinkled grey showing on the temples. And then comes aged winter, with faltering step and shivering, its locks all gone or hoary.[16]

16. Ovid, *Metamorphoses*, Book XV, 199-213. Translation by A.D. Melville, *Ovid: Metamorphoses* (Oxford: Oxford World's Classics, 1986), p. 358.

At the heart of Ovid's philosophies rests a central tenet of stoicism, namely that the cycle of human life from birth to death is a reflection of the order of nature. Following the perspective of Ovid, Poussin approached the paintings of his last years as a final formulation of his own philosophy of life; he gives a much less prominent role to humanity and greater importance to inanimate nature and becomes preoccupied with the themes of birth, death, and transformation in nature. His final cycle depicts a mood of philosophical resignation to the passing of time but also, viewed in the context of the artist's entire output, it provides a conclusive formulation of his thoughts on the human condition.

Richard Verdi argues that *The Four Seasons* are startlingly original and unique not only in Poussin's oeuvre but also in the entire history of art.[17] Their utter originality lies in the fact that he takes four quite unrelated biblical episodes and makes them symbolic of the four seasons; each episode forms part of a large allegorical cycle that sum up universal themes of life and death. Before Poussin, artists generally depicted the four seasons in one of two ways: like Guido Reni, they could use human or divine figures to represent different times of the year, especially the figures of gods and goddesses: for example the goddess Ceres to symbolize summer and Bacchus to represent Autumn. The second way was, for example in the paintings of Pieter Bruegel, to depict landscapes with agricultural workers performing tasks appropriate to particular times of the year. But Poussin's approach is unique in that he employs a biblical theme for each season and in doing so he creates an entirely new perspective from which to view the four biblical episodes he chooses. He takes the biblical story of the Garden of Eden to represent spring, the meeting of Ruth and Boaz in the corn field to evoke summer, the spies with the grapes from the Promised Land as autumn and the Flood to represent winter; in addition, he places the four episodes at different times of the day— morning time in the Garden of Eden, noontime in the corn field of Boaz, and afternoon in the Valley of Eschol; while the flood takes place in the darkness of night. In order to emphasize the natural world, his settings contain little or no architecture and he chooses his Old Testament stories not only for their evocative landscapes but also to suggest early moments in the primeval history of the Bible. Stylistically, the most striking aspect of each painting is its colour. Each is dominated by a single prevailing hue: green for spring, golden-yellow for summer, greyish-brown for autumn and blackish-grey for winter. The emotional essence of his theme is thus conveyed through colour alone.

17. Verdi, *Nicolas Poussin*, p. 317.

Spring, *or* The Earthly Paradise

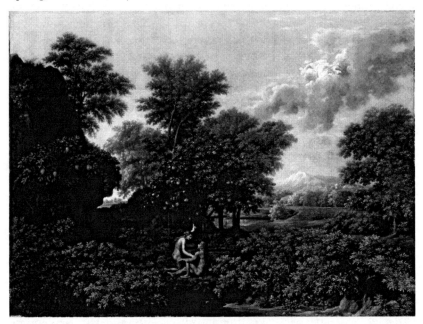

Fig. 45. Nicolas Poussin, *Spring,* or *The Earthly Paradise* (1660–64) © Photo RMN, Musée du Louvre, Paris.

Poussin depicts the landscape of the Garden of Eden as one of overpowering richness with dense foliage and trees laden with fruit while verdant greens evoke the vitality and freshness of nature at springtime. The uncultivated land suggests a landscape that is completely natural and untouched by human hand. In the centre of this idyllic landscape the artist places Adam and Eve with the tree of knowledge behind them in the centre middle distance, and depicts God departing at the upper right. At the left, the dawning rays of the sun emerge between a cleft in the landscape. Apart from Adam and Eve, the only other signs of life are the birds that swim peacefully on a lake in the distant background.

In this painting, Poussin conflates a number of aspects of the creation story in Genesis—and, as we saw already, this was a common technique in his earlier work where he compressed different aspects of the story into a single moment to draw the viewer into the scene so that we might 'read' and appropriate the moral contained in the painting. Here, God has completed all his acts of creation and departs at the top right from his created universe. Adam is presented as if waking from sleep and is dominated by the figure of Eve who kneels over him; the entwining of their limbs suggests not only the close intimacy that exists between the two but also the idea that Eve's body has

emerged from the body of Adam. Eve points to the tree of knowledge with her left hand and converses with Adam about its significance. Their state of nakedness (in contrast to the fully clothed departing God) corresponds to the natural landscape around them.

There is something unsettling about God departing from the scene of creation in the upper right—we cannot see his face and his left hand is held up in a kind of farewell gesture; in other biblical paintings we are more likely to see God or his angel messengers descending into the picture, bringing the reassurance of a divine presence to the viewer. The image of God departing, on the other hand, suggests abandonment: for example, in Chagall's *Consolation*, painted in the despair of 1930s Europe, the departing angel together with the closed Torah and the silent musical instrument evokes the idea of the Jewish God distancing himself from his people and abandoning them to their fate. That Poussin intended deliberately to depict God abandoning the world he created is shown by comparing the style and subject matter of *Spring* to his *The Birth of Bacchus*. Both paintings are concerned with the fundamental theme of creation in nature, but whereas in *Spring*, God is depicted as leaving his created world, the god Jupiter in *The Birth of Bacchus*, on the other hand, is depicted in the same upper right corner reclining in a permanent state with his face towards the viewer. Jupiter, unlike the god in *Spring* is portrayed as being interested and involved in the created world. A second similarity between the two paintings is the depiction of the dawn to the left: in *The Birth of Bacchus*, the rising sun alludes to the god Apollo and it has been suggested that in *Spring* it has the same function. While the god of the Hebrew Bible departs to the right, it is Apollo, representing the natural force and vitality of the sun emerging from the left that takes his place. Poussin thus suggests that the power that determines the seasons and cycle of human existence is nature, represented by the sun, and not any other supernatural force and that we must play out our lives in the context of the natural world alone. Humanity must determine and accept its own fate.

Into this earthly paradise Poussin introduces one of his favourite themes, water. As in Genesis, there is water to irrigate the garden (Gen. 2.10) and rain to water the earth (2.5), here in the form of the clouds. The depiction of clouds serves to unify the four paintings: in spring and summer, water is important for the crops but in winter it becomes a source of destruction. Against a background of inanimate nature, the clouds provide a pointed reminder of those unpredictable forces that shape and govern the lives of humans. Conspicuously absent from the Garden of Eden is the serpent; this is particularly striking since we have seen above that the serpent was a favourite symbol of Poussin to depict the presence of death and malevolent forces generally. But in this cycle, he places it in the story of the Flood for two reasons: first, the absence of the serpent, together with the departure of God,

leaves the newly created world a morally neutral place without any overt
reference to the presence of good or evil and second, the serpent associates
the story of the Flood with that of creation and draws attention to the fact
that it is the Flood that is the consequence of evil and not creation.

Summer, *or* Ruth and Boaz

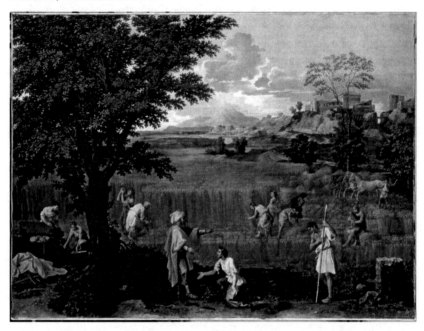

Fig. 46. Nicolas Poussin, *Summer, or Ruth and Boaz* (1660–64)
© Photo RMN, Musée du Louvre, Paris.

One of the reasons for Poussin's choice of subject for *Summer* was
undoubtedly the biblical setting of the wheat field for the story of Boaz and
Ruth.[18] Unlike *Spring*, the earth has now been cultivated and this is mirrored
in the rigorously constructed forms of the landscape. The natural paradise of
Genesis has now been replaced by one created by human hand. The number
and variety of people that animate the painting illustrate how humankind
has engaged with the landscape and works in harmony with it. The picture is
highly organized and all the workers—and the horses—show how nature has
been harnessed by humankind in contrast with *Spring* with its natural land-
scape and its idyllic and virginal state. The steady noon-day sun reminds us

18. In Jewish tradition, the Book of Ruth is associated with the harvest celebration of
Pentecost. See Grace I. Emmerson, 'Ruth', in John Barton and John Muddiman (eds.),
The Oxford Bible Commentary (Oxford: Oxford University Press, 2001), pp. 192-95 (192).

that we are now at the pinnacle of life. The number of people dressed in a rich variety of ways allows for even more colour and contrasts with the primaeval nakedness of Adam and Eve.

Ruth kneels before Boaz and begs to glean wheat in his fields (Ruth 2.1-17). Both characters are depicted in strict profile and placed in the centre foreground; Ruth kneels to highlight her suppliant attitude while Boaz stands over her to denote his status and majesty. Thus, the position of the male and female figures are reversed from those in *Spring* where Eve towers over Adam. Richard Verdi notes that many of Poussin's paintings illustrate the artist's preoccupation with depicting either the male or female in a subservient pose but suggests that the reason for doing so remains known only to the artist.[19] Here, the viewer can only note the parallel that Poussin evidently wanted to draw between Adam and Eve and Ruth and Boaz. While Eve is associated with the fruit of the tree, Ruth becomes associated with the corn (other early seventeenth-century engravings often depict Ruth holding wheat as Ceres, classical goddess of the harvest); some suggest that the symbol of the wheat evokes the Eucharist and so Ruth becomes a redemptive figure as opposed to Eve who introduces evil by picking the fruit from the tree. The picture may contain other symbolism: the seated bagpiper on the right may suggest the future marriage of Ruth and Boaz—a marriage that, according to mediaeval interpretation, was symbolic of the union of Christ and the Church. Poussin may also have wished to include another of his favourite themes, namely exile: just as Adam and Eve were exiled from the Garden, so too Ruth remains always the exile, always the Moabitess.

But there may be other reasons why Poussin chose this story to represent a key aspect of the cycle of life. The biblical story of Ruth moves from famine to harvest, from death to birth and from emptiness to fullness and all these movements are reflected in the natural landscape described by the text. Furthermore, Grace Emmerson highlights how in the biblical Book of Ruth, there is no overt intervention by God in the course of human events: significant occurrences in life are attributed to chance (2.3 and 3.18).[20] In the first instance, Ruth 'happened' to be in the part of the corn field belonging to Boaz and in the second Naomi advises Ruth to see 'how things will turn out'. The idea of important events happening by chance would have appealed to Poussin. Emmerson also draws attention to the hiddenness of God throughout the book; sometimes 'he is not even in the shadows'.[21] This general absence of God from the story may also have appealed to Poussin and

19. Verdi, *Nicolas Poussin*, p. 37.

20. Emmerson, 'Ruth', p. 192. God is largely absent from the story and his active intervention is acknowledged only twice—first by the provision of food (1.6) and second by the conception of a child (4.13).

21. Emmerson, 'Ruth', p. 192.

enabled him to continue the theme of the absent God with which he intro-
duces the first painting, *Spring*. Finally the emphasis throughout the book on
hesed, the human obligation to act according to loyalty and kindness,[22] corre-
sponds to the qualities of virtue and right-living that the artist believed were
essential, faced with the unpredictability of life and the inevitability of fate.[23]

Autumn, *or* The Spies with the Grapes from the Promised Land

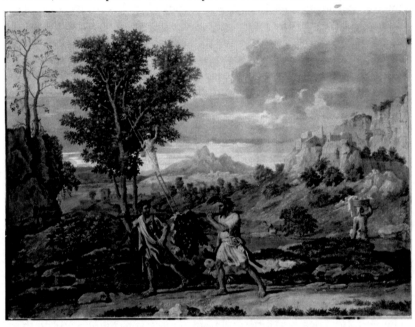

Fig. 47. Nicolas Poussin, *Autumn*, or *The Spies with the Grapes from the Promised Land*
(1660–64) © Photo RMN, Musée du Louvre, Paris.

To depict autumn, Poussin takes the story from Numbers 13 where Moses
sends the spies into the Promised Land and they return with a bunch of grapes,
the size of which become greatly exaggerated in the painting. The spies at the
centre of the painting replace the figures of Adam and Eve in *Spring* and
Boaz and Ruth in *Summer*. The artist makes a deliberate connection between
the Garden of Eden and the Promised Land which now becomes the new
earthly paradise: the woman picking apples from the tree in *Autumn* reminds

22. Emmerson, 'Ruth', p. 194.
23. Verdi, *Nicolas Poussin*, p. 31.

us of the figure of Eve and the position of the ladder joins together the bunch of grapes at one end and the apples on the tree at the other. The landscape of *Autumn* represents the fruitfulness of the season but thick clouds gather and some of the trees lose their leaves in anticipation of winter. The painting is dominated by decaying colours and the hurried movement of the spies suggests the idea of a coming storm while the man seated at the water's edge anticipates the waters of the Flood. In comparison to the serene figures of *Summer*, the figures in this painting suggest the fleeting nature of life itself.

The cluster of greatly enlarged grapes is the most significant symbol in the painting. Some suggest that it may be a reference to Bacchus, god of wine, while others argue that it is intended to complement the eucharistic symbolism of the bread present in the previous painting, *Summer*. Taken together, the wheat and the grapes would then represent the bread and wine of the Eucharist. But this explanation does not do justice to the landscape in which the spies with the grapes are placed. From Numbers 13, we can deduce that the background landscape in the painting is the Promised Land and specifically the Valley of Eschkol—the Hebrew word for 'cluster' of grapes (אשכול) becomes the name given to the valley from which they are plucked (Num. 13.24). The cluster of grapes therefore becomes the key to interpreting the picture. It is interesting to note that the image appears only rarely in the Old Testament and often in negative contexts. In Numbers 13, when the spies show the grapes, the fruit of the land, to the people, they are still not persuaded to enter it. The idea is repeated in Num. 32.9: those who had gone up to the Valley of Eshcol and saw the land discourage others from entering it and the same episode is referred to again in Deut. 1.24. Poussin's preoccupation with the theme of exile may be reflected in this painting. While Adam and Eve are exiled from the Garden and Ruth is an exile, the Israelites, represented by the two spies, remain outside their Promised Land and hesitate to enter it. In Mic. 7.1, the prophet Micah uses the image of a poor harvest in which 'there is no cluster (אשכול) to eat' as an introduction to a lament for a society in which all justice and right-living has vanished and corruption and evil is widespread—the exact opposite of what God demands of the people in 6.8, namely 'to do justice and love kindness'.[24] It is impossible to know whether Poussin had these other texts in mind when choosing his theme for autumn but the text from Micah reflects the artist's own outlook on life, namely that the unpredictable nature of fate can be countered only by virtue, justice and right-living.

24. See H.G.M. Williamson, 'Micah', in Barton and Muddiman (eds.), *The Oxford Bible Commentary*, pp. 595-99 (598).

Winter, *or* The Deluge

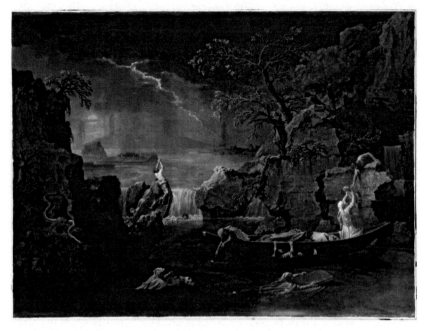

Fig. 48. Nicolas Poussin, *Winter*, or *The Deluge* (1660–64)
© Photo RMN, Musée du Louvre, Paris.

As the first great landscape in the classical tradition to depict the elemental fury of nature, this painting is regarded as one of the summits of the artist's achievements and a turning point in the entire history of art. Depicting the helplessness and insignificance of humanity in the face of wrathful nature, it became particularly popular during the romantic period among artists such as Turner and Géricault.[25]

The subject of the painting is the biblical Flood in which the ark of Noah floats under a pale moon while a cross-section of humanity, all of whom are destined to perish, struggle in vain against the overwhelming power of the waters. The figures in this painting are few and are dominated by a most violent landscape in which unrelieved tones of leaden grey evoke the pallor and presence of death. Unlike the previous seasons where two figures (Adam and Eve, Boaz and Ruth, and the two spies) dominate the paintings and suggest a future of promise, here all the characters in the foreground face annihilation—a mother striving to lift her child to the safety of its father's arms while other desperate figures cling for life to the edge of a sinking boat. In the middle distance, a boat is thrashed against the waves and one of its occupants

25. Verdi, *Nicolas Poussin*, p. 325.

raises his hands in prayer—a plea that is answered by a streak of lightning across the darkened sky.

At the left, a monstrous serpent slithers to safety on a rock. The serpent, which we would expect to see in *Spring* rather than as an element of the Flood story, serves to bring together the account of the creation of the world and its subsequent destruction. In Gen. 6.5-7, God regrets that he has created humankind on the earth because every inclination of their hearts is towards evil. Now he wishes to blot out and reverse his act of creation. As Whybray points out,[26] the story of the flood is the climax of a sequence that begins with the creation of the world and ends after almost total disaster for humankind. It is the torrents of water that signal the undoing of God's creation. The unleashing of the fountains of the great deep that burst forth in Gen. 7.11 remind us of how the waters 'on the face of the deep' in Gen. 1.2 are contained and controlled by God. Now they burst forth and destroy humankind. At the end of the story, however, God accepts that the evil tendency is innate and ineradicable in humanity (Gen. 8.21), a view shared by the artist. God also promises in Gen. 8.22 never again to interfere with the order of day and night or the seasons:

> As long as the earth endures, seed time and harvest, cold and heat, summer and winter, day and night shall not cease.

This promise may provide a further reason why the artist chose the flood to represent winter. In spite of the evil inherent in humankind, the cycle of nature must continue.

Richard Verdi argues that we should read this painting in the light of Mt. 24.30-42.[27] According to Matthew, the Flood is a prefiguration of the coming of Christ at the Day of Judgment. This painting may therefore be seen as a 'disguised Last Judgment' with the saved in the ark of Noah at the upper left and the damned in the lower right, exactly as they would appear in a traditional portrayal of this theme:

> Then the sign of the Son of Man will appear in heaven, and then all the tribes of the earth will mourn, and they will see the Son of Man coming on the clouds of heaven with power and great glory. And he will send out his angels with a loud trumpet call, and they will gather his elect from the four winds, from one end of heaven to the other. From the fig tree learn its lesson: as soon as its branch becomes tender and puts forth its leaves, you know that summer is near. So also, when you see all these things, you know that he is near, at the very gates. Truly I tell you, this generation will not pass away until all these things have taken place. Heaven and earth will pass away, but

26. R.N. Whybray, 'Genesis', in John Barton and John Muddiman (eds.), *The Oxford Bible Commentary* (Oxford University Press, 2001), pp. 38-66 (46).

27. Verdi, *Nicolas Poussin*, p. 324.

my words will not pass away. But about that day and hour no one knows, neither the angels of heaven, nor the Son, but only the Father. For as in those days before the flood they were eating and drinking, marrying and giving in marriage, until the day Noah entered the ark, and they knew nothing until the flood came and swept them all away, so too will be the coming of the Son of Man. Then two will be in the field; one will be taken and one will be left. Two women will be grinding meal together; one will be taken and one will be left. Keep awake therefore, for you do not know on what day your Lord is coming (Mt. 24.30-42).

However, that Poussin assigns Noah's ark to the far distance and fore-grounds the utter destruction of humanity (in close proximity to the viewer) suggests that his intention is to intensify the impact of the unpredictable forces of nature and the inexplicable workings of fate. The artist may have been more interested in suggesting the complete absence of God in this painting—to correspond with the departing God in *Spring*—than in the dra-matic coming of Christ at the Last Judgment.

Conclusion

The cycle of *The Four Seasons* represents highly original and innovative work on the part of Poussin. Never before had an artist chosen four such familiar, but unrelated, biblical themes to depict the seasons or to visualize the four ages of humankind as described by Ovid. In addition, *Winter* became the first great landscape in the classical tradition to depict the elemental fury of nature. But this cycle of paintings that at first sight might appear relatively uncomplicated includes a range of symbolism that makes it impossible to settle on any one particular interpretation.

The most striking aspect of the four vast canvases is the way elements of the natural landscape, trees and vegetation, cliffs and mountains, sky and water, dominate the human figures and make them appear diminutive and passive. The figures in each painting are inseparable from the natural ele-ments with which they are associated in the Bible and in subsequent tradi-tion. While Adam reclines on the soil from which he is formed, Eve points to the apple on the tree; God floats on the clouds of heaven and Ruth kneels on sheaves of barley; a wooden beam supports the large cluster of grapes and unites the figures of the spies while one of them carries pomegranates in his right hand; the ark of Noah floats on top of the swollen waters while other doomed figures swim or sink in the floods or clutch desperately at pieces of wood or rocks. The minor, anonymous figures (for example, the reapers and the women preparing bread in *Summer*, the man seated at the water's edge, the woman carrying a basket of fruit on her head and the woman picking apples in *Autumn*) are presented as extensions of the natural landscape and their distance from the viewer makes it impossible to distinguish their features

or their reactions to events—even their elaborate gestures point back to specific elements of the landscape. Humankind is presented as belonging totally to the natural world and is at its mercy. Not only does Poussin diminish the role and importance of the human characters but he also effectively removes any real involvement by God in the four stories—God is depicted as departing from his created world in *Spring*, he is absent from the next two paintings and his presence with Noah, symbolized by the ark in *Winter*, has receded so far into the distance that we barely give it a second look.

At one level, this allows us to interpret the cycle as having no overtly religious significance. The paintings simply express the idea that just as nature can keep us alive through the nourishment it provides (represented by the harvests of Summer and the fruits of Autumn), its destructive force also causes death and annihilation (Winter). The primaeval biblical landscapes form the background against which we play out our lives—they hold up a mirror to our own existence as we move from birth through life to inevitable death. Unlike other artists, Poussin does not appear particularly concerned with suggesting the existence of a hidden God who is able to control the events he depicts.

Many art critics over the years, however, have interpreted the paintings allegorically, arguing that these biblical episodes were chosen by the artist to prefigure the New Testament: for example, Adam may be seen as prefiguring Christ and the marriage between Ruth and Boaz symbolizes the marriage between Christ and the Church while the wheat and the grapes represent the Eucharist and the Flood prefigures the Last Judgment.[28] Others hold that the first three seasons represent three different stages of human life: spring the state before the giving of the law to Moses, autumn the time under the Mosaic Law and summer under the new disposition of Christ—the direct descendant of the marriage of Ruth and Boaz. It seems highly unlikely, however, that Poussin intended his last artistic testament as an illustration of how Old Testament events prefigure the New—he was much more interested in portraying how the vast forces of nature dominate our lives; noone, not even God, can turn back the flow of time or change the order or pace of the advancing seasons. But it may also indicate the skill of the artist that he included symbols designed to draw a wide range of viewers into his paintings.

Poussin's bringing together of four unrelated biblical subjects to express philosophical ideas about life in which God plays no part is quite unique. It represents a reading of the Old Testament that pays close attention to the significance of the background landscape in the different stories—an aspect we often ignore when reading the text, focused as we generally are on the characters, but oblivious of the powerful natural landscapes they inhabit. The

28. See Verdi, *Nicolas Poussin*, p. 318.

comments on the artist's uniqueness and profundity made by Alain Mérot are especially apt, particularly in relation to Poussin's original interpretation of biblical stories:

> Never before, perhaps, in the history of Western painting, had so many different and often difficult things been stated with such simplicity. Never before had a painter had such a sense of the universe as a whole. Poussin was neither projecting a personal view of the world nor imbuing it with his own feelings, however: his sense of the universe was impersonal, and it is in this fact, seen by some as a defect, that his greatness lies.[29]

29. Alain Mérot, *Nicolas Poussin* (New York: Abbeville, 1990), p. 243.

BIBLIOGRAPHY

Adams, L.S., 'Iconographic Aspects of the Gaze in Some Paintings by Titian', in Patricia
 Meilman (ed.), *The Cambridge Companion to Titian* (Cambridge: Cambridge Uni-
 versity Press, 2004), pp. 225-40.
Aikema, B., *Jacopo Bassano and his Public: Moralizing Pictures in an Age of Reform ca.
 1535–1600* (Princeton: Princeton University Press, 1996).
Ainsworth, M.W. and K. Christiansen (eds.), *From van Eyck to Bruegel: Early Netherland-
 ish Painting in the Metropolitan Museum of Art* (New York: Metropolitan Museum of
 Art, 1998).
Alexander, L.C.A., 'Acts', in John Barton and John Muddiman (eds.), *The Oxford Bible
 Commentary* (Oxford: Oxford University Press, 2001), pp. 1028-61.
Alter, R., *The Art of Biblical Narrative* (London: George Allen & Unwin, 1981).
—*Genesis* (New York: W.W. Norton, 1996).
—*The Art of Biblical Poetry* (Edinburgh: T. & T. Clark, 1985).
Amishai-Maisels, Z., *Depiction and Interpretation: The Influence of the Holocaust on the
 Visual Arts* (Oxford: Pergamon Press, 1993).
Andrews, L., *Story and Space in Renaissance Art: The Rebirth of Continuous Narrative* (Cam-
 bridge: Cambridge University Press, 1995).
Anon., 'Dreams and Visions', in David Lyle Jeffrey (ed.), *A Dictionary of Biblical Tradition
 in English Literature* (Grand Rapids: Eerdmans, 1991), pp. 213-16.
Anon., 'Exile', in Leland Ryken, James C. Wilhoit and Tremper Longman III (eds.),
 Dictionary of Biblical Imagery (Downers Grove, IL: Intervarsity Press; Leicester,
 England: Intervarsity Press, 1998), pp. 250-51.
Anon., 'Exile and Pilgrimage', in David Lyle Jeffrey (ed.), *A Dictionary of Biblical Tradition
 in English Literature* (Grand Rapids: Eerdmans, 1993), pp. 254-59.
Anon., *Marc Chagall 1887–1985* (Nice: Musée National Message Biblique Marc Chagall,
 1998).
Anon., *The Story of Jesus* (Pleasantville, NY: The Reader's Digest Association, Inc., 1993).
Appleton, T.G., *Syrian Sunshine* (Boston: Robert Brothers, 1877).
Apter-Gabriel, R., *Chagall: Dreams and Drama* (Jerusalem: Israel Museum, 1993).
Ateek, N., 'The Flight into Egypt', *Cornerstone* 13 (1988), pp. 6-10.
Austin, M., *Explorations in Art, Theology and the Imagination* (London: Equinox, 2005).
Baal-Teshuva, J., *Marc Chagall* (Cologne: Taschen, 1998).
Backhouse, J., *The Illuminated Page: Ten Centuries of Manuscript Painting in the British
 Library* (London: The British Library, 1997).
Bahat, D. and S. Sabar, *Jerusalem—Stone and Spirit: Three Thousand Years of History and
 Art* (Jerusalem: Matan Arts Publishers, 1997).
Baker, R.J., *Propertius I* (Warminster: Aris & Phillips, 2000).
Bal, M., *Reading 'Rembrandt': Beyond the Word–Image Opposition* (Cambridge: Cambridge
 University Press, 1991).

—'Memories in the Museum: Preposterous Histories for Today', in Mieke Bal, Jonathan Crewe and Leo Spritzer (eds.), *Acts of Memory: Cultural Recall in the Present* (Hanover, NH: University Press of New England, 1999), pp. 171-90.

—'Metaphors He Lives By', *Semeia* 61 (1993), pp. 185-208.

—'On Grouping: The Caravaggio Corner', in Mieke Bal (ed.), *Looking In: The Art of Viewing* (Amsterdam: G+B Arts, 2001), pp. 161-90.

—'On Show: inside the Ethnographic Museum', in Mieke Bal (ed.), *Looking In: The Art of Viewing* (Amsterdam: G+B Arts, 2001), pp. 117-60.

Barber, A. (ed.), *Nicholas Poussin: A Rediscovered Masterpiece* (Jerusalem: The Israel Museum, 1999).

Barber, C., *Figure and Likeness: On the Limits of Representation in Byzantine Iconoclasm* (Princeton: Princeton University Press, 2002).

Barkan, E., and M. Shelton, *Borders, Boundaries, Diasporas* (Stanford, CA: Stanford University Press, 1998).

Barron, S., *Exiles and Émigrés: The Flight of European Artists from Hitler* (Los Angeles: Los Angeles County Museum of Art, 1997).

Baxandall, M., *Painting and Experience in Fifteenth Century Italy* (Oxford: Oxford University Press, 1972).

Bayen, B., *La fuite en Égypte* (Paris: L'Arche, 1999).

Beckett, W., *The Gaze of Love: Meditations on Art* (London: Marshall Pickering, 1998).

Beecham, N., *Jerusalem and its Surroundings through the Ages* (Jerusalem: Palphot Press, 1984).

Belting, H., *The Image and its Public in the Middle Ages: Form and Function of Early Paintings of the Passion* (New Rochelle, NY: A.D. Caratzas, 1990).

Berdini, P., *The Religious Art of Jacopo Bassano: Painting as Visual Exegesis* (Cambridge: Cambridge University Press, 1997).

Blunt, A., 'Poussin at Rome and Düsseldorf', *The Burlington Magazine* 120 (1978), pp. 423-24.

Bohm-Duchen, M., *Chagall* (London: Phaidon, 1998).

Bohrer, F., *Orientalism and Visual Culture: Imagining Mesopotamia in Nineteenth-Century Europe* (Cambridge: Cambridge University Press, 2003).

Bond, R.B., 'Blindness', in David Lyle Jeffrey (ed.), *A Dictionary of Biblical Tradition in English Literature* (Grand Rapids: Eerdmans, 1991), pp. 93-95.

Boyd, J., and P.F. Esler, *Visuality and the Biblical Text* (Florence: Leo S. Olschki Editore, 2004).

Brosh, N., and R. Milstein, *Biblical Stories in Islamic Painting* (Jerusalem: Israel Museum, 1991).

Brown, D., *Tradition and Imagination* (Oxford: Oxford University Press, 1999).

Brown, R.E., *The Birth of the Messiah* (New York: Doubleday, 1993).

Brueggemann, W., *Cadences of Home: Preaching among Exiles* (Louisville, KY: Westminster John Knox Press, 1997).

Buhler, S.M., 'Marsilio Ficino's *De stella magorum* and Renaissance Views of the Magi', *Renaissance Quarterly* 43 (1990), pp. 348-71.

Busse, H., *Islam, Judaism and Christianity: Theological and Historical Affiliations* (Princeton, NJ: Markus Wiener Publications, 1998).

Calkins, R.G., *Illuminated Books of the Middle Ages* (London: Thames & Hudson, 1983).

Calvino, I., *Six Memos for the Next Millennium* (London: Random House, 1996).

Camille, M., 'Mimetic Identification and Passion Devotion in the Later Middle Ages: A Double-sided Panel by Meister Francke', in A.A. MacDonald, H.N.B. Ridderbos

and R.M. Schlusemann (eds.), *The Broken Body: Passion Devotion in Late-Medieval Culture* (Groningen: Egbert Forsten, 1998), pp. 183-210.

—'Seductions of the Flesh: Meister Francke's Female "Man" of Sorrows', in Marc Müntz (ed.), *Frommigkeit im Mittelalter: politisch-soziale Kontexte, visuelle Praxis, körperliche Ausdrucksformen* (Munich: Fink, 2002), pp. 243-59.

Carli, E., *Duccio's Maestà* (Florence: Istituto Fotocromo Italiano, 1998).

Carr, D., *Andrea Mantegna: The Adoration of the Magi* (Getty Museum Studies in Art; Los Angeles: Getty Museum, 1997).

Carroll, R.P., *Wolf in the Sheepfold: The Bible as a Problem for Christianity* (London: SCM Press, 1991), pp. 34-61.

—'Blindness and the Vision Thing: Blindness and Insight in the Book of Isaiah', in Craig C. Broyles and Craig A. Evans (eds.), *Writing and Reading the Scroll of Isaiah: Studies of an Interpretive Tradition* (VTSup, 70; Leiden: Brill, 1997), pp. 79-93.

—'Exile! What Exile? Deportation and the Discourses of Diaspora', in Lester L. Grabbe (ed.), *Leading Captivity Captive* (European Seminar in Historical Methodology, 2; JSOTSup, 278; Sheffield: Sheffield Academic Press, 1998), pp. 62-79.

Chi, He, 'Image', *Christ and Art in Asia* 76 (September 1998), p. 5.

Clifford, R.J. and R.E. Murphy, 'Genesis', in Raymond E. Brown, Joseph A. Fitzmyer and Roland E. Murphy (eds.), *The New Jerome Biblical Commentary* (London: Geoffrey Chapman, 1990), pp. 8-43.

Clines, D.J.A., *I, He, We and They: A Literary Approach to Isaiah 53* (JSOTSup, 1; Department of Biblical Studies, University of Sheffield, 1976).

Cocke, R., *Paolo Veronese: Piety and Display in an Age of Reform* (Aldershot: Ashgate, 2001).

Colimon, M.T., *Le chant des sirènes* (Port-au-Prince, Haiti: Editions du Soleil, 1979).

Creach, J.F.D., *Yahweh as Refuge and the Editing of the Hebrew Psalter* (JSOTSup, 217; Sheffield: Sheffield Academic Press, 1996).

Curzon, D., *Modern Poems on the Bible: An Anthology* (Philadelphia, PA: Jewish Publication Society, 1994).

Davey, N., 'The Hermeneutics of Seeing', in Ian Heywood and Barry Sandwell (eds.), *Interpreting Visual Culture: Explorations in the Hermeneutics of the Visual* (London: Routledge, 1999), pp. 3-29.

—'Between the Human and the Divine: On the Question of the In-Between', in A. Wiercinski (ed.), *Between the Human and the Divine: Philosophical and Theological Hermeneutics* (Toronto: The Hermeneutic Press, 2002), pp. 88-97.

Davidson, B., *The Analytical Hebrew and Chaldee Lexicon* (London: Bagster & Son, 1970).

Davies, P.R., 'Exile? What Exile? Whose Exile?', in Lester L. Grabbe (ed.), *Leading Captivity Captive* (European Seminar in Historical Methodology, 2; JSOTSup, 278; Sheffield: Sheffield Academic Press, 1998), pp. 128-38.

Davis, J., *The Landscape of Belief: Encountering the Holy Land in Nineteenth-Century American Art and Culture* (Princeton: Princeton University Press, 1996).

De Hamel, C., *A History of Illuminated Manuscripts* (London: Guild Publishing, 1st edn, 1986).

—*A History of Illuminated Manuscripts* (London: Phaidon, 2nd edn, 1994).

Derbes, A., *Picturing the Passion in Late Medieval Italy: Narrative Painting, Franciscan Ideologies and the Levant* (Cambridge: Cambridge University Press, 1998).

Dille, S.J., *Mixing Metaphors: God as Mother and Father in Deutero-Isaiah* (JSOTSup, 398; London: T. & T. Clark International, 2004).

Dixon, J.W., *Art and the Theological Imagination* (New York: Seabury Press, 1978).

Dockery, J., *Emile Zola's Influence upon van Gogh* (www.vangoghgallery.com/visitors/009.htm).

Doré, G., *La Bible* (Paris: Ars Mundi, 1998).

Drury, J., *Painting the Word* (New Haven: Yale University Press, 1999).

Duchet-Suchaux, G., and M. Pastoureau (eds.), *The Bible and the Saints* (Flammarion Iconographic Guides; Paris: Flammarion Press, 1994).

Duquesne, J., *La Bible et ses peintures* (Paris: Fixot, 1989).

Ebeling, G., *The Word of God and Tradition* (London: Collins, 1968).

—*The Study of Theology* (London: Collins, 1974).

Heywood, I. and B. Sandwell, 'Explorations in the Hermeneutics of Vision', in Heywood and Sandwell (eds.), *Interpreting Visual Culture: Explorations in the Hermeneutics of the Visual* (London: Routledge, 1999), pp. ix-xviii.

Edson, L., *Reading Relationally: Postmodern Perspectives on Literature and Art* (Ann Arbor: University of Michigan Press, 2001).

Elliott, J.K. (ed.), *The Apocryphal New Testament: A Collection of Apocryphal Christian Literature* (Oxford: Clarendon Press, 1993).

—*The Apocryphal Jesus: Legends of the Early Church* (Oxford: Oxford University Press, 1996).

Ellis, M.H., *A Reflection on the Jewish Exile and the New Diaspora* (Liverpool: Friends of Sabeel UK, 1998).

Emmerson, G.I., 'Ruth', in John Barton and John Muddiman (ed.), *The Oxford Bible Commentary* (Oxford: Oxford University Press, 2001), pp. 192-95.

Erickson, K.P., *At Eternity's Gate: The Spiritual Vision of Vincent van Gogh* (Grand Rapids: Eerdmans, 1998).

Erickson, R.J., 'Divine Injustice? Matthew's Narrative Strategy and the Slaughter of the Innocents (Matthew 2.13-23)', *JSNT* 64 (1996), pp. 5-27.

Esrock, E.J., *The Reader's Eye* (Baltimore: John Hopkins University Press, 1994).

Exum, J.C., *Plotted, Shot, and Painted: Cultural Representations of Biblical Women* (Gender, Culture, Theory, 3; JSOTSup, 215; Sheffield: Sheffield Academic Press, 1996).

Farrar, F.W. 'The Massacre of the Innocents and the Flight into Egypt', in *The Life of Christ as Represented in Art* (London: Adam & Charles Black, 1894).

Foray, J.-M., *Message biblique Marc Chagall* (Paris: Réunion des musées nationaux, 2000).

Frankel, E., *The Illustrated Hebrew Bible* (New York: Stewart, Tabori & Chang, 2000).

Freedberg, D., *The Power of Images: Studies in the History and Theory of Response* (Chicago: University of Chicago Press, 1989).

Fretheim, T.E., 'Numbers', in John Barton and John Muddiman (eds.), *The Oxford Bible Commentary* (Oxford: Oxford University Press, 2001), pp. 110-34.

Gadamer, H.-G., *Truth and Method* (London: Sheed & Ward, 1975).

—*Heidegger's Ways* (Albany: New York University Press, 1994).

—'The Play of Art', in *The Relevance of the Beautiful and Other Essays* (ed. Nicholas Walker; Cambridge: Cambridge University Press, 1986), pp. 123-30.

Geyer-Ryan, H., 'Venice and the Violence of Location', in Mieke Bal (ed.), *The Practice of Cultural Analysis: Exposing Interdisciplinary Interpretations* (Stanford, CA: Stanford University Press, 1999), pp. 143-50.

Goldingay, J., 'The Place of Ishmael', in Philip R. Davies and David J.A. Clines (eds.), *The World of Genesis: Persons, Places, Perspectives* (JSOTSup, 257; Sheffield: Sheffield Academic Press, 1998), pp. 146-49.

Gombrich, E.H., *Shadows: The Depiction of Cast Shadows in Western Art* (London: National Gallery, 1995).

Gosse, B., 'Isaïe 28–32 et la redaction d'ensemble du livre d'Isaïe', *SJOT* 9 (1995), pp. 75-82.

Grabbe, L., *Leading Captivity Captive: 'The Exile' as History and Ideology* (European Seminar in Historical Methodology, 2; JSOTSup, 278; Sheffield: Sheffield Academic Press, 1998).

Grant, M. and J. Hazel, *Who's Who in Classical Mythology* (London: Routledge, 1996).

Greer, J.E., 'Man of Sorrows and Acquainted with Grief': The Christological Image of the Artist in Van Gogh's *Still Life with Open Bible*', *Jong Holland* 3 (1997), pp. 30-42.

Grubb, N., *The Life of Christ in Art* (New York: Abbeville, 1996).

Gundry, R.H., *Matthew: A Commentary on his Handbook for a Mixed Church under Persecution* (Grand Rapids: Eerdmans, 2nd edn, 1994).

Gunn, D.M., 'Yearning for Jerusalem: Reading Myth on the Web', in Fiona C. Black, Roland Boer and Erin Runions (eds.), *The Labour of Reading: Desire, Alienation, and Biblical Interpretation* (Semeia Studies, 36; Society of Biblical Literature, Atlanta: Scholars Press, 1999), pp. 123-40.

Hagen, R.M. and R. Hagen, *Pieter Bruegel* (Cologne: Taschen, 1994).

Hare, D.R.A., *Matthew* (Interpretation Series; Louisville: John Knox Press, 1993).

Harris, J.C., 'Art and Images in Psychiatry: *Still Life with Open Bible* and Zola's *La joie de vivre*', *Archives of General Psychiatry* 60 (2003), p. 1182.

Harris, R., *A Gallery of Reflections: The Nativity of Christ* (Oxford: Lion Publishing, 1995).

Harthan, J., *Books of Hours and their Owners* (London: Thames & Hudson, 1978),

—*The History of the Illustrated Book* (London: Thames & Hudson, 1997).

Harvey, P., *The Oxford Companion to Classical Literature* (Oxford: Oxford University Press, 1986).

Hatfield, R., *Botticelli's Uffizi 'Adoration': A Study in Pictorial Content* (Princeton: Princeton University Press, 1976).

Heidegger, M., *On the Way to Language* (New York: HarperCollins, 1982).

Heywood I., and B. Sandwell (eds.), *Interpreting Visual Culture: Explorations in the Hermeneutics of the Visual* (London: Routledge, 1999).

Hoekstra, H., *Rembrandt and the Bible* (London: Magna Books, 1990).

Horbury, W., 'The Wisdom of Solomon', in John Barton and John Muddiman (eds.), *The Oxford Bible Commentary* (Oxford: Oxford University Press, 2001), pp. 650-67.

Houston, W., 'Exodus', in John Barton and John Muddiman (eds.), *The Oxford Bible Commentary* (Oxford: Oxford University Press, 2001), pp. 67-91.

Hull, J.M., 'Open Letter from a Blind Disciple to a Sighted Saviour', in Martin O'Kane (ed.), *Borders, Boundaries and the Bible* (JSOTSup, 313; Sheffield: Sheffield Academic Press, 2002), pp. 154-77.

Hutchinson, J., *Patrick Hall* (Catalogue of Exhibition; Dublin: The Douglas Hyde Gallery, 1995).

Imberciadori, J.V., *The Collegiate Church of San Gimignano* (Poggibonsi, Tuscany: Nencini, 1998).

Jasper, D., 'Review of Boyd J., and P.F. Esler, *Visuality and the Biblical Text* (Florence: Leo S. Olschki Editore, 2004)', *Art and Christian Enquiry* 44 (2005), pp. 8-9.

Jay, M., *Downcast Eyes: The Denigration of Vision in Twentieth-Century French Thought* (Berkeley: University of California Press, 1993).

Jeffrey, D.L., *A Dictionary of Biblical Tradition in English Literature* (Grand Rapids: Eerdmans, 1992).

Jolly, P.H., *Made in God's Image? Adam and Eve in the Genesis Mosaics at San Marco, Venice* (Berkeley: University of California Press, 1997).

Jouanny, C., *Correspondance de Nicolas Poussin* (Paris: Archives de l'art français, 1911).

Kahvedjian, K., *Jerusalem through my Father's Eyes* (Jerusalem: Elia Photo Service, 1998).

Kaplan, P.D.H., *The Rise of the Black Magus in Western Art* (Ann Arbor: UMI Research Press, 1983).

Kauffmann, J.-P., *Wrestling with the Angel: The Mystery of Delacroix's Mural* (London: The Harvill Press, 2003).

Keane, J., *The Inconvenience of History: Paintings from Gaza and the West Bank* (London: Christian Aid, 2004).

Kent, C.F., *Biblical Geography and History* (New York: Charles Scribner's Sons, 1900).

Kessler, E., 'The Sacrifice of Isaac (the Akedah) in Christian and Jewish Tradition: Artistic Interpretations', in Martin O'Kane (ed.), *Borders, Boundaries and the Bible* (JSOTSup, 313; Sheffield: Sheffield Academic Press, 2002), pp. 74-98.

King, A., *Looking Forward: A Dream of the United States of the Americas in 1999* (New York: L.C. Childs & Son, 1899).

Kleiman, S., '"Museum and Vision": Interview with James Snyder', *Ariel: The Israel Review of Arts and Letters* 114 (2002), pp. 45-49.

Klemm, D.E., 'Hermeneutics', in John J. Hayes (ed.), *Dictionary of Biblical Interpretation* (Nashville: Abingdon Press, 1999), pp. 497-502.

König, E., 'On Deciphering the Pictures of the *Rest during the Flight into Egypt*—a Pastoral or Caravaggio's First Great Work?', in *Michelangelo Merisi da Caravaggio 1571–1610* (Cologne: Könemann, 1997).

Korpel, M., 'The Female Servant of the Lord in Isaiah 54', in Bob Becking (ed.), *On Reading Prophetic Texts: Gender-Specific and Related Studies in Memory of Fokkelien van Dijk-Hemmes* (Leiden: Brill, 1996), pp. 153-67.

Koudelka, J., *Exiles* (London: Thames & Hudson, 1997).

Kramer, P.S., 'The Dismissal of Hagar in Five Art Works of the Sixteenth and Seventeenth Centuries', in Athalya Brenner (ed.), *Genesis: A Feminist Companion to the Bible* (Sheffield: Sheffield Academic Press, 1998), pp. 195-217.

Kreitzer, L.J., *Film and Fiction in the Old Testament: On Reversing the Hermeneutical Flow* (The Biblical Seminar, 24; Sheffield: Sheffield Academic Press, 1994).

—*Gospel Images in Fiction and Film: On Reversing the Hermeneutical Flow* (The Biblical Seminar, 84; Sheffield: Sheffield Academic Press, 2002).

Kwakkel, G., 'Taking Refuge in the Shadow of YHWH's Wings' (unpublished paper, European Association of Biblical Studies, Dresden: August 2005).

Lakoff, G., and M. Johnson, *Metaphors We Live By* (Chicago: University of Chicago Press, 1980).

Landy, F., 'Strategies of Concentration and Diffusion in Isaiah 6', in Francis Landy (ed.), *Beauty and the Enigma and Other Essays on the Hebrew Bible* (JSOTSup, 312; Sheffield: Sheffield Academic Press, 2001), pp. 298-327.

Langdon, H., *Caravaggio: A Life* (London: Chatto & Windus, 1998).

Leeuw, R. de. *The Letters of Vincent van Gogh* (London: Penguin, 1997).

Lemaire, G.-G., *The Orient in Western Art* (Cologne: Könemann, 2001).

Lincoln, F., *The First Christmas* (London: The National Gallery, 1992).

Long, B.O., 'Reading the Land: Holy Land as Text and Witness', in Fiona C. Black, Roland Boer and Erin Runions (eds.), *The Labour of Reading: Desire, Alienation, and Biblical Interpretation* (Semeia Studies, 36; Society of Biblical Literature, Atlanta: Scholars Press, 1999), pp. 141-59.

Lubin, A.J., *Strangers on the Earth: A Psychological Biography of Vincent van Gogh* (New York: Da Capo Press, 1972).

Luz, U., *The Theology of the Gospel of Matthew* (Cambridge: Cambridge University Press, 1995).

—*Matthew 1–7: A Commentary* (Edinburgh: T. & T. Clark, 1989).

MacGregor, N., *Seeing Salvation* (London: The National Gallery, 2000).

Magonet, J., *Bible Lives* (London: SCM Press, 1992).

Mahon, D., *Nicholas Poussin: Works from his First Years in Rome* (Jerusalem: The Israel Museum, 1999).

Marciari, J., 'Review of Paulo Berdini, *The Religious Art of Jacopo Bassano: Painting as Visual Exegesis* (Cambridge: Cambridge University Press, 1997)', *Speculum* 75 (2000), pp. 440-41.

Marguerat, D., and Y. Bourquin, *How to Read Bible Stories* (London: SCM Press, 1999).

Marks, H., 'The Twelve Prophets', in Robert Alter and Frank Kermode (eds.), *The Literary Guide to the Bible* (London: Fontana, 1987), pp. 207-33.

McIntyre, J., *Faith, Theology and Imagination* (Edinburgh: Handsel Press, 1987).

McNamee, M.B., *Vested Angels: Eucharistic Allusions in Early Netherlandish Paintings* (Leuven: Peeters, 1998).

Melville, A.D., *Ovid: Metamorphoses* (Oxford: Oxford World's Classics, 1986).

Merback, M.B., 'Reverberations of Guilt and Violence, Resonances of Peace: A Comment on Caroline Walker Bynum's Lecture', *German Historical Institute Bulletin* 30 (Spring 2002), pp. 37-50.

Mérot, A., *Nicolas Poussin* (New York: Abbeville, 1990).

Miller, J., *On Reflection* (London: The National Gallery, 1998).

Miller, J.E., *The Western Paradise: Greek and Hebrew Traditions* (San Francisco: International Scholars Publications, 1997).

Miller, M., *Chartres Cathedral* (Andover, Hampshire: Pitkin, 1996).

Mintz, A., *Hurban: Responses to Catastrophe in Hebrew Literature* (New York: Columbia University Press, 1984).

Mitchell, W.J.T., *Iconology: Image, Text, Ideology* (Chicago: Chicago University Press, 1985).

Moberly, R.W.L., *Genesis 12–50* (Old Testament Guides; Sheffield: JSOT Press, 1992).

Morgan, D., *The Sacred Gaze: Religious Visual Culture in Theory and Practice* (Berkeley: University of California Press, 2005).

Mormando, F., 'An Early Renaissance Guide for the Perplexed: Bernardino of Siena's *De inspirationibus*', in John C. Hawley (ed.), *Through a Glass Darkly: Essays in the Religious Imagination* (New York: Fordham University Press, 1996), pp. 24-49.

Murray, P., and L. Murray, *The Oxford Companion to Christian Art and Architecture* (Oxford: Oxford University Press, 1996).

Neusner, J., *Understanding Seeking Faith: Essays on the Case in Judaism* (Atlanta: Scholars Press, 1986).

Nickelsburg, G.W.E., *Jewish Literature between the Bible and the Mishnah* (London: SCM Press, 1981).

Noble, T.F.X., 'Review of M.A. Powell, *Chasing the Eastern Star: Adventures in Biblical Reader-Response Criticism* (Louisville: Westminster John Knox Press, 2001)', *History of Religions* 40 (2001), pp. 304-06.

O'Kane, M., 'The Biblical King David and his Artistic and Literary Afterlives', *BibInt* 6 (1998) pp. 313-47.

—'The Flight into Egypt: Icon of Refuge for the H(a)unted', in Martin O'Kane (ed.), *Borders, Boundaries and the Bible* (JSOTSup, 313; Sheffield: Sheffield Academic Press, 2002), pp. 15-60.

Onians, J., 'The Biological Basis of Renaissance Aesthetics', in Frances Ames-Lewis and Mary Rogers (eds.), *Concepts of Beauty in Renaissance Art* (Aldershot: Ashgate, 1998), pp. 2-27.

Pann, A., *The Five Books of Moses: Abel Pann* (Jerusalem: Mayanot Gallery, 1996).

Peck, R.A., 'Rebekah', in David Lyle Jeffrey (ed.), *A Dictionary of Biblical Tradition in English Literature* (Grand Rapids: Eeerdmans, 1992), pp. 656-57.

Pelikan, J., *Imago Dei: The Byzantine Apologia for Icons* (Princeton: Princeton University Press, 1990).

Perez, N.N., *Visions d'orient* (Jerusalem: The Israel Museum, 1995).

—*Revelation: Representations of Christ in Photography* (London: Merrell Publishers, 2003).

Peters, F.E., *Jerusalem* (Princeton: Princeton University Press, 1985).

Powell, M.A., *The Gospels* (Philadelphia: Fortress Press, 1998).

—*Chasing the Eastern Star: Adventures in Biblical Reader-Response Criticism* (Louisville: Westminster John Knox Press, 2001).

—'The Magi as Kings: An Adventure in Reader-Response Criticism', *CBQ* 62 (2000), pp. 459-80.

—'The Magi as Wise Men: Re-examining a Basic Assumption', *NTS* 46 (2000), pp. 1-20.

Prickett, S., 'The Idea of Character in the Bible: Joseph the Dreamer', in Martin O'Kane (ed.), *Borders, Boundaries and the Bible* (JSOTSup, 313; Sheffield: Sheffield Academic Press, 2002), pp. 180-93.

Prior, M., *Zionism and the State of Israel: A Moral Inquiry* (London: Routledge, 1999).

Quinn-Miscall, P., *Reading Isaiah: Poetry and Vision* (Louisville: Westminster John Knox Press, 2001).

Rad, G. von, *Genesis* (Philadelphia, Westminster Press, 1972).

Ragusa, I., and R.B. Green (eds.), *Meditations on the Life of Christ* (Princeton, NJ: Princeton University Press, 1961).

Ran, N., *The Holy Land: 123 Coloured Facsimile Lithographs of David Roberts* (Jerusalem: Terra Sancta Arts, 1982).

Rhymer, J., *The Illustrated Life of Jesus Christ* (London: Bloomsbury, 1994).

Ricoeur, P., *The Rule of Metaphor: Multi-disciplinary Studies of the Creation of Meaning in Language* (Toronto: Toronto University Press, 1977).

—*Hermeneutics and the Human Sciences* (ed. and trans. John B. Thompson; Cambridge: Cambridge University Press, 1981).

Ridderbos, B., 'The Man of Sorrows: Pictorial Images and Metaphorical Statements', in A.A. MacDonald, H.N.B. Ridderbos and R.M. Schlusemann (eds.), *The Broken Body: Passion Devotion in Late-Medieval Culture* (Groningen: Egbert Forsten, 1998), pp. 146-81.

Ronen, A., 'Poussin's *Destruction of Jerusalem* and yis Early Years in Rome', in Anna Barber (ed.), *Nicholas Poussin: A Rediscovered Masterpiece* (Jerusalem: The Israel Museum, 1999), pp. 13-15.

Ruda, J., *Fra Filippo Lippi: Life and Work* (London: Phaidon, 1999).

Rulon-Miller, N., 'Hagar: A Woman with an Attitude', in Philip R. Davies and David J.A. Clines (eds.), *The World of Genesis: Persons, Places, Perspectives* (JSOTSup, 257; Sheffield: Sheffield Academic Press, 1998.), pp. 60-89.

Ruvoldt, M., *The Italian Renaissance Imagery of Inspiration: Metaphors of Sex, Sleep and Dreams* (Cambridge: Cambridge University Press, 2004).

Ryken, L., J.C. Wilhoit, and T. Longman III, *The Dictionary of Biblical Imagery* (Downers Grove, IL: Intervarsity Press; Leicester, England: Intervarsity Press, 1998).

Sandys-Wunsch, J. (ed.), 'Graven Image', in David Lyle Jeffrey (ed.), *A Dictionary of Biblical Tradition in English Literature* (Grand Rapids: Eerdmans, 1992), pp. 320-23.

Santoni, E. *La vie de Jésus* (Paris: Editions Hermé, 1990).

Sawyer, J.F.A., 'Daughter of Zion and Servant of the Lord in Isaiah: A Comparison', *JSOT* 44 (1989), pp. 89-107.

—*The Fifth Gospel: Isaiah in the History of Christianity* (Cambridge: Cambridge University Press, 1996).

Schama, S., *Rembrandt's Eyes* (London: Penguin Books, 1999).

Schwebel, H., *Das Christusbild in der bildenden Kunst der Gegenwart* (Giessen: Wilhelm Schmitz Verlag, 1980).

Senior, D., *What Are They Saying about Matthew?* (New York: Paulist Press, 1996).

Sherry, P., *Spirit and Beauty* (London: SCM Press, 2nd edn, 2002).

Shuger, D.K., *The Renaissance Bible: Scholarship, Sacrifice and Subjectivity* (Berkeley: University of California Press, 1994).

Solinas, F., 'The Destruction and Sack of Jerusalem in its Cultural and Political Context', in Anna Barber (ed.), *Nicholas Poussin: A Rediscovered Masterpiece* (Jerusalem: The Israel Museum, 1999), pp. 7-12.

Sölle, D., J.H. Kirchberger and H. Haag (eds.), *Great Women of the Bible in Art and Literature* (Grand Rapids: Eerdmans, 1994).

Sonnet, J.-P., 'Le motif de l'endurcissement (Is 6, 9-10) et la lecture d' "Isaïe"', *Bib* 73 (1992), pp. 208-39.

Stanton, G.N., 'Galatians', in John Barton and John Muddiman (eds.), *The Oxford Bible Commentary* (Oxford: Oxford University Press, 2001), pp. 1152-65.

Steinsalt, A., *Biblical Images* (Northvale, NJ: Jason Aronson, 1994).

Stepanov, A., *Lucas Cranach the Elder, 1472–1553* (Bournemouth: Parkstone, 1997).

Stock, A., *The Method and Message of Matthew* (Collegeville, MN: Liturgical Press, 1994).

Tamez, E., 'Ishmael', in J.S. Pobee and B. von Wartenberg-Potter (eds.), *New Eyes for Seeing* (Quezon City, Philippines: Claretian, 1987), pp. 5-17.

Tarragon, J.-M. de, *Al-Quds Al-Sharif: Photographies 1890–1925: patrimoine musulman de la Vielle Ville de Jérusalem* (Jerusalem: Ecole Biblique, 2002).

Thevoux, M., *L'académisme et ses fantasmes: le réalisme imaginaire de Charles Gleyre* (Paris: Editions de Minuit, 1980).

Thiessen, G.E., *Theology and Modern Irish Art* (Dublin: Columba Press, 1999).

Thiselton, A.C., *The Two Horizons: New Testament Hermeneutics and Philosophical Description* (Exeter: Paternoster Press, 1980).

—'Biblical Studies and Theoretical Hermeneutics', in John Barton (ed.), *The Cambridge Companion to Biblical Interpretation* (Cambridge: Cambridge University Press, 1998), pp. 95-113.

Thomas, A., *Illustrated Dictionary of Narrative Painting* (London: The National Gallery Publications, 1994).

Thomson, W.M., *The Land and the Book* (London: T. Nelson & Sons, 1880).

Tillich, P., 'Art and Ultimate Reality', in Michael Palmer (ed.), *Paul Tillich: Main Works* (Berlin: de Gruyter, 1990), II, pp. 317-22.

Topping, E.C., 'St Romanos the Melodos and his First Nativity Kontakion', *Greek Orthodox Review* 21 (1976), pp. 231-50.

Torito, M., *Pinacoteca Nazionale di Siena* (Genova: Sagep Editrice, 1993).

Trexler, R., 'Gendering Christ Crucified', in Brendan Cassidy (ed.), *Iconography at the Crossroad* (Princeton: Princeton University Press, 1996), pp. 107-19.

—*The Journey of the Magi: Meanings in History of a Christian Story* (Princeton: Princeton University Press, 1997).

Trible, P., *Texts of Terror: Literary-Feminist Readings of Biblical Narratives* (London: SCM Press, 1992).

Turner, L., *Genesis* (Readings; Sheffield: Sheffield Academic Press, 2000).

Usherwood, N., *The Bible in 20th Century Art* (London: Pagoda, 1987).

Van Dyke, H., *Harper's New Monthly Magazine* (December 1889).

Verdi, R., *Nicholas Poussin 1594–1665* (London: The Royal Academy of Arts, 1995).

—*Art Treasures of England: The Regional Collections* (London: The Royal Academy of Arts, 1998).

—*Matthias Stom: Isaac Blessing Jacob* (Birmingham: The Barber Institute of Fine Arts, 1999).

—*The Barber Institute of Fine Arts* (London: Scala, 1999).

—*Anthony van Dyck: Ecce Homo and the Mocking of Christ* (Birmingham: The Barber Institute of Fine Arts, 2002).

Verkerk, D., *Early Medieval Bible Illumination and the Ashburnham Pentateuch* (Cambridge: Cambridge University Press, 2004).

Wainwright, E., 'The Gospel of Matthew', in Elisabeth Schüssler Fiorenza (ed.), *Searching the Scriptures: A Feminist Commentary* (London: SCM Press, 1995), pp. 635-77.

Walker Bynum, C., 'Violent Imagery in Late Medieval Piety', *German Historical Institute Bulletin* 30 (Spring 2002), pp. 3-36.

Wessels, A., '*A Kind of Bible'*: *Vincent van Gogh as Evangelist* (London: SCM Press, 2000).

Westermann, C., *Isaiah 40–66: A Commentary* (Louisville, KY: Westminster John Knox Press, 1969).

Whybray, R.N., *Second Isaiah* (Old Testament Guides; Sheffield: JSOT Press, 1983).

—'Genesis', in John Barton and John Muddiman (ed.), *The Oxford Bible Commentary* (Oxford: Oxford University Press, 2001), pp. 38-66.

Wielenga, B., 'Experiences with a Biblical Story', in R.S. Sugirtharajah (ed.), *The Postcolonial Bible* (Sheffield: Sheffield Academic Press, 1998), pp. 189-98.

Williamson, H.G.M., 'Micah', in John Barton and John Muddiman (ed.), *The Oxford Bible Commentary* (Oxford: Oxford University Press, 2001), pp. 595-99.

Wilson, C.A., *Italian Paintings XIV–XVI Centuries in the Museum of Fine Arts, Houston* (Houston: Museum of Fine Arts, Rice University Press. London: Merrell Holberton, 1996).

Wilson, E., and M. Blum, *Jerusalem: Reflections of Eternity* (London: Shepheard–Walwyn Publishers, 1990).

Wright, S., *The Bible in Art* (New York: Smithmark, 1996).

Wylie, J.A., *Over the Holy Land* (London; James Nisbet & Company, 1883).

Zalmona, Y., 'A Rediscovered Masterpiece Reaches Jerusalem', in Anna Barber (ed.), *Nicholas Poussin: A Rediscovered Masterpiece* (Jerusalem: The Israel Museum, 1999), pp. 4-6.

Zemel, C., 'Sorrowing Women, Rescuing Men: Van Gogh's Images of Women and Family', *Art History* 10.3 (1987), pp. 351-68.

—'Imagining the "Shtetl": Visual Theories of Nationhood', in Mieke Bal (ed.), *The Practice of Cultural Analysis: Exposing Interdisciplinary Interpretations* (Stanford: Stanford University Press, 1999), pp. 102-21.

Zenger, E., 'David as Musician and Poet: Plotted and Painted', in J. Cheryl Exum and Stephen D. Moore (eds.), *Biblical Studies, Cultural Studies* (JSOTSup, 266; Sheffield: Sheffield Academic Press, 1998), pp. 263-98.

Zlotowitz, M., *Bereishis* (Jerusalem: Mesorah Publications, 1995).

INDEXES

INDEX OF REFERENCES

BIBLE

<center>OTHER ANCIENT LITERATURE</center>

INDEX OF AUTHORS

Lightning Source UK Ltd.
Milton Keynes UK
UKOW052100100113

204689UK00002B/27/P